MEXICAN DESIGN

Architects / Designers	Project	Page

INTRODUCTION

LIVING SPACES – PRIVATE HOUSES, APARTMENTS & LOFTS

PUBLIC SPACES – RELIGIOUS, CULTURAL & SPORTS

HOSPITALITY SPACES – HOTELS & RESORTS

Architects / Designers	Project	Page

HOSPITALITY SPACES – HOTELS & RESORTS

LEISURE SPACES – RESTAURANTS, LOUNGES & BARS

RETAIL SPACES – SHOWROOMS, SHOPS & MARKETS

WORKING SPACES – CORPORATE BUILDINGS & INTERIORS

INTRODUCTION

Mexican design is a weaving layer of ancient high cultures from the sacred metropolis of the Aztec civilization up to the present. The relationship between the past and the present is manifested with the use of materials, light, uninhibited colors, contrasting tones, textures and the delicate conservancy of space. By synthesizing new dynamisms in the treatment of architectonic elements the contemporary language is contextualized to create a map of details that adds to the continuous natural landscape of Mexico's seductive geography. The transformation and tendencies of Mexican design of the last decade are the result of continuous changes in the country as well as the international influences. This book features a fine selection of the most vibrant spaces created by a new generation of architects and designers; fusing naturally function and aesthetics, focusing on details to embrace its context mutually. It includes projects from TEN Arquitectos that seeks to unite the aspirations of the modern world with the traditions of the native culture and environment. Another example is Legorreta + Legorreta that with his own vision follows the tradition of Luís Barragan who gave character to Mexican architecture. Higuera + Sánchez whose design focuses not on spectacular audience, but rather on form following function to generate spaces with its own poetry. By keeping a fundamental honesty and clarity of its makers, architects and designers have conceived a timeless path. This embryonic architecture and design seeks for perpetuation…

El diseño de México ha sido formado a través de un tejido de altas culturas antiguas desde la sagrada metrópolis de la civilización Azteca hasta el presente. La relación entre el pasado y presente se manifiesta con el uso de materiales, luz, desinhibidos colores, tonos opuestos, texturas y la delicada conservación del espacio. Sintetizando nuevos dinamismos en el tratamiento de elementos arquitectónicos el lenguaje contemporáneo esta contextualizado para crear un mapa de detalles que añade al continuo paisaje natural de la geografía seductiva de México. La transformación y tendencias del diseño mexicano de la última década han sido el resultado de los cambios continuos en el país así como de las influencias internacionales. Este libro presenta una magnifica selección de los espacios más vibrantes creados por una nueva generación de arquitectos y diseñadores; fundiendo naturalmente la función y estética, enfocándose en los detalles para abrazar su contexto mutuamente. Incluyendo proyectos de TEN Arquitectos quienes intentan unir las aspiraciones del mundo moderno con las tradiciones de las culturas indígenas y el ambiente. Entre otros ejemplos Legorreta + Legorreta que con visión propia sigue la tradición de Luís Barragán quien le dio carácter ala arquitectura mexicana. Higuera + Sánchez cuyo diseño se enfoca no solo en el auditorio espectacular, en lugar en la forma siguiendo ala función para generar espacios con su propia poesía. Manteniendo una honestidad y claridad fundamental con sus trabajadores, arquitectos y diseñadores han concebido un sendero eterno. Este embrión de arquitectura y diseño busca perpetuación…

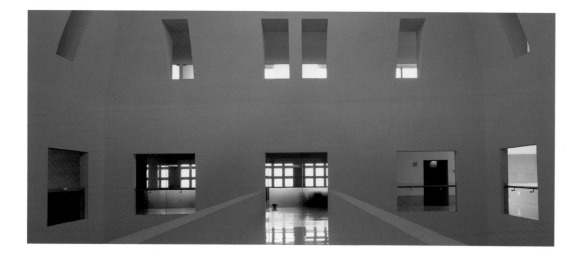

Mexican Design gleicht einem Mosaik, dessen Steinchen sich von den ehemaligen Hochkulturen bis in die Gegenwart zu einer starken Gestaltungsidentität zusammenfügen. Die diesem Land eigene Vermengung aztekischer Wurzeln mit moderner Technologie manifestiert sich im unverkrampften Umgang mit Werkstoffen, Licht, Oberflächenstrukturen und kraftvollen Farben, aber auch in behutsamen Neuinterpretationen von Traditionen. Die zeitgenössische Formensprache weist eine Dynamik auf, die an die geographische Struktur des Landes erinnert, mit Ecken und Kanten, Höhen und Tiefen, weichen Sandstränden und schroffen Felsformationen. Architektur und Design der Gegenwart spiegeln aber auch die gesellschaftlichen Umwälzungen der letzten Dekade wider, in der sich Mexiko als zukunftsorientierter Staat mit enormen Potentialen positioniert hat. Internationale Designeinflüsse sind erkennbar, sie verwässern aber nicht zu einer globalen Soße. Mexican Design enthält vielmehr eine Auswahl der aufregendsten Projekte, die die Designidentität des Landes nachhaltig verkörpern. Fast ausnahmslos tragen sie die Handschrift einer selbstbewussten Generation von Architekten und Designern. Ihre klare Formensprache mit oftmals poetischer Ästhetik entwickelt sich erkennbar aus einem funktionalen Fundament heraus. Auffällig ist die Konzentration auf Details, die den hier gezeigten Projekten ihre Spannung verleihen und den Leser inspirieren. Wie Tradition und Moderne intelligent miteinander verwoben sein können, zeigen u.a. die Projekte der mexikanischen Architekturstars TEN Arquitectos. Meister im Umgang mit Farbe sind Legorreta + Legorreta, die in ihrer Ausdrucksweise der Tradition von Luís Barragan folgen, der wie kaum ein anderer mexikanische Architektur geprägt hat. Higuera + Sánchez beweisen wiederum, wie sich Weltklassedesign auch ganz ohne spektakuläre Inszenierungen durchsetzen kann. Ehrlichkeit und Klarheit sind Tugenden dieser energiegeladenen Macher, die zeitloses Design mit lateinamerikanischer Lebensfreude kreieren. Diese gerade erst startende Gestaltungskraft begehrt nach Verewigung.

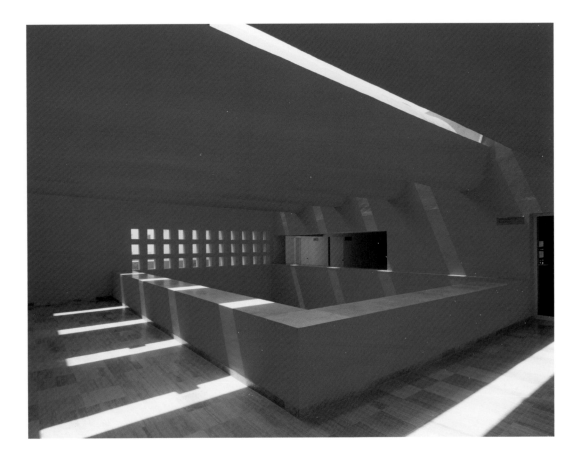

Mexican design est semblable à un canevas des anciennes civilisations depuis la métropole sacrée des Aztèques jusqu'à notre époque actuelle. Cette relation entre le passé et le présent se manifeste par l'utilisation de matériaux, de la lumière, de couleurs puissantes, de tons contrastants, de textures mais aussi par une nouvelle interprétation pleine de délicatesse des traditions. Le langage contemporain des formes démontre une dynamique qui rappelle la structure géographique du pays, avec son caractère, ses hauts et ses bas, ses belles plages de sable et ses formations rocheuses escarpées. La transformation et les tendances du design mexicain de la dernière décennie sont le résultat de changements constants dans le pays ainsi que d'influences internationales. Cet ouvrage illustre une sélection représentative des projets les plus intéressants que l'on doit à une nouvelle génération d'architectes et de concepteurs qui associent naturellement fonctionnalité et esthétique, se concentrent sur les détails pour arriver à une synthèse parfaite. Il présente des projets du groupe TEN Arquitectos qui cherche à répondre aux aspirations du monde moderne tout en respectant les traditions de la culture mexicaine et l'environnement. Autres exemples : Legorreta + Legorreta qui, avec sa propre vision, suit la tradition de Luís Barragan qui a marqué l'architecture mexicaine, ou encore Higuera + Sánchez dont le design ne repose pas sur une mise en scène spectaculaire, mais plutôt sur une adaptation de la forme à la fonction pour donner le jour à des espaces avec leur propre poésie. Les architectes et les concepteurs ont su créer un design intemporel tout en conservant l'honnêteté et la clarté fondamentales de ses bâtisseurs. Cette architecture et ce design, encore à un stade embryonnaire, sont à la recherche de l'immortalité.

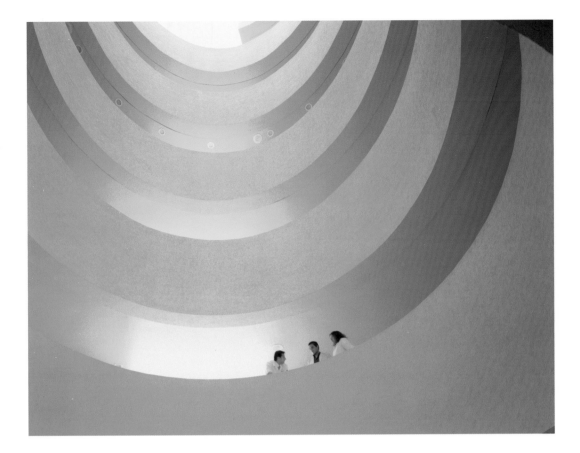

Lo stile messicano parte dalle vecchie culture alte della sacra metropoli della civiltà azteca fino al presente. La relazione tra il passato e il presente viene rappresentata attraverso l'uso di materiale, luce, colori sfrenati, cromatiche distinguenti, superfici e la conservazione di spazi. Sintetizzando nuovi dinamismi nel trattamento di elementi architettonici, il linguaggio contemporaneo viene contestualizzato per creare carta geografica di dettagli da aggiungere al paesaggio naturale continuo della seducente geografia messicana. La trasformazione e le tendenze dello stile messicano dell'ultimo decennio sorgono dai cambiamenti continui nel paese come anche dalle influenze internazionali. Questo libro rappresenta una scelta fine degli spazi più dinamici creati da una nuova generazione di architetti e designer che uniscono la funzione naturale con l'estetica concentrandosi su dei dettagli per considerare mutualmente il contesto. Esso include dei progetti della TEN Arquitectos che cerca di unire i desideri del mondo moderno con le tradizioni dell'ambiente e della cultura nativa. Legorreta + Legorreta è un altro esempio che con la sua visione segue la tradizione di Luís Barragan, che ha caratterizzato l'architettura messicana. Higuera + Sánchez, di cui design non si concentra su una audienza spettacolare ma piuttosto su delle forme che seguono una funzione per creare degli spazi con la propria poesia. Gli architetti e designer hanno concepito un sentiero non soggetto al tempo mantenendo una onestà e chiarezza dei suoi creatori. Questo design e questa architettura ancora non sviluppata desidera essere perpetuata...

LIVING SPACES – PRIVATE HOUSES, APARTMENTS & LOFTS

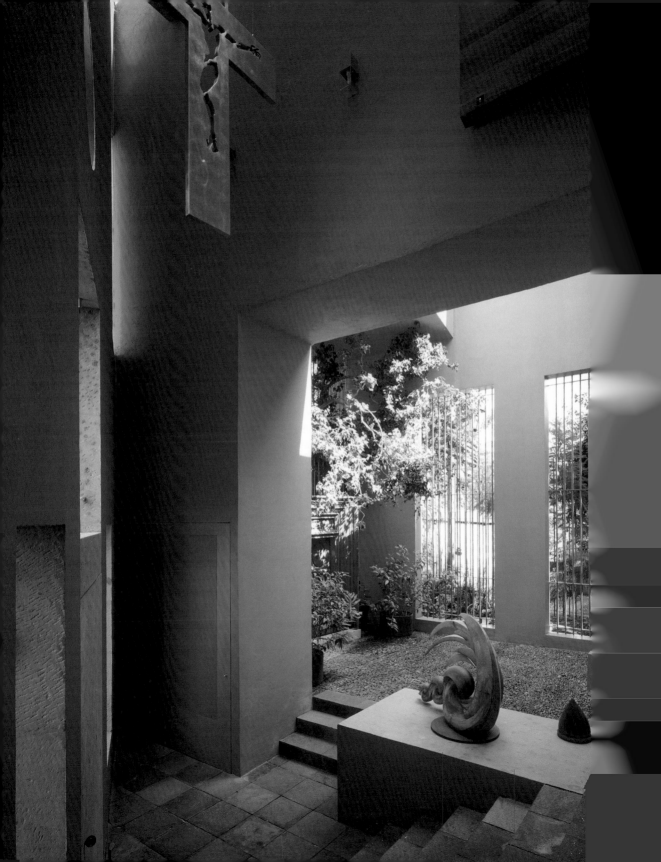

ARQUINTEG, S.A. DE C.V. | MEXICO CITY
SERGIO MEJÍA ONTIVEROS
Casa Diego Rivera
Living Spaces
San Ángel, Mexico City | 2004
Photos: Luis Gordoa

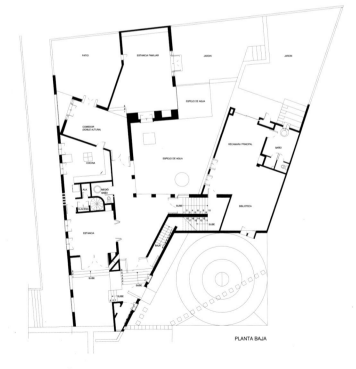

PLANTA BAJA

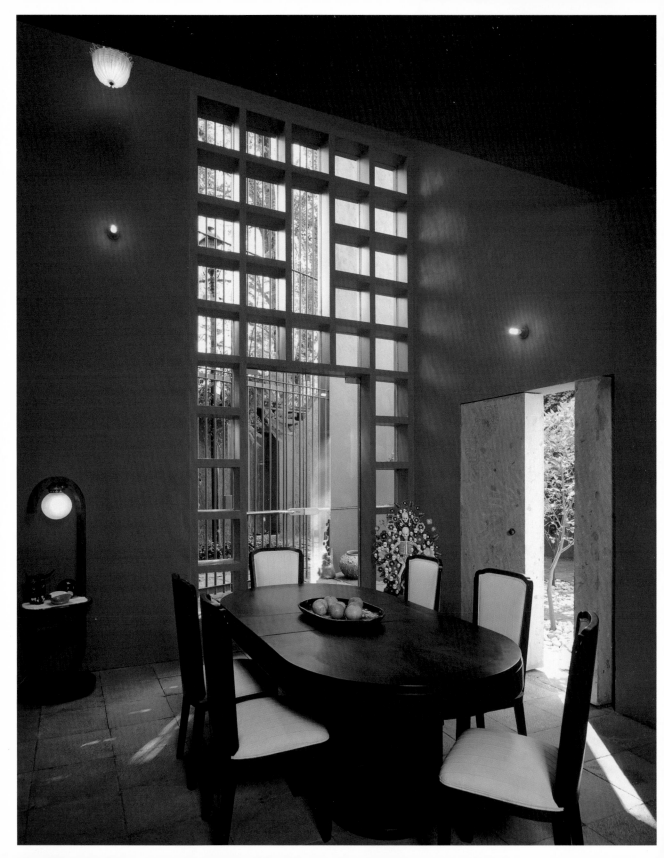

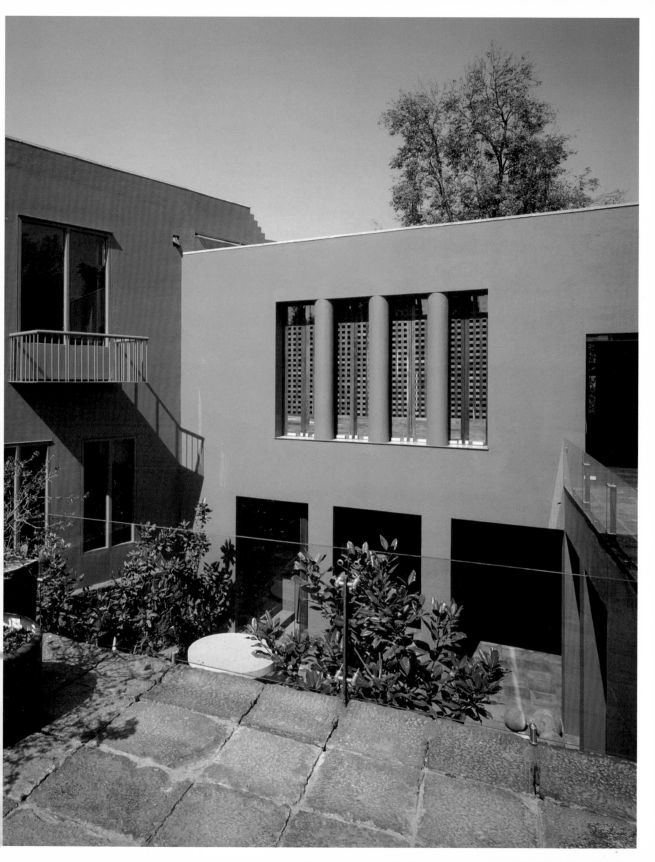

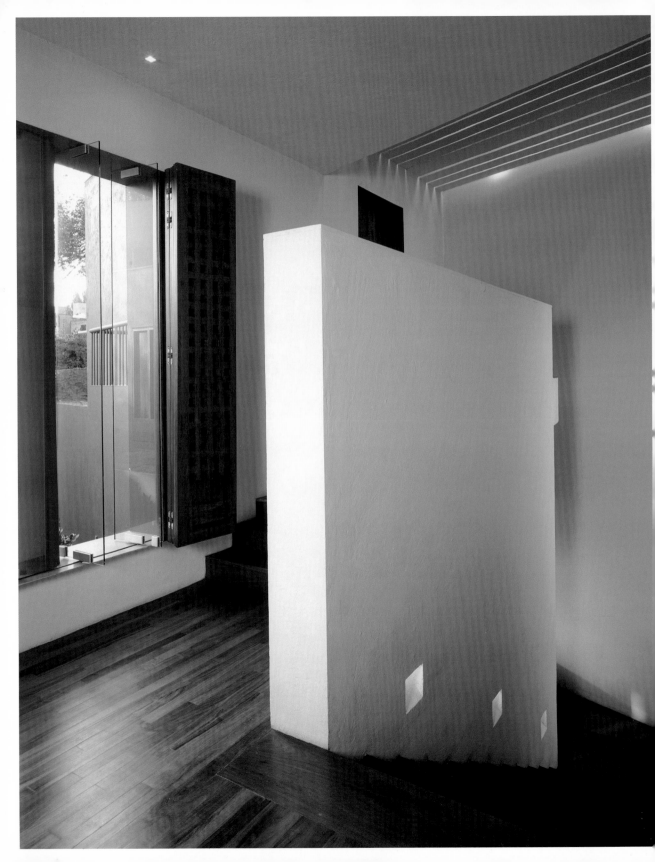

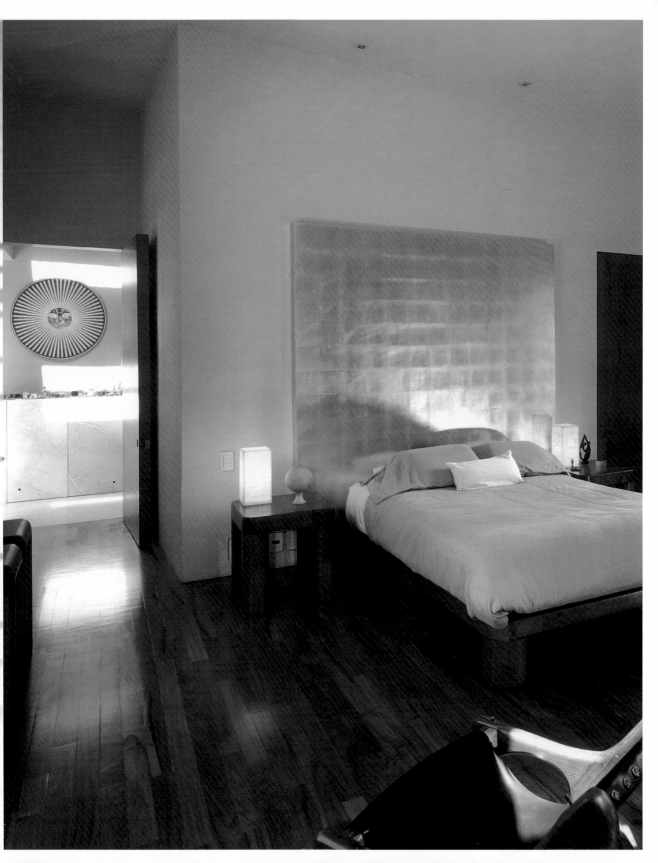

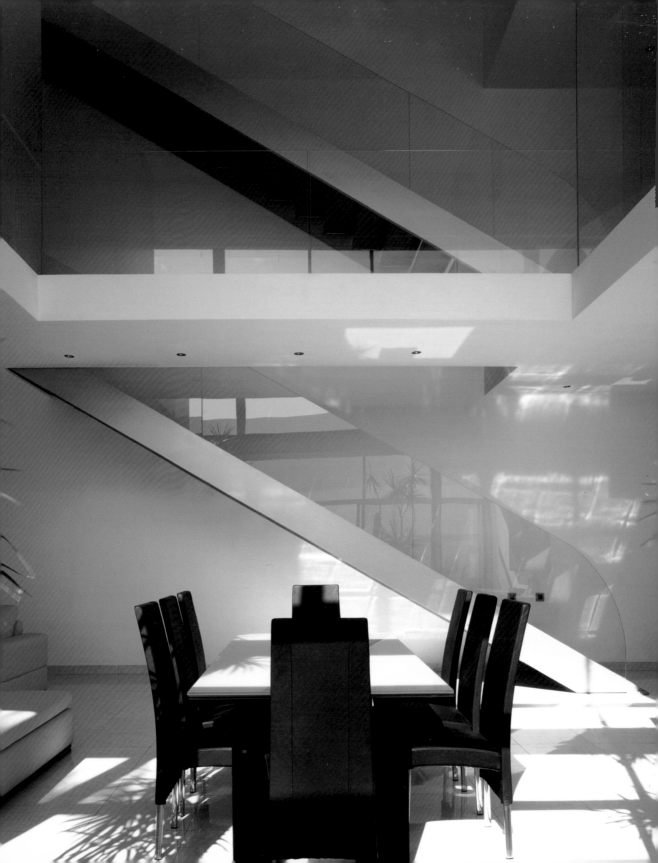

AUGUSTO QUIJANO ARQUITECTOS, S.C.P. | MÉRIDA, YUCATÁN
AUGUSTO QUIJANO AXLE, GASPAR PÉREZ AXLE
Casa Corta
Living Spaces
Mérida, Yucatán | 2003
Photos: Roberto Cárdenas Cabello

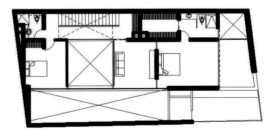

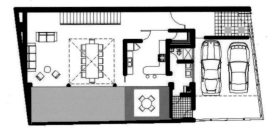

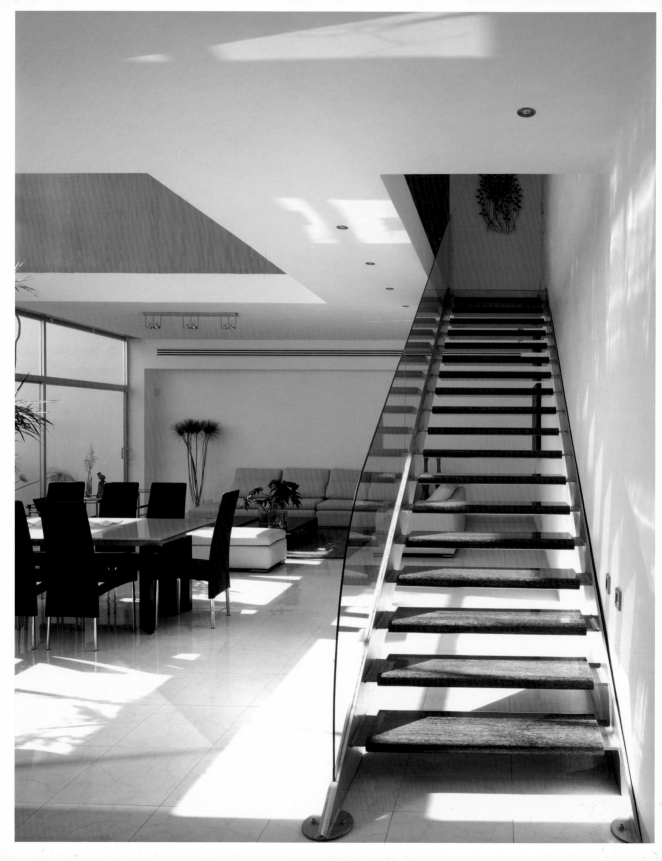

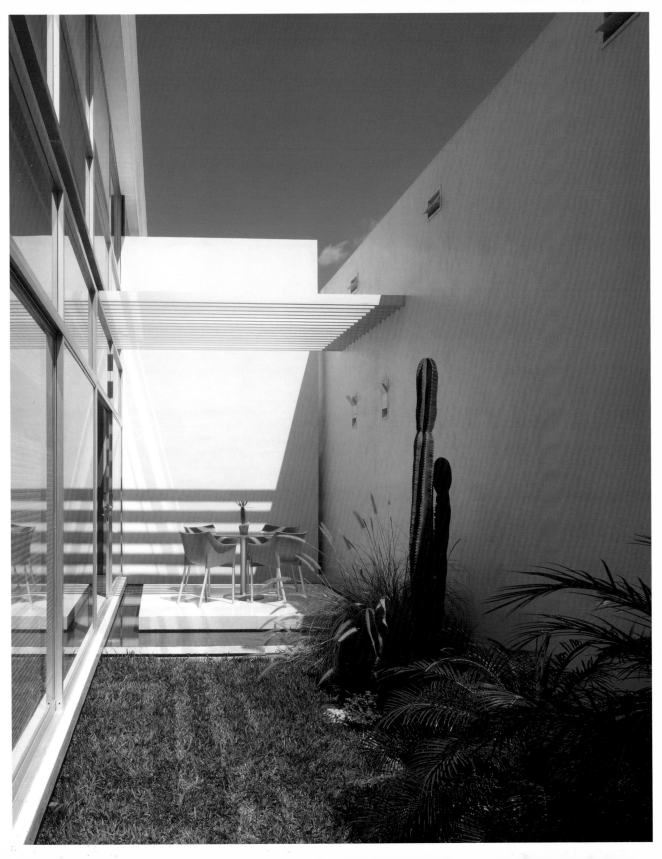

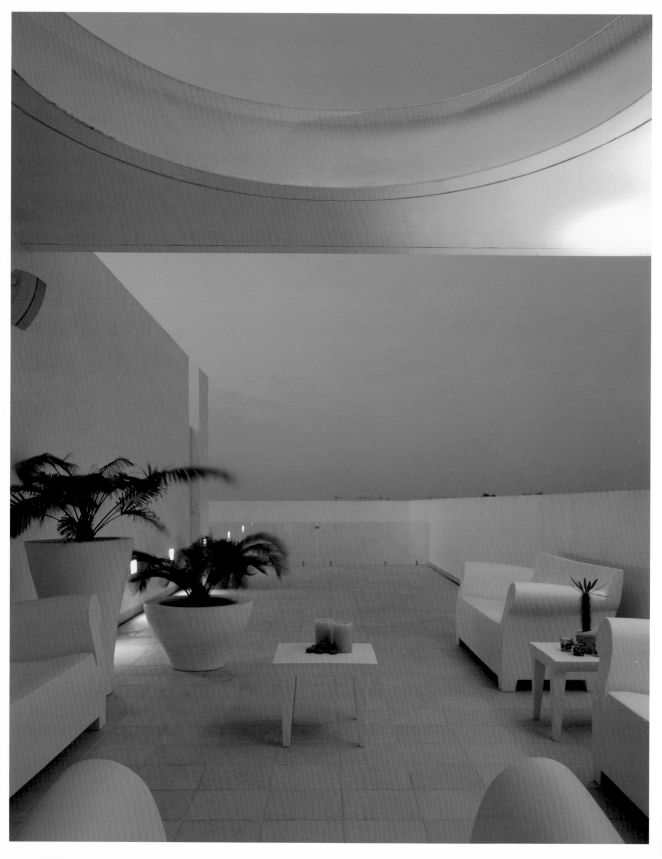

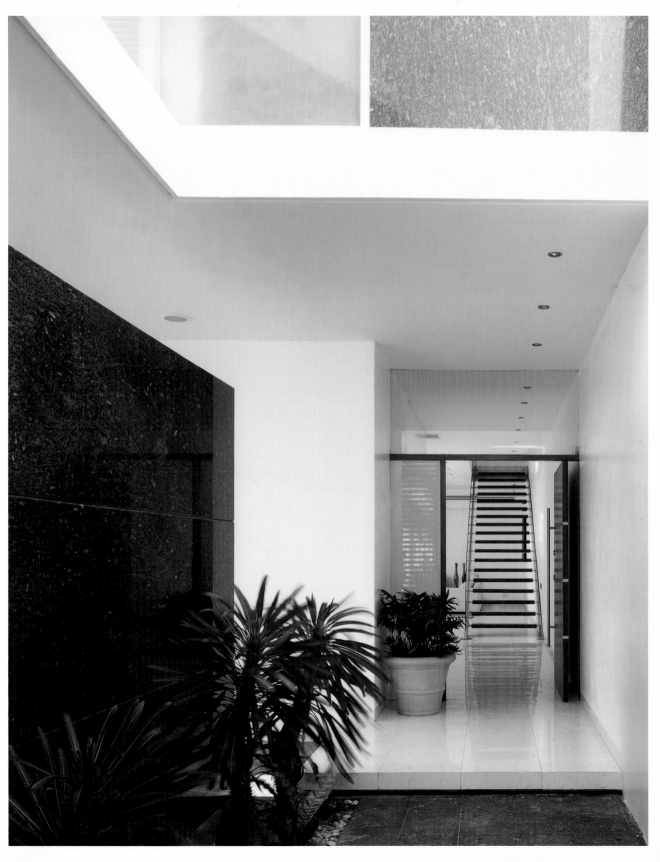

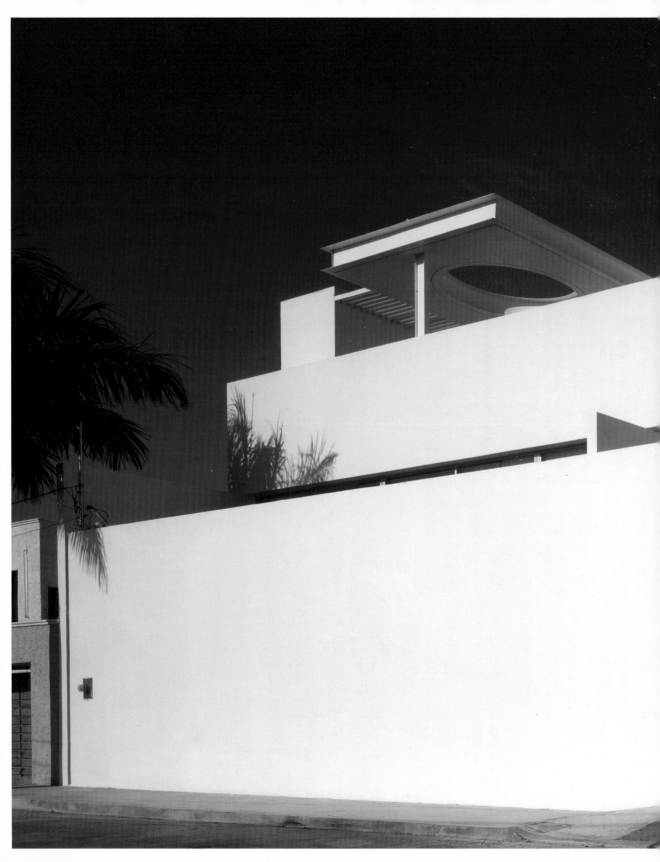

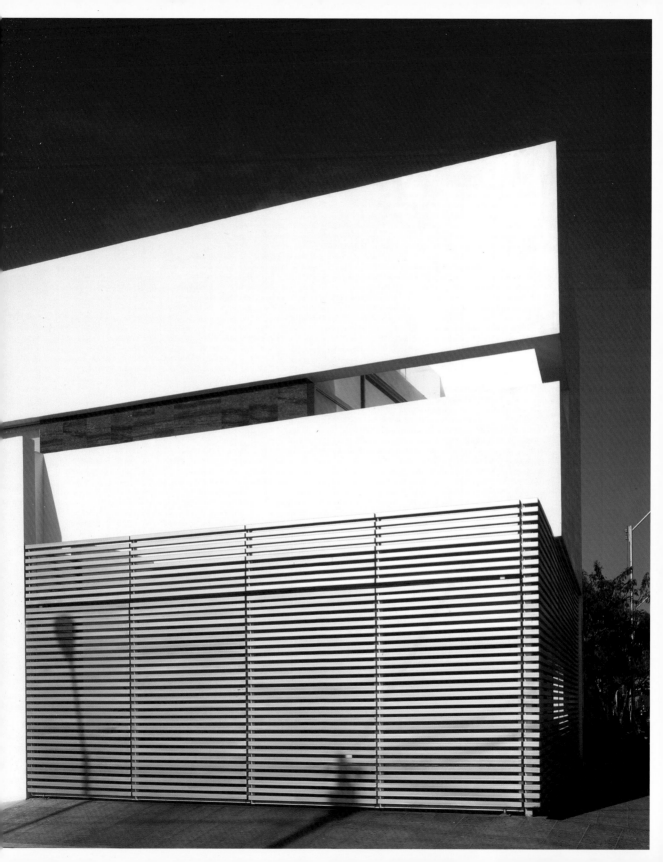

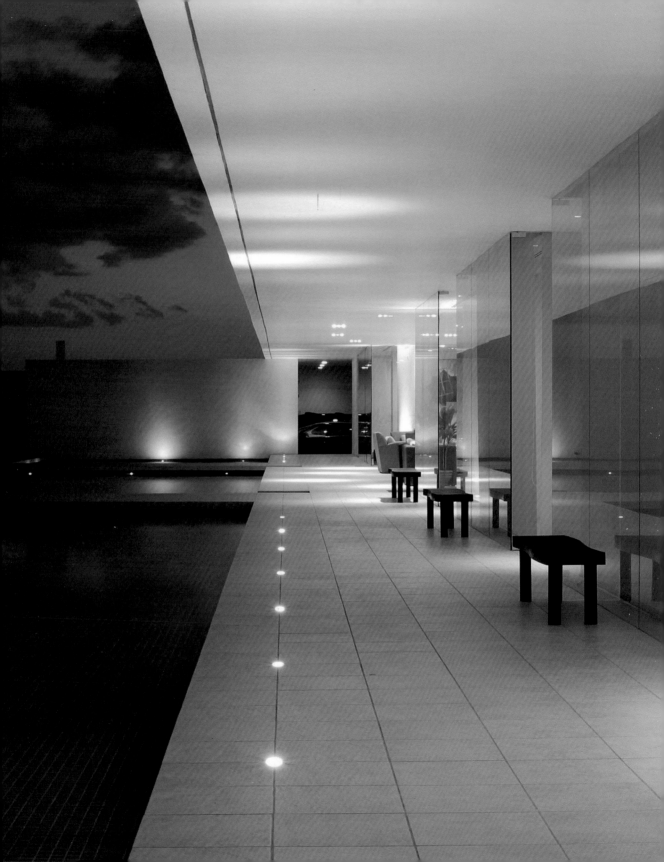

AUGUSTO QUIJANO ARQUITECTOS, S.C.P. | MÉRIDA, YUCATÁN
AUGUSTO QUIJANO AXLE, GASPAR PÉREZ AXLE
Casa Larga
Living Spaces
Mérida, Yucatán | 2003
Photos: Roberto Cárdenas Cabello

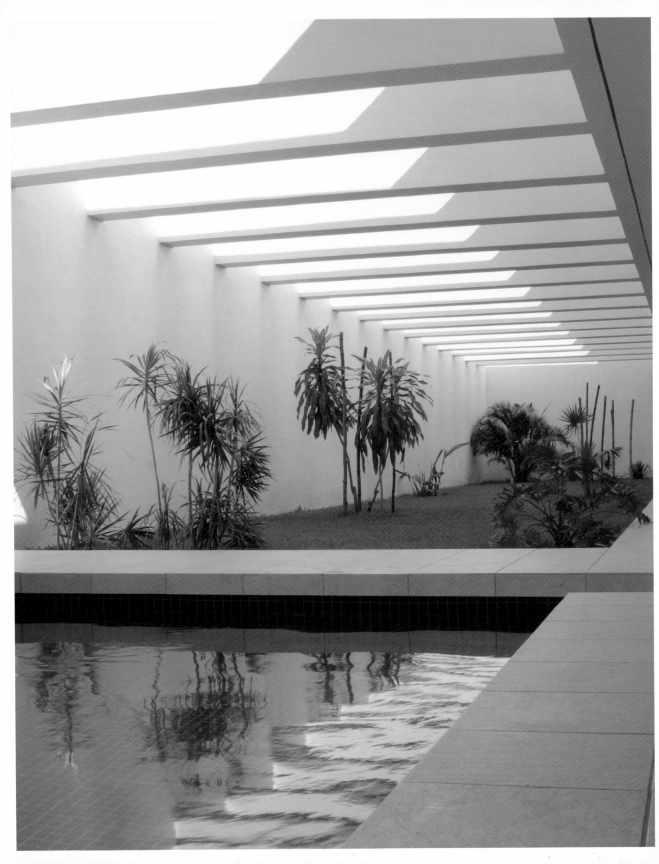

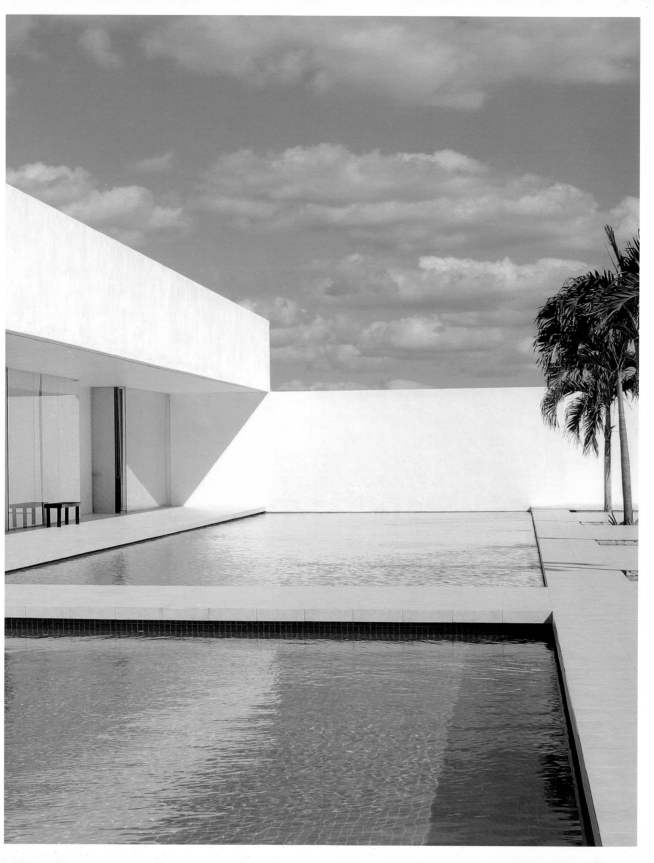

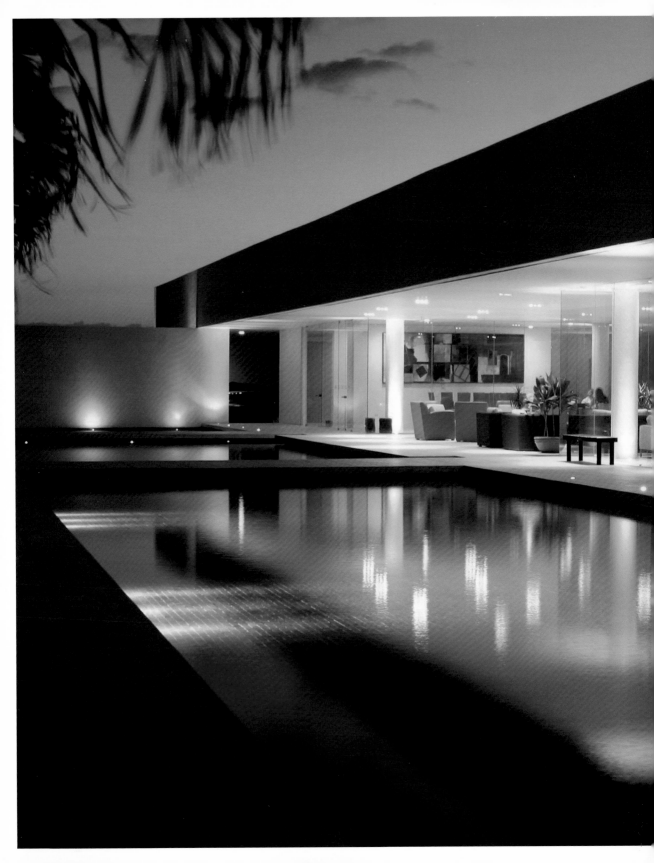

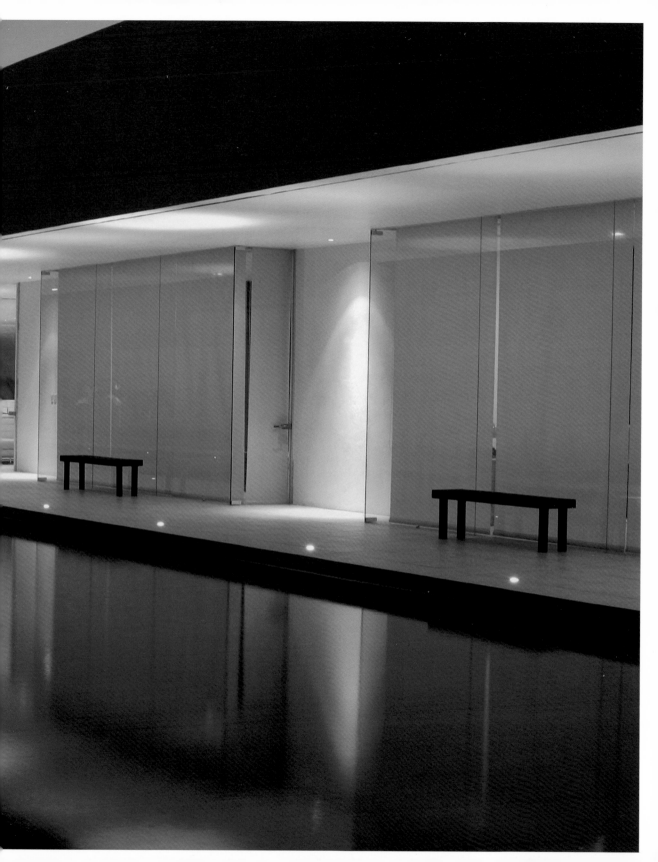

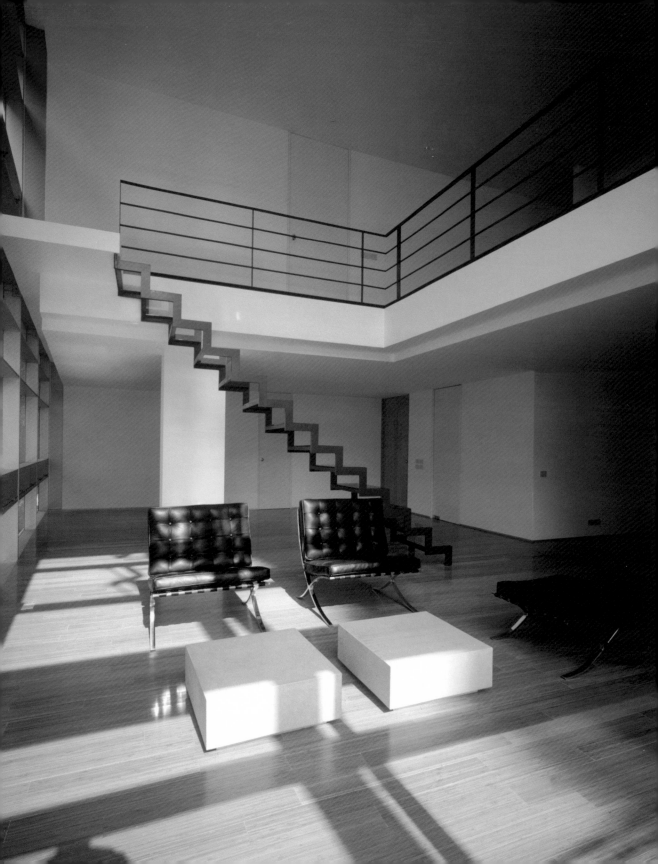

CENTRAL DE ARQUITECTURA | MEXICO CITY
Amsterdam + Sonora
Living Spaces
Colonia Condesa, Mexico City | 2003
Photos: Luis Gordoa

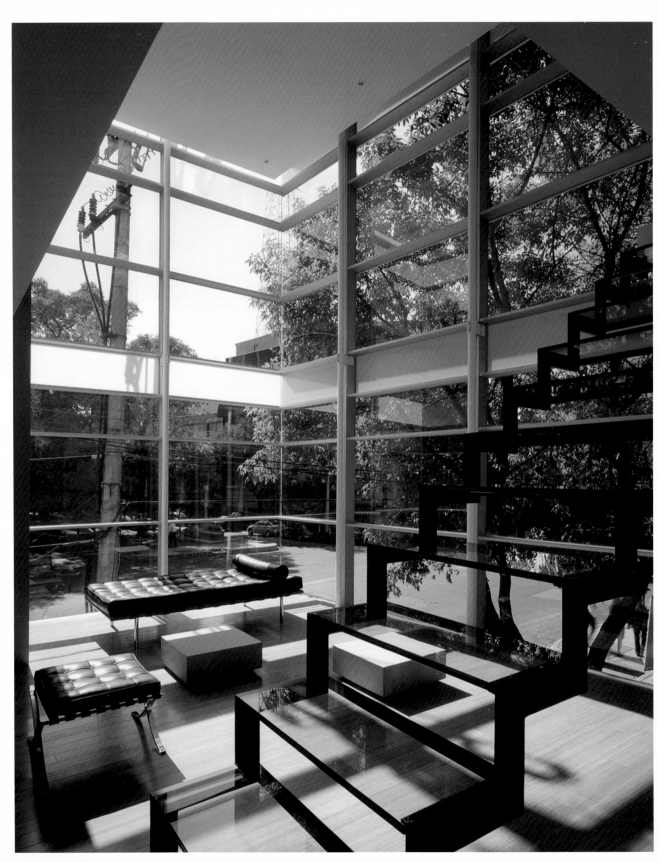

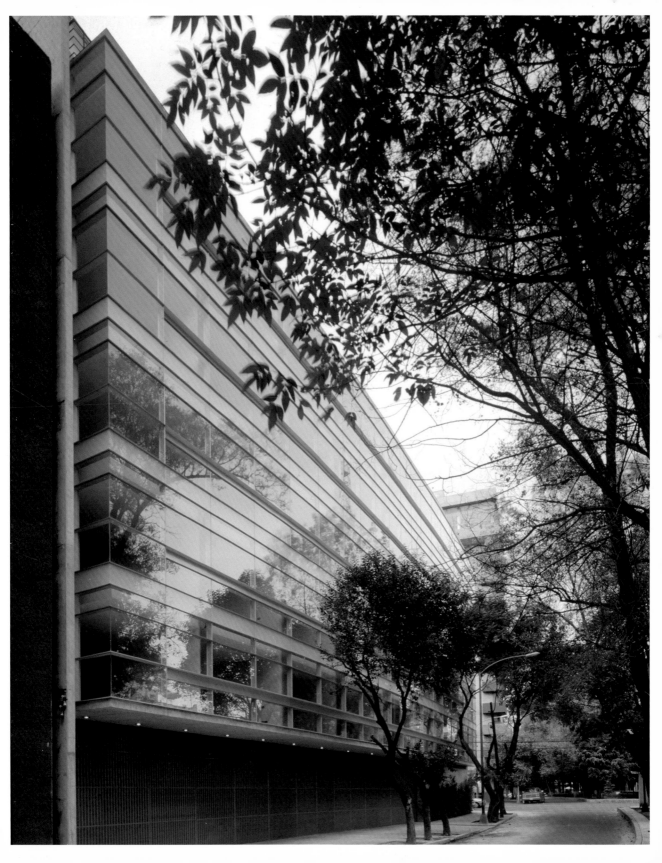

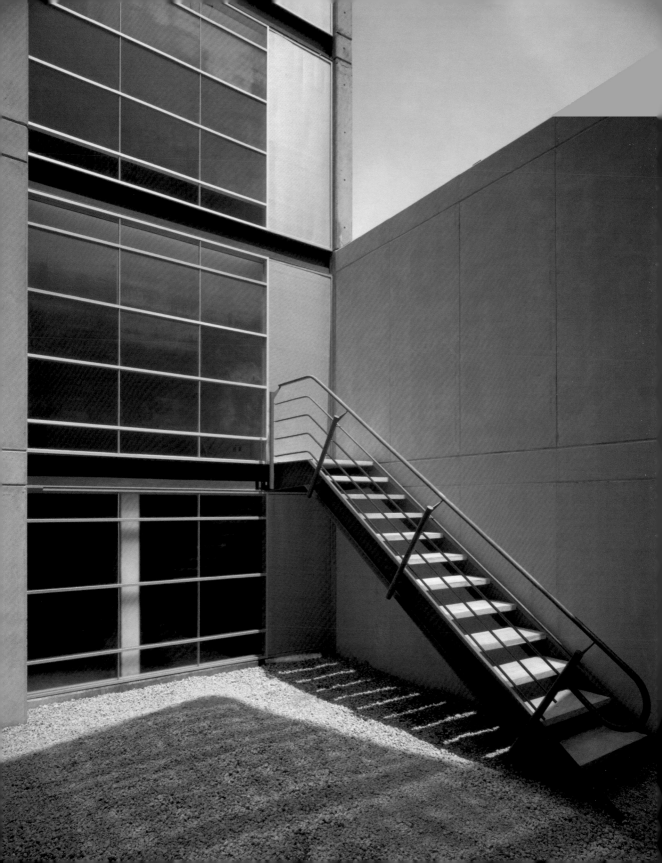

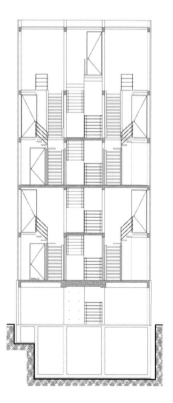

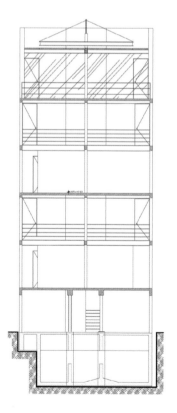

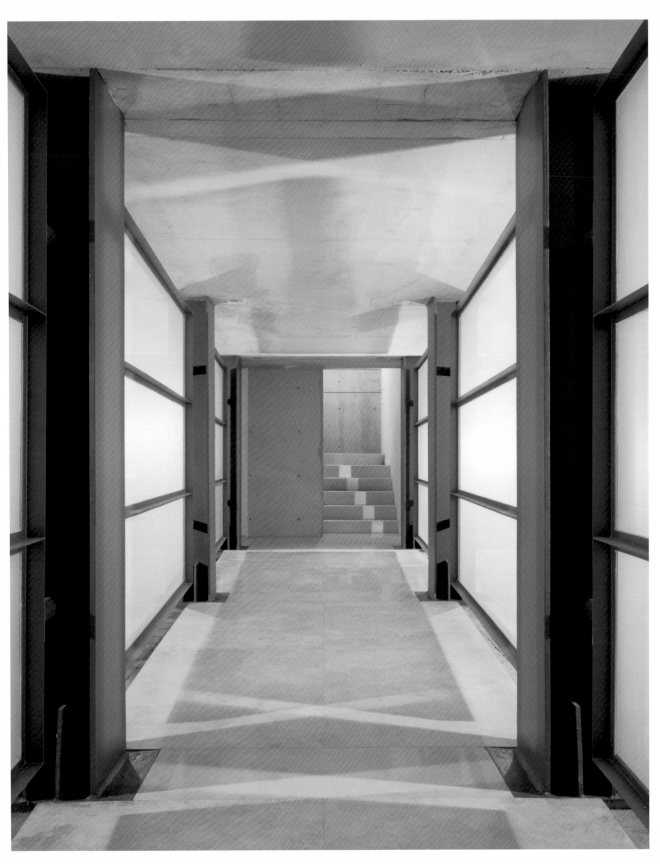

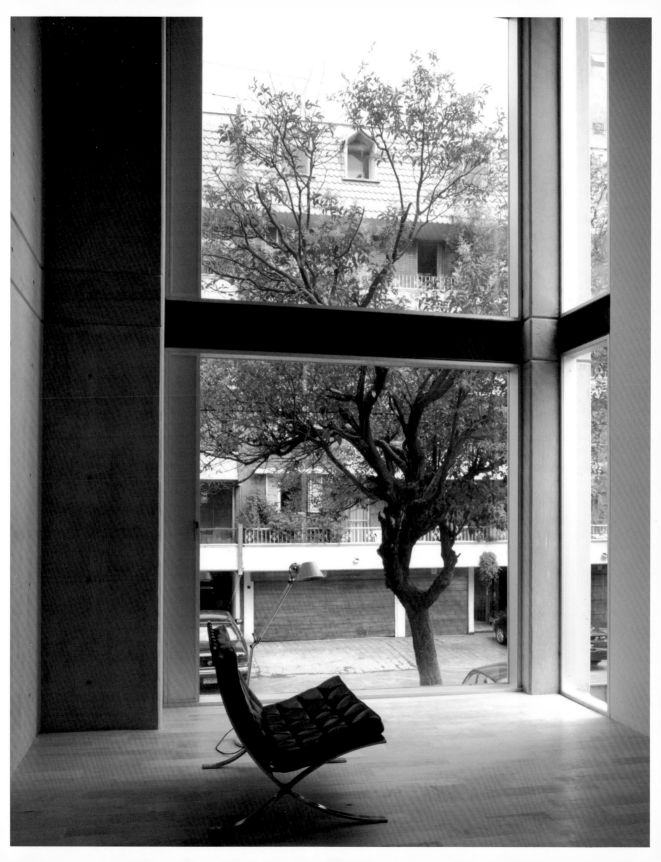

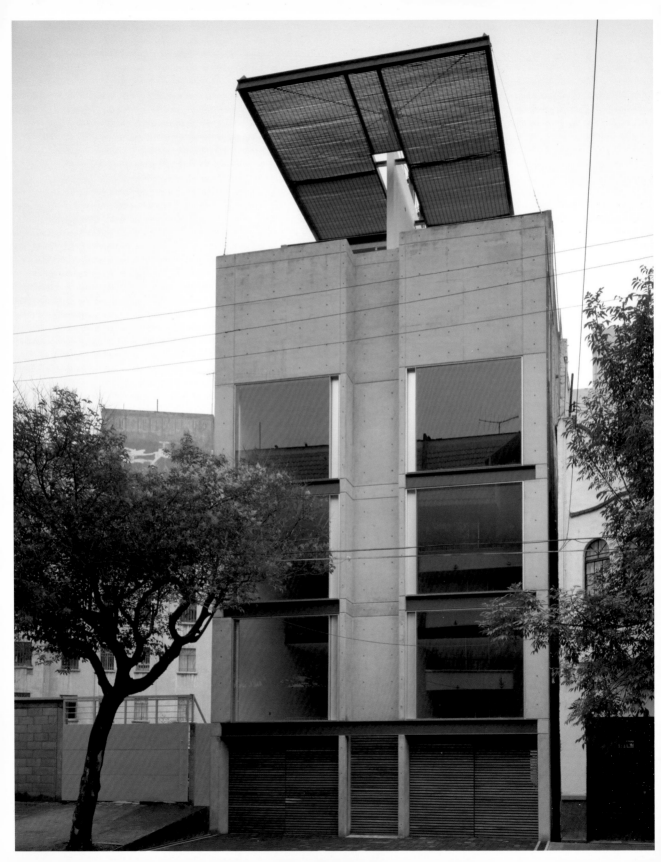

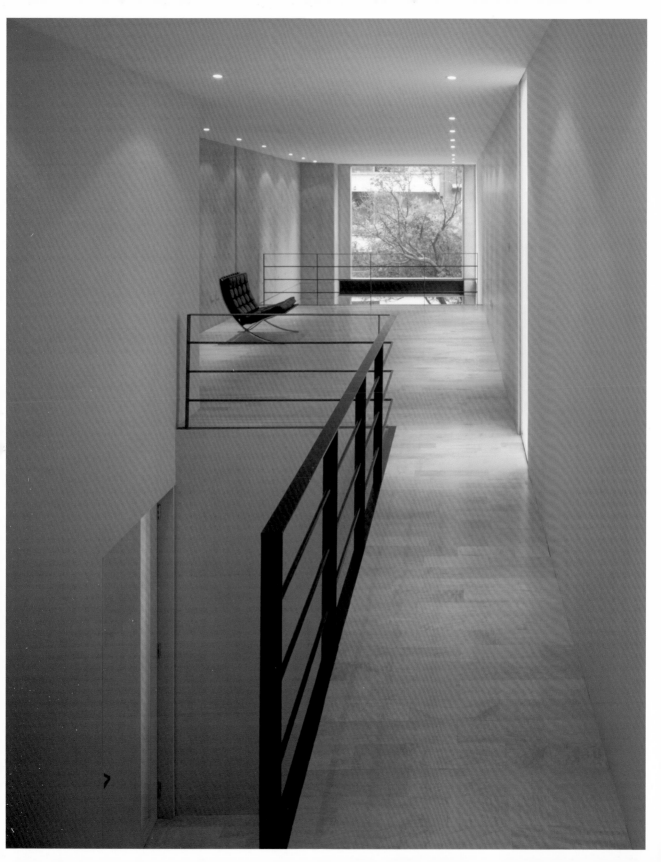

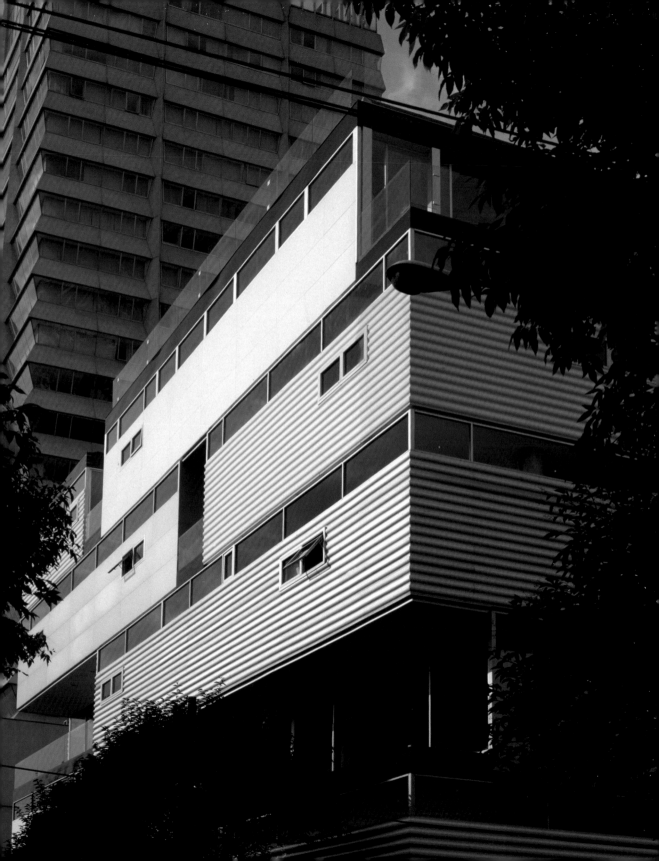

DELLEKAMP ARCHITECTS | MEXICO CITY
AR 58
Living Spaces
Colonia Condesa, Mexico City | 2002
Photos: Oscar Necoechea, Lara Becerra (44-45)

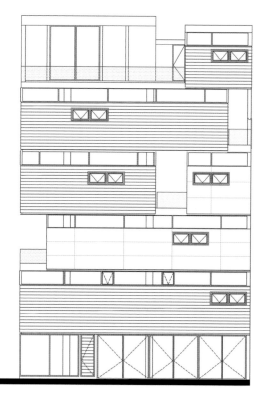

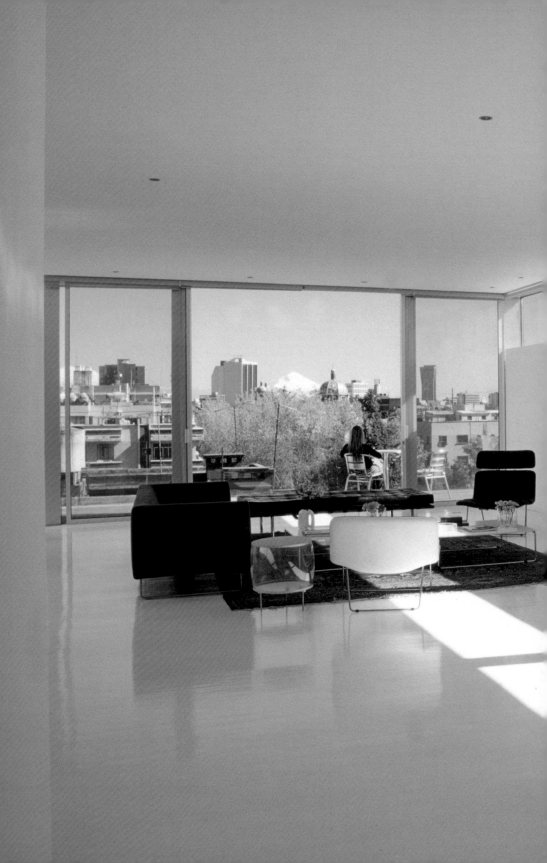

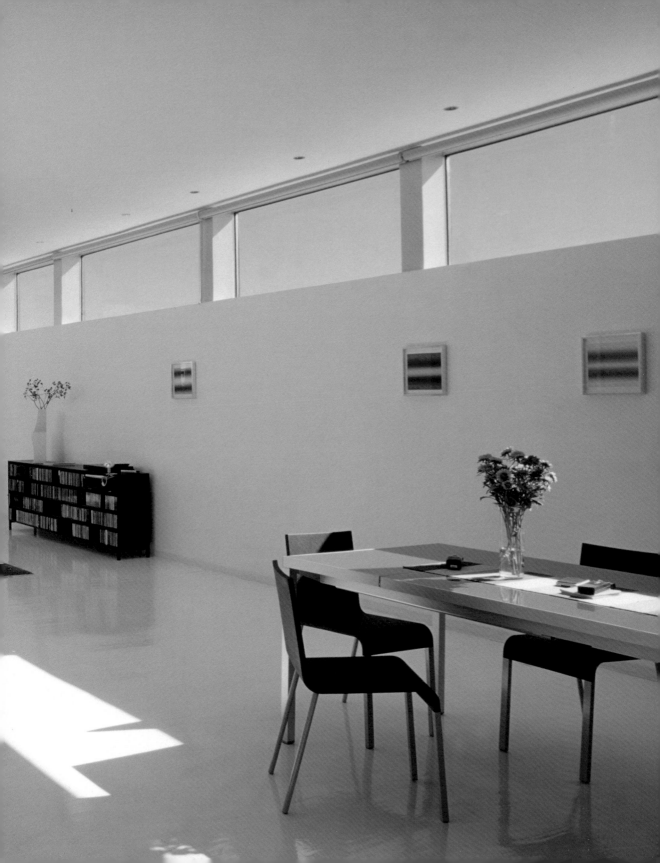

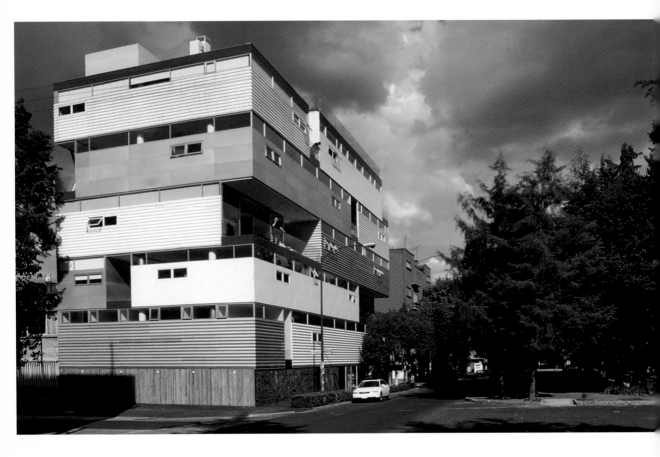

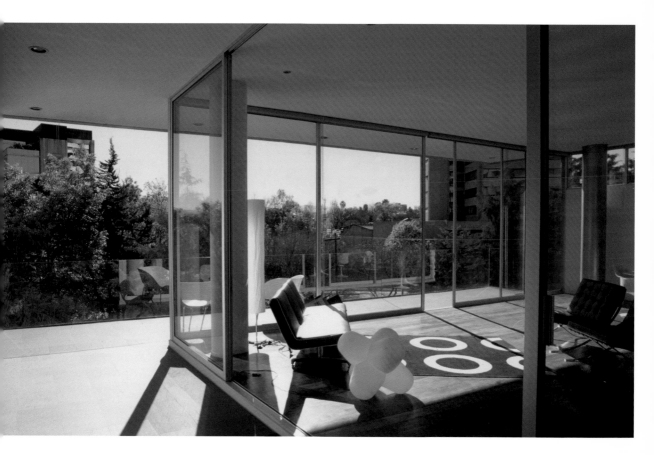

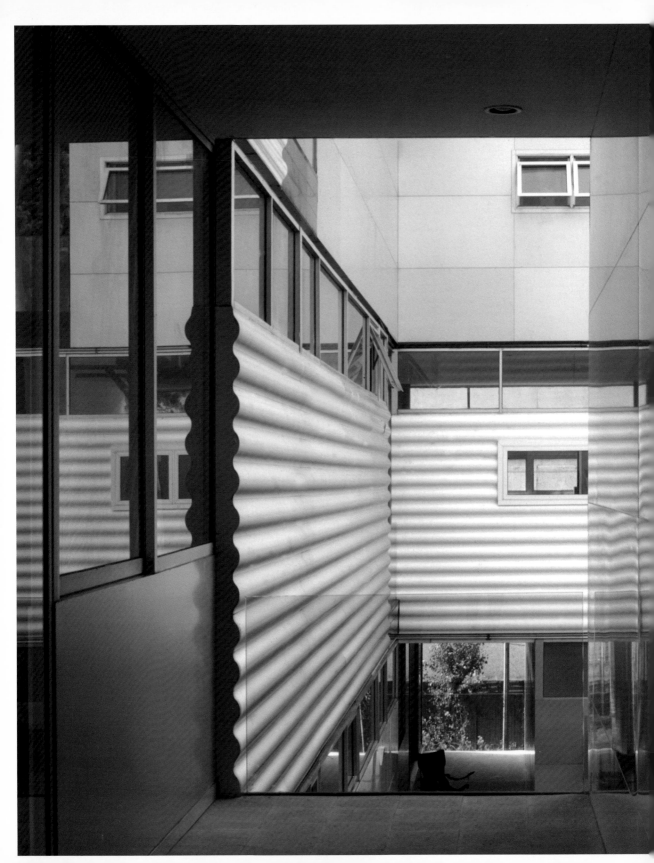

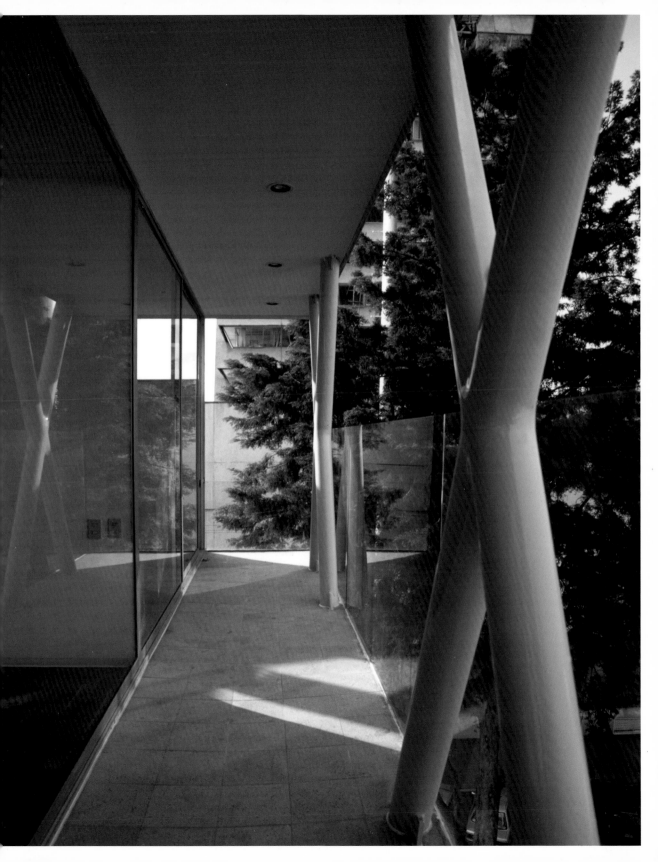

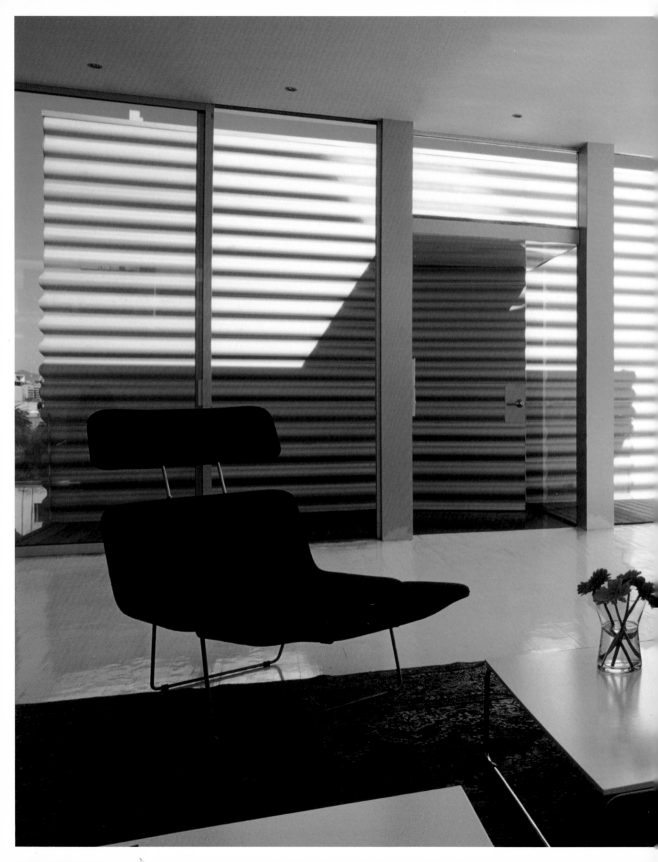

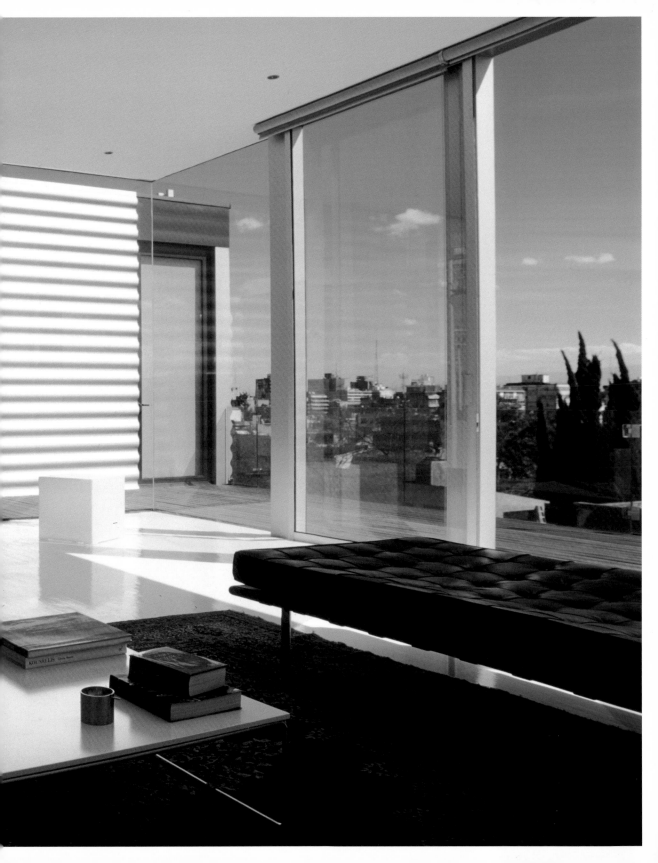

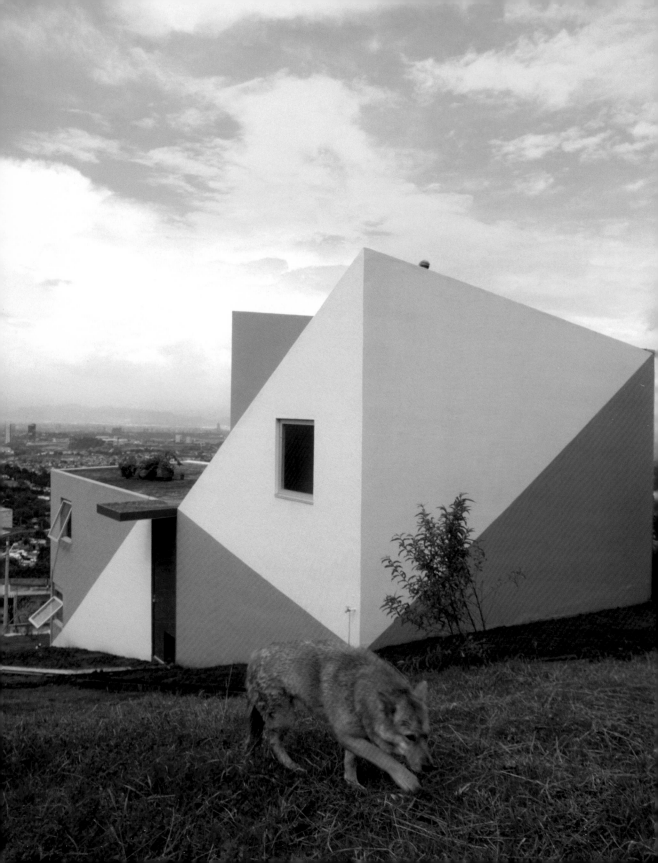

DELLEKAMP ARCHITECTS | MEXICO CITY
Casa en el Desierto de los Leones
Living Spaces
Desierto de los Leones, Mexico City | 2003
Photos: Lara Becerra

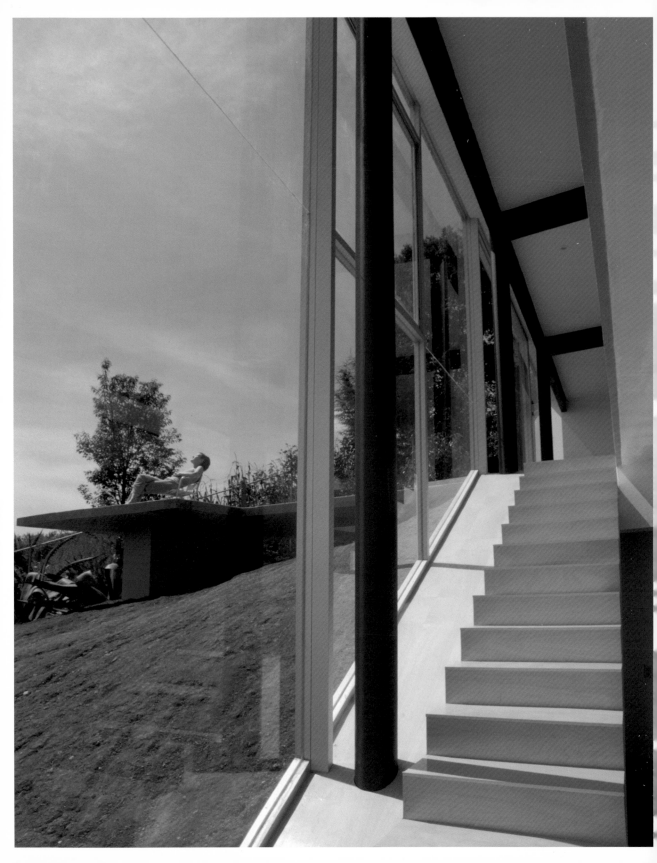

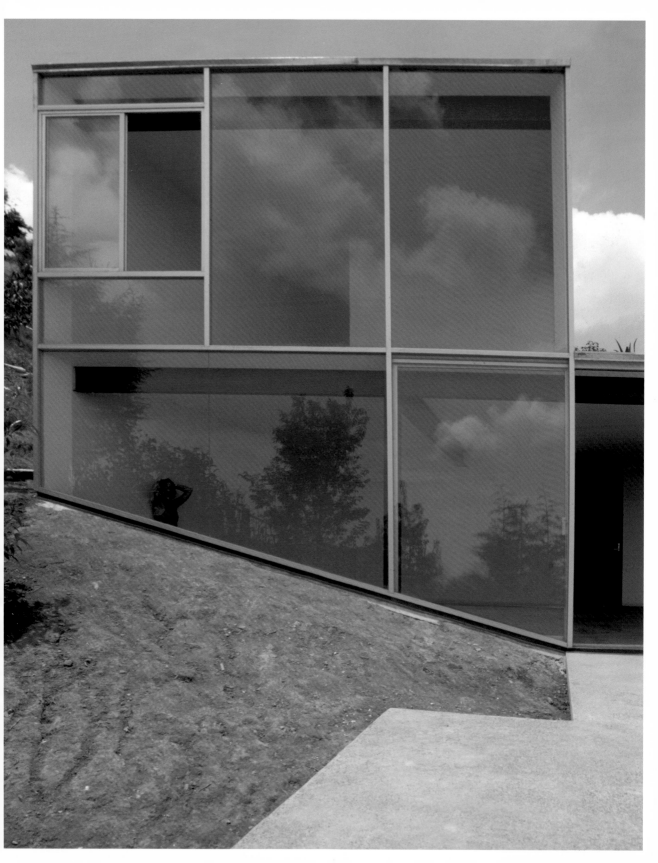

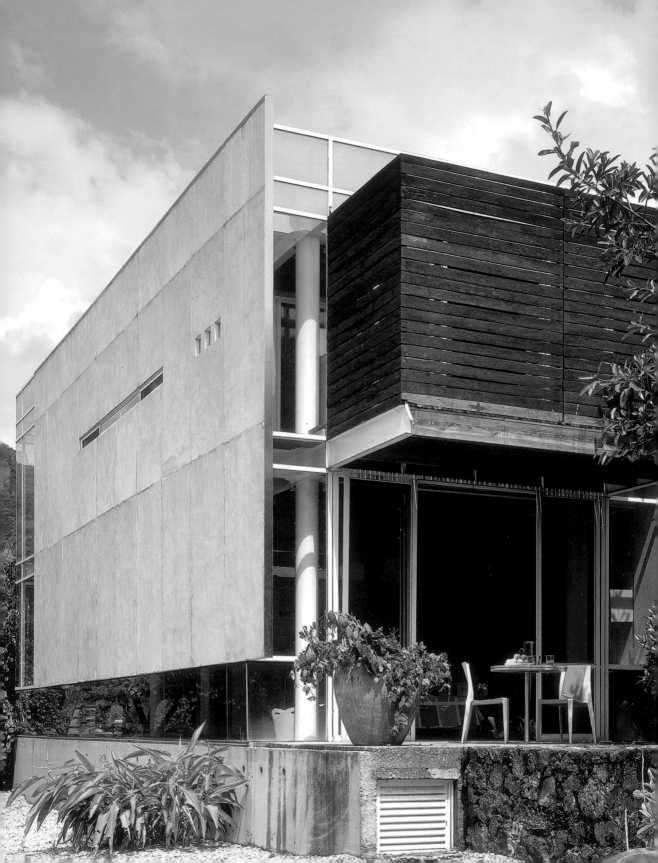

GA GRUPO ARQUITECTURA, DANIEL ALVAREZ | MEXICO CITY
INTERIOR DESIGN: EZEQUIEL FARCA| MEXICO CITY
Casa Farca
Living Spaces
Tepoztlán Valley , Mexico City | 2000
Photos: Luis Gordoa, Paul Czitrom (62-63)

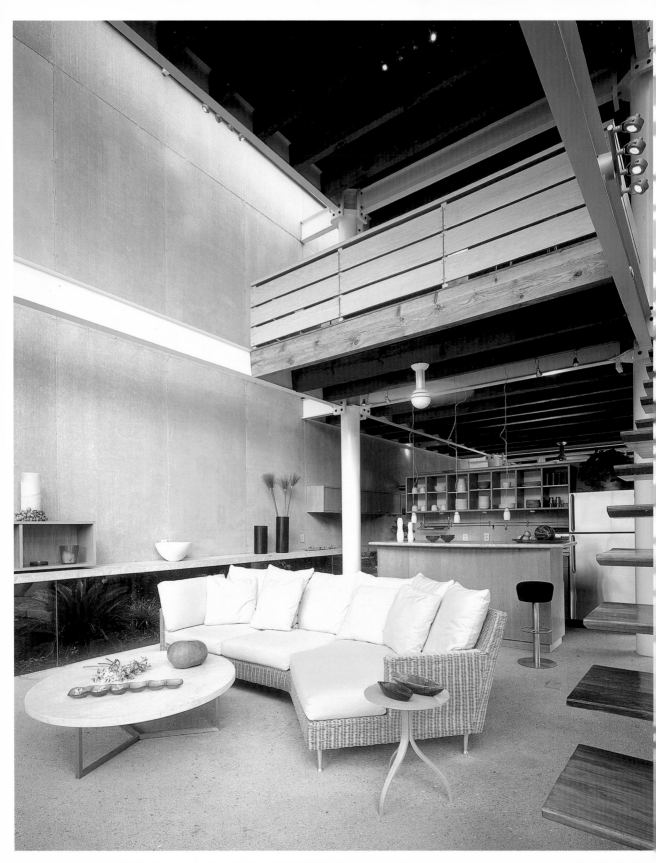

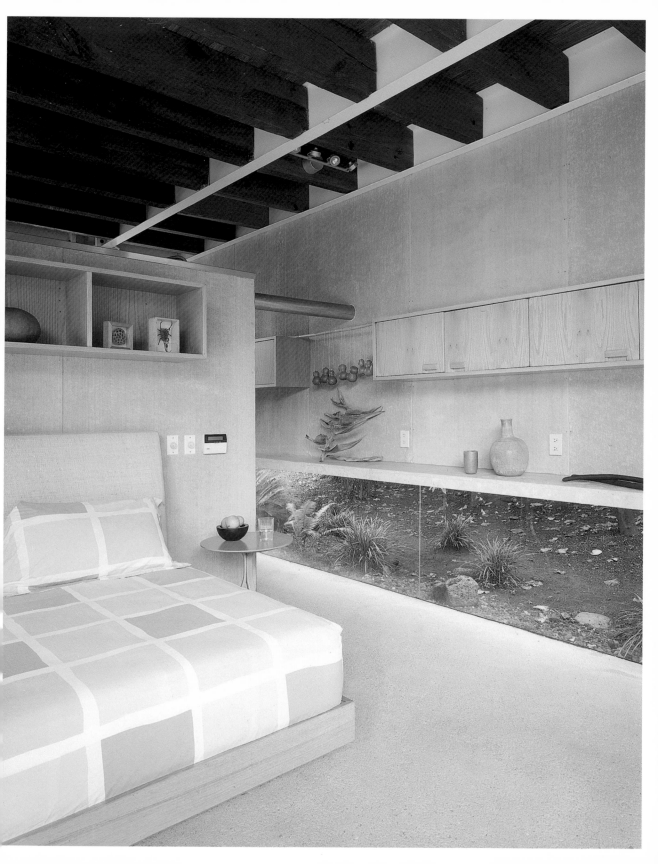

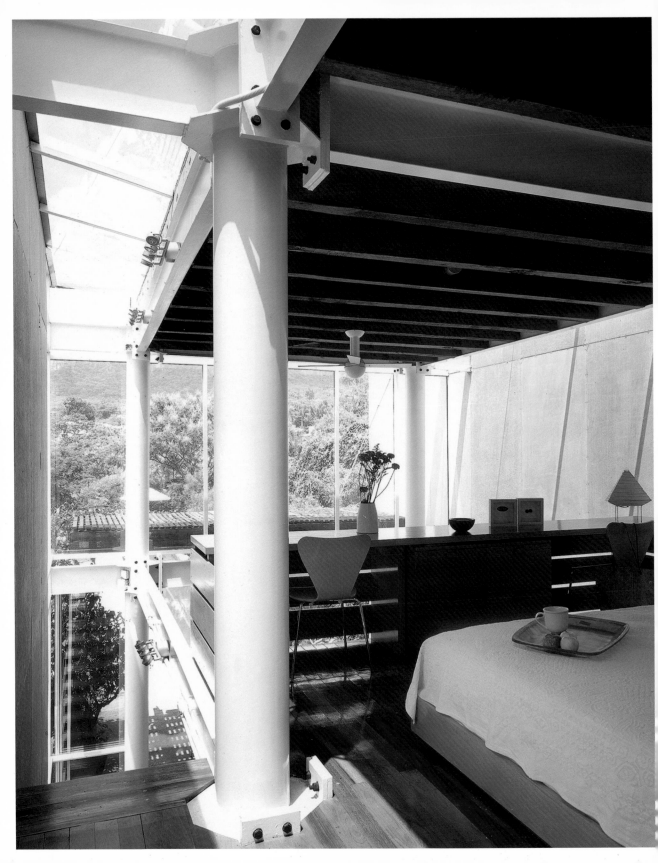

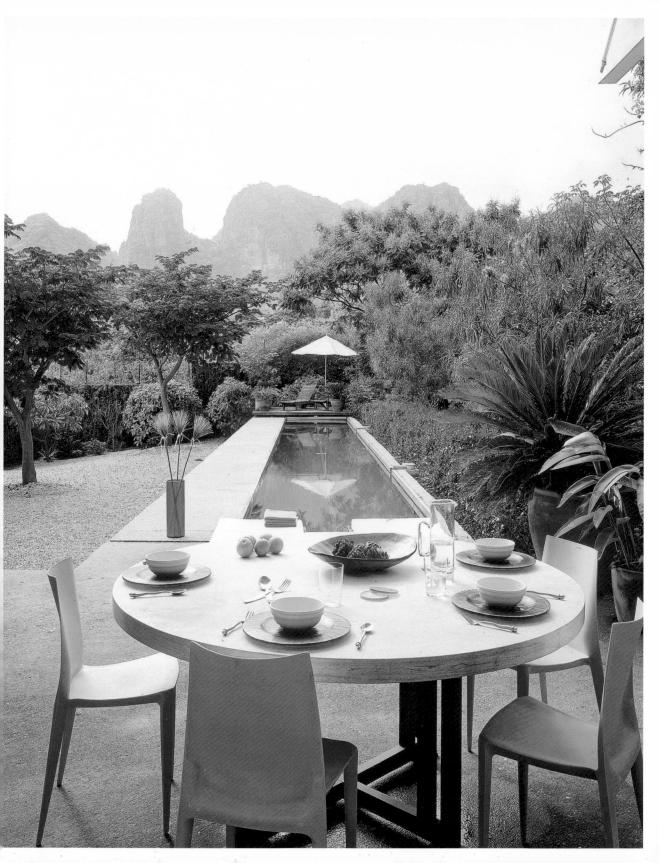

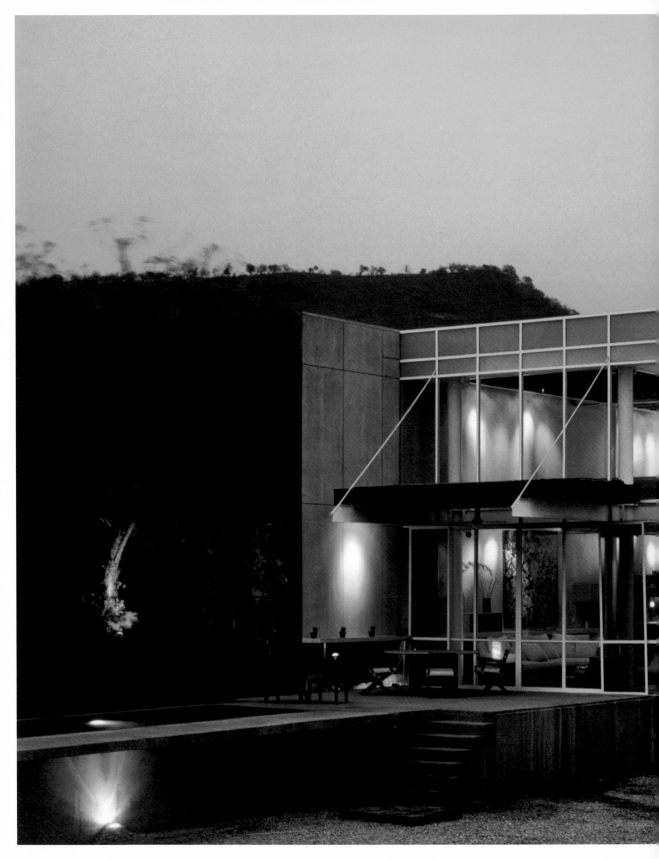

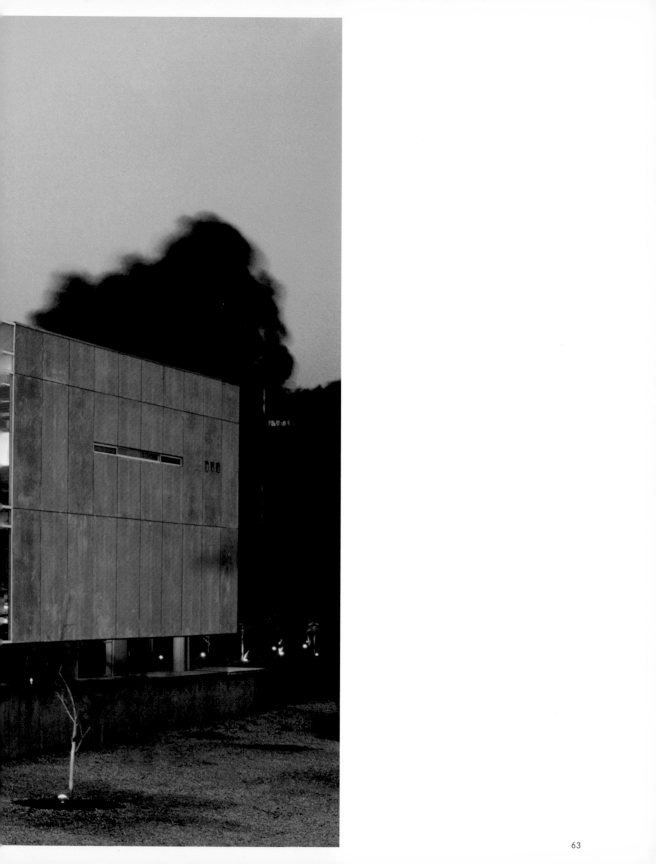

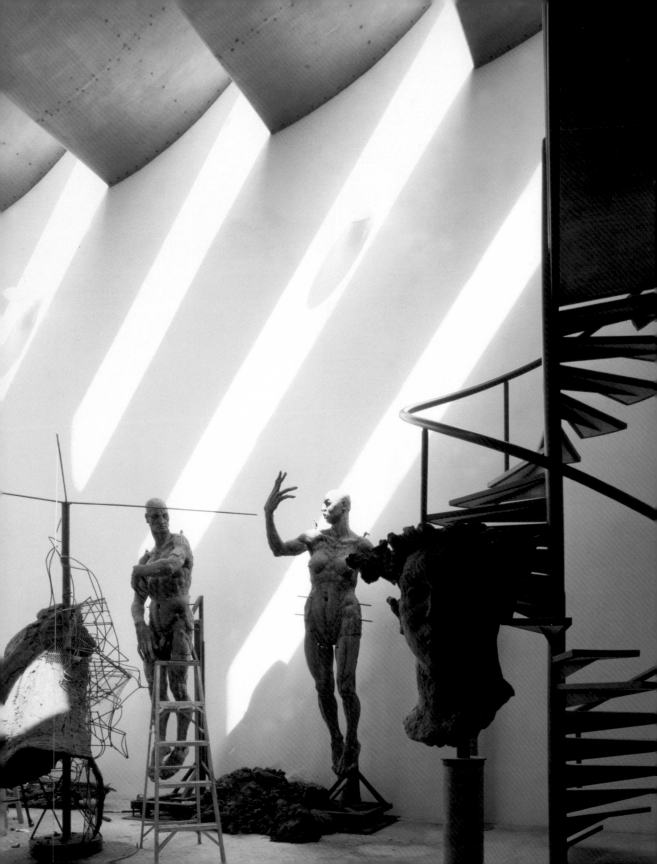

GANTOUS ARQUITECTOS | MEXICO CITY
CLAUDIO Y CHRISTIAN GANTOUS
Casa Estudio Javier Marín
Living Spaces
Colonia Roma, Mexico City | 2000
Photos: Hector Velasco

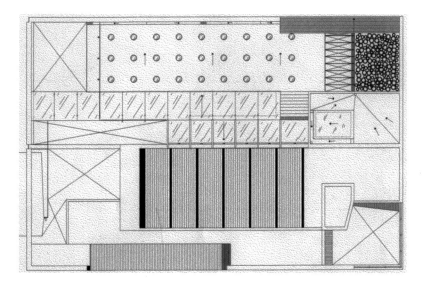

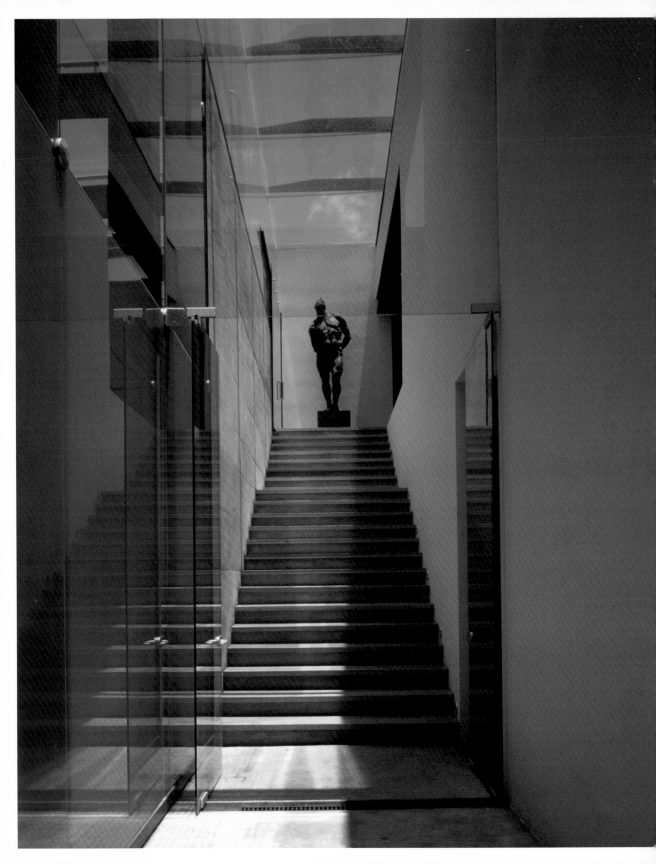

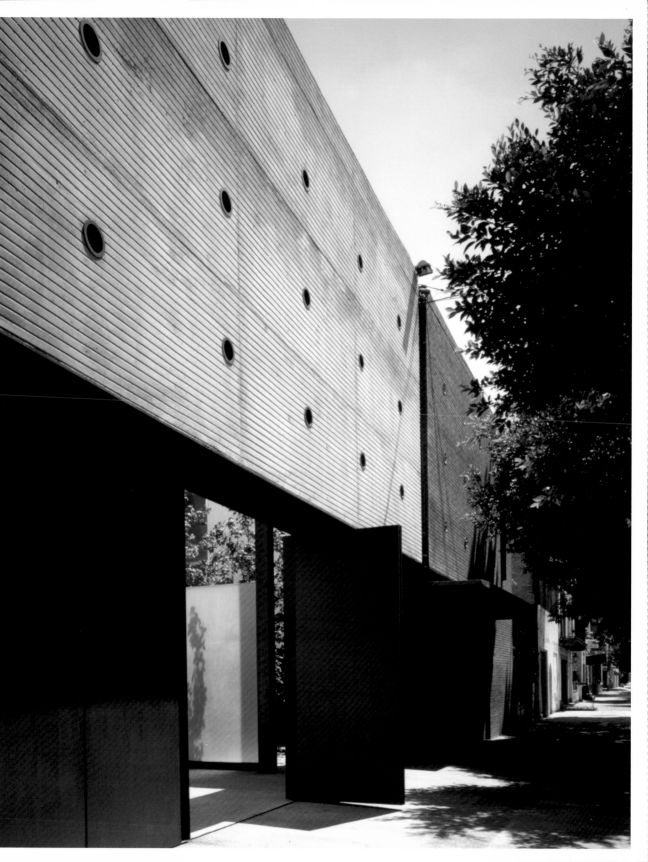

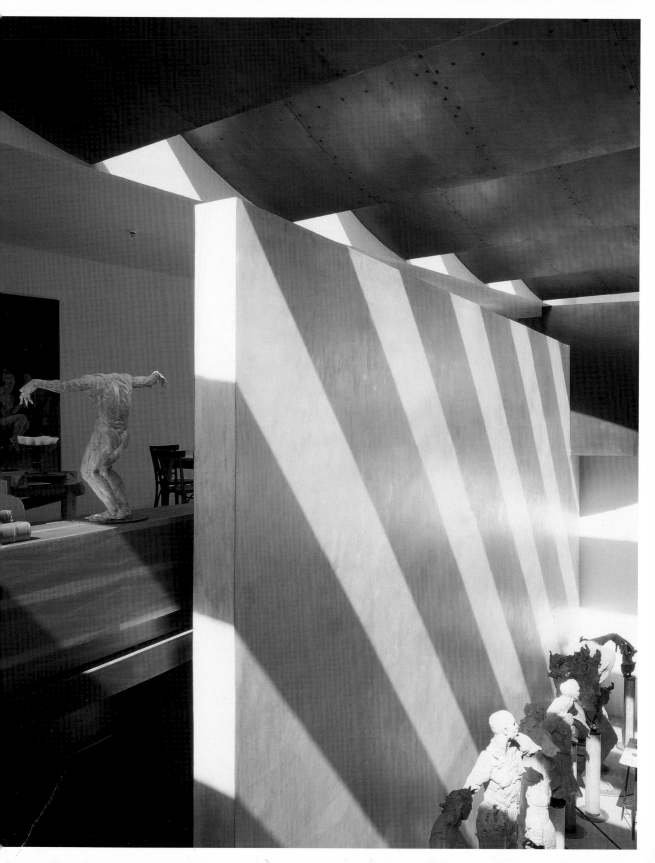

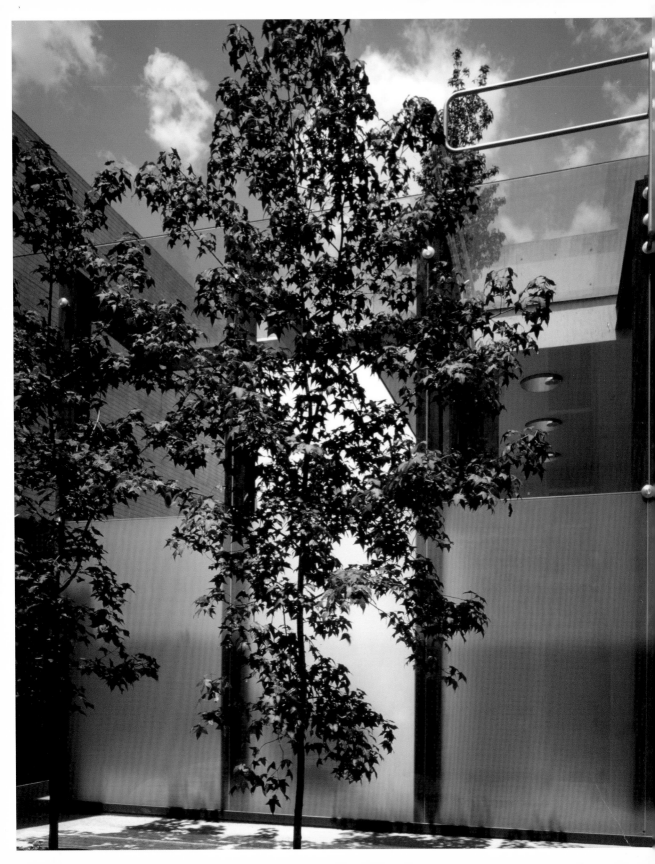

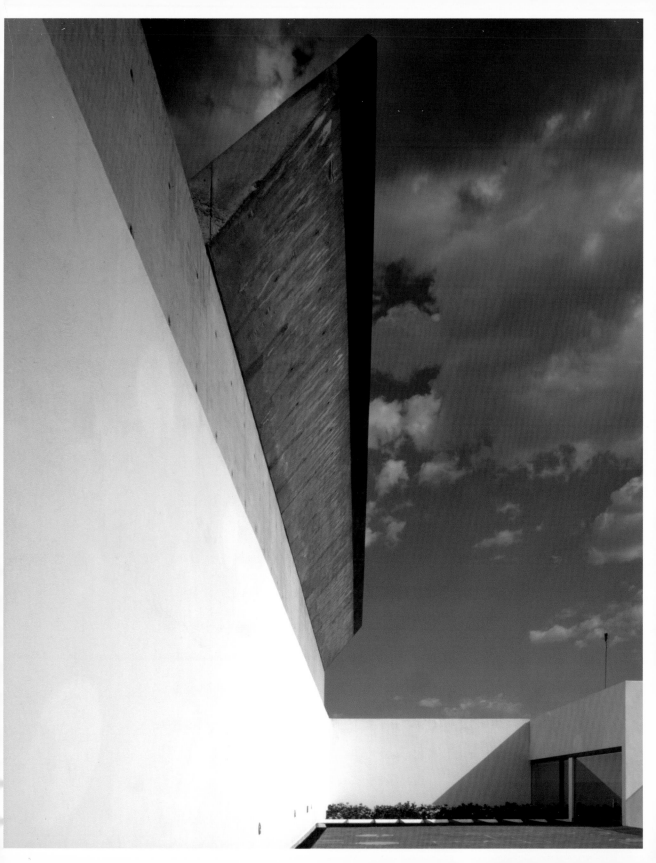

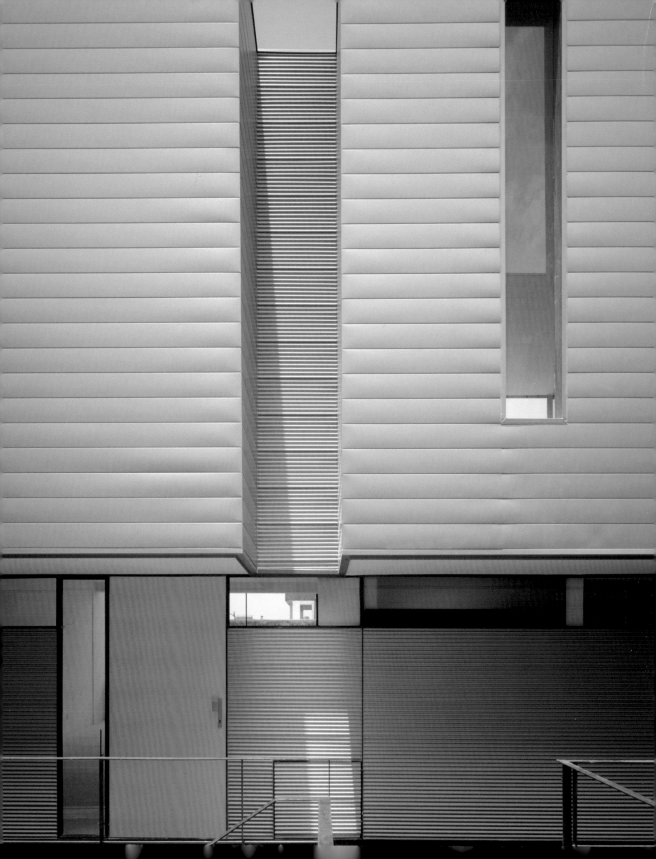

HIGUERA + SÁNCHEZ | MEXICO CITY
13 de Septiembre
Living Spaces
Mexico City | 2004
Photos: Luis Gordoa
Rendering: Higuera + Sánchez (78-79)

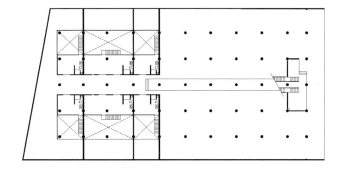

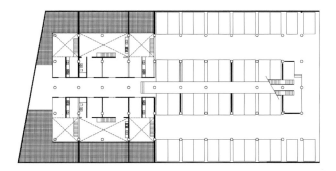

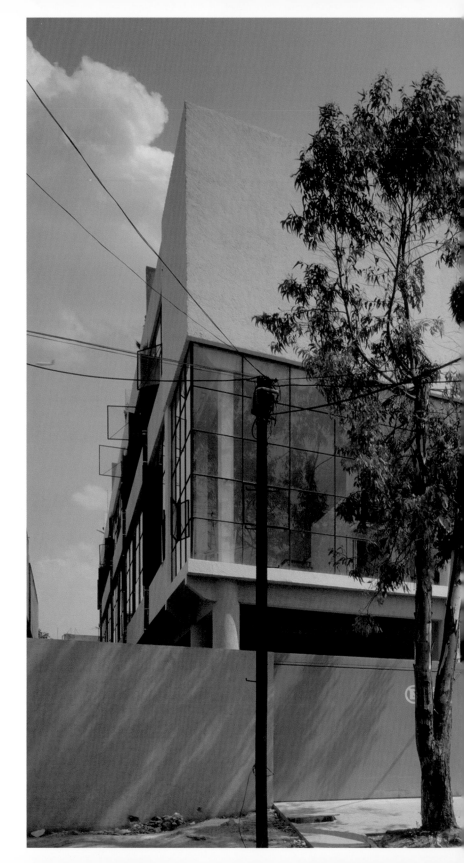

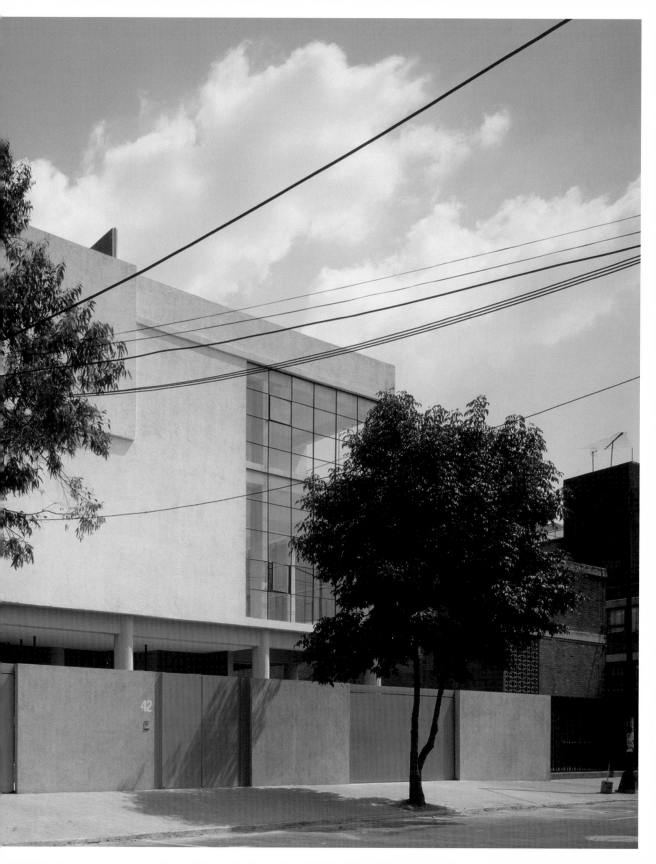

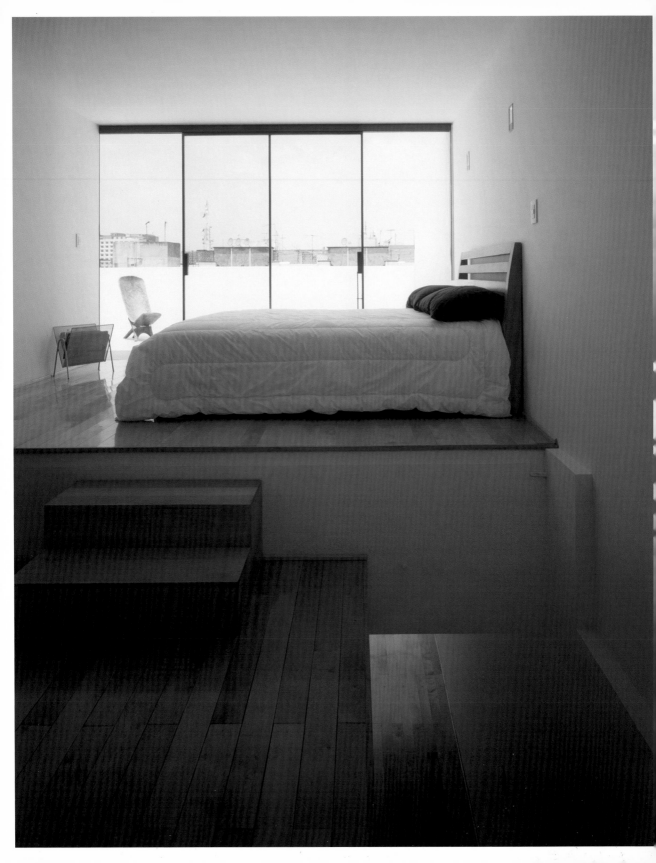

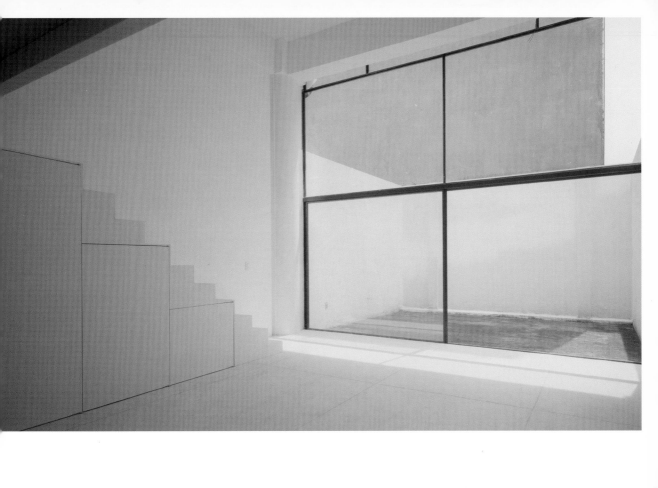

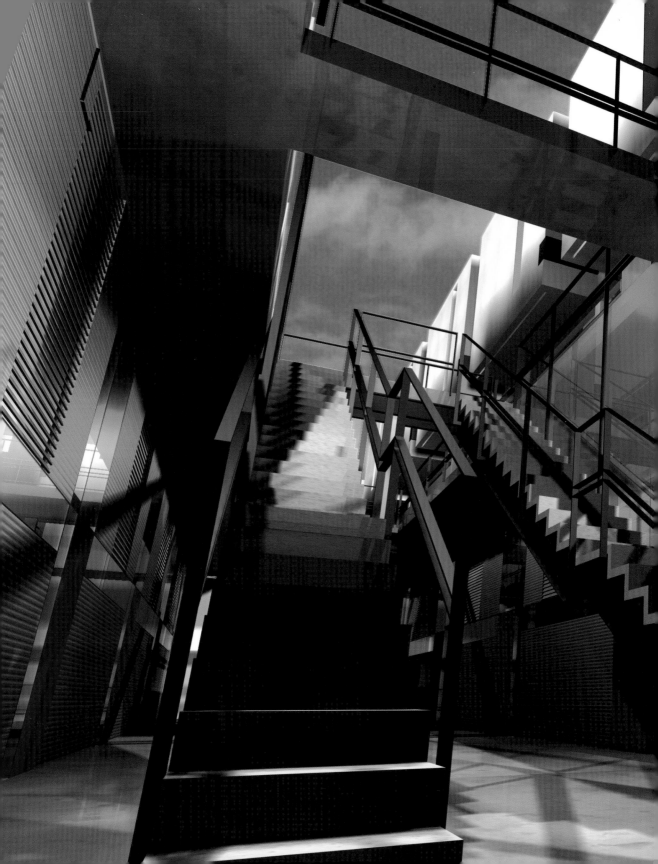

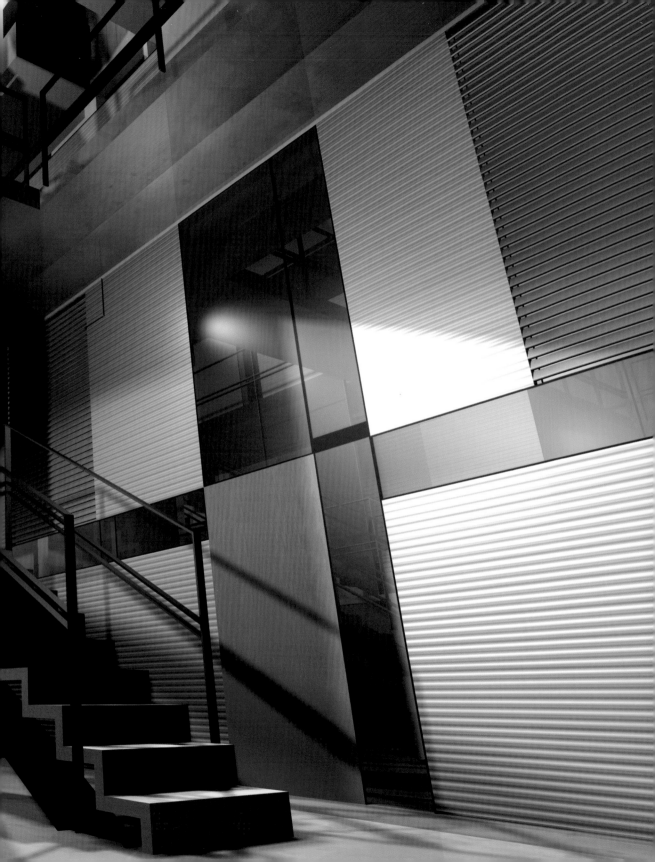

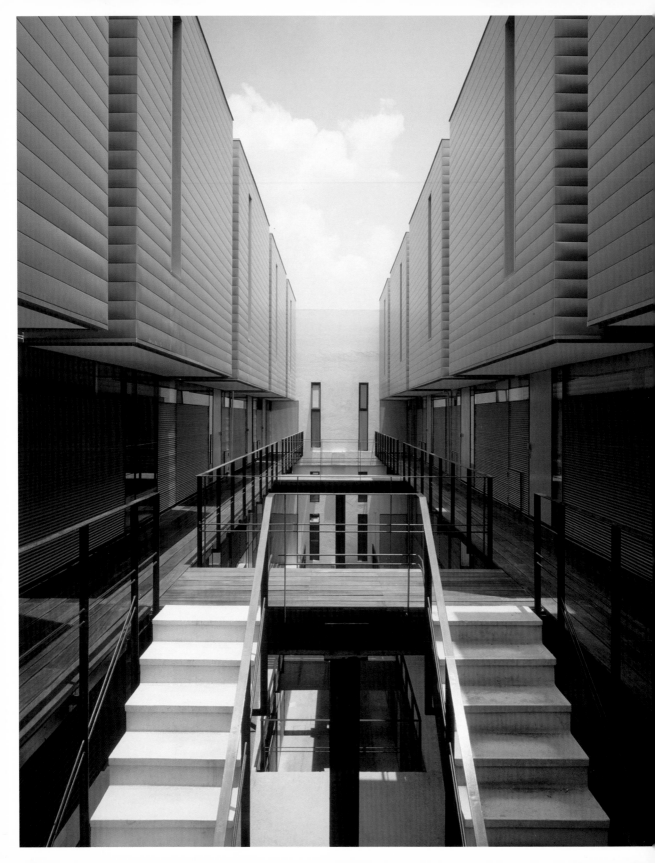

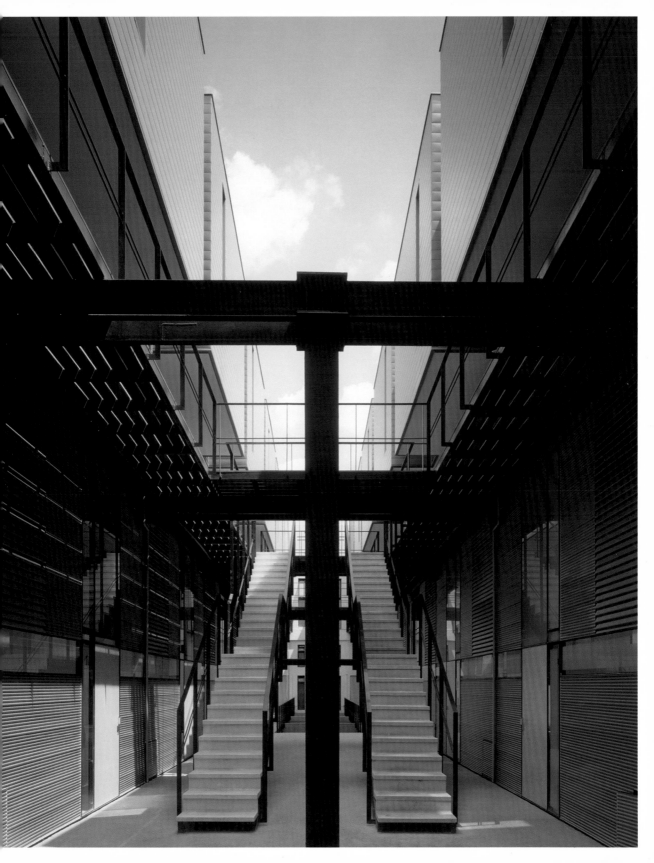

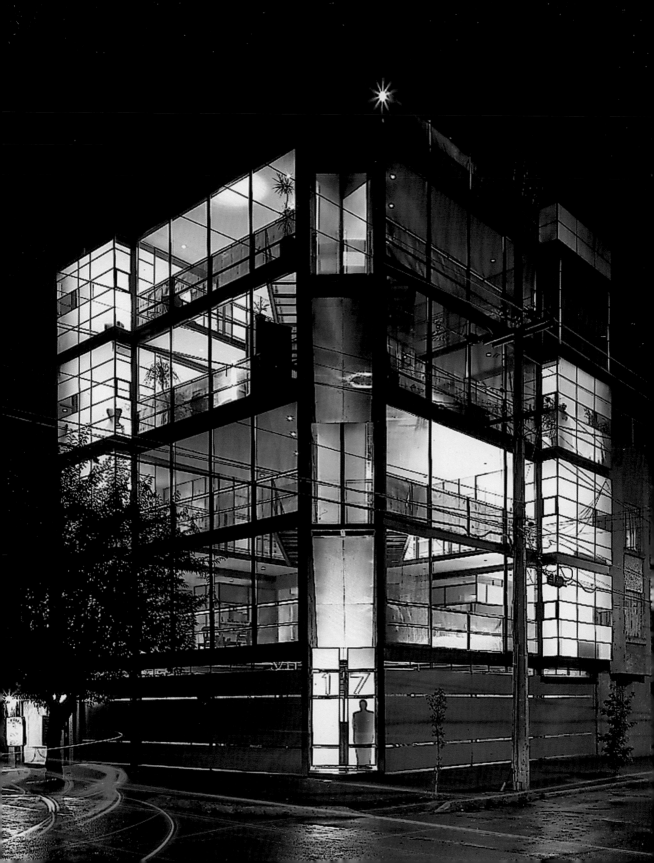

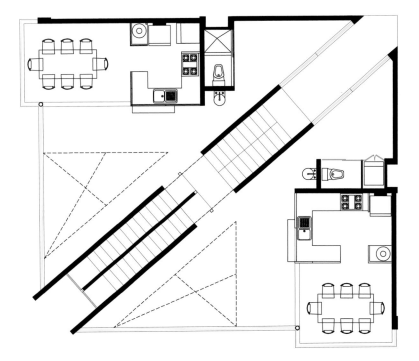

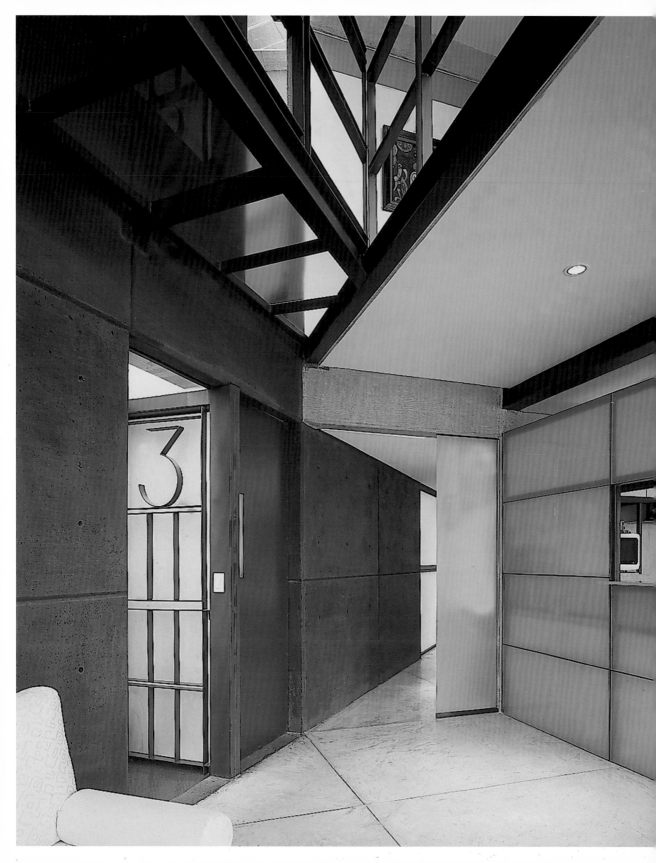

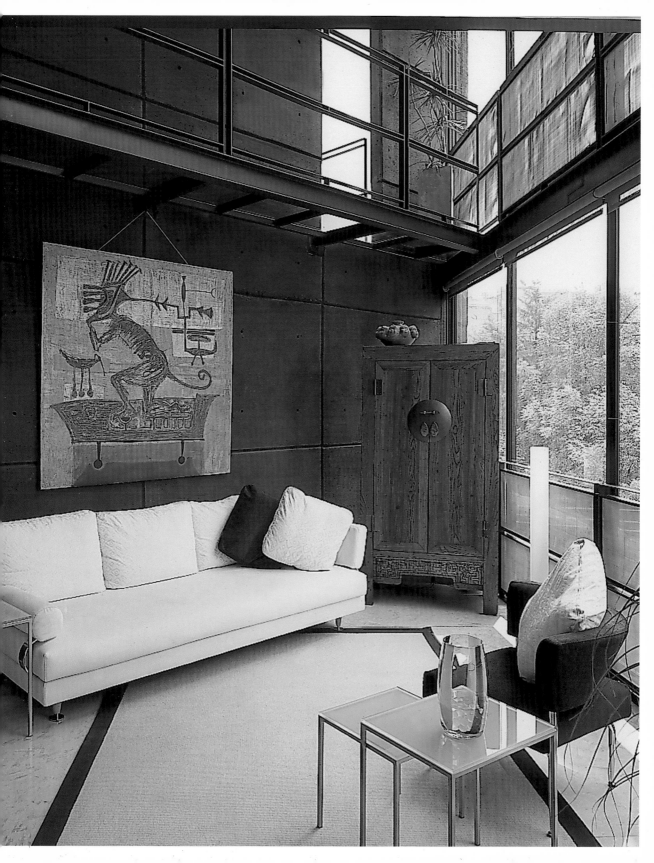

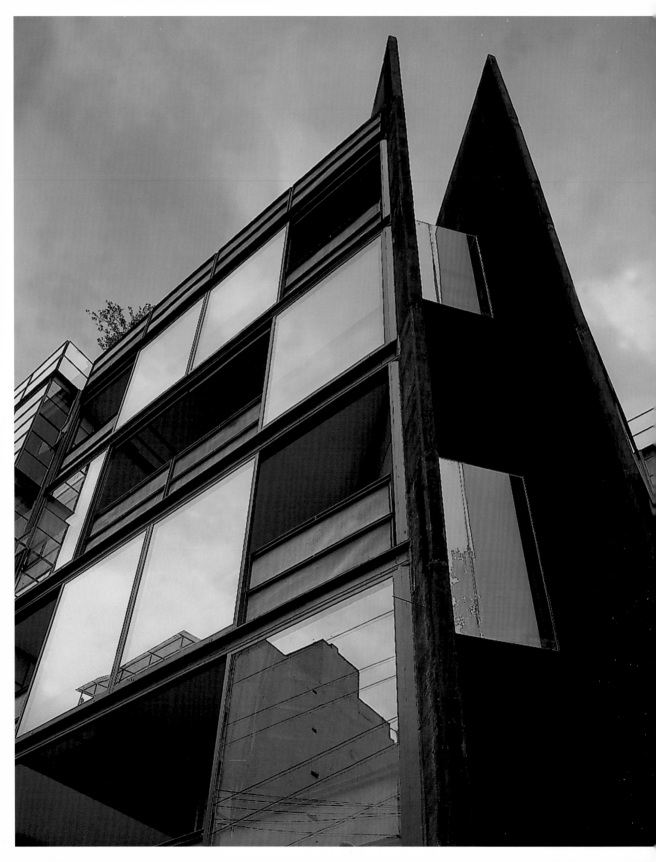

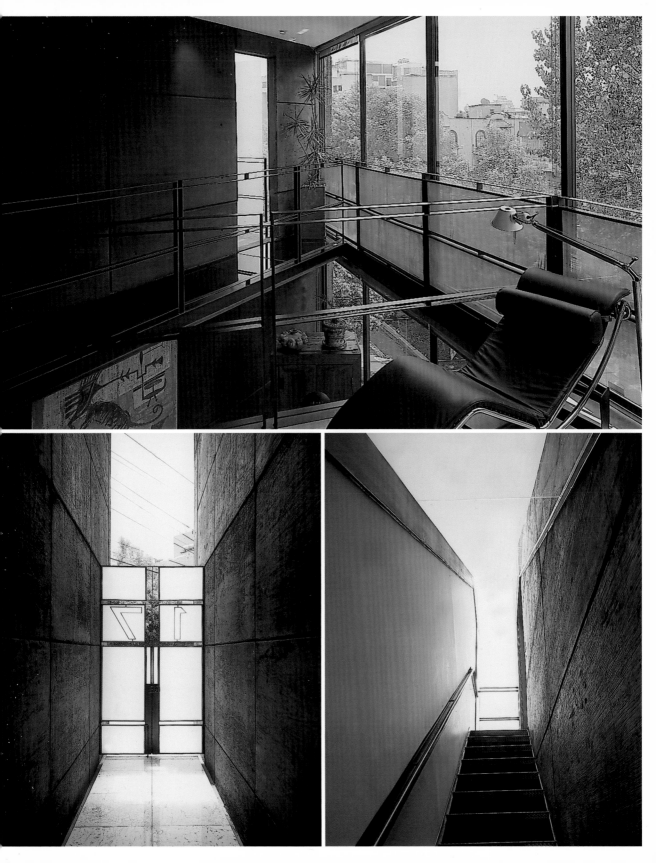

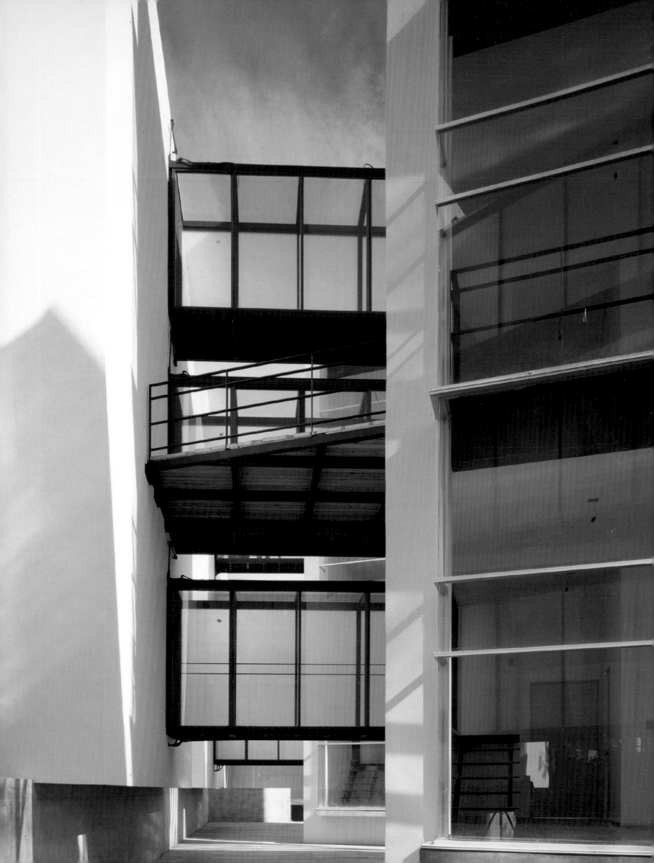

HIGUERA + SÁNCHEZ | MEXICO CITY
Ofelia 37
Living Spaces
Mexico City | 2001
Photos: Luis Gordoa

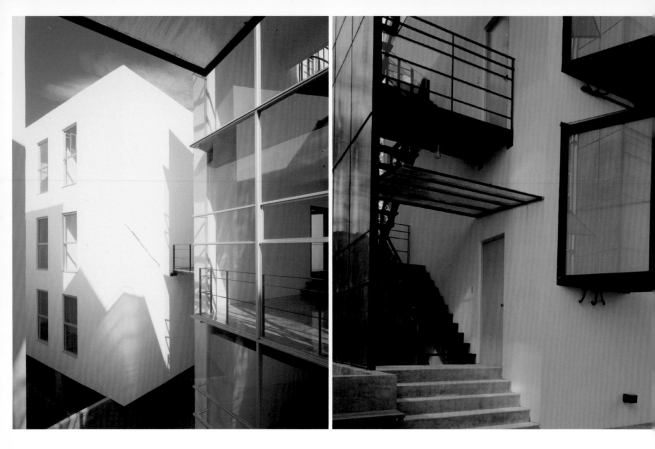

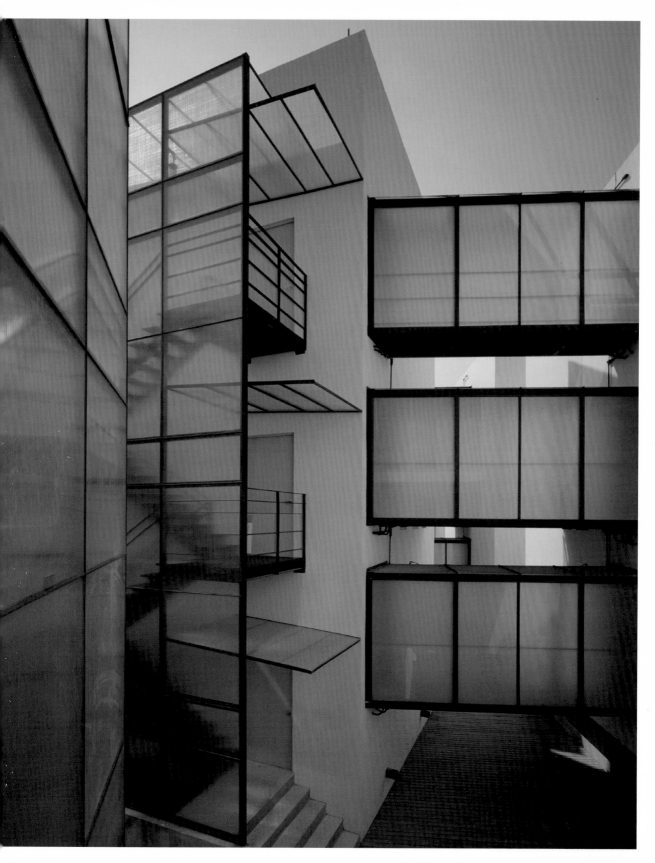

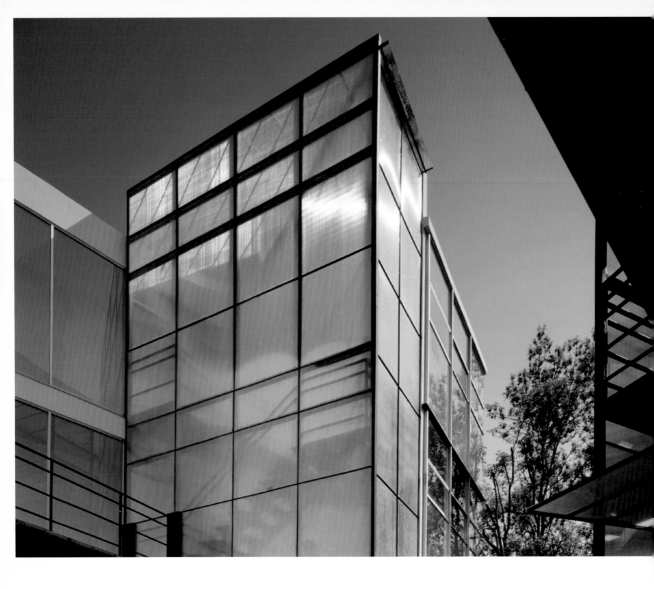

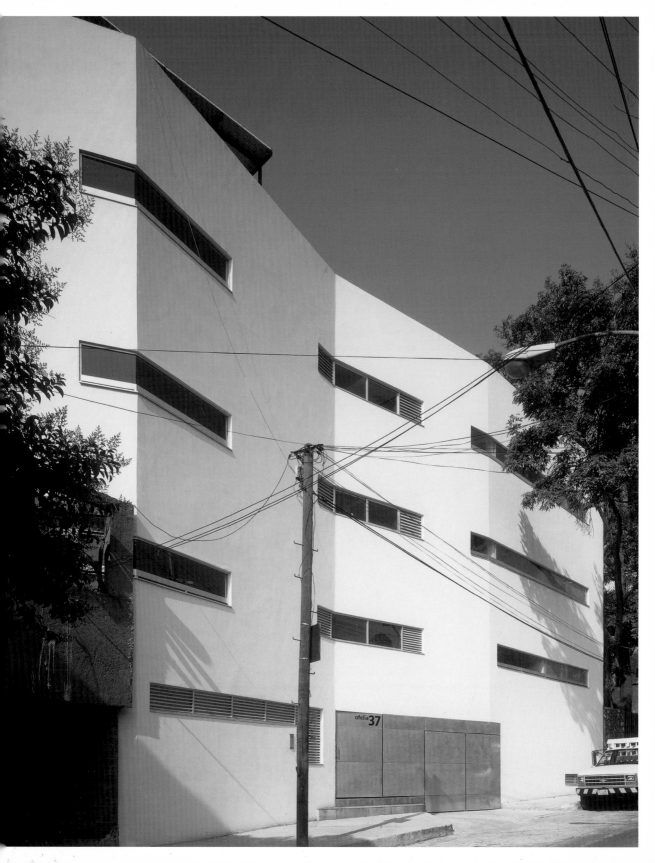

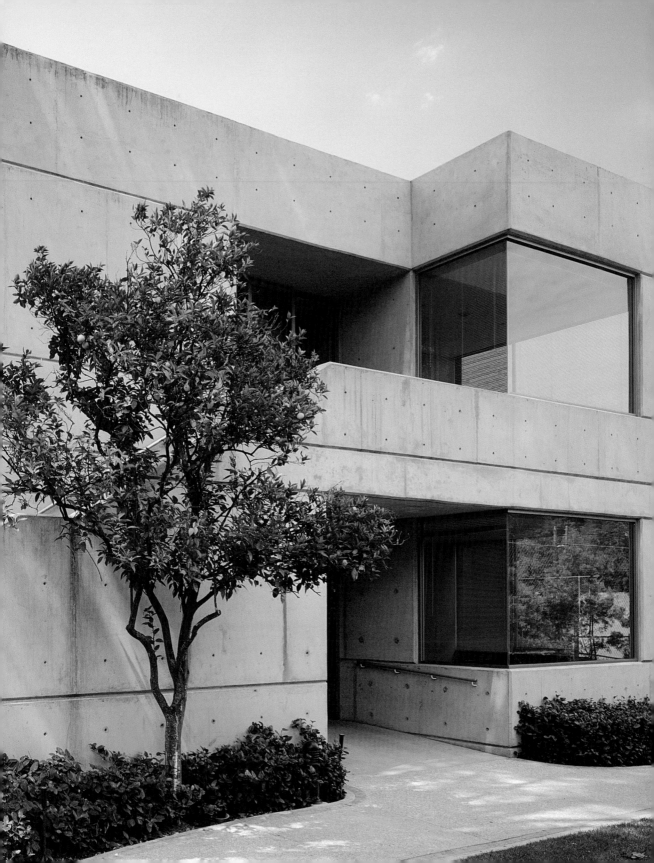

NUÑO-MAC GREGOR-DE BUEN ARQUITECTOS, S.C. | MEXICO CITY
CLARA DE BUEN, CARLOS MAC GREGOR, AURELIO NUÑO
Casa Hogar para la Tercera Edad
Asociación de Ayuda Social de la Comunidad Alemana
Living Spaces
Delegación Xochimilco, Mexico City | 2002
Photos: Pedro Hiriart

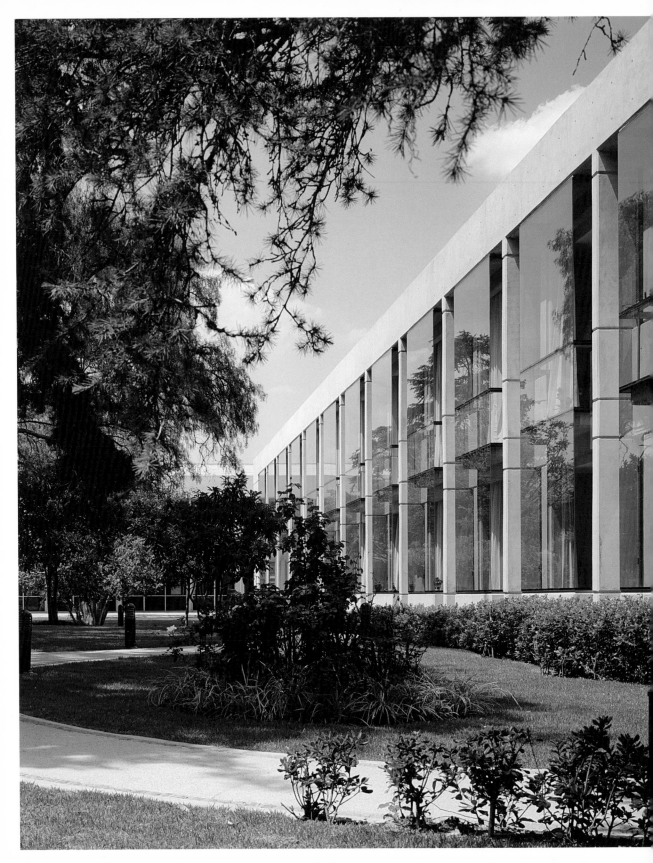

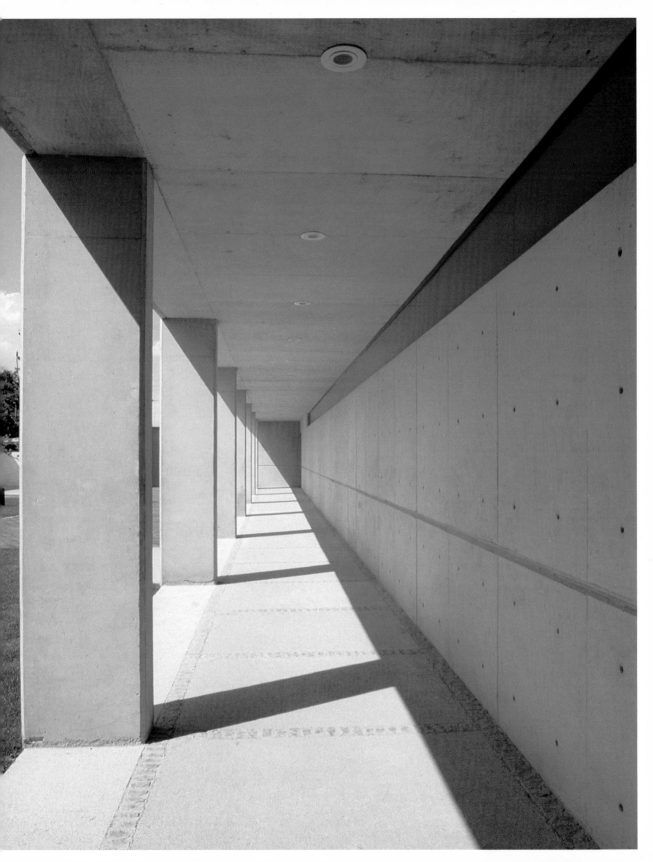

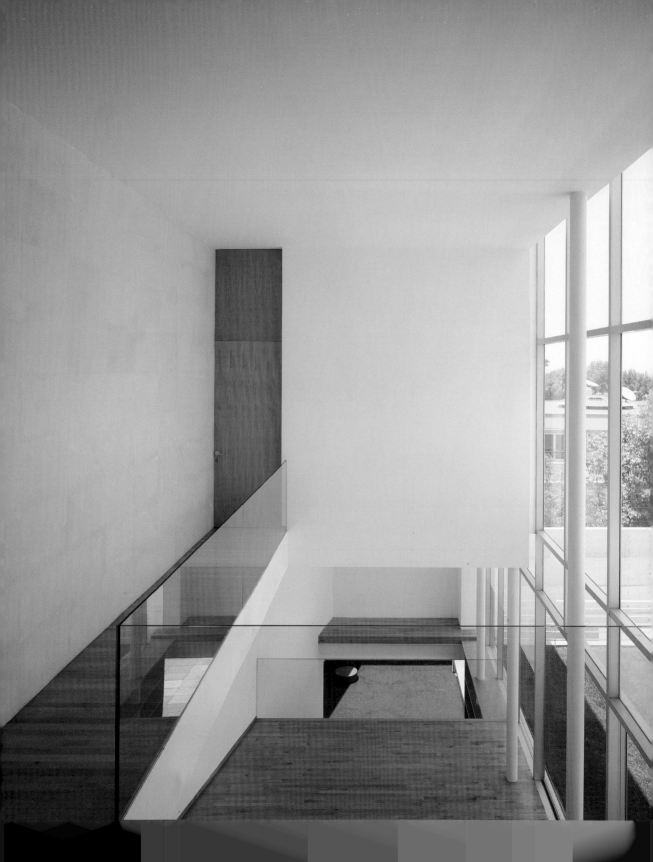

TALLER DE ENRIQUE NORTEN ARQUITECTOS, SC | MEXICO CITY (TEN ARQUITECTOS)
House C
Living Spaces
Lomas de Chapultepec, Mexico City | 2004
Photos: Luis Gordoa

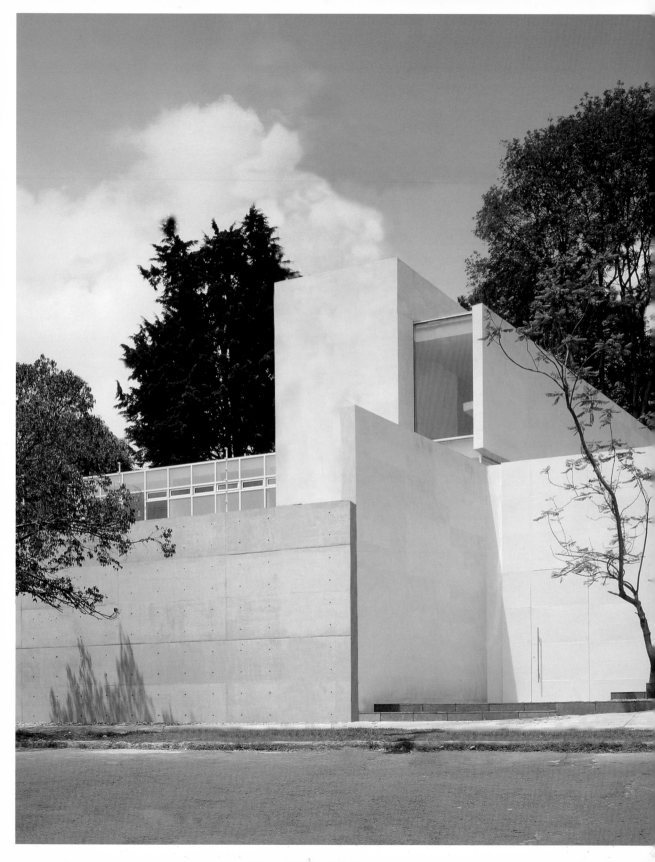

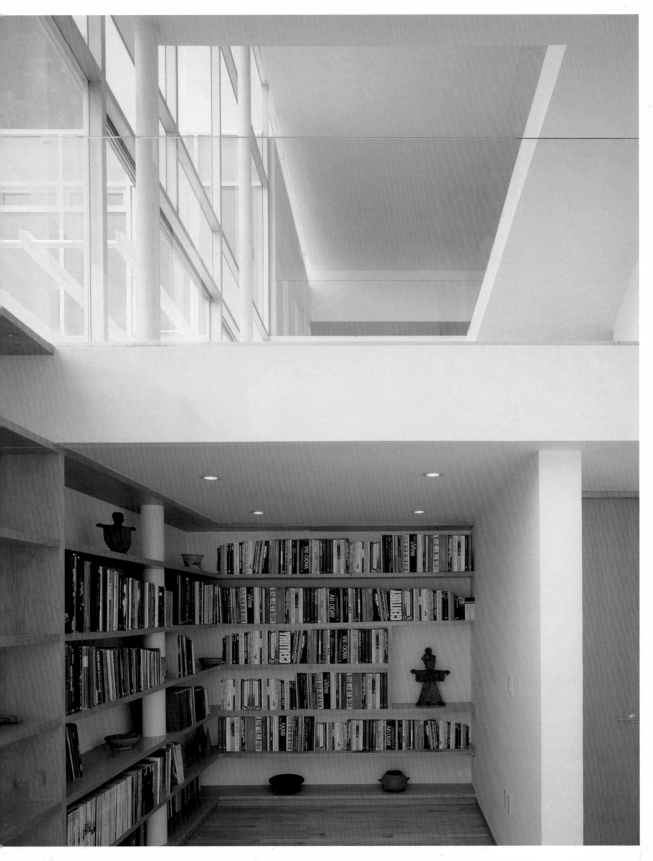

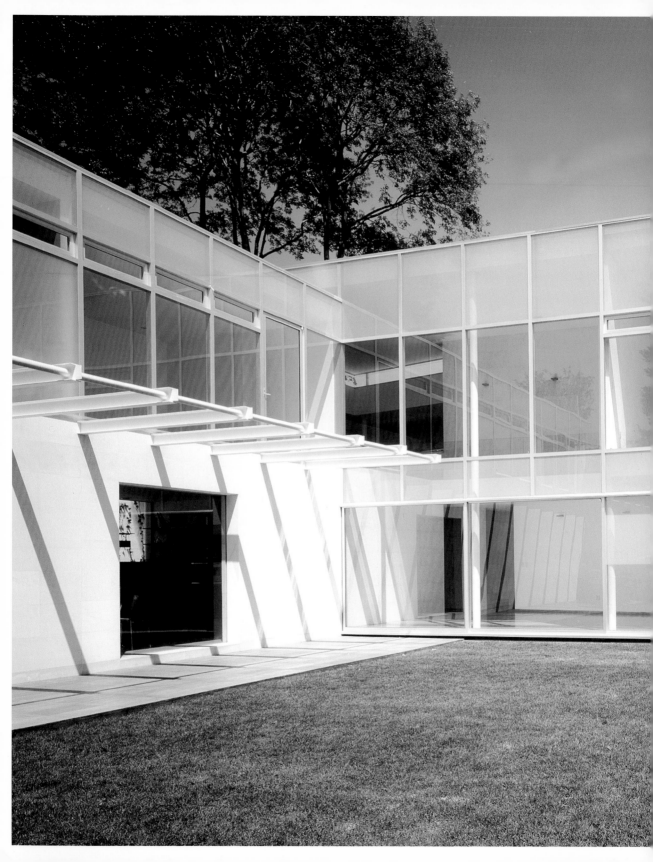

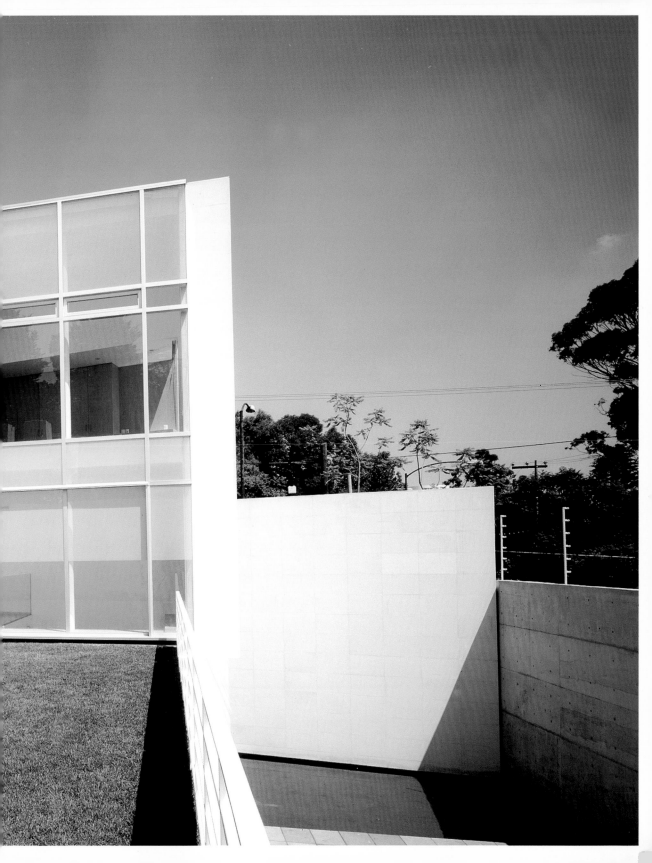

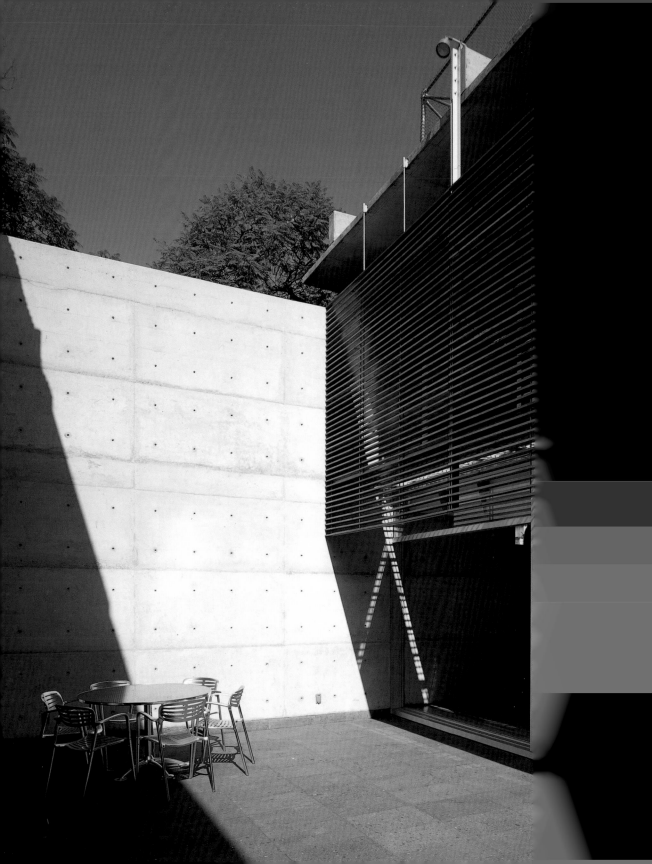

**TALLER DE ENRIQUE NORTEN ARQUITECTOS, SC | MEXICO CITY
(TEN ARQUITECTOS)**
House Le
Living Spaces
Mexico City | 1995
Photos: Luis Gordoa, Undine Pröhl (106)

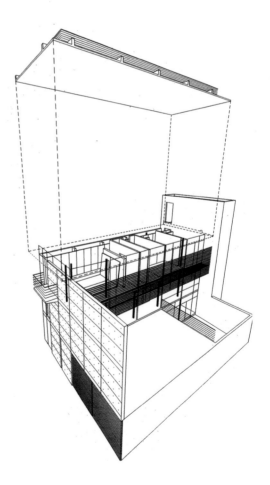

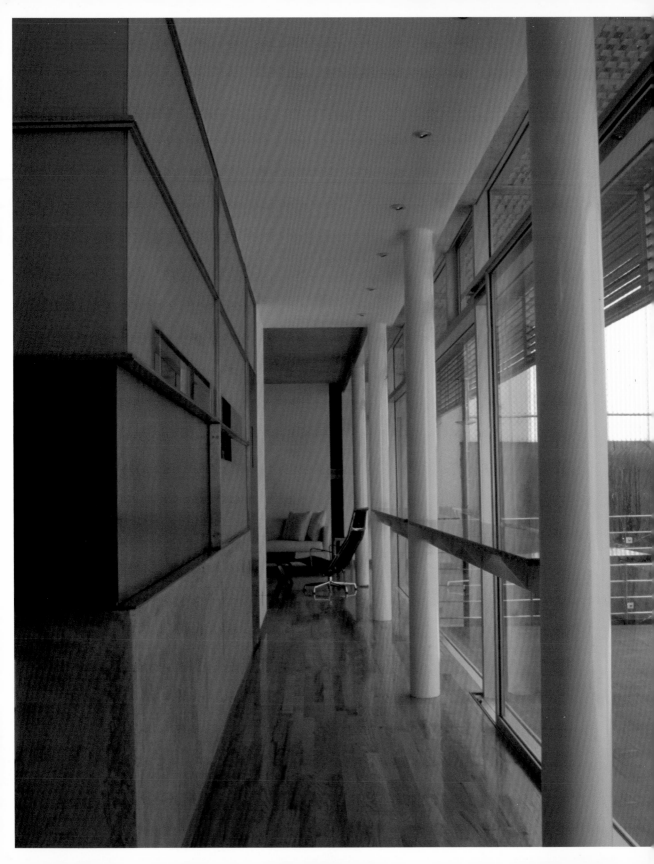

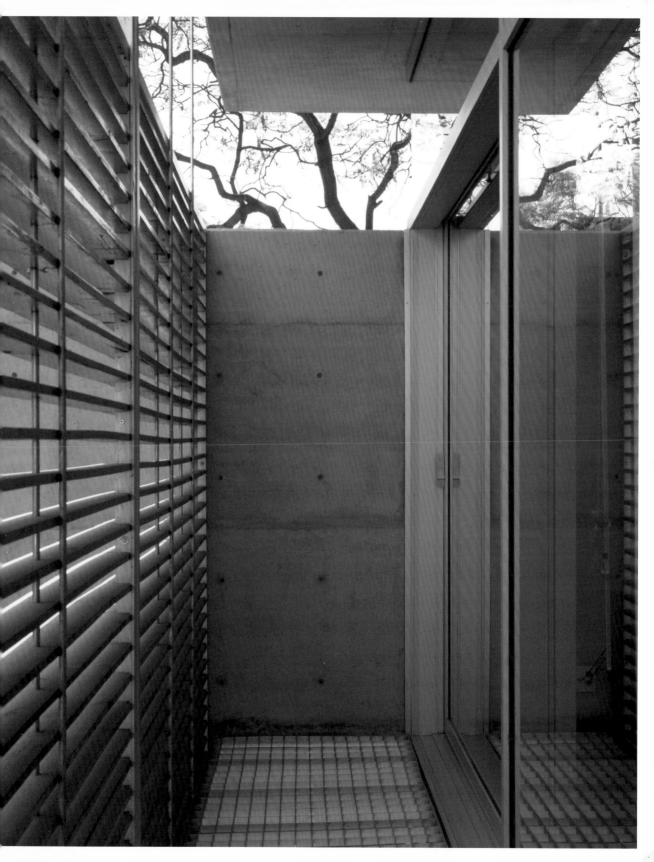

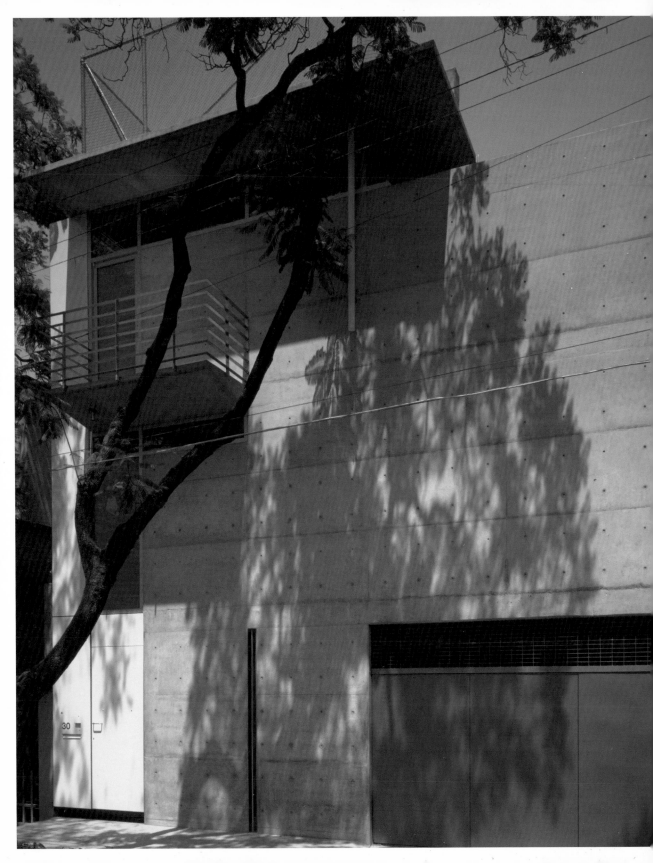

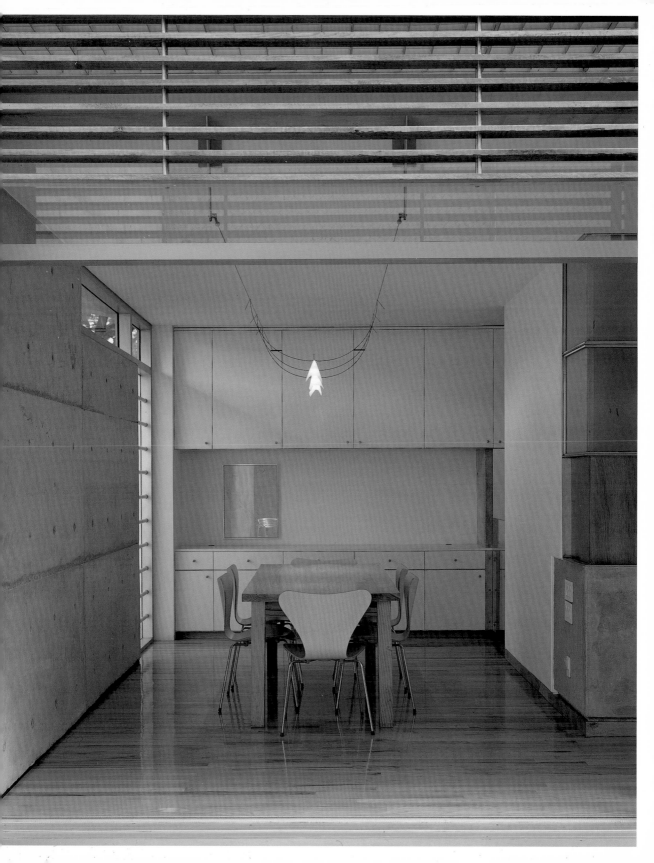

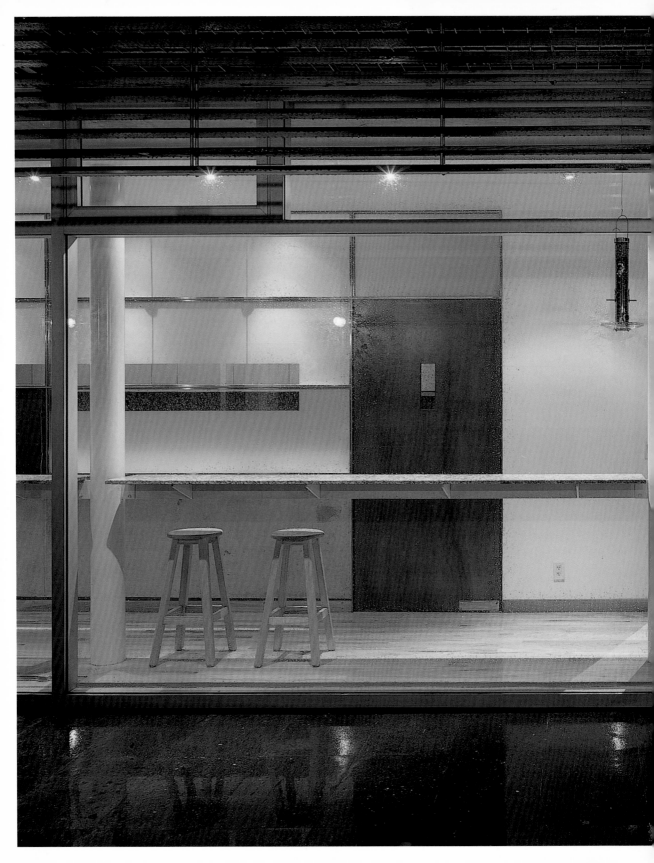

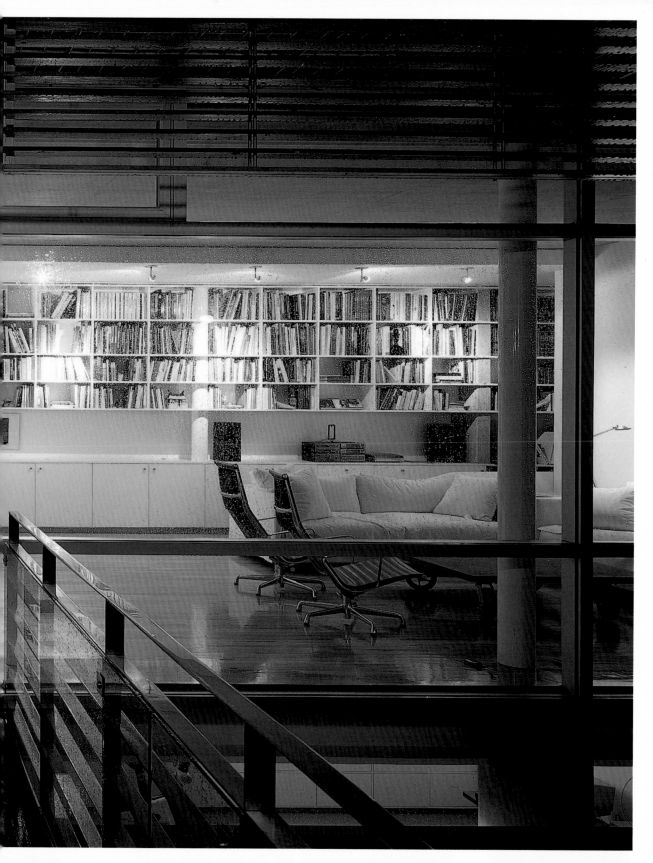

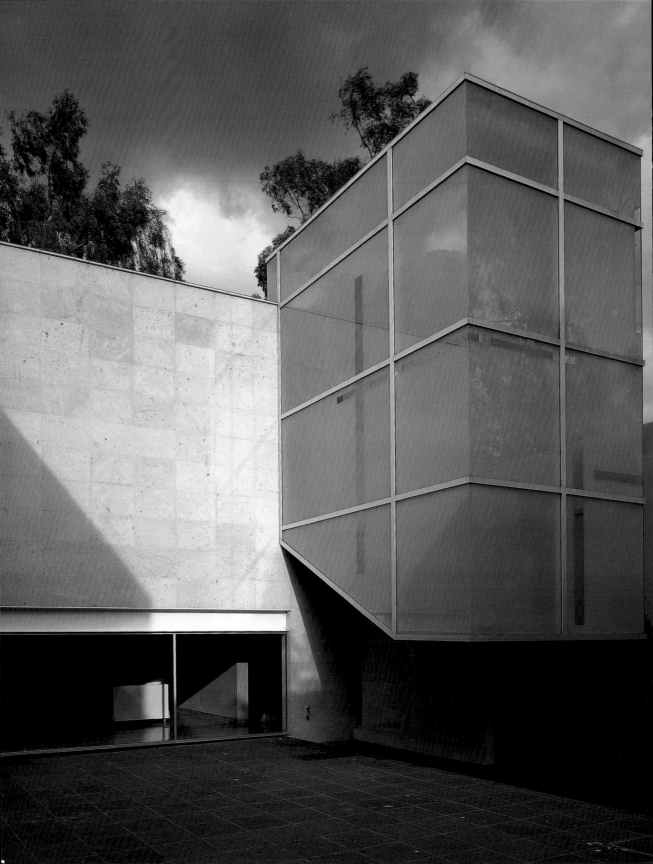

TALLER DE ENRIQUE NORTEN ARQUITECTOS, SC | MEXICO CITY (TEN ARQUITECTOS)
House RR
Living Spaces
Mexico City | 1997
Photos: Luis Gordoa

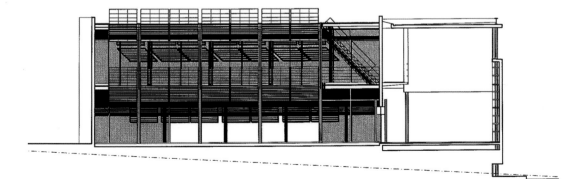

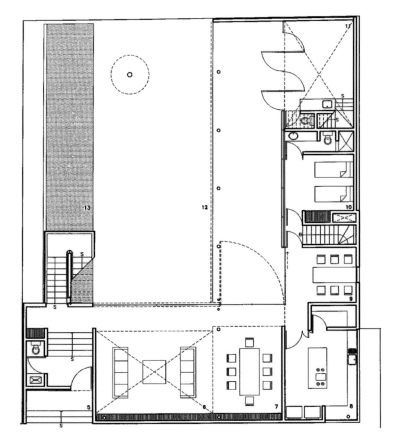

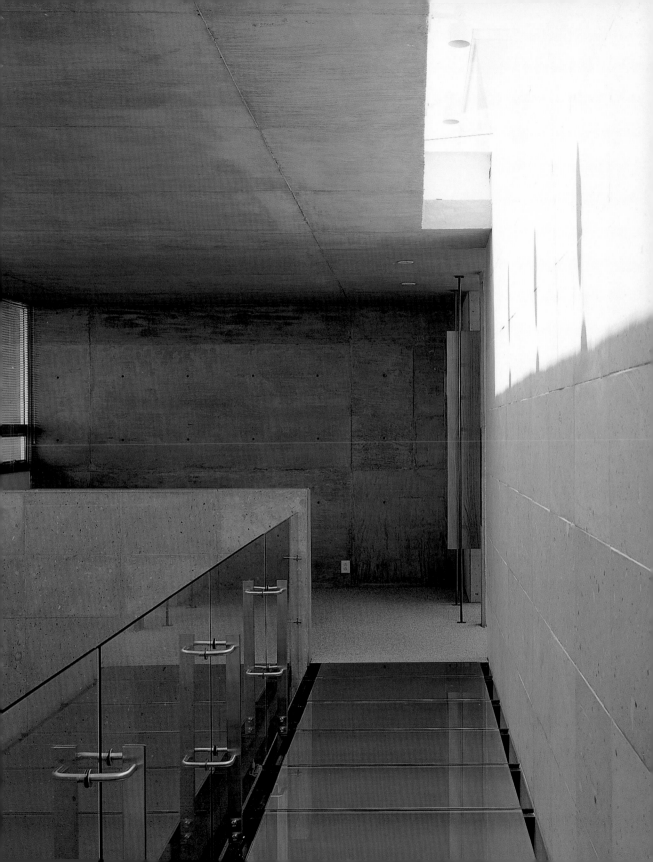

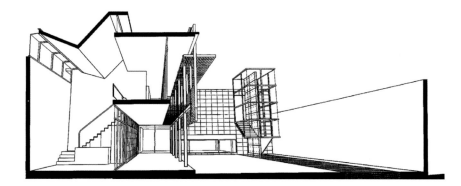

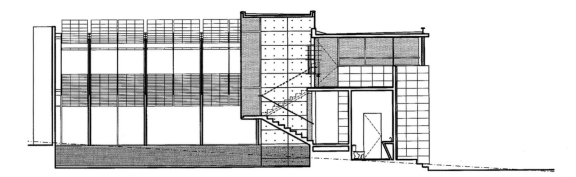

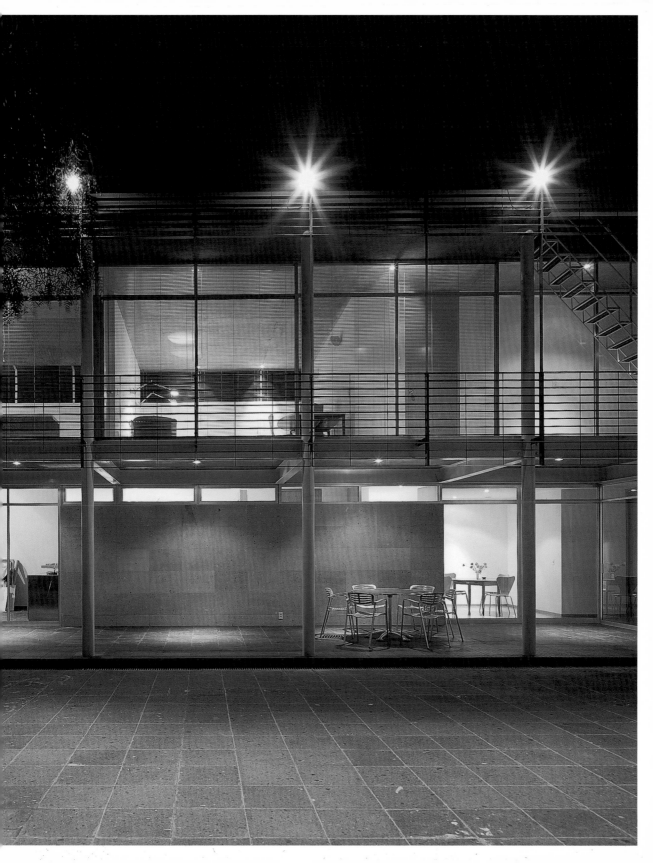

PUBLIC SPACES – RELIGIOUS, CULTURAL & SPORTS

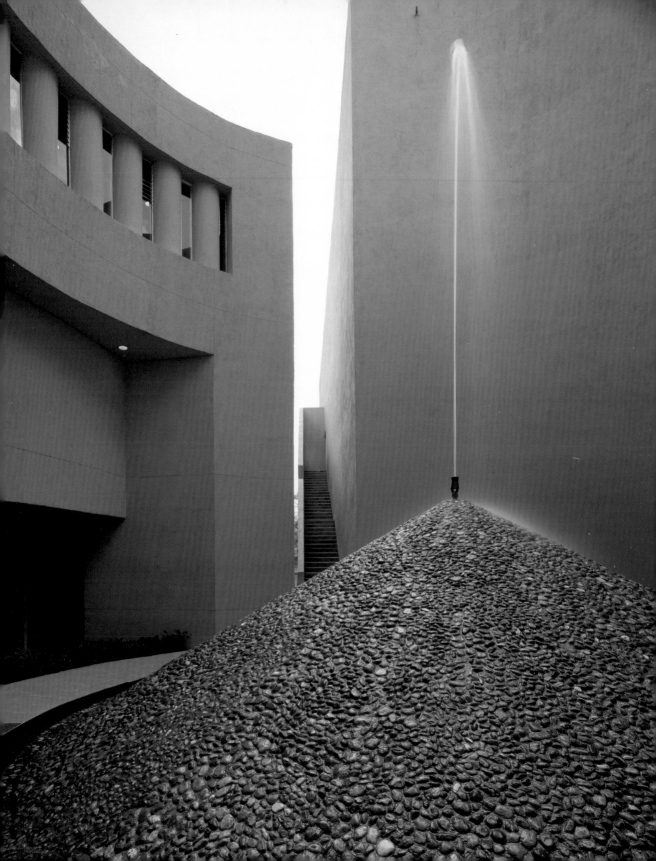

SERGIO MEJÍA ONTIVEROS / ARQUINTEG, S.A. DE C.V. | MEXICO CITY
Centro Nacional de Rehabilitación
Public Spaces - Rehabilitation Center
Delegación Tlalpan, Mexico City | 2004
Photos: Guillermo Soto

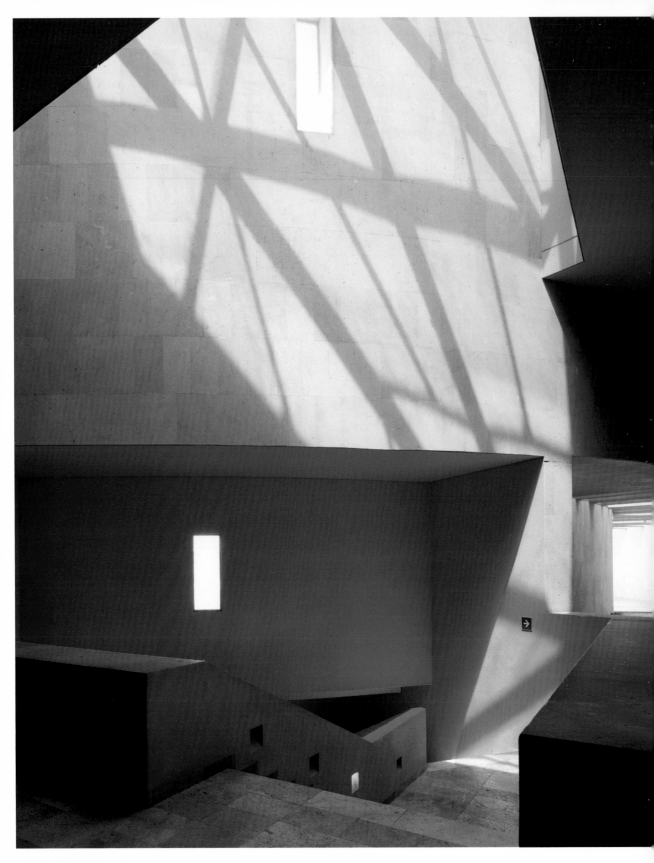

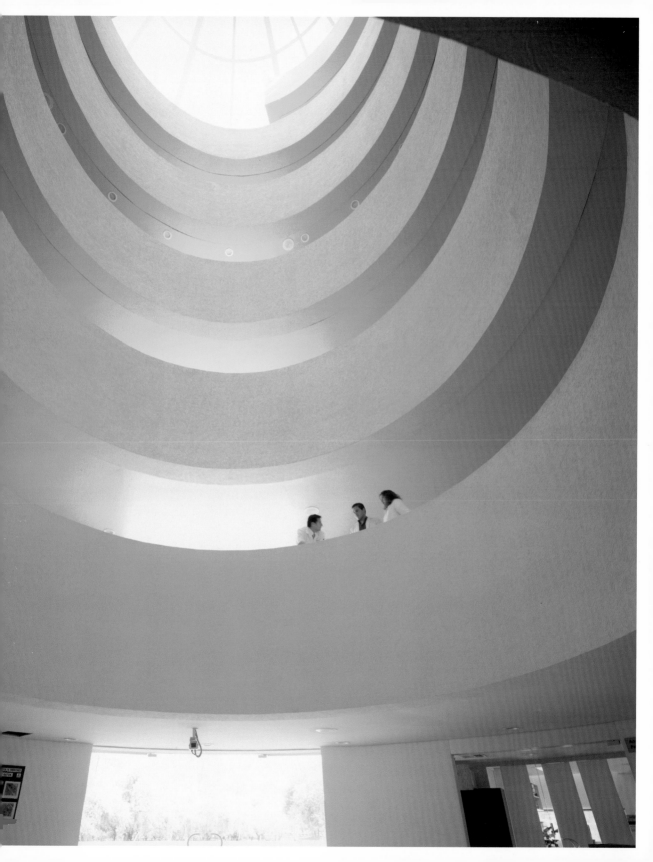

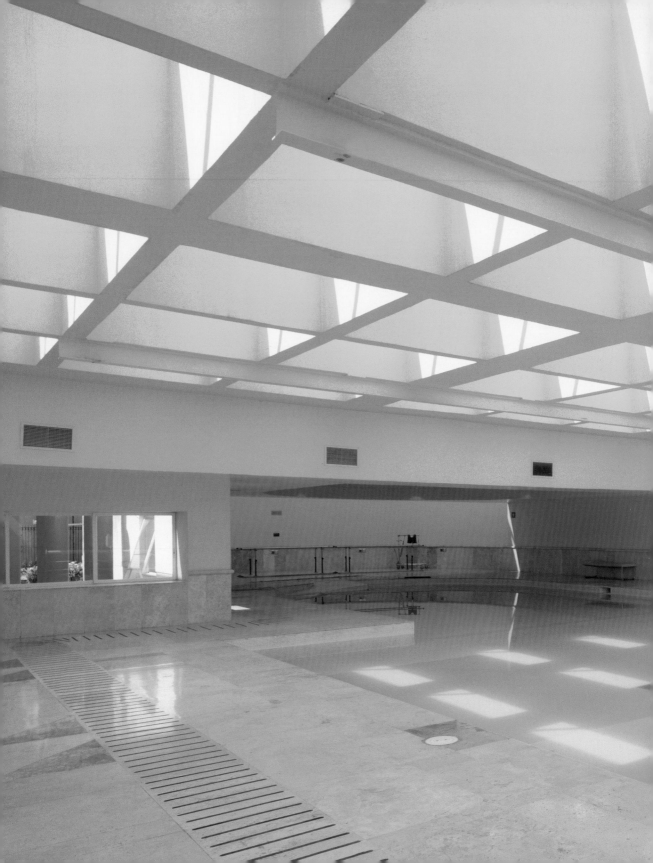

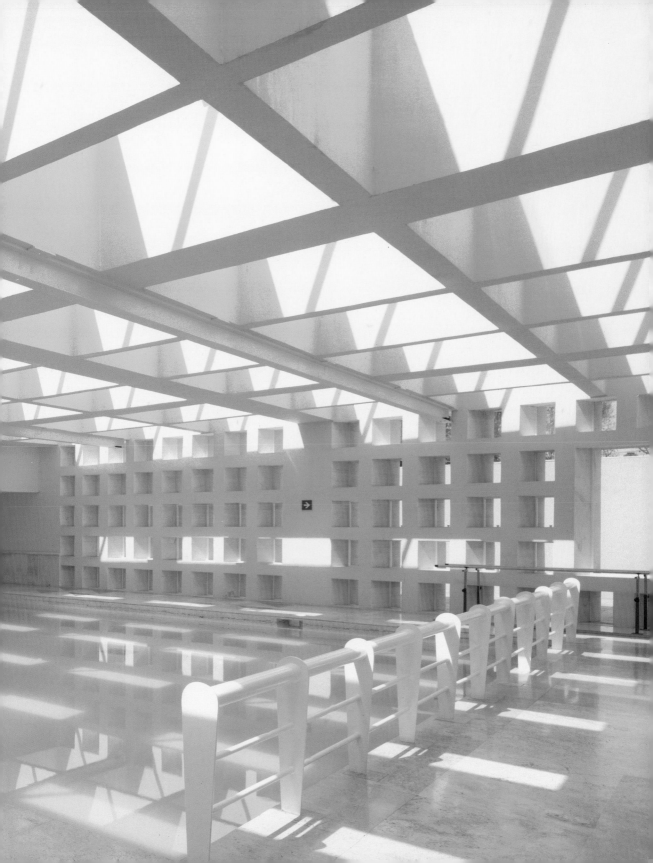

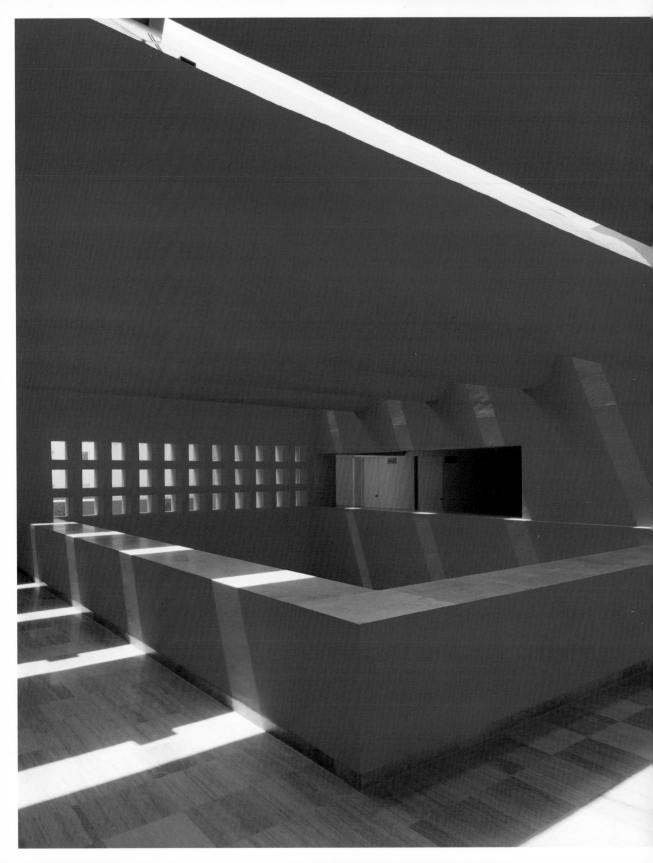

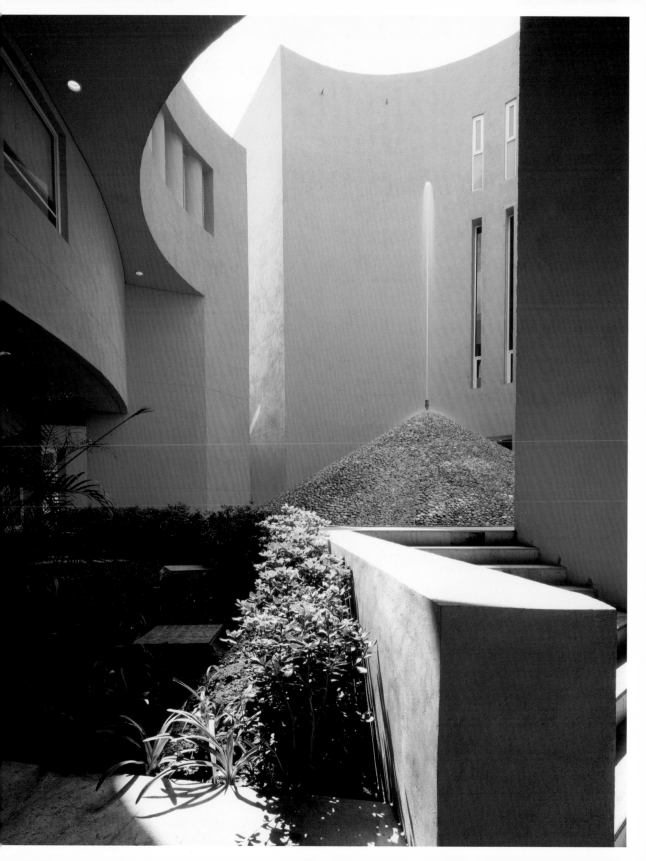

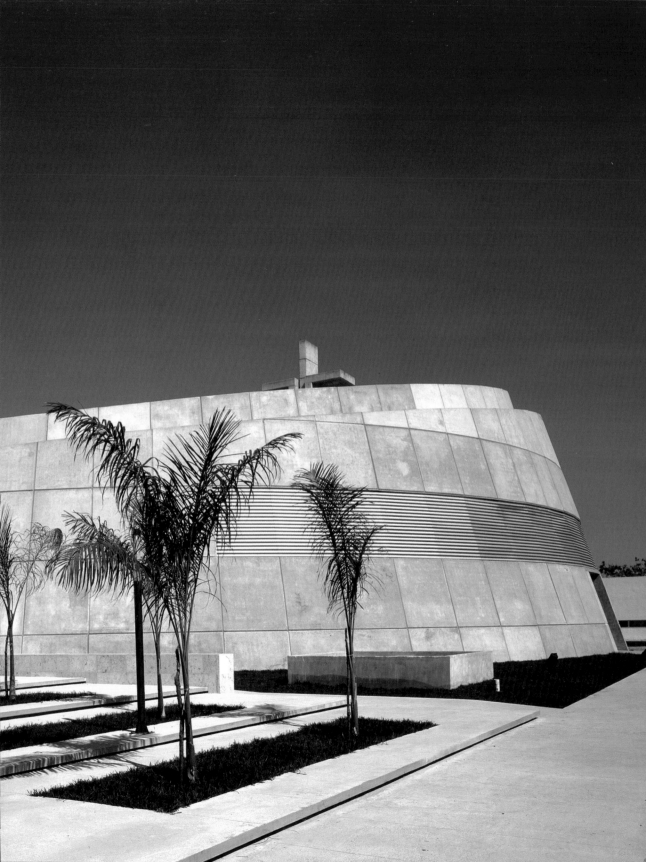

AUGUSTO QUIJANO ARQUITECTOS, S.C.P. | **MÉRIDA, YUCATÁN**
AUGUSTO QUIJANO AXLE, ENRIQUE CABRERA PENICHE
Parroquia de Cristo Resucitado
Public Spaces - Church
Mérida, Yucatán | 2004
Photos: Roberto Cárdenas Cabello

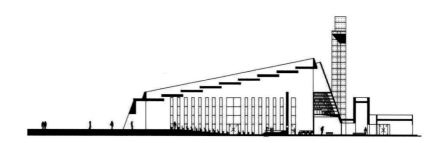

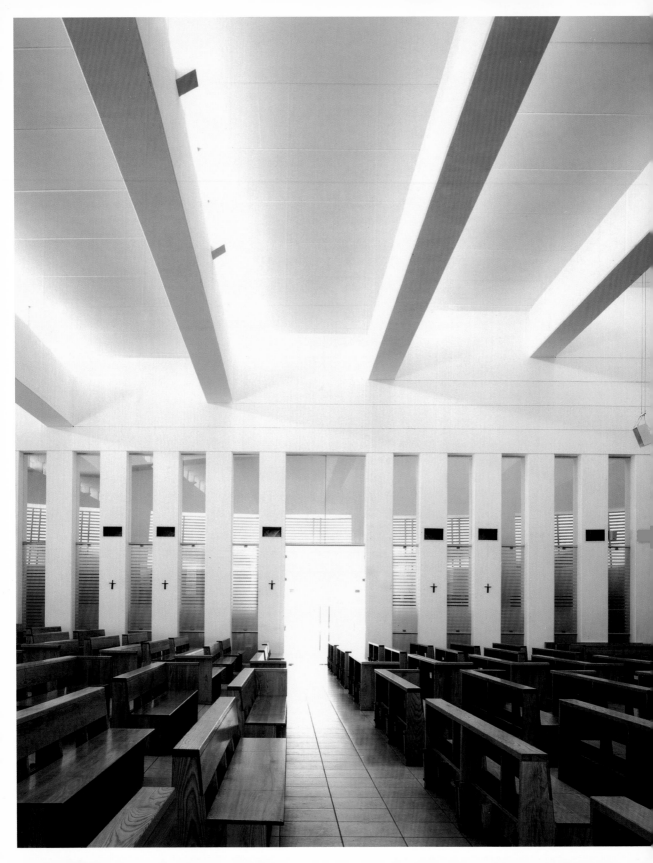

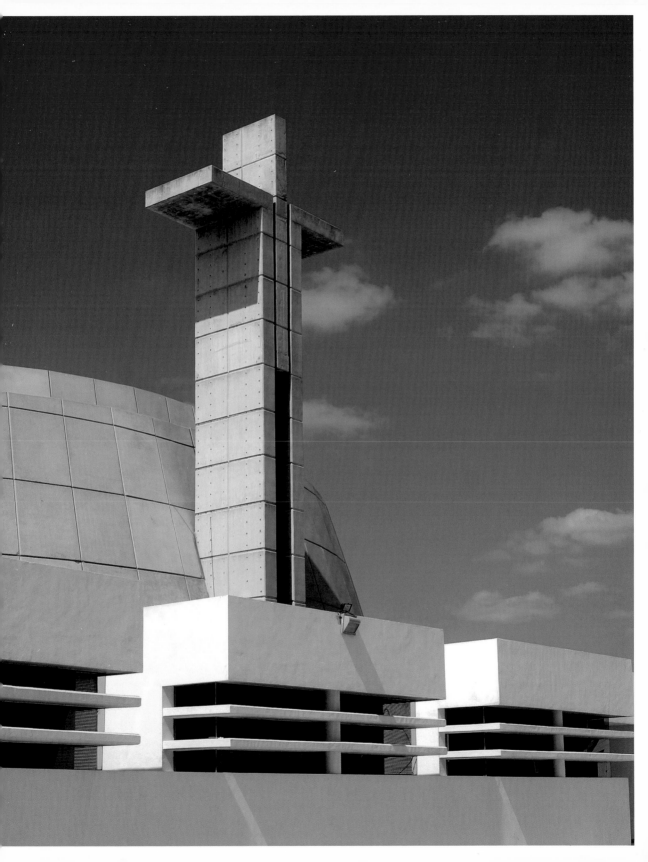

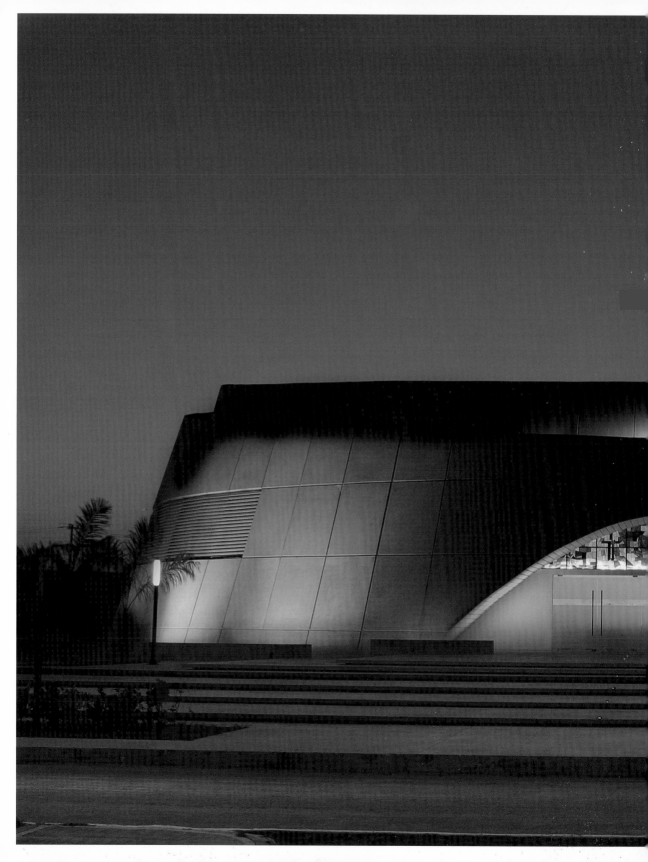

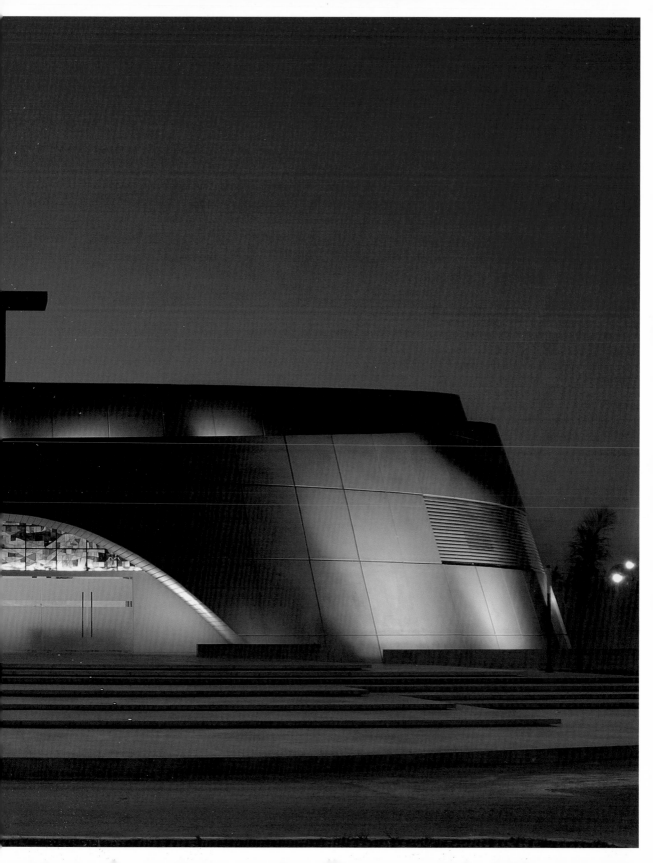

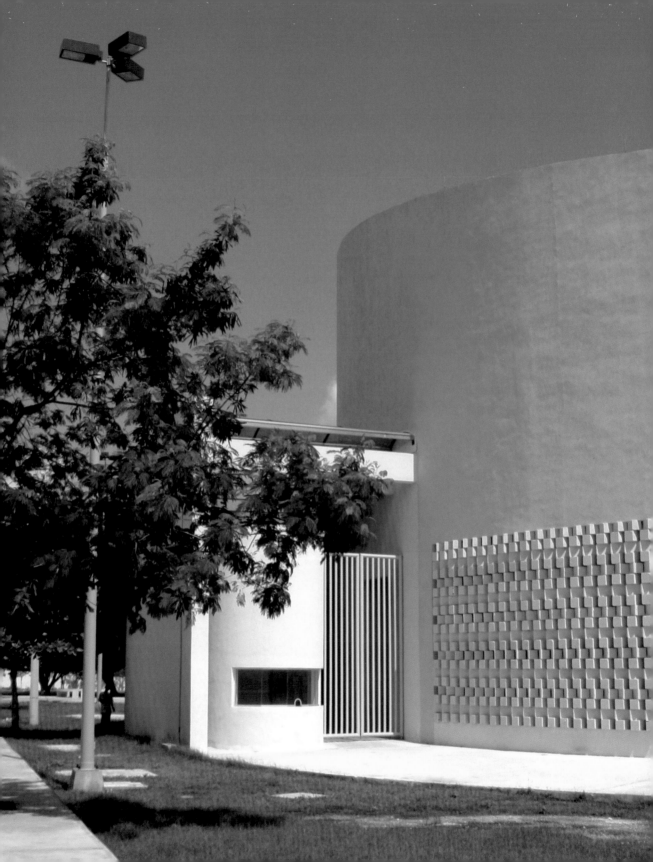

DUARTE AZNAR ARQUITECTOS, S.C.P | **MÉRIDA, YUCATÁN**
Multifuncional Gimnasium of Tizimín
Public Spaces - Gimnasium
Tizimín, Yucatán | 2001
Photos: Roberto Cárdenas Cabello, Enrique Duarte Aznar (134, 137)

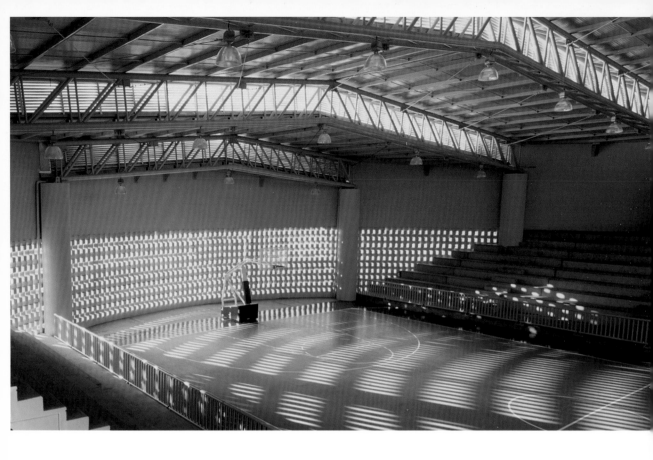

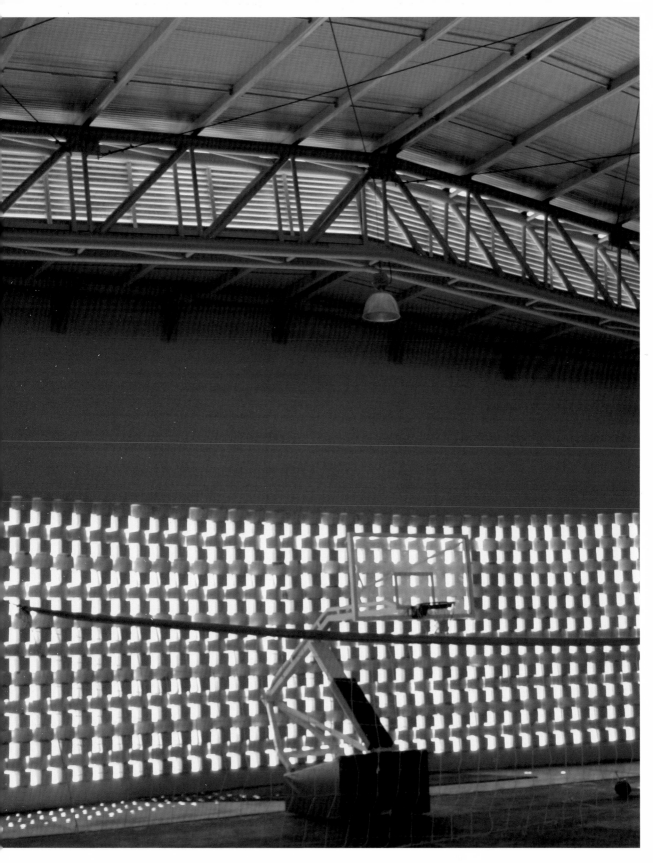

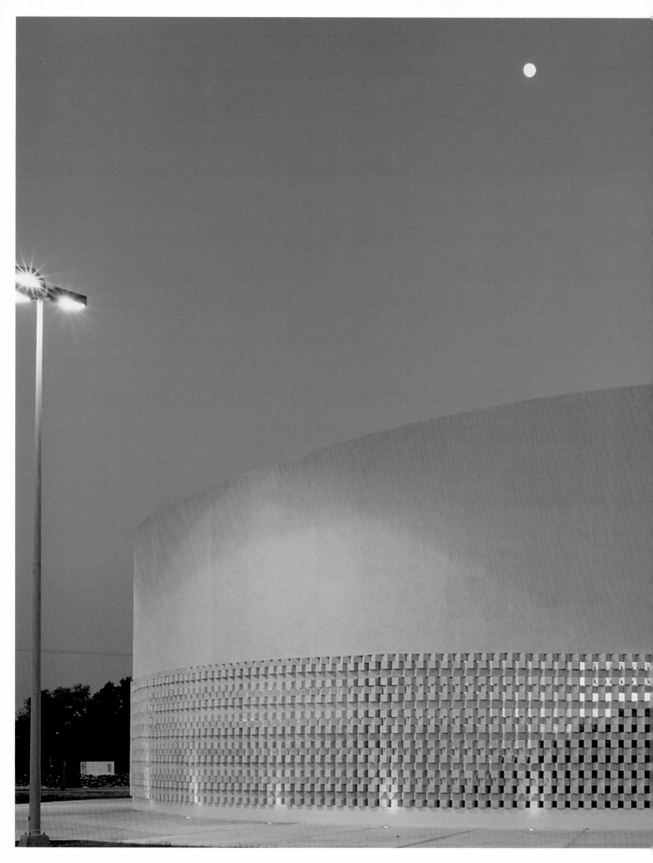

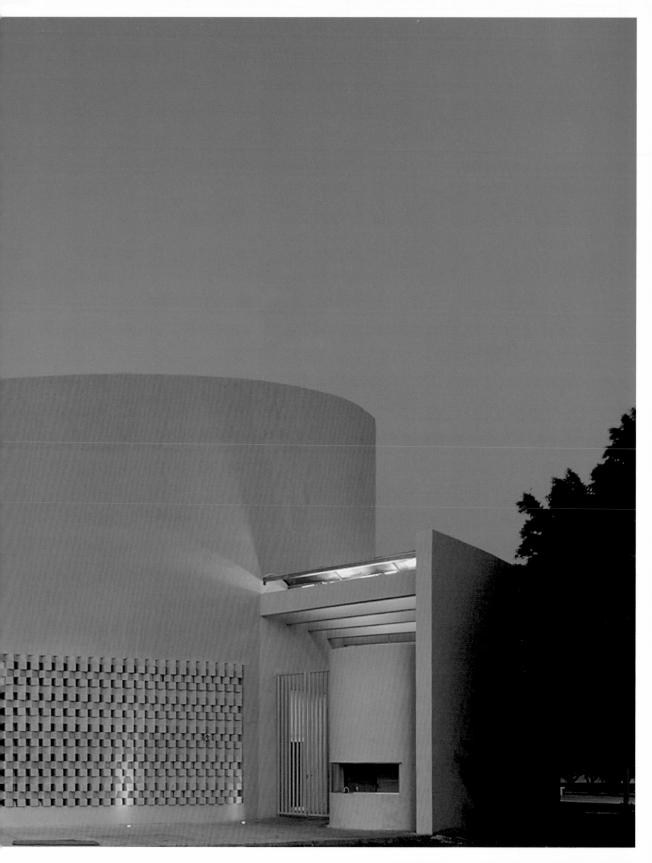

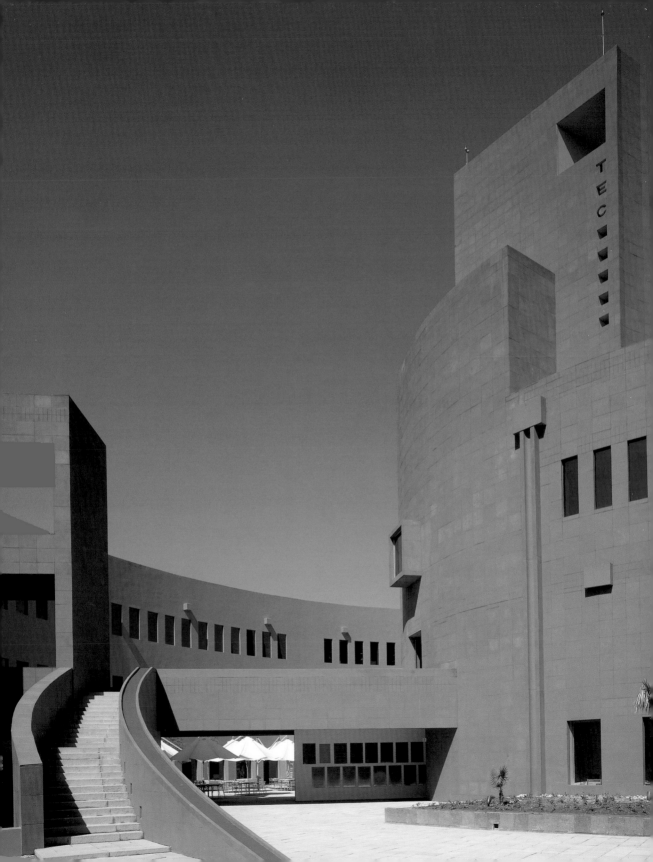

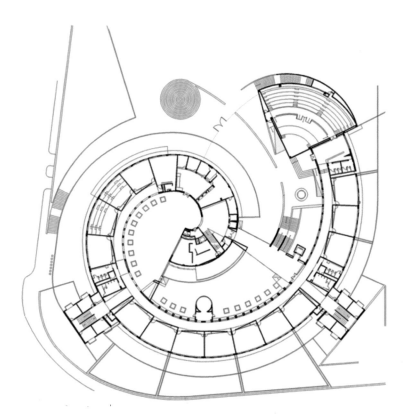

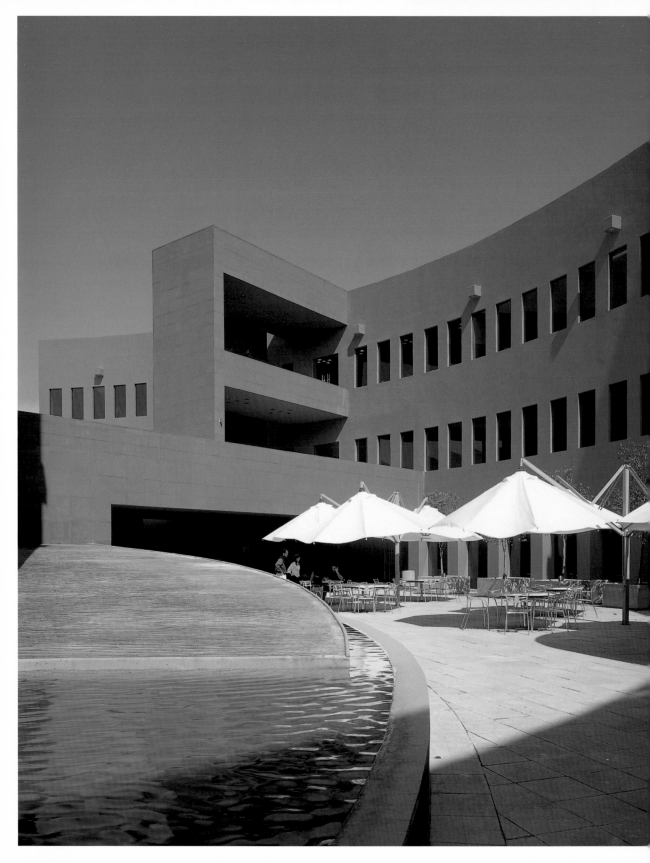

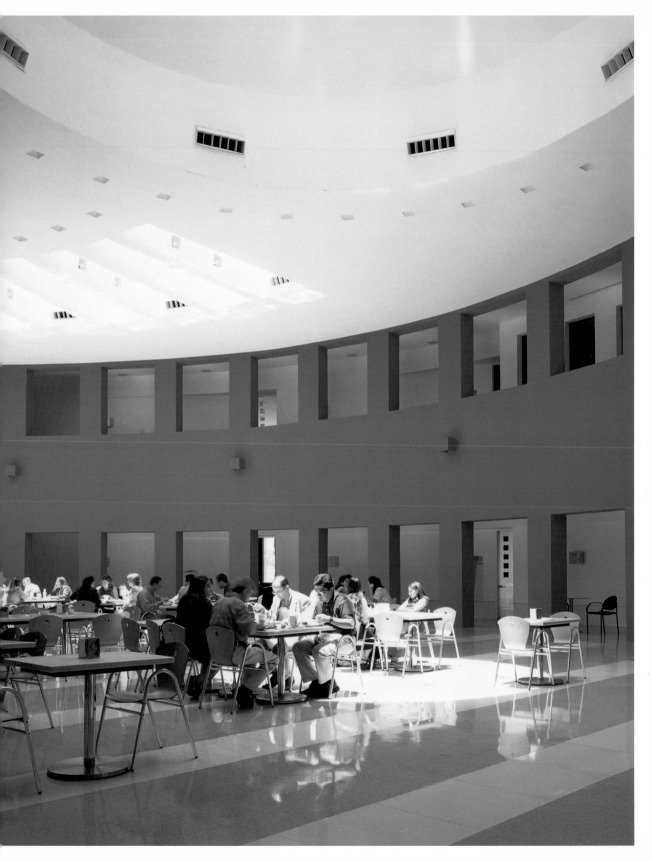

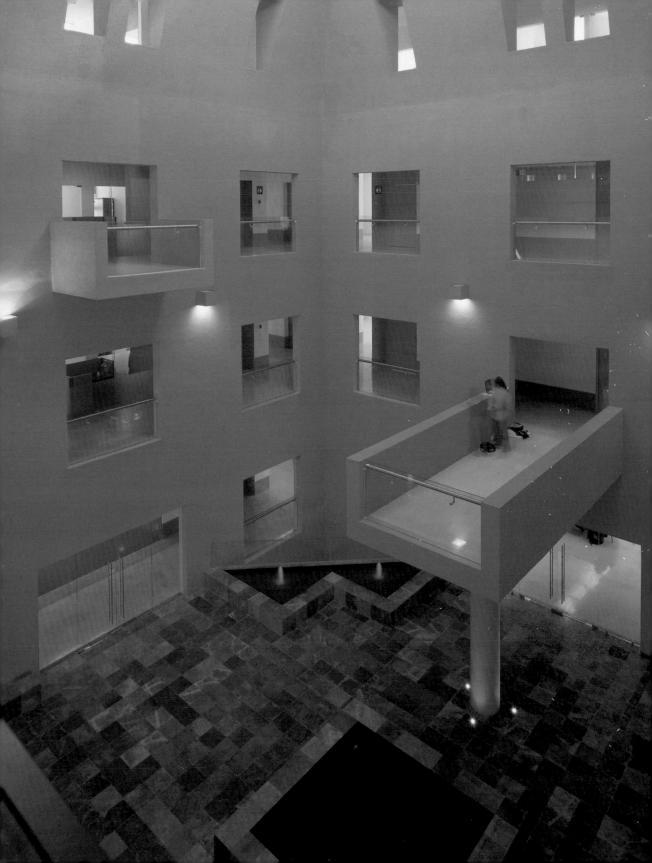

LEGORRETA + LEGORRETA | MEXICO CITY
ITESM Campus Santa Fe
Public Spaces - Educational
Santa Fe, Mexico City | 2001
Photos: Lourdes Legorreta

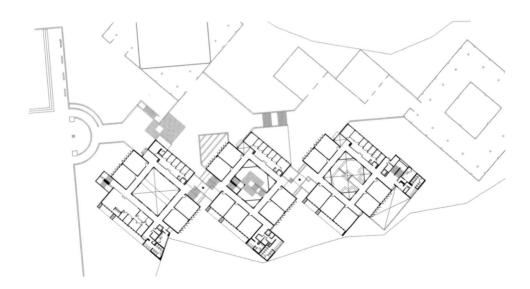

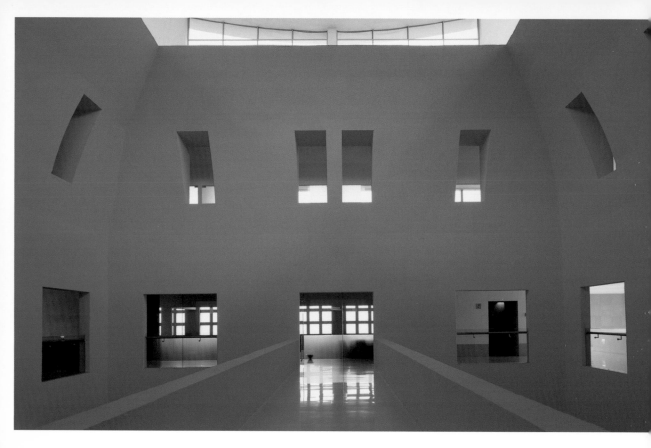

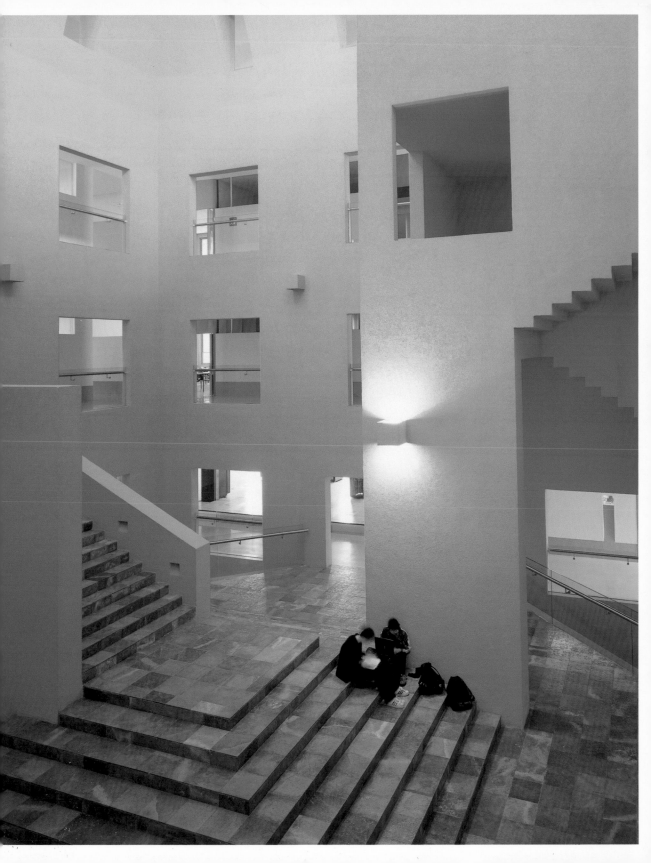

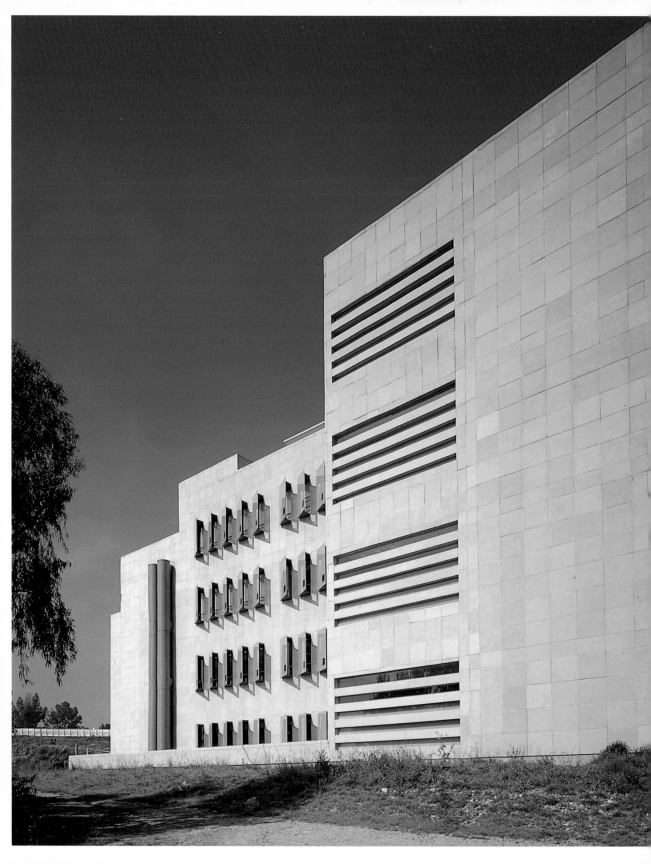

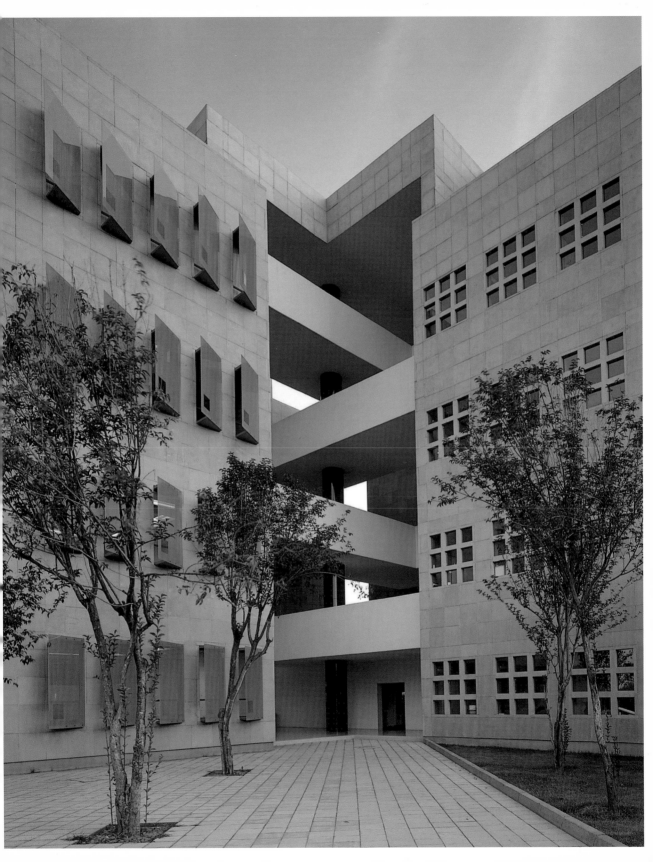

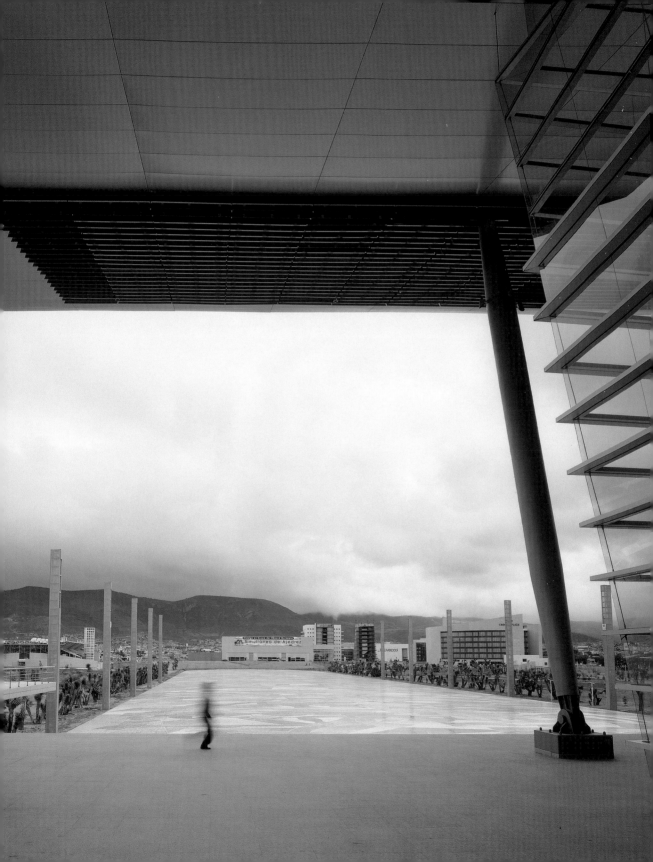

JAIME VARON, ABRAHAM & ALEX METTA, MIDGAL ARQUITECTOS | MEXICO CITY
Teatro Auditorio Gota de Plata
Public Spaces - Theater
Pachuca, Hidalgo | 2005
Photos: Paul Czitrom

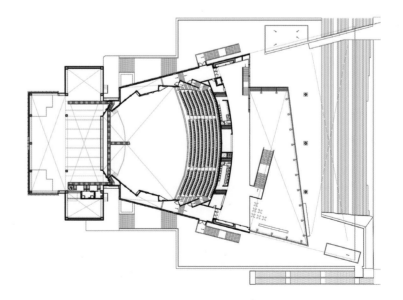

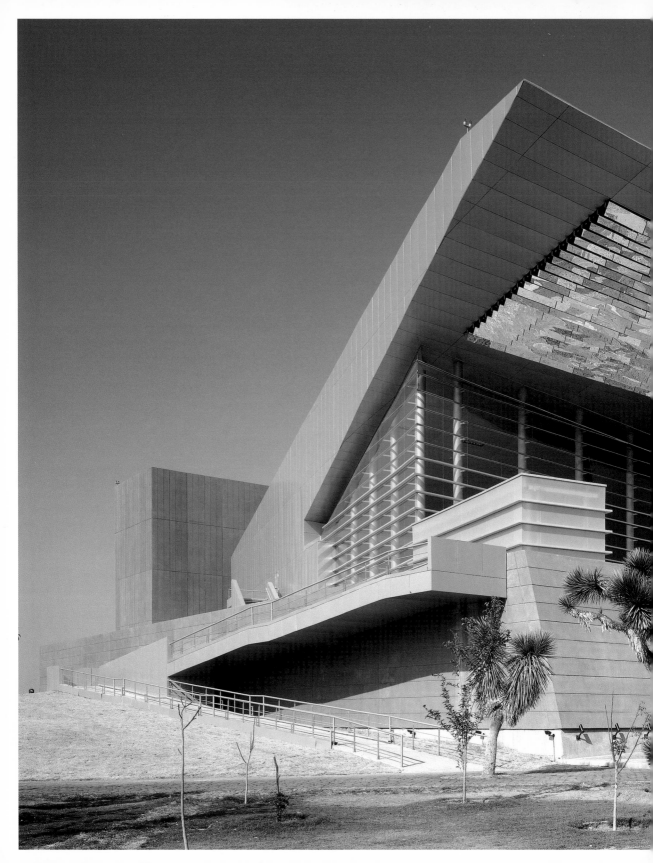

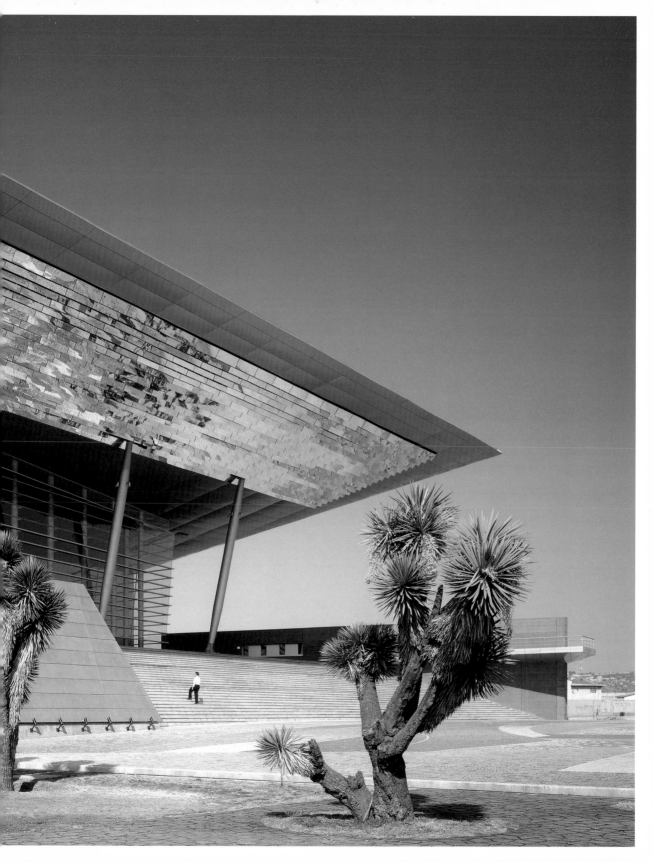

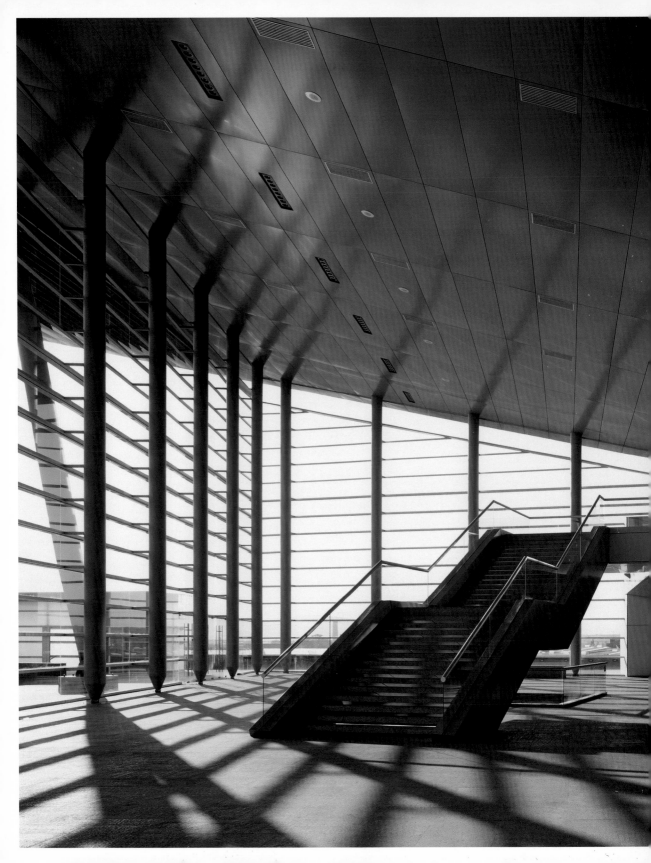

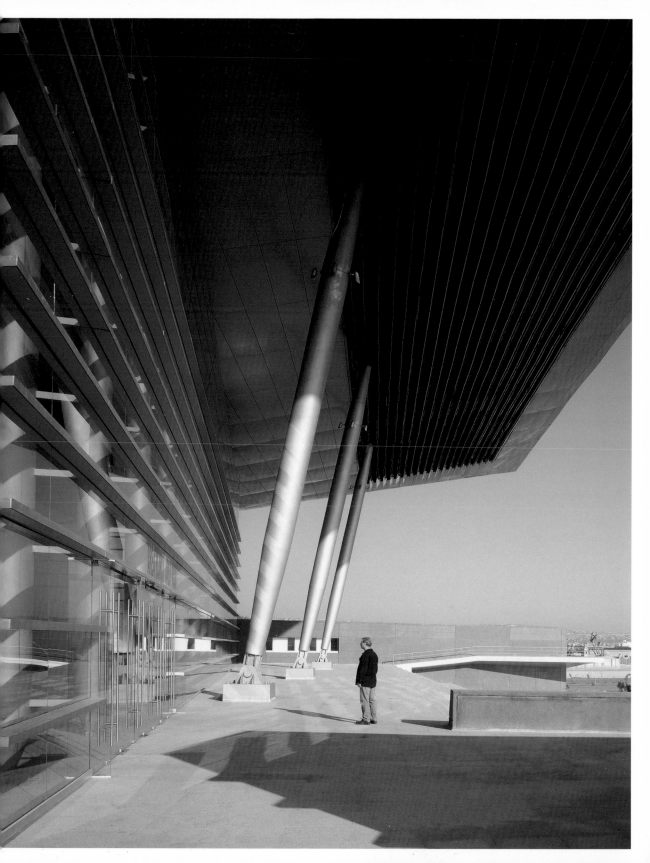

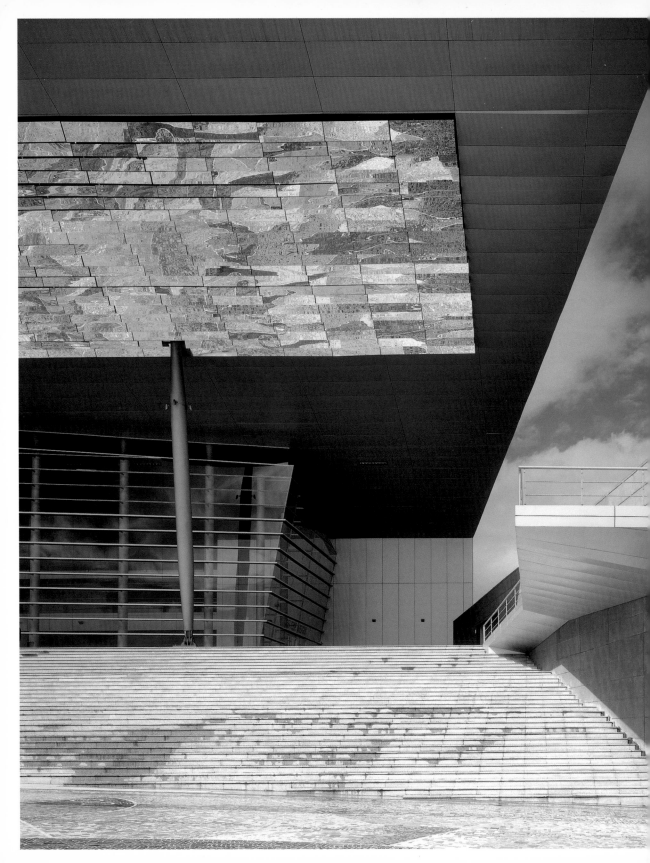

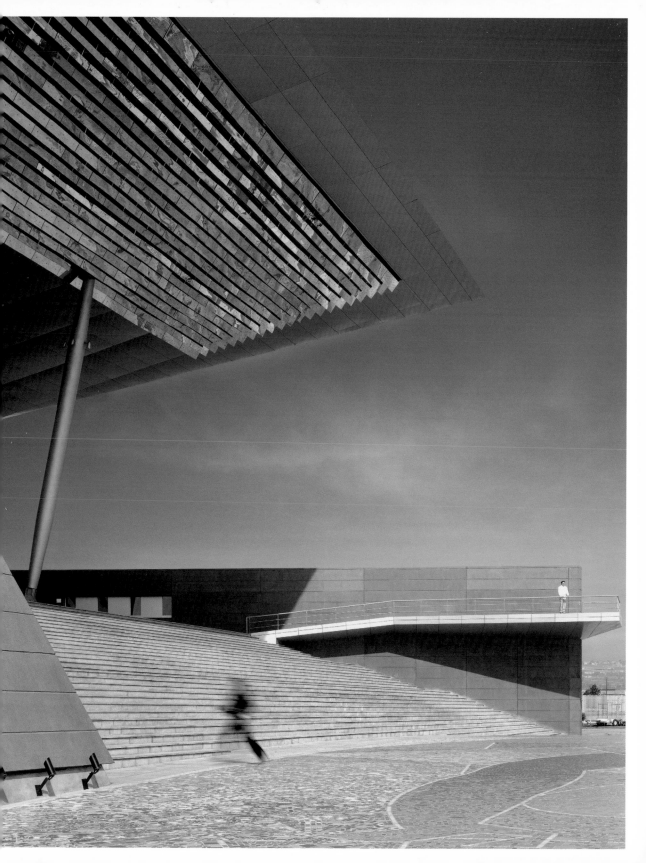

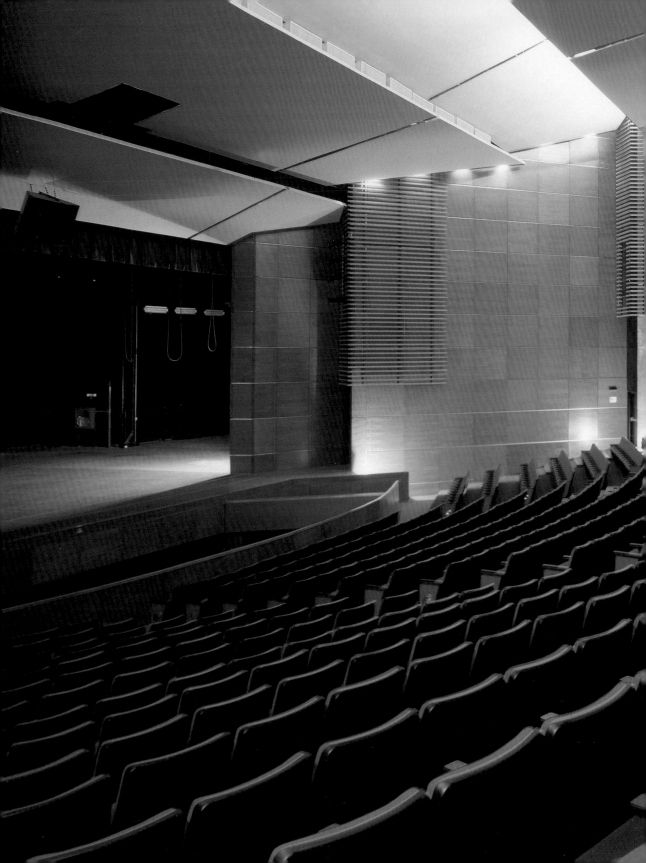

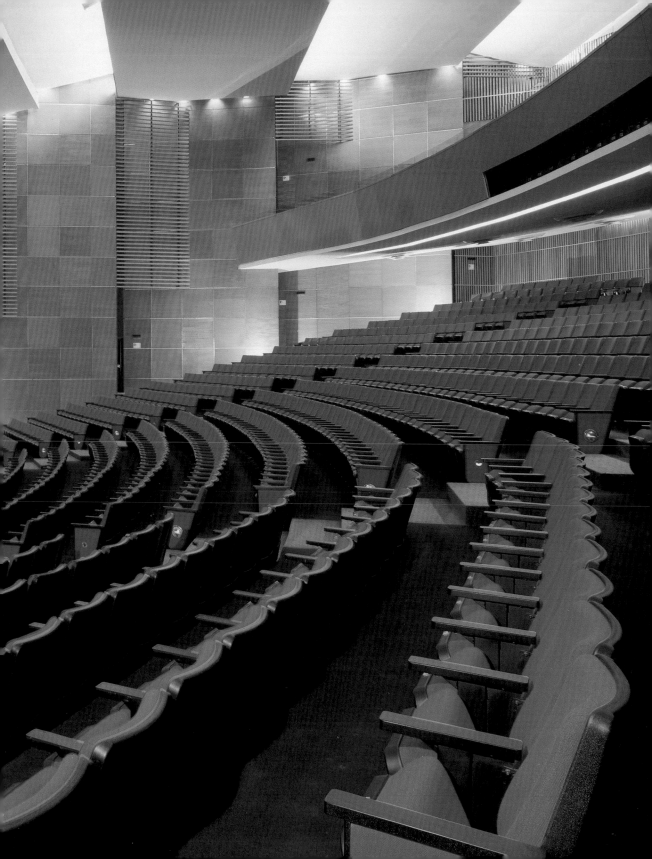

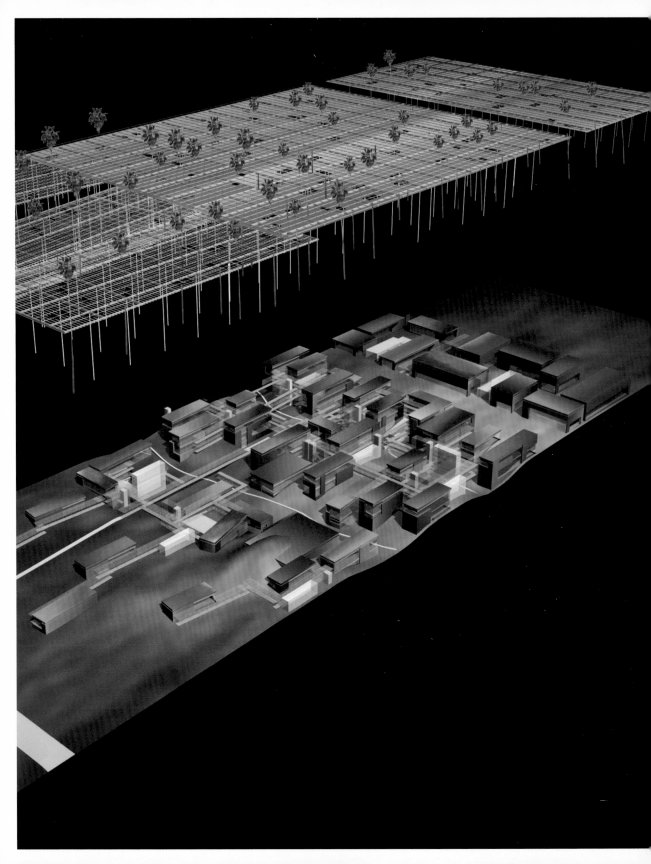

ATELIERS JEAN NOUVEL | PARIS
JVC Omnilife Headquarters
JVC Cultural and Business Center Master Plan
Public Spaces
Zapopan, Jalisco | in process
Renderings: Atelier Jean Nouvel

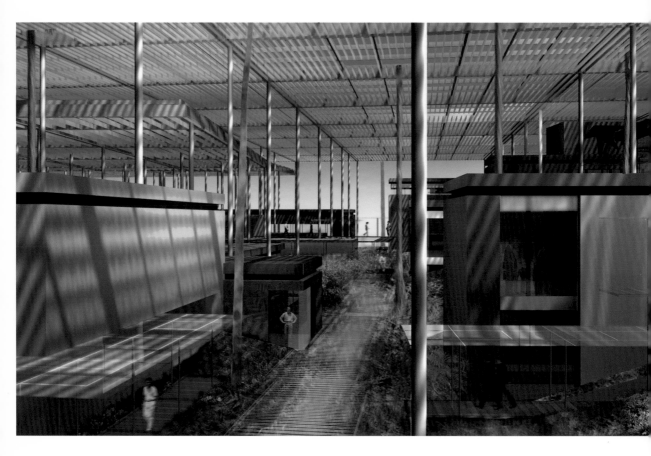

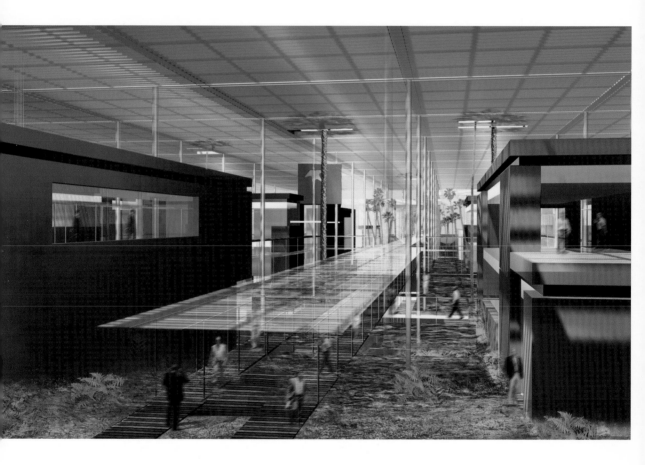

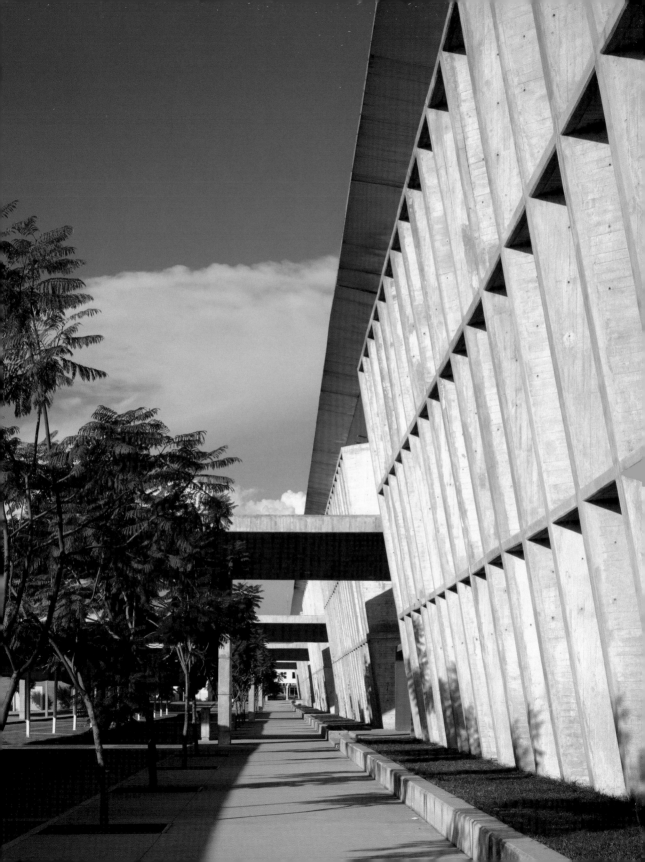

NUÑO-MAC GREGOR-DE BUEN ARQUITECTOS, S.C. | MEXICO CITY
CLARA DE BUEN, CARLOS MAC GREGOR, AURELIO NUÑO,
FRANCIS X. SÁENZ DE VITERI
Centro de Congresos y Exhibiciones Poliforum León
Public Spaces - Convention & Exhibition Center
León, Guanajuato | 2002
Photos: Pedro Hiriart, Gerardo Villanueva (171)

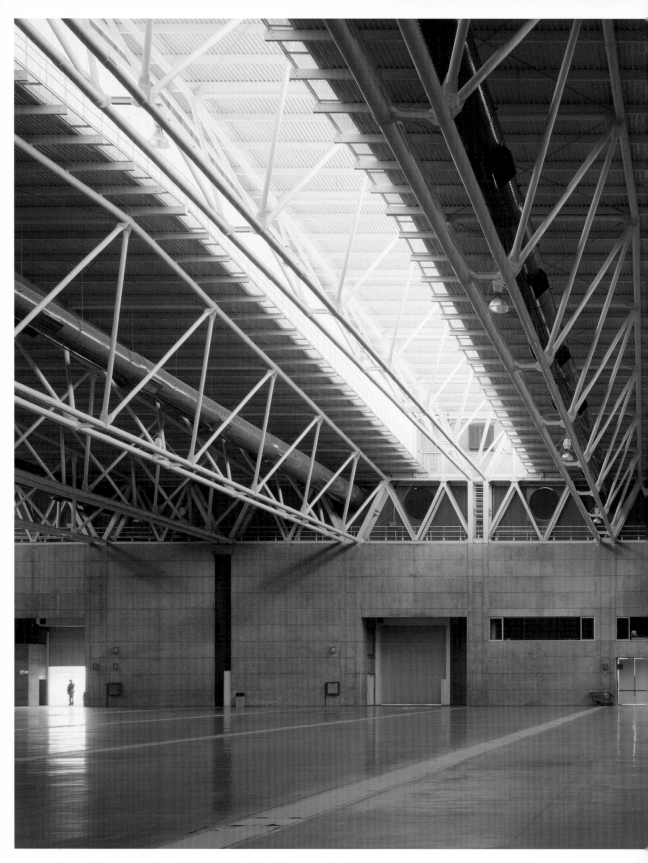

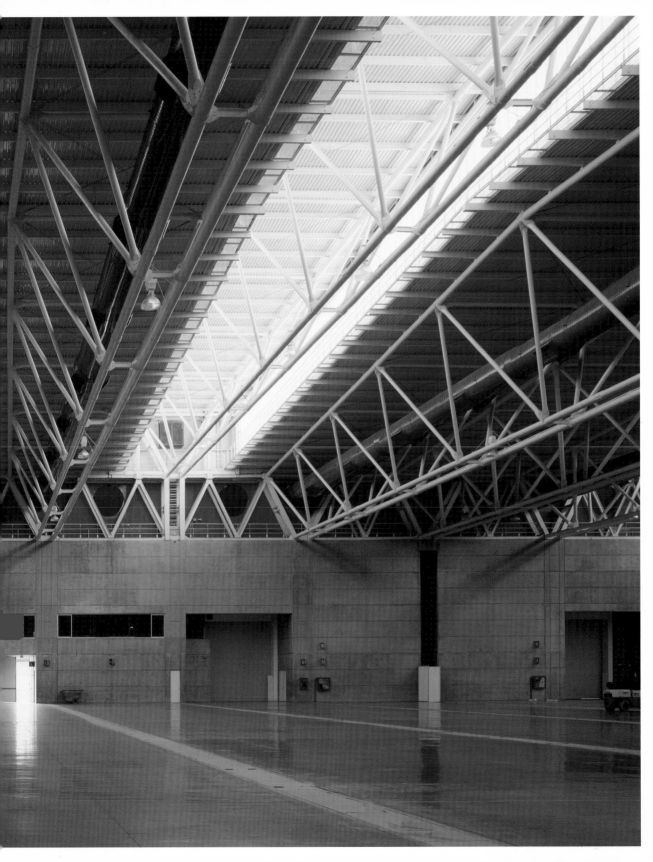

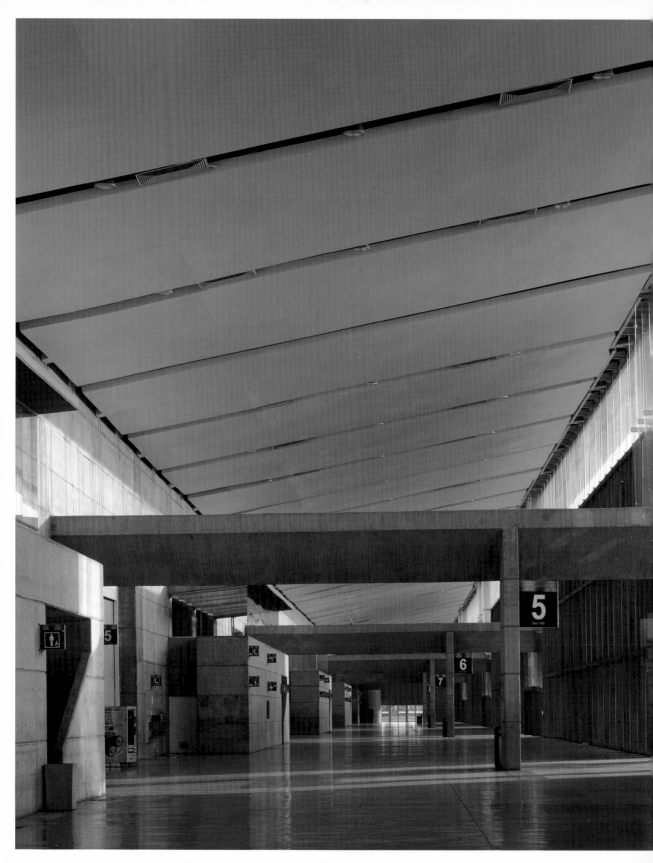

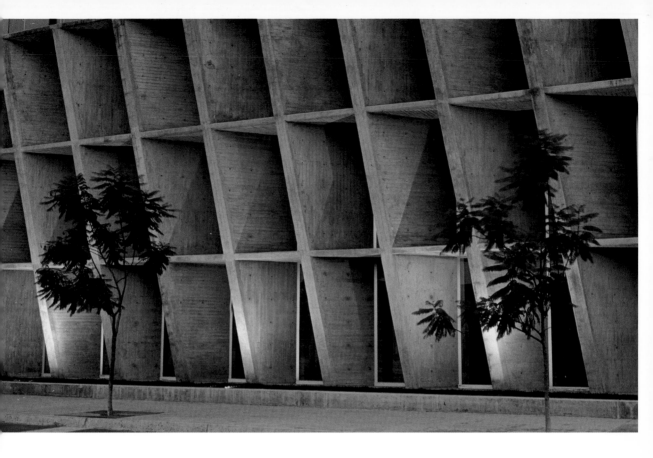

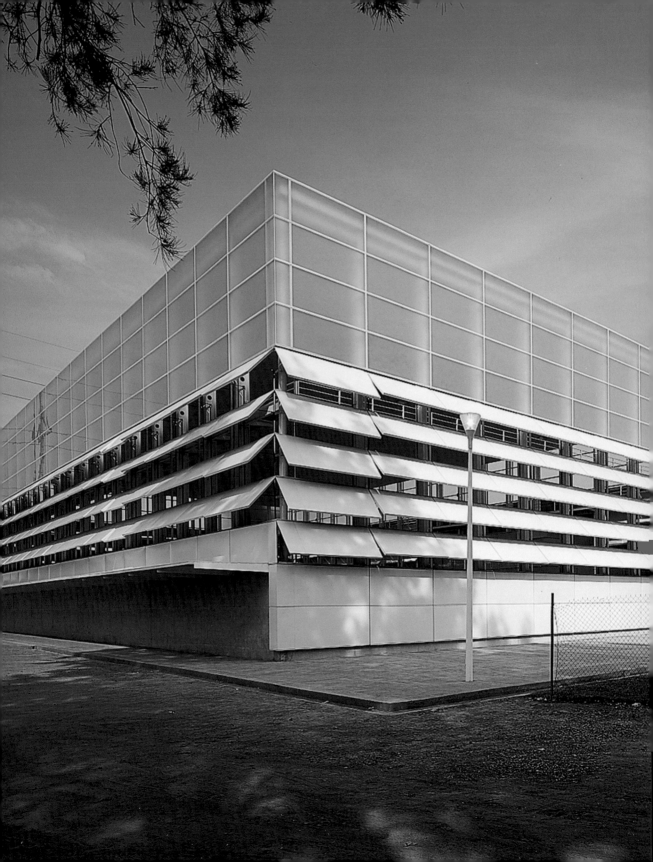

TALLER DE ENRIQUE NORTEN ARQUITECTOS, SC | MEXICO CITY (TEN ARQUITECTOS)
Educare Sports Facilities
Public Spaces - Educational
Zapopan, Jalisco | 2001
Photos: Jaime Navarro

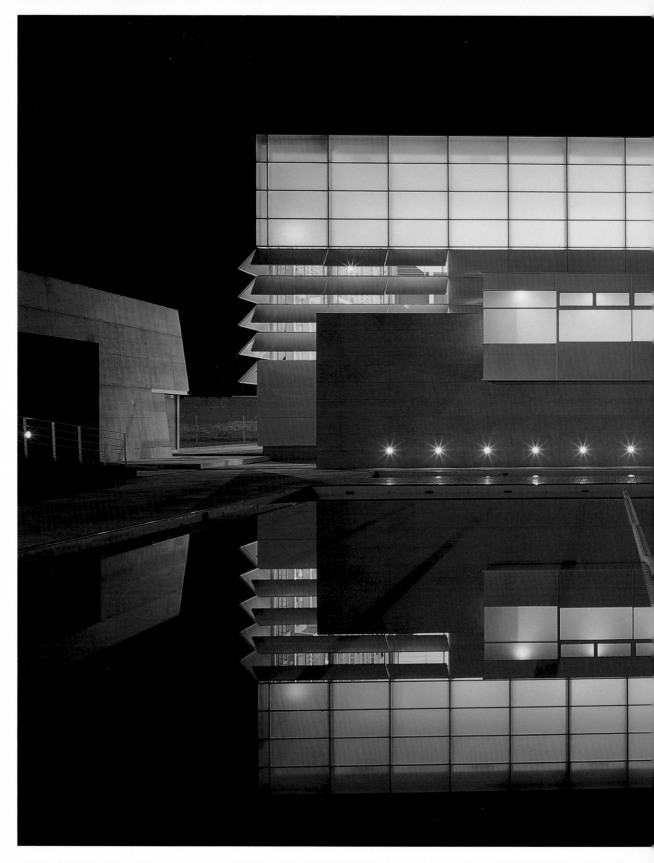

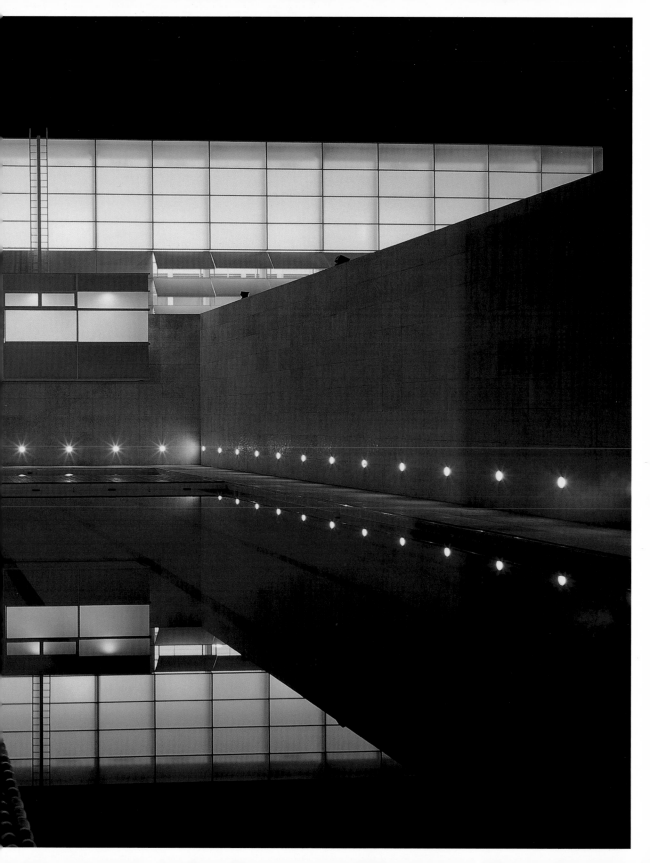

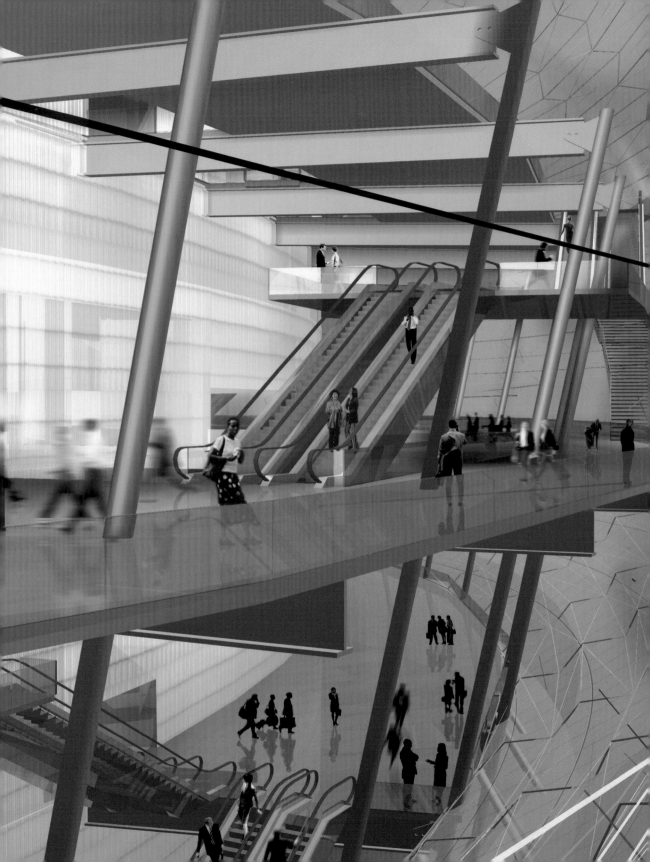

TALLER DE ENRIQUE NORTEN ARQUITECTOS, SC I MEXICO CITY (TEN ARQUITECTOS)
JVC Convention and Exhibition Center
JVC Cultural and Business Center Master Plan
Public Spaces
Zapopan, Jalisco I in process
Renderings: TEN Arquitectos

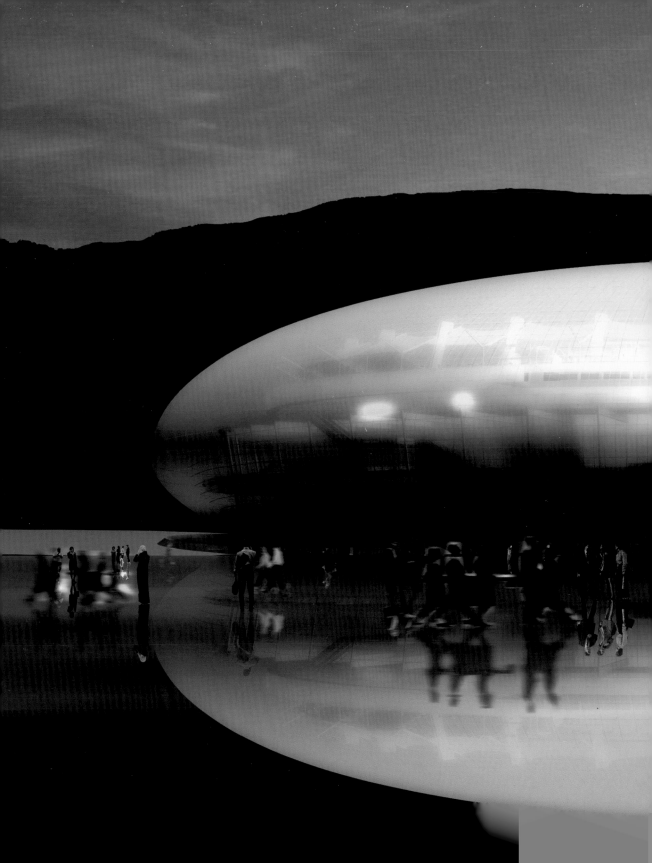

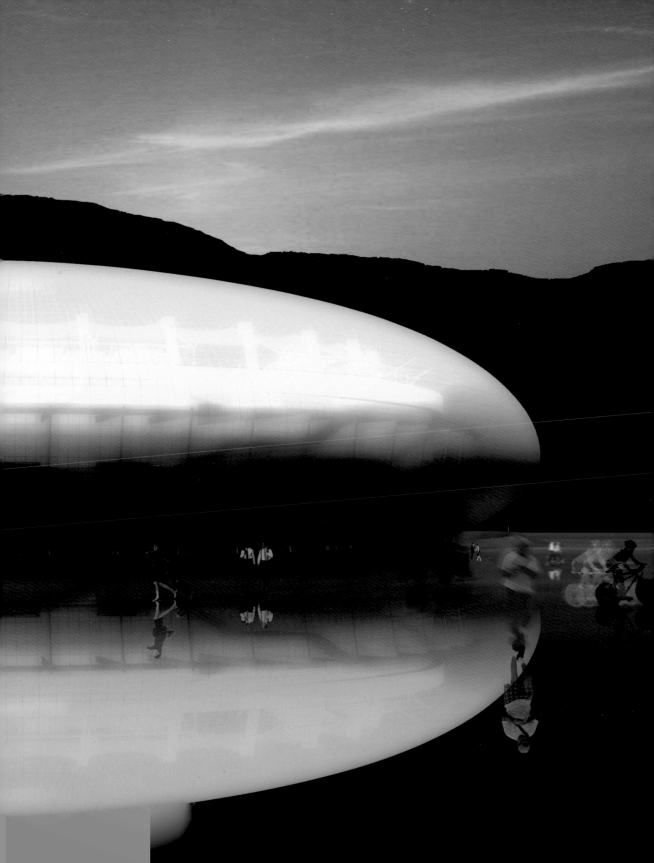

HOSPITALITY SPACES – HOTELS & RESORTS

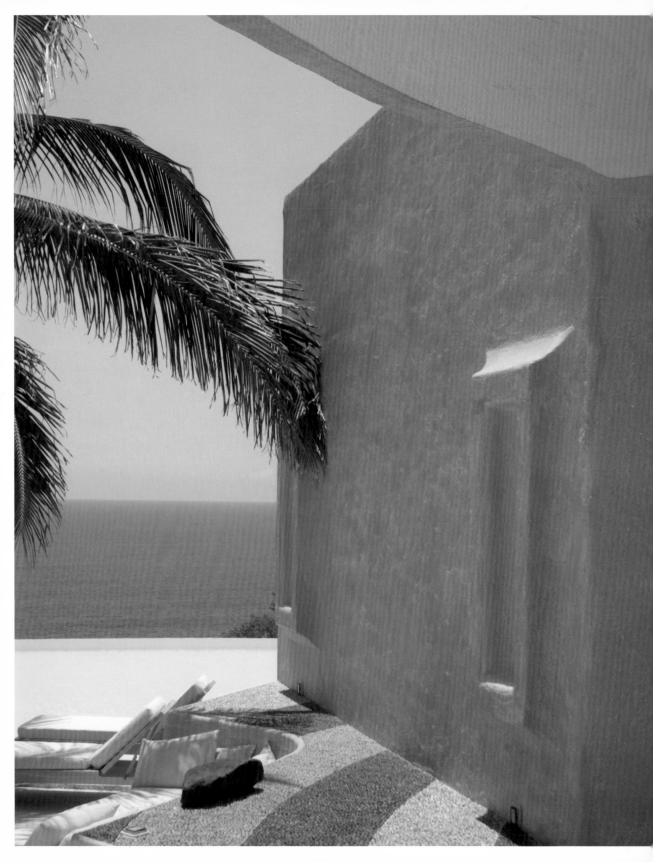

MARCO ALDACO, GIANFRANCO BRIGNONE,
JEAN CLAUDE GALIBERT, DIEGO VILLASEÑOR
Casas de Careyes
ww.careyes.com.mx
Hospitality Spaces
Costalegre, Jalisco | 1972
Photos: Martin Nicholas Kunz, Sofia Brignone (194, 196, 197)

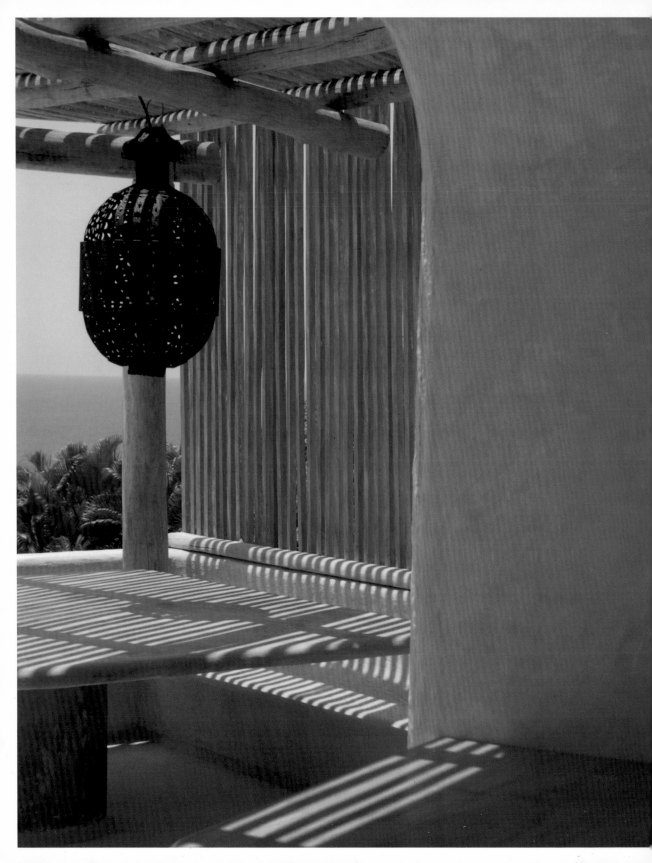

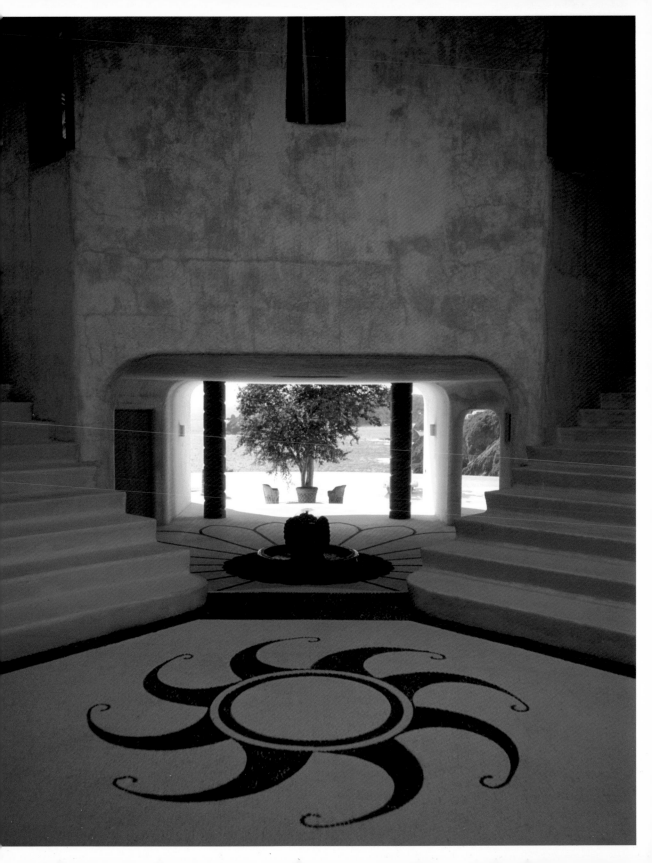

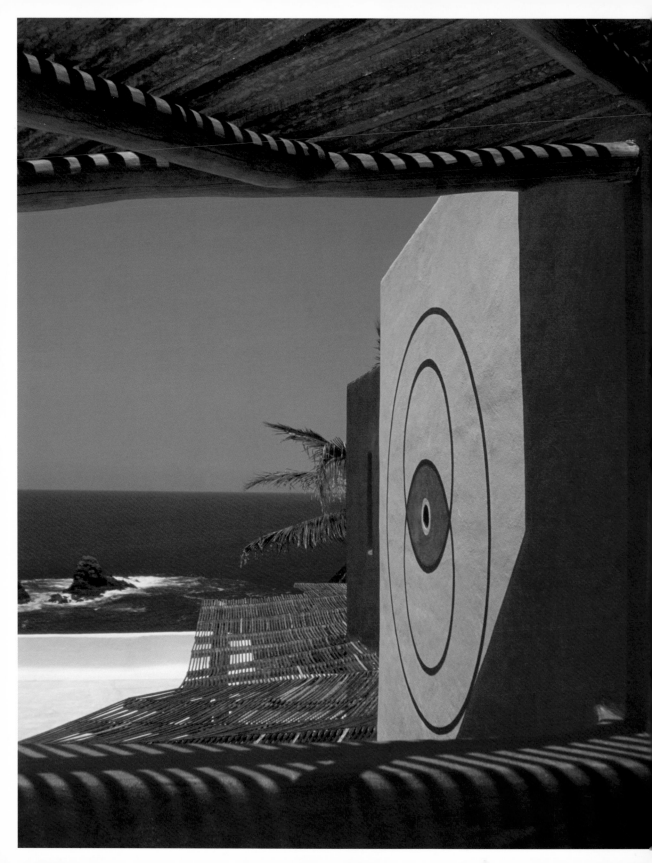

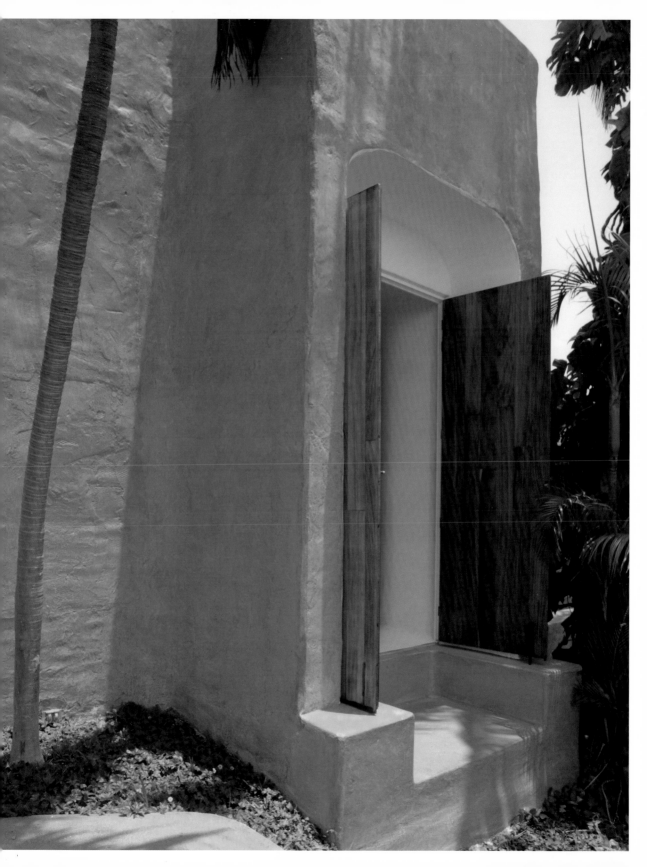

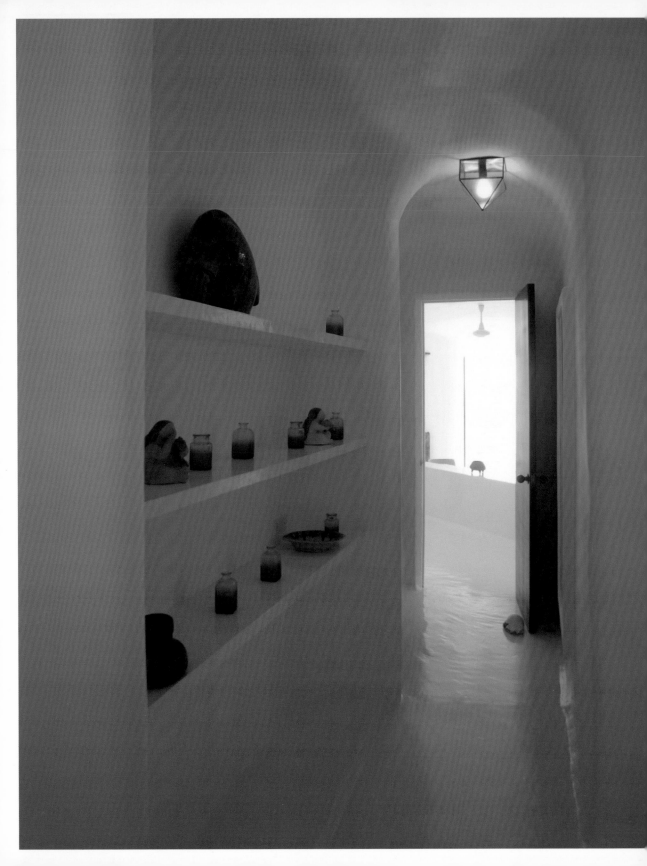

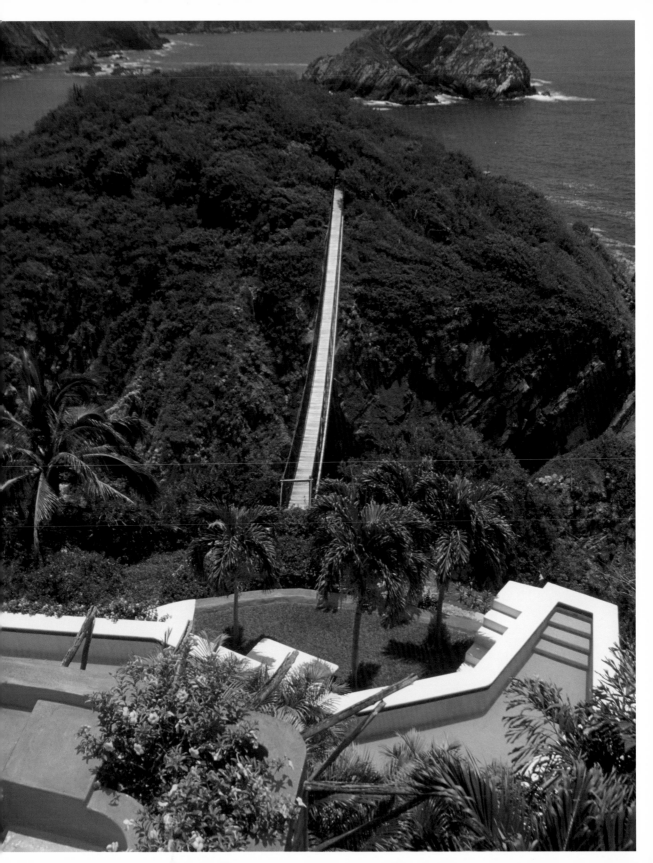

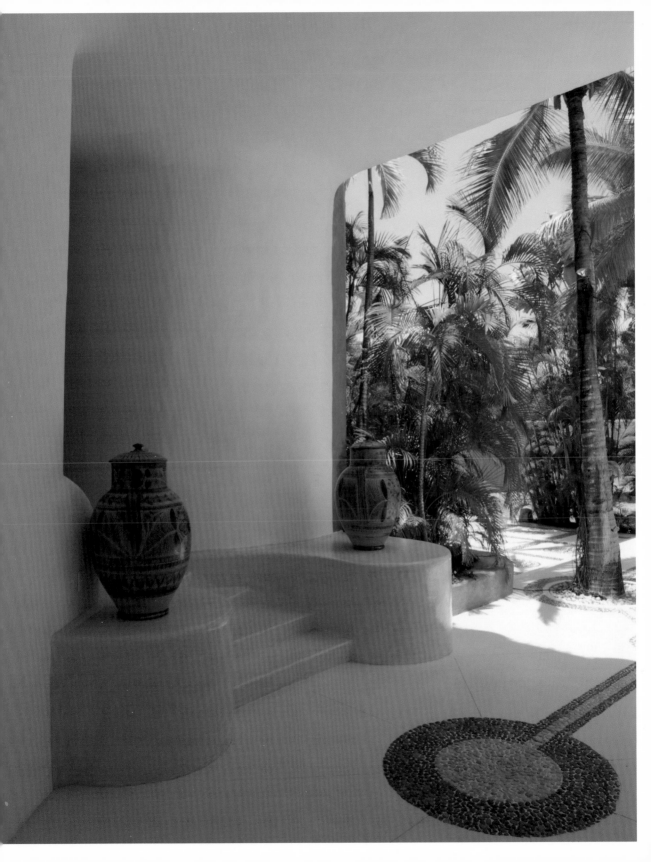

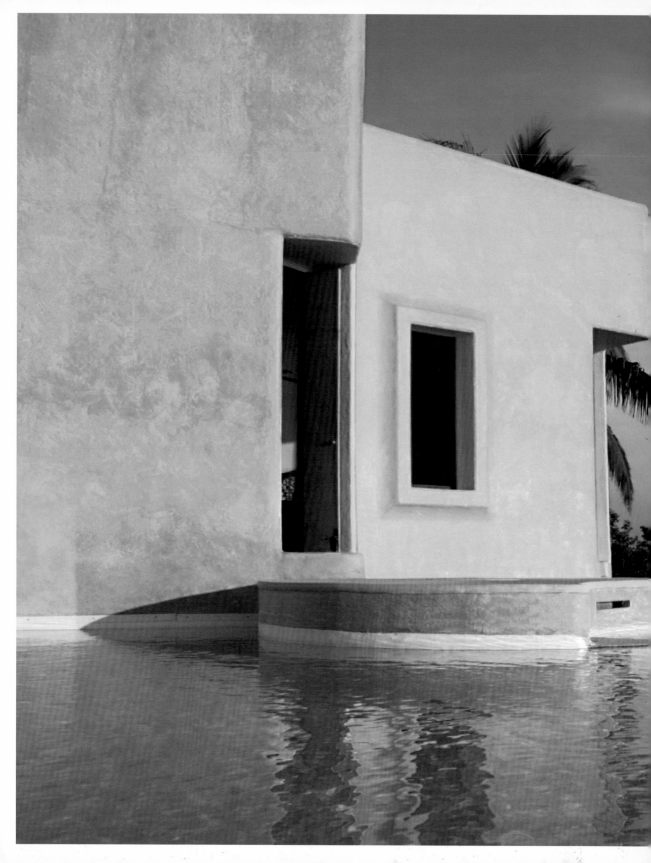

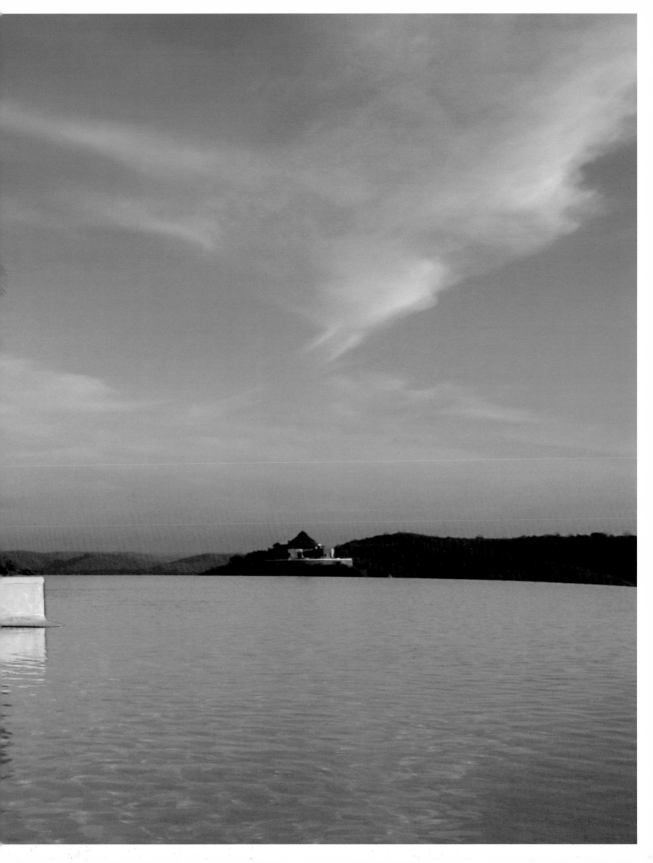

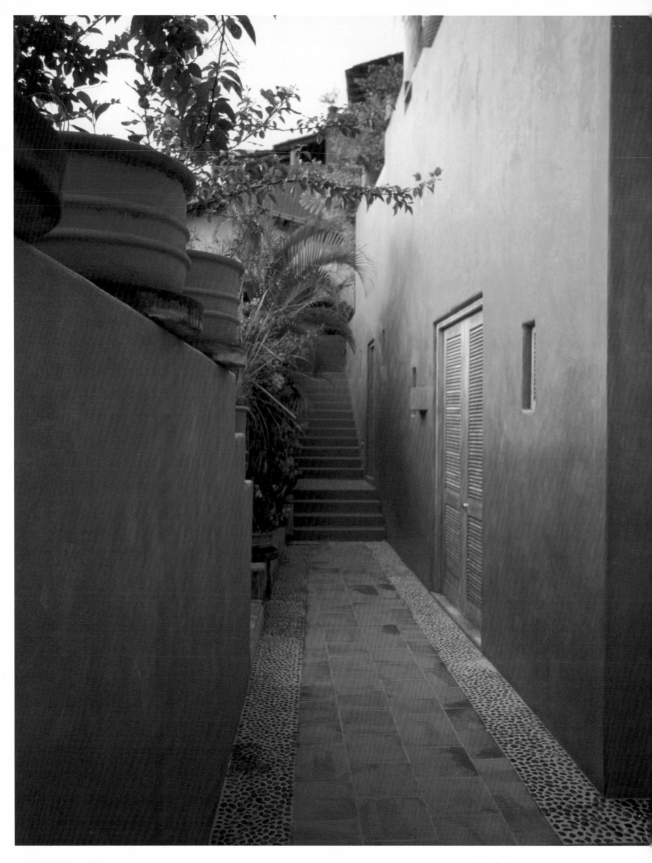

**MARCO ALDACO, GIANFRANCO BRIGNONE,
JEAN CLAUDE GALIBERT, DIEGO VILLASEÑOR**
Casitas de las Flores
ww.careyes.com.mx
Hospitality Spaces
Costalegre, Jalisco | 1972
Photos: Sofia Brignone, Martin Nicholas Kunz (272)

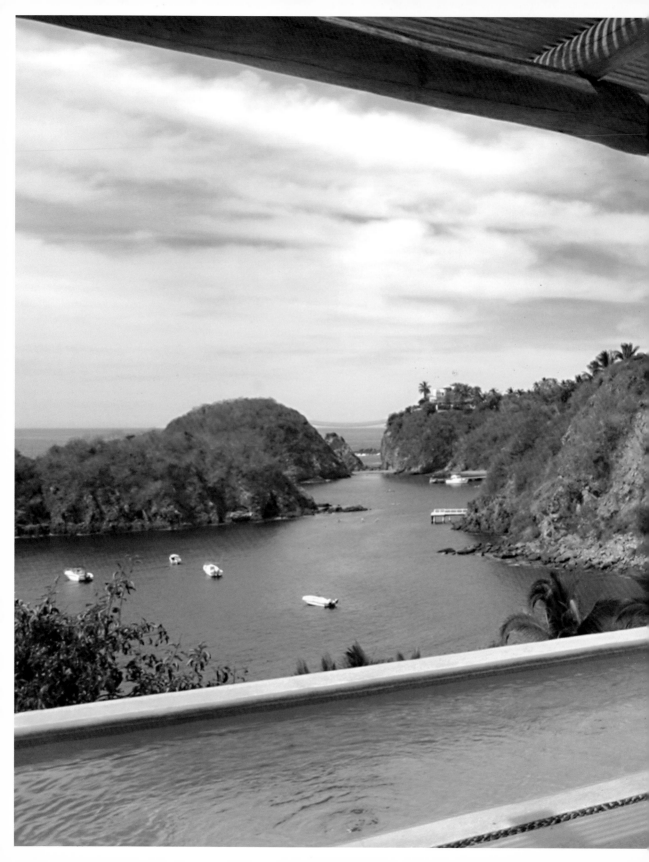

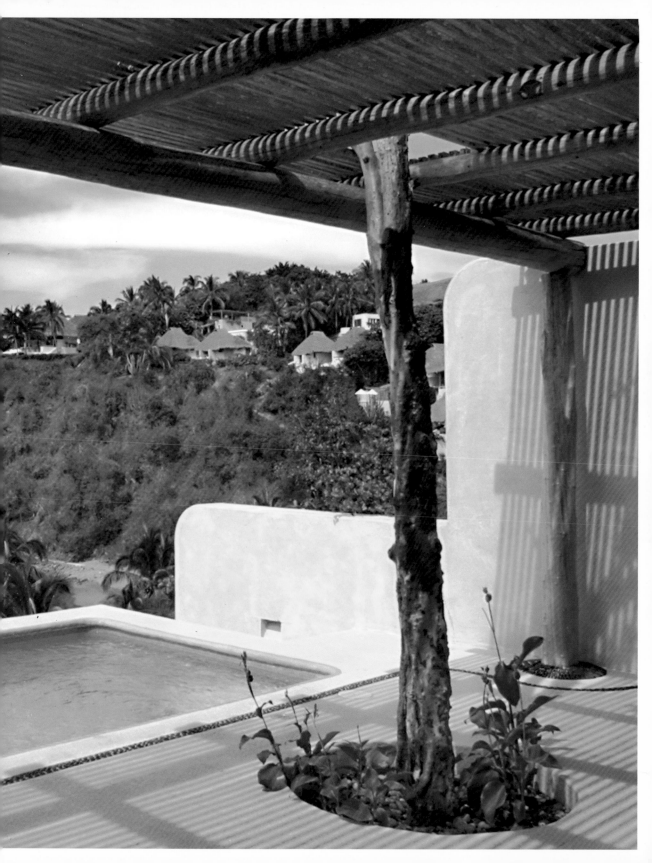

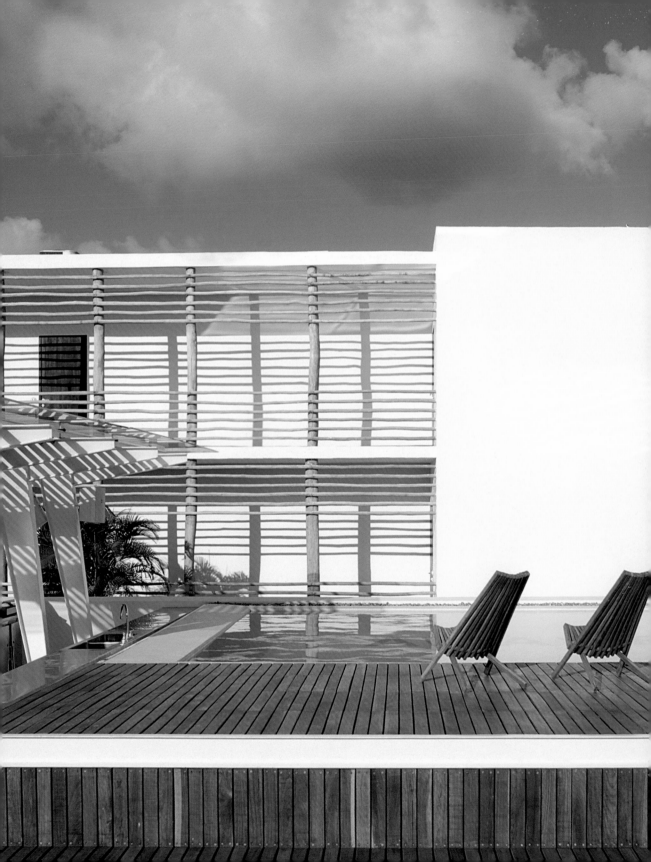

CENTRAL DE ARQUITECTURA | MEXICO CITY
MANUEL CERVANTES, MOISÉS ISÓN, JOSÉ SÁNCHEZ
Deseo
www.hoteldeseo.com
Hospitality Spaces
Playa Del Carmen, Quintana Roo | 2002
Photos: Undine Pröhl

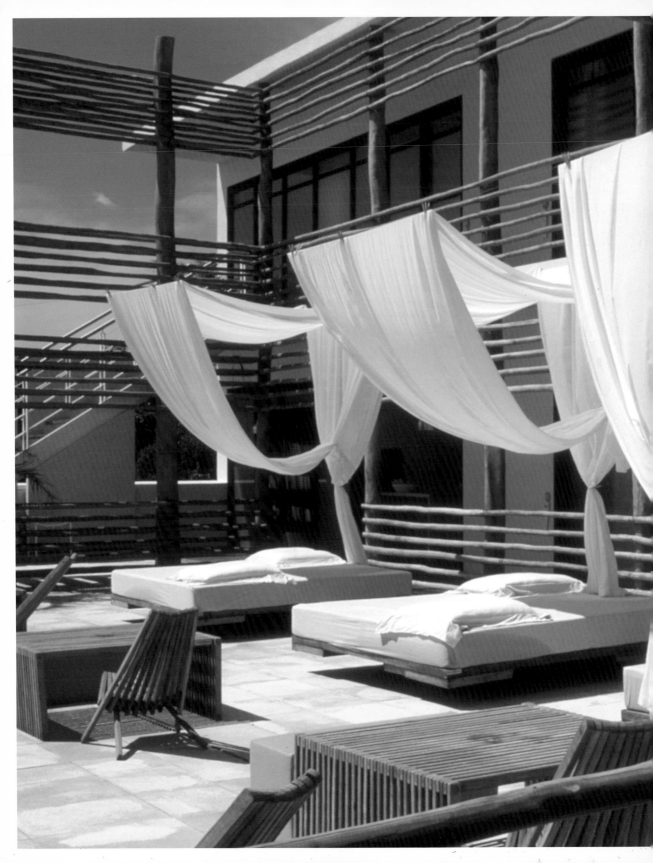

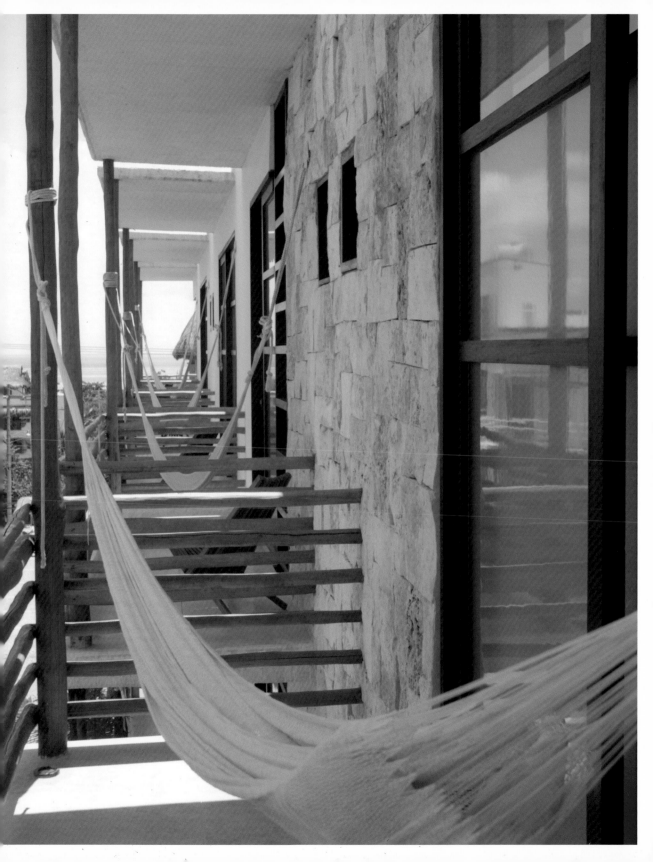

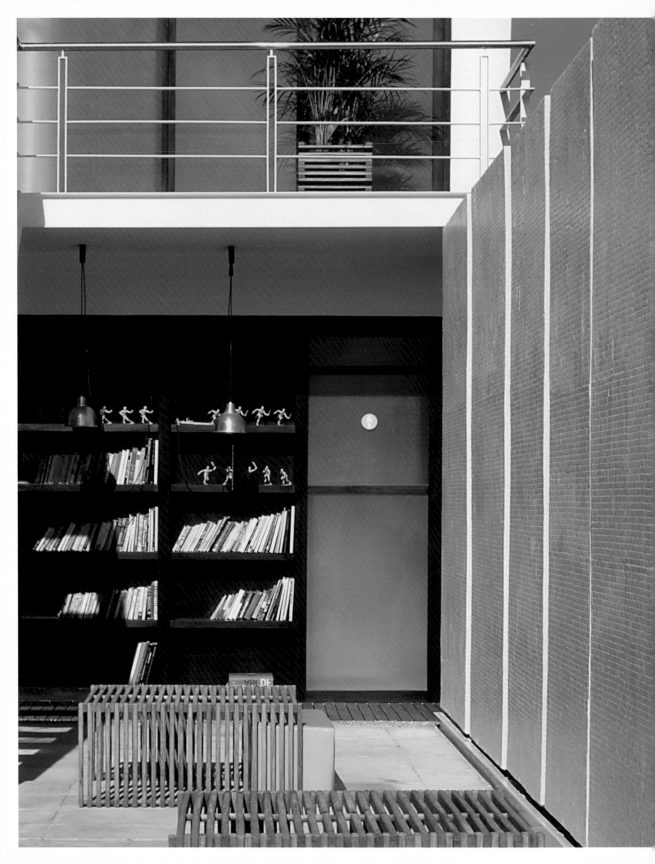

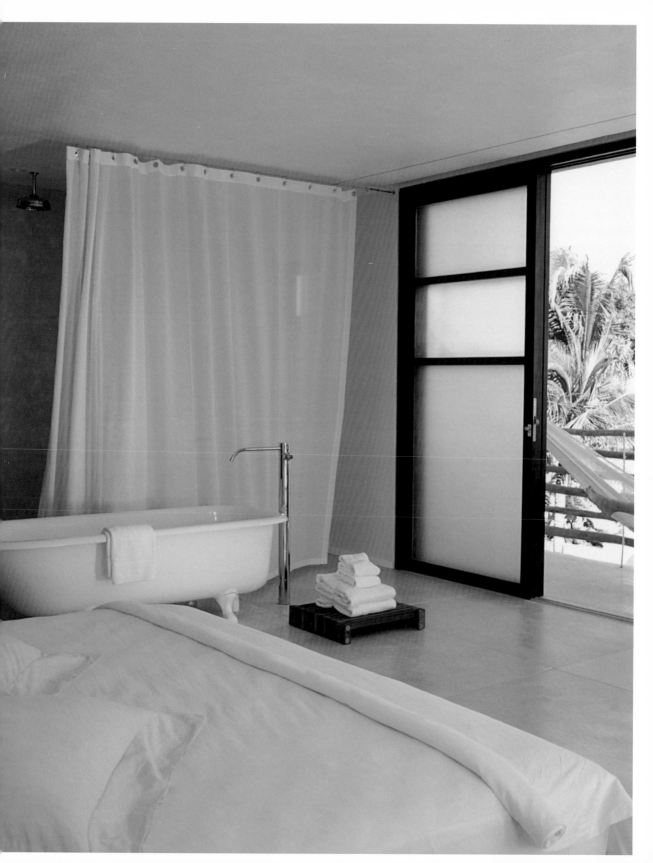

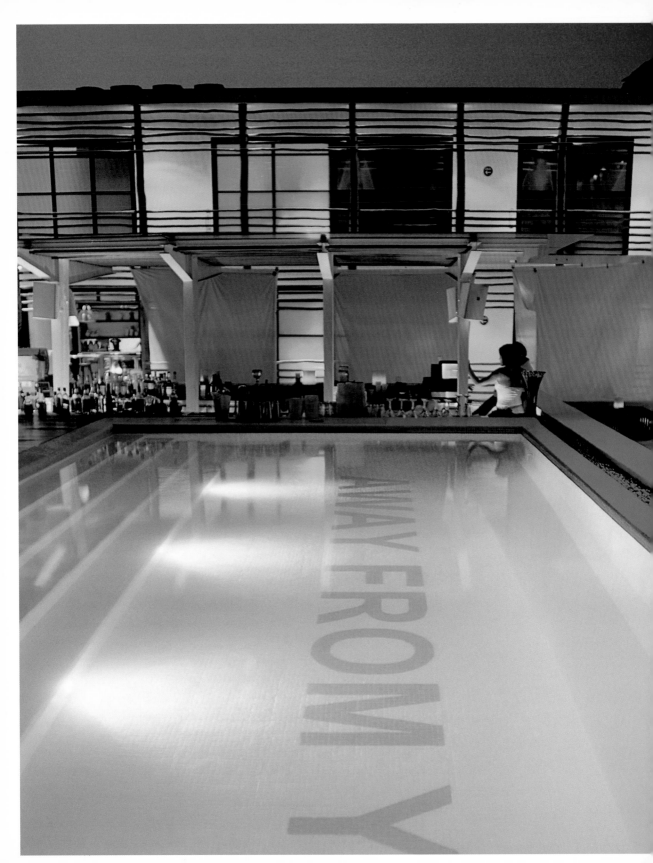

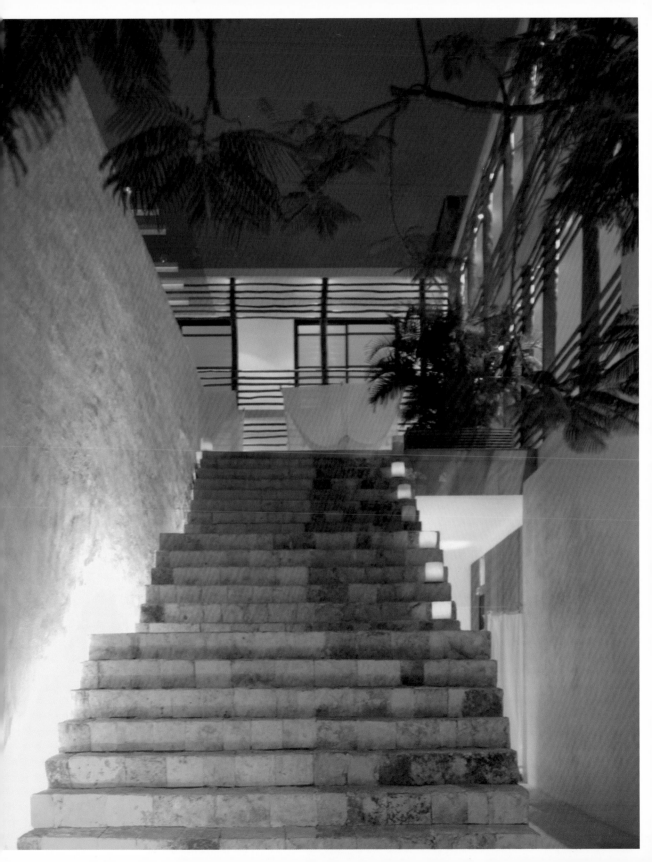

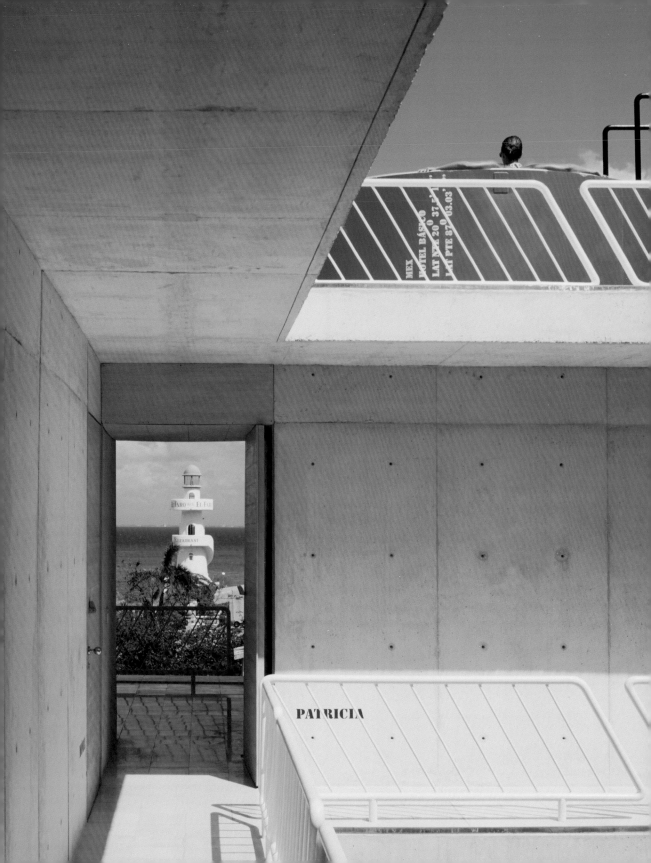

CENTRAL DE ARQUITECTURA | MEXICO CITY
MOISÉS ISÓN, JOSÉ A. SÁNCHEZ
OMELETTE, HECTOR GALVAN (INTERIOR DESIGN) | MEXICO CITY
Hotel Básico
Hospitality Spaces
Playa del Carmen, Quintana Roo | 2005
Photos: Undine Pröhl

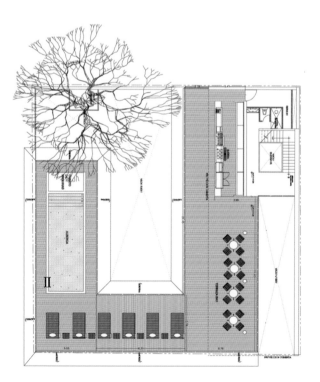

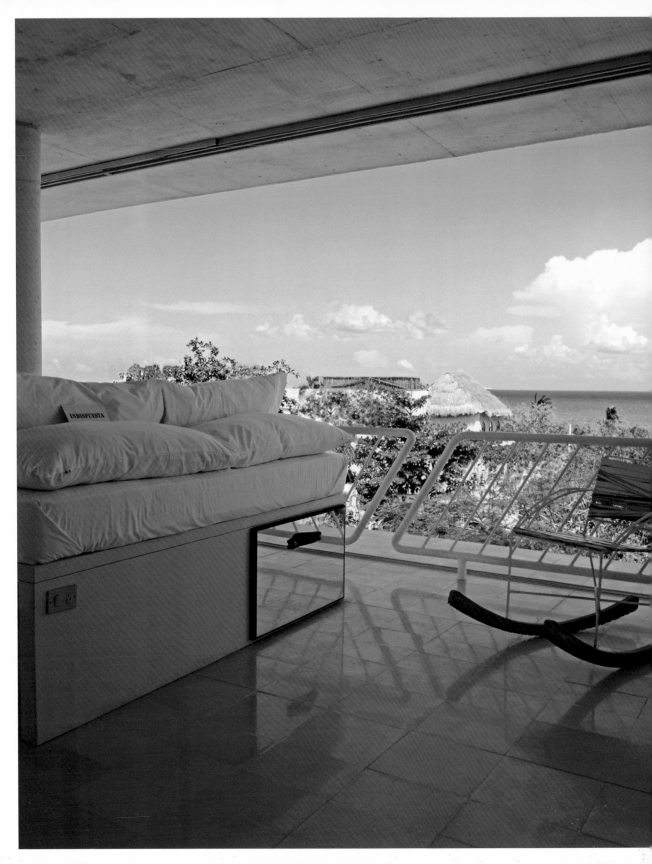

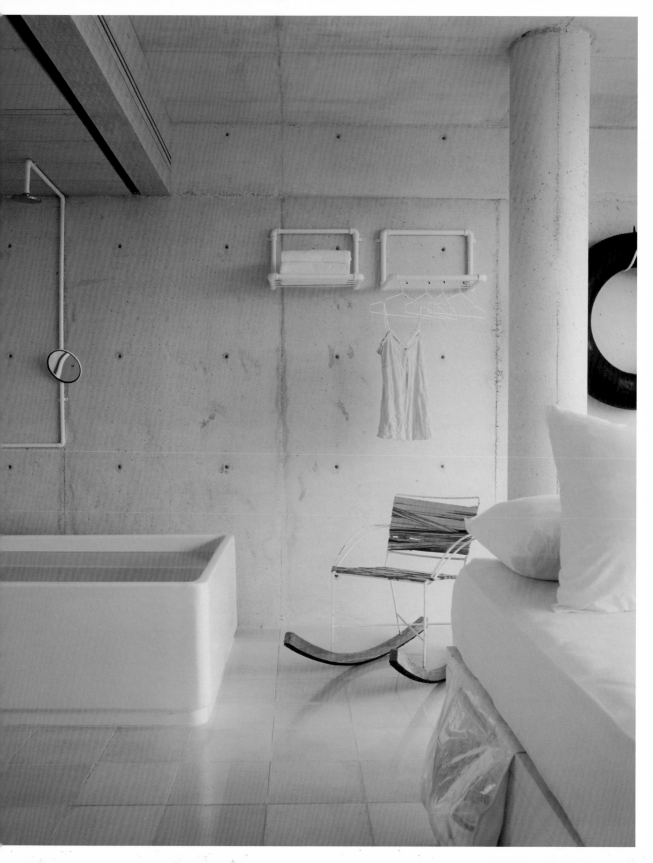

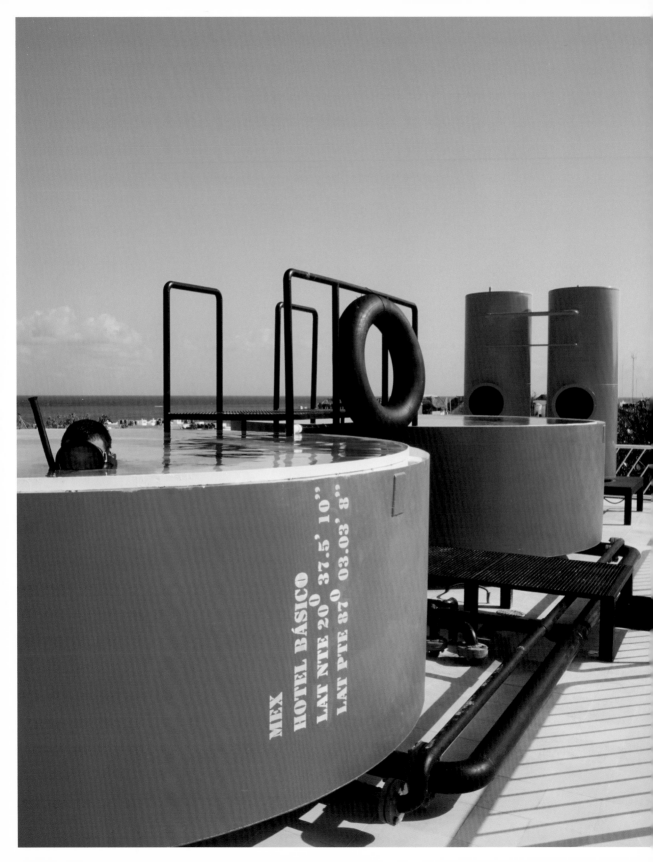

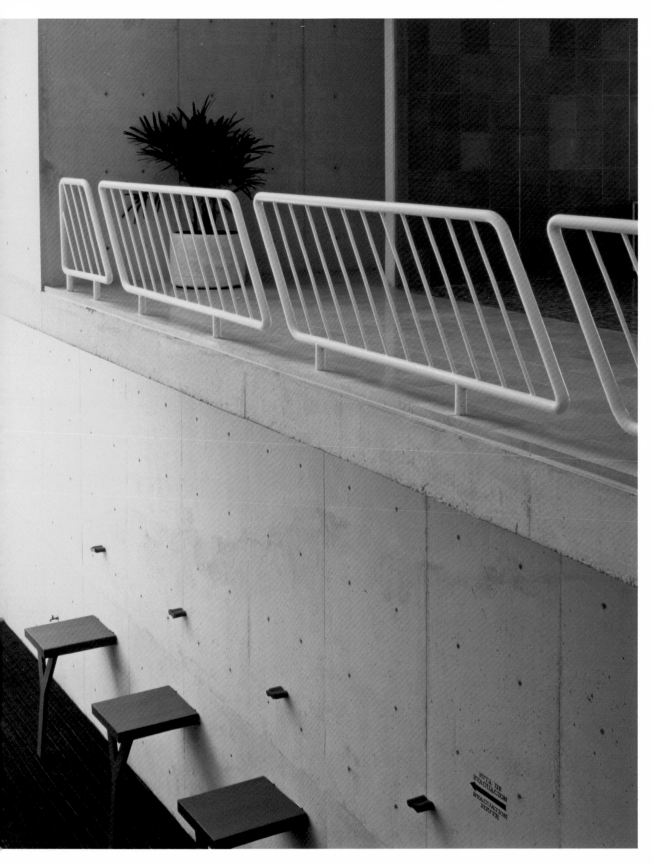

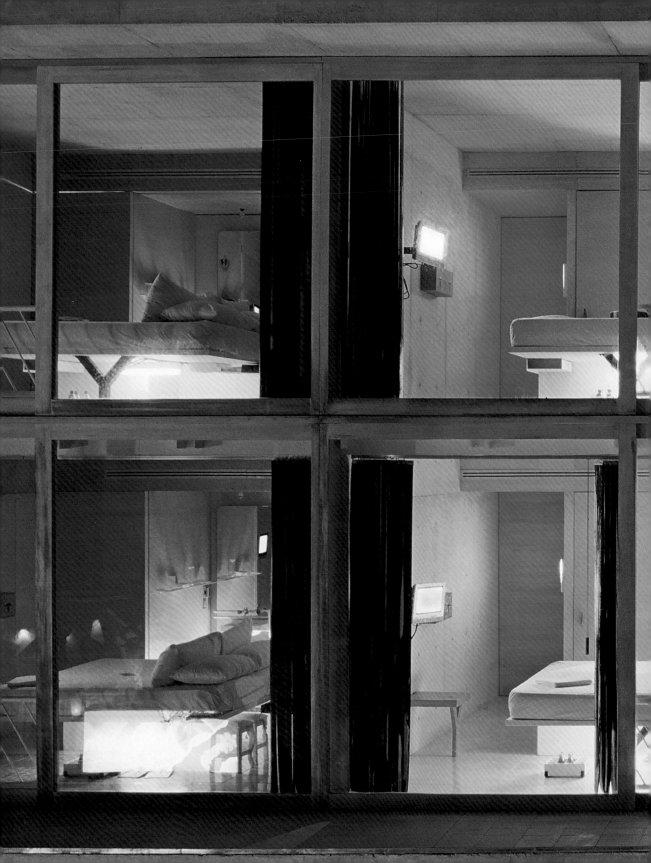

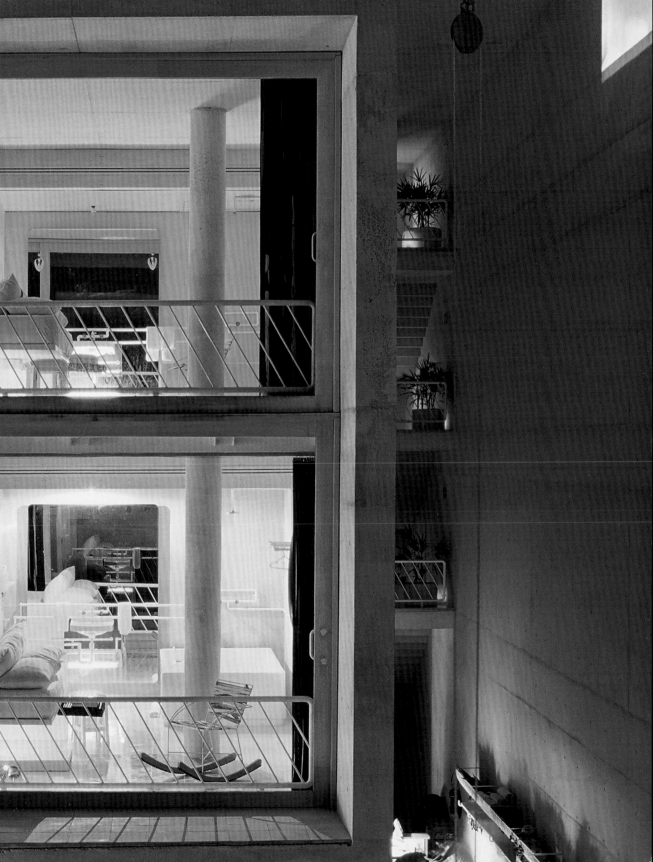

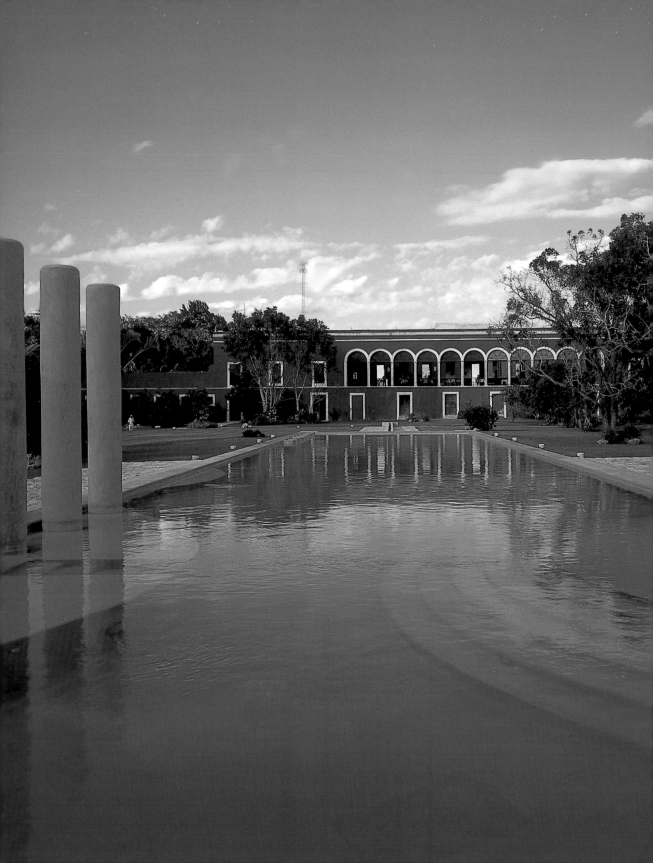

GRUPO PLAN | **MEXICO CITY**
Hacienda Temozón
Hospitality Spaces
Mérida, Yucatán | 1997
Photos: Klaus Brechenmacher & Rainer Baumann

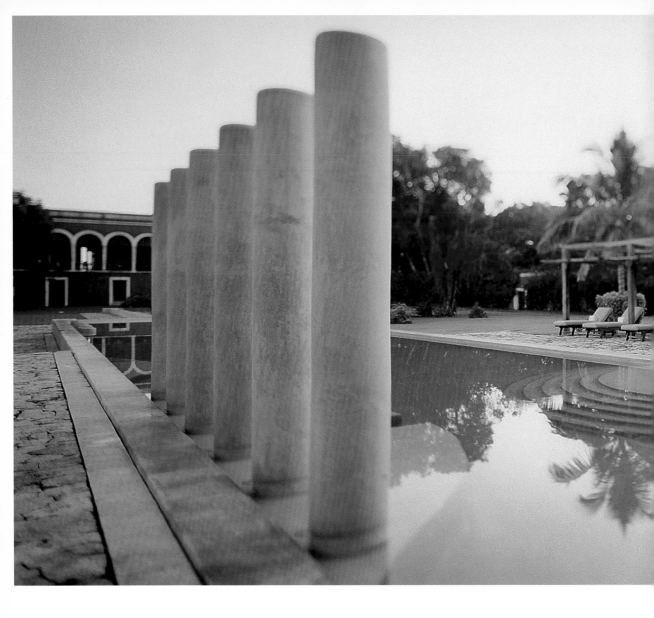

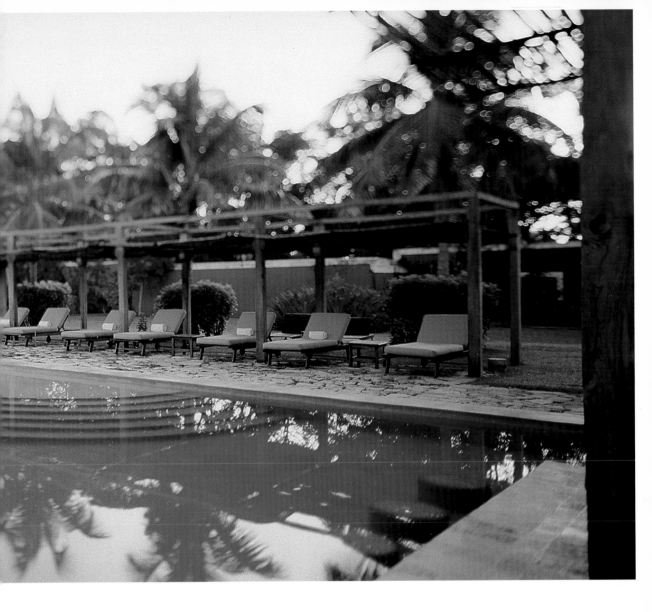

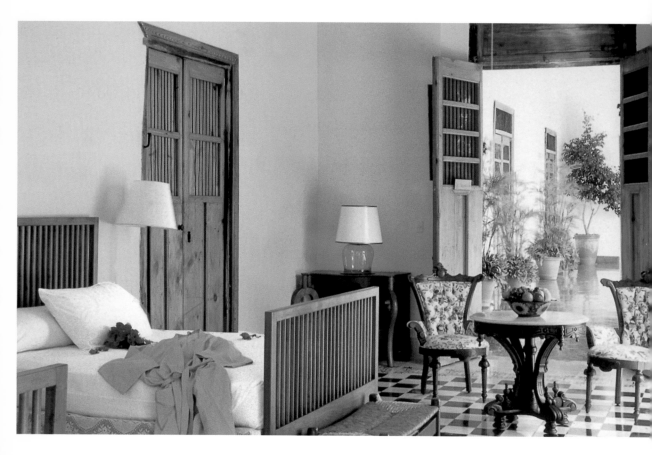

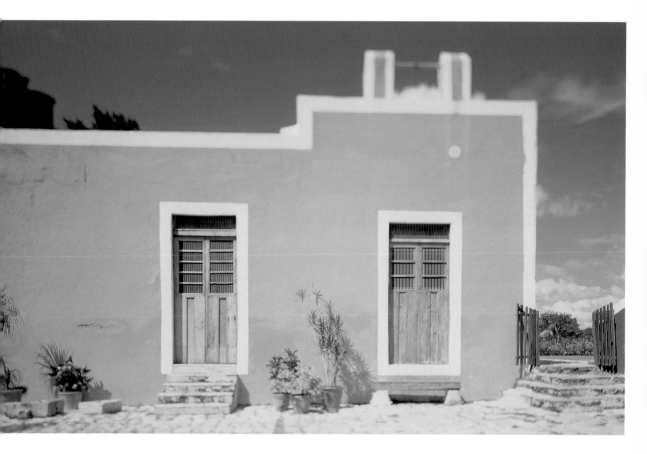

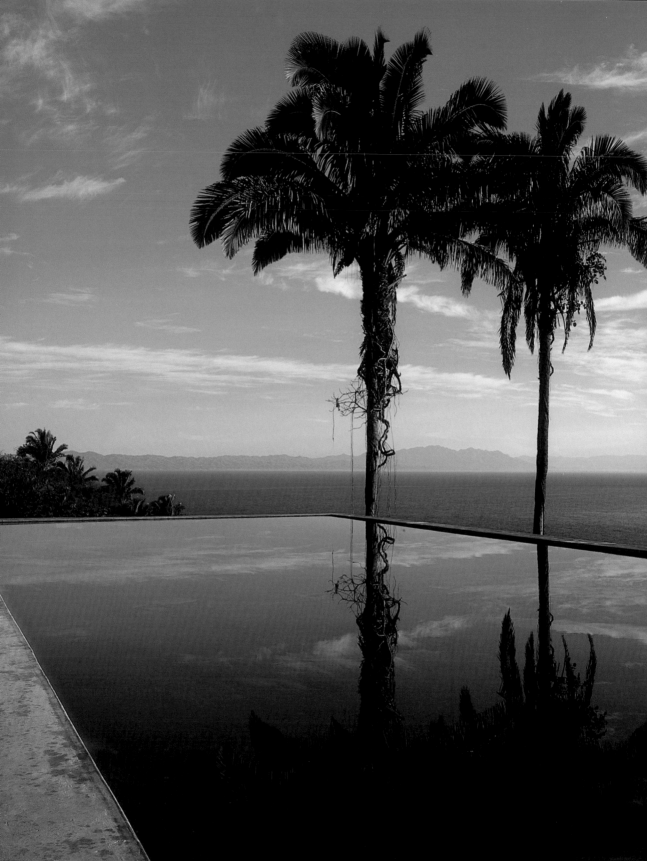

HEINZ LEGLER, VERONIQUE LIÈVRE | LOS ANGELES
Verana
www.verana.com
Hospitality Spaces
Puerto Vallarta, Jalisco | 2000
Photos: Heinz Legler

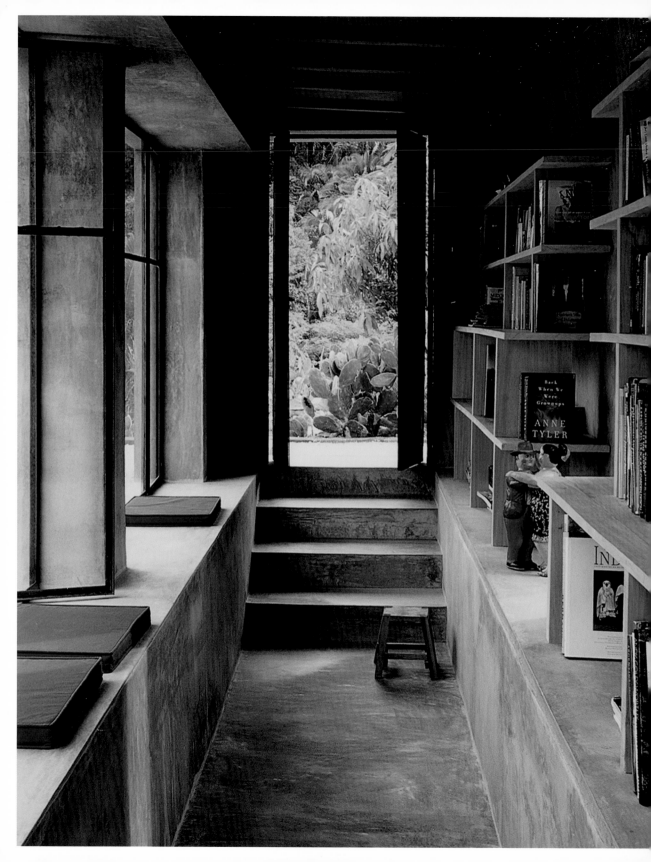

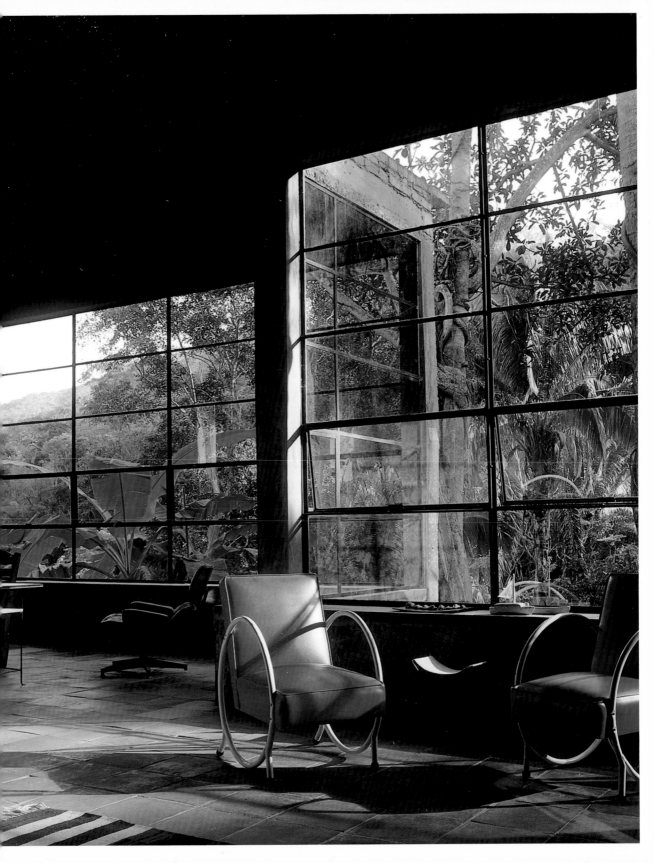

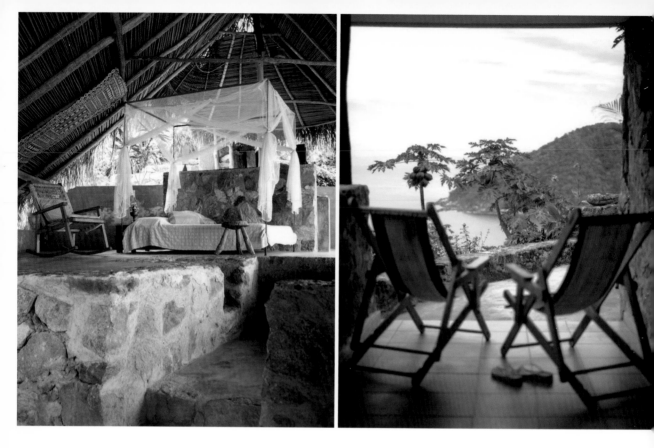

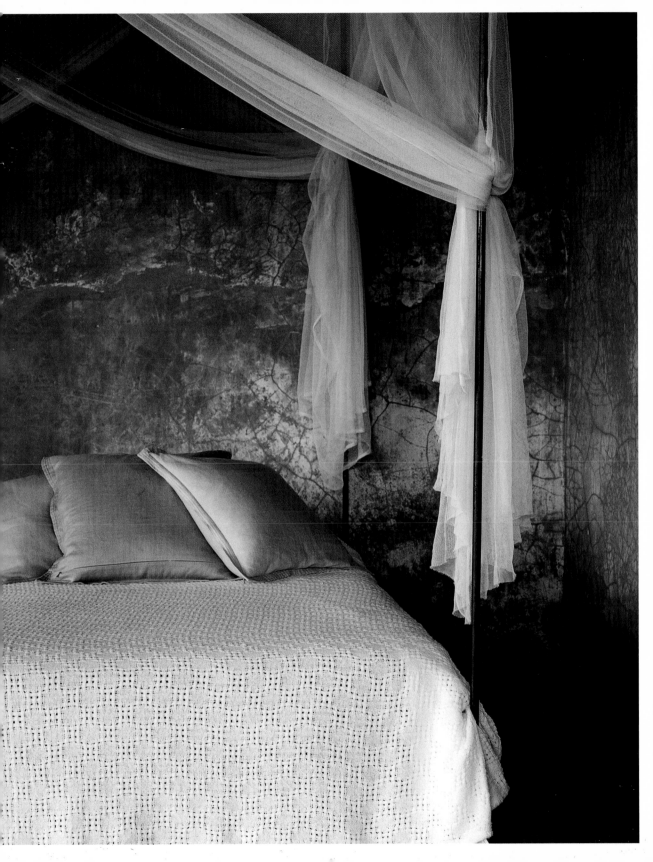

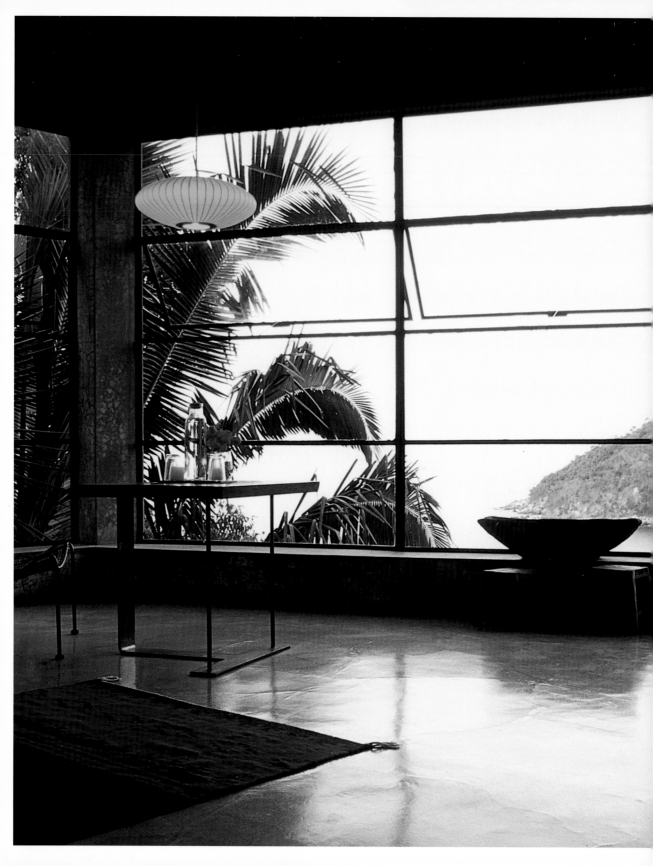

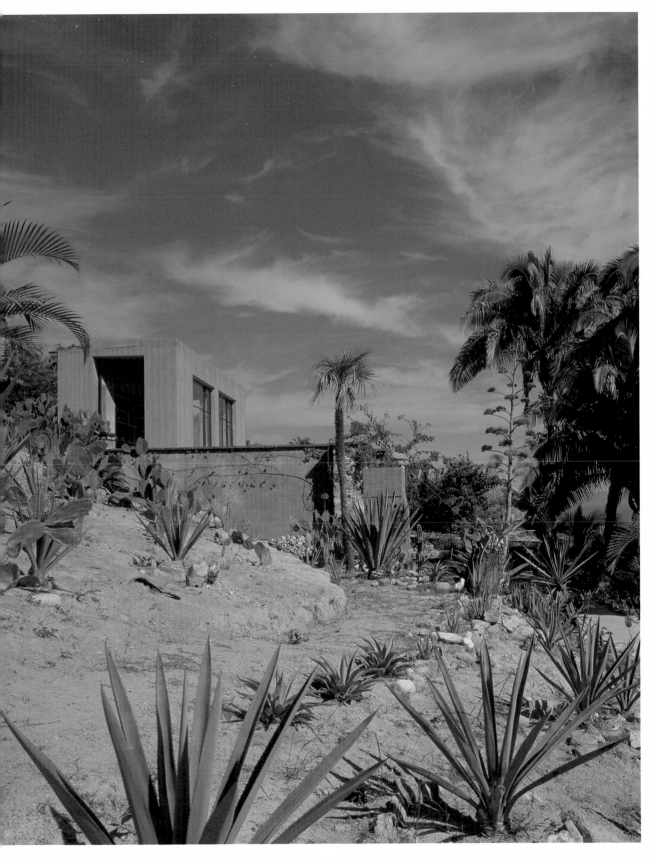

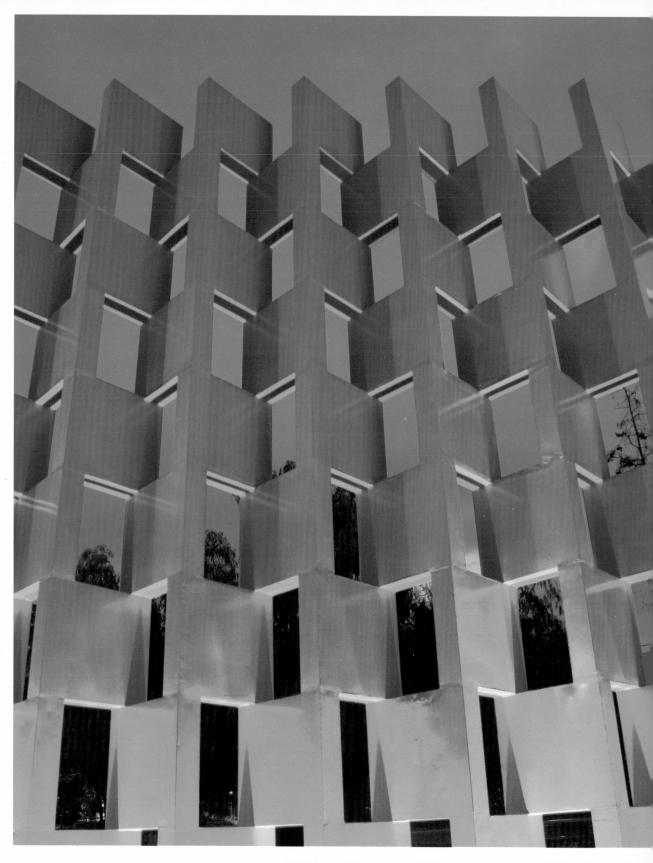

LEGORETTA + LEGORETTA| MEXICO CITY
Camino Real México
www.caminoreal.com
Hospitality Spaces
Mexico City | 2000
Photos: Martin Nicholas Kunz, Michelle Galindo

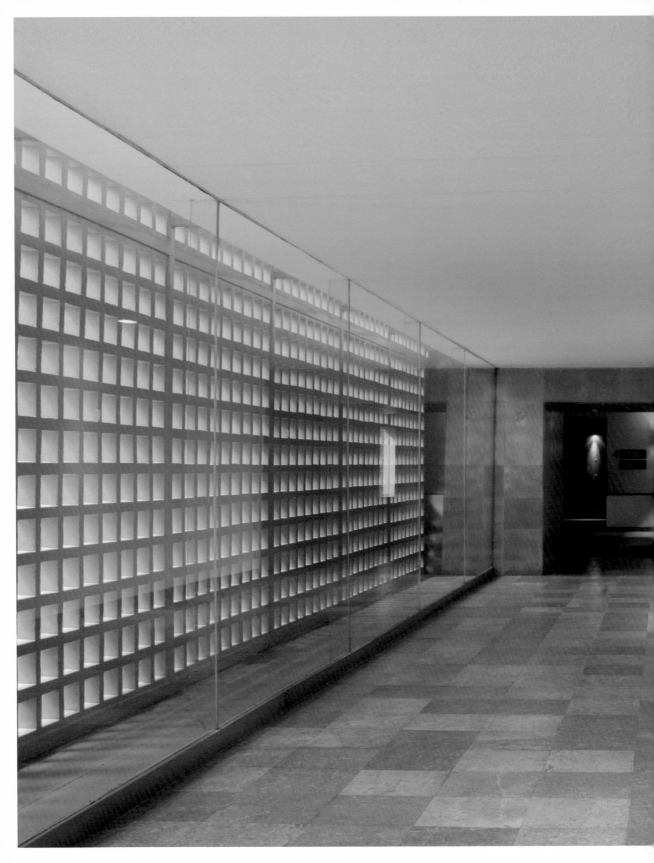

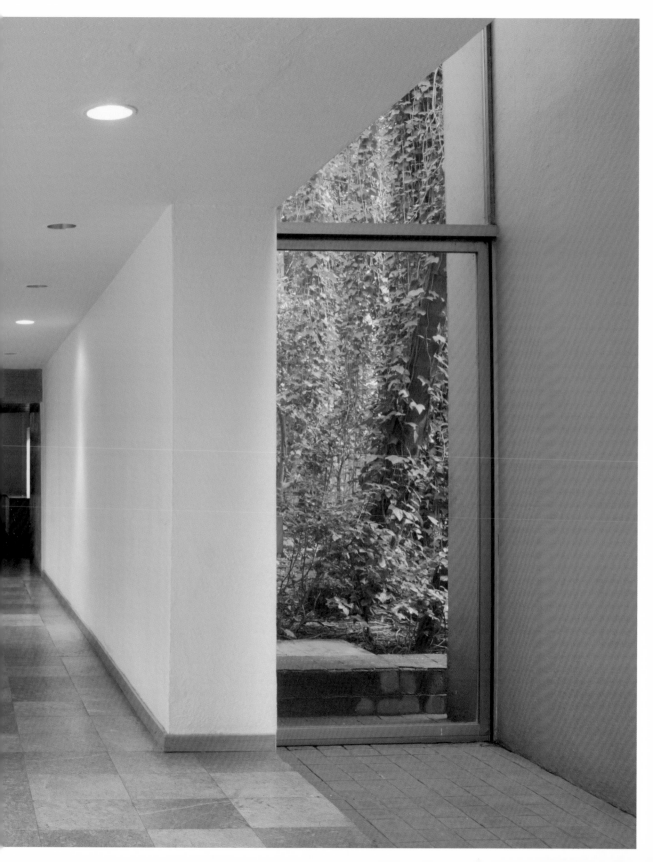

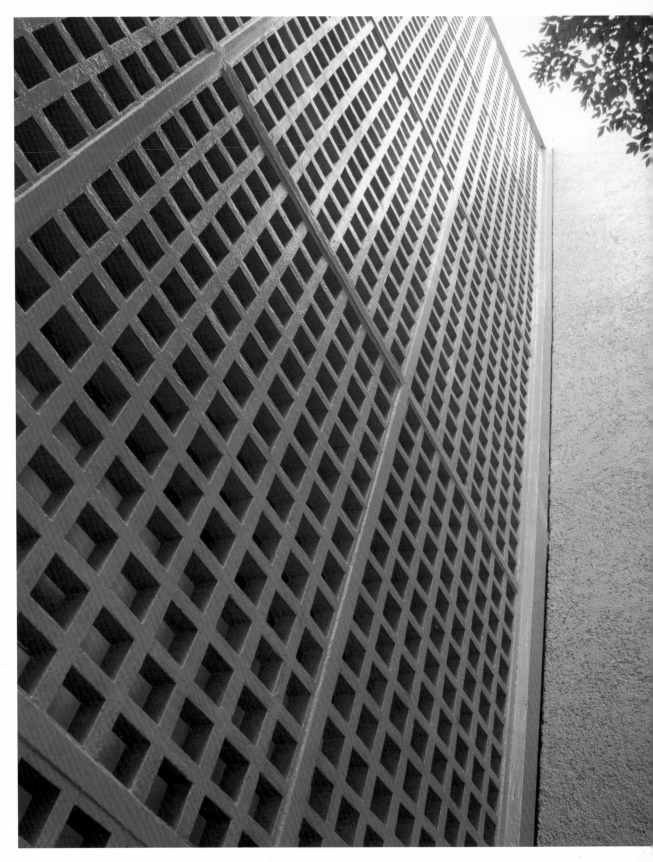

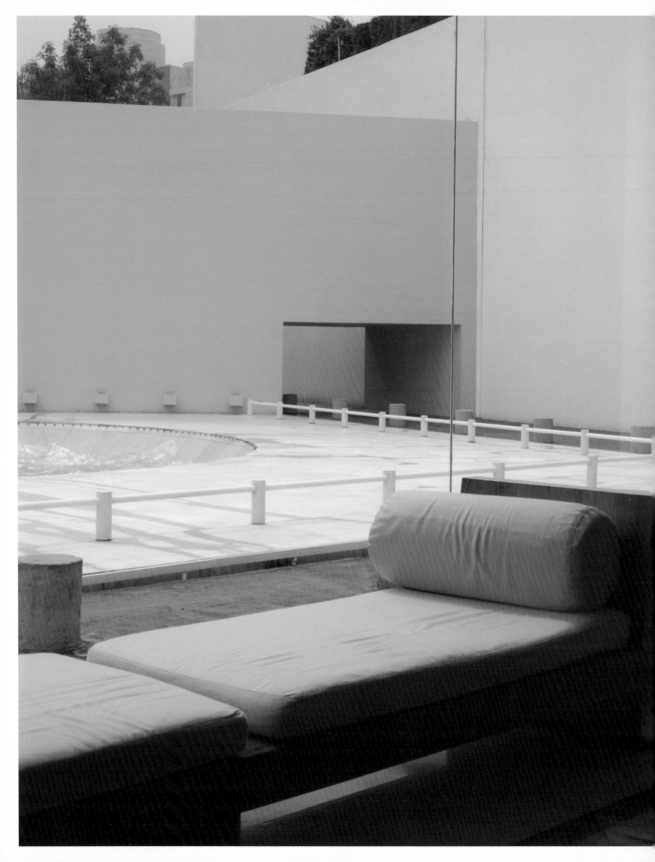

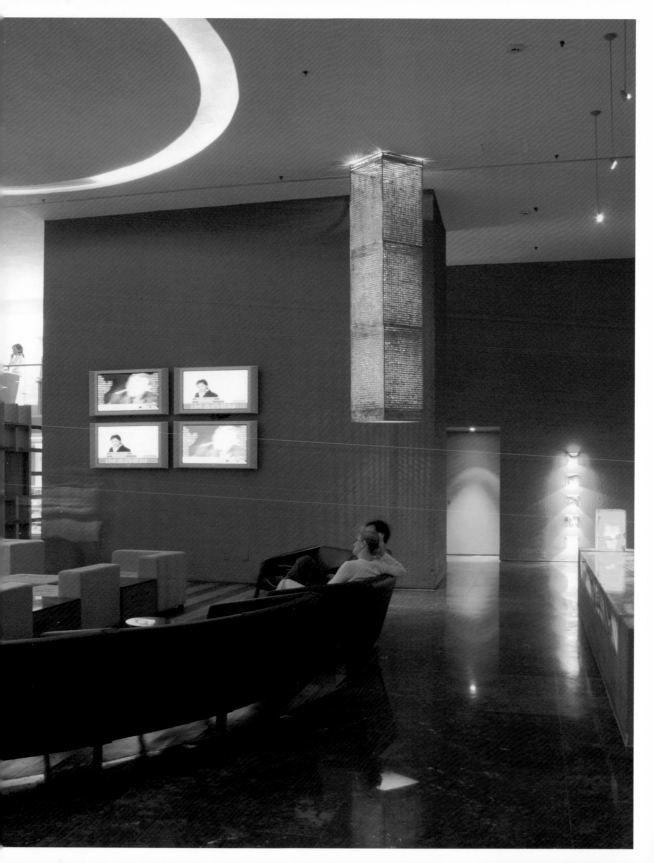

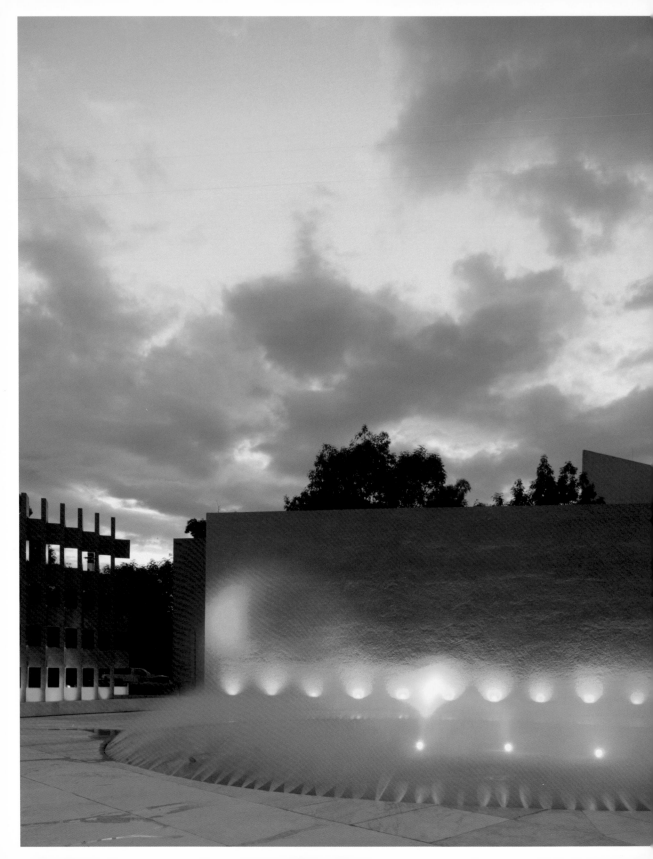

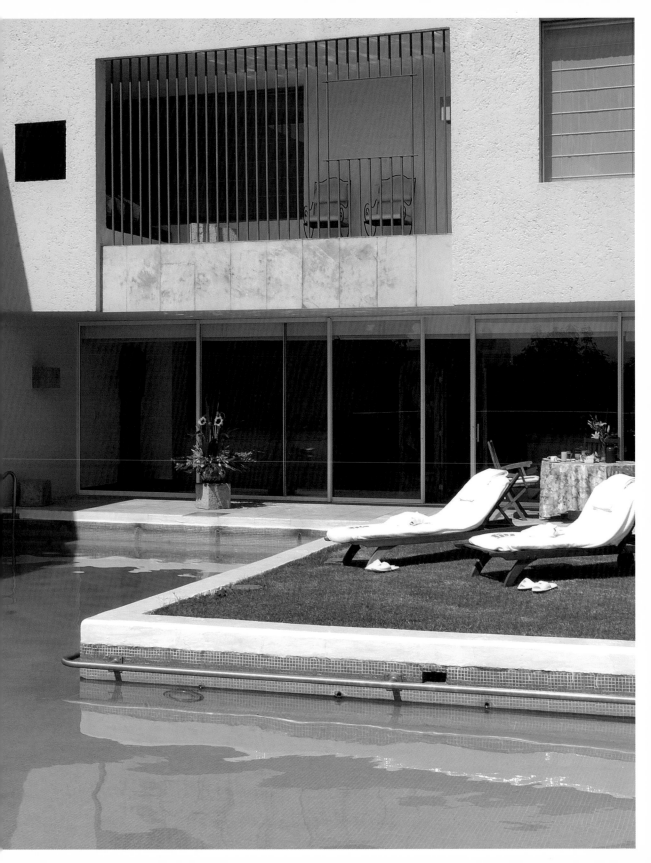

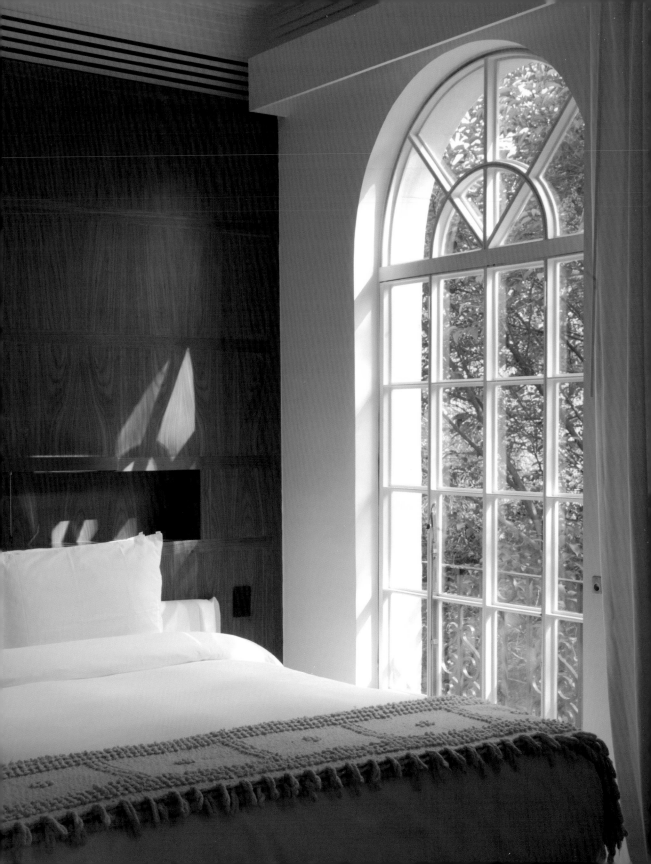

HIGUERA + SÁNCHEZ | MEXICO CITY
INDIA MAHDAVI IMH INTERIORS | PARIS
CONDESA df
www.condesadf.com
Hospitality Spaces
Mexico City | 2005
Photos: Martin Nicholas Kunz, Michelle Galindo,
Undine Pröhl (248-249)

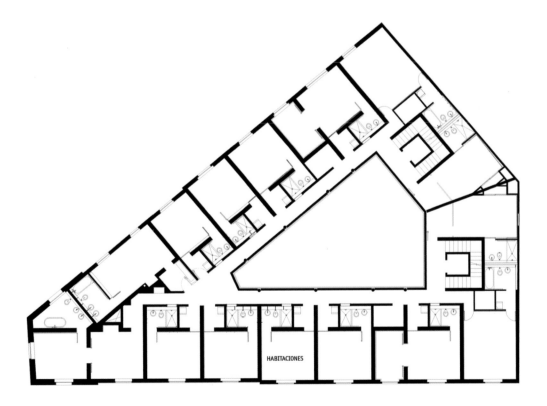

HABITACIONES

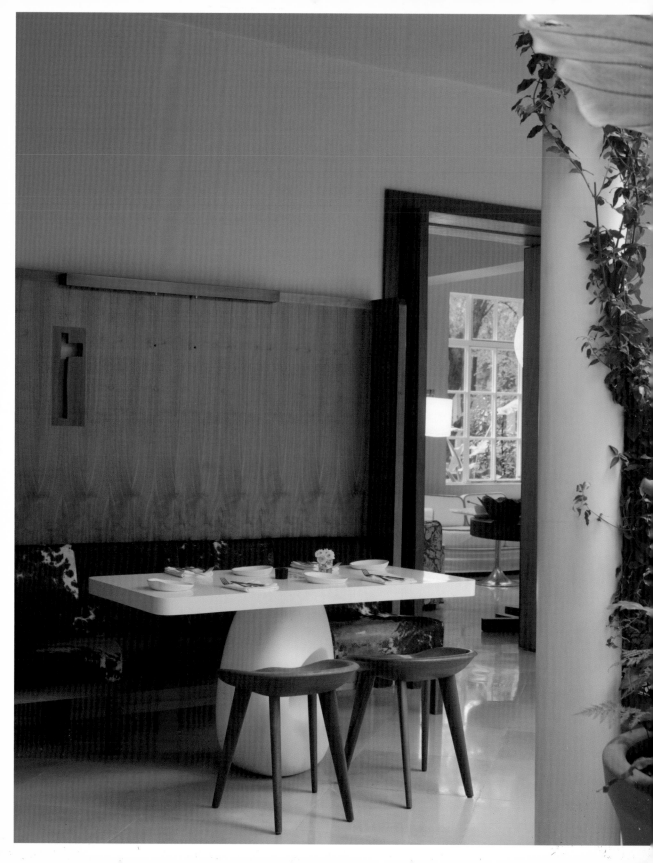

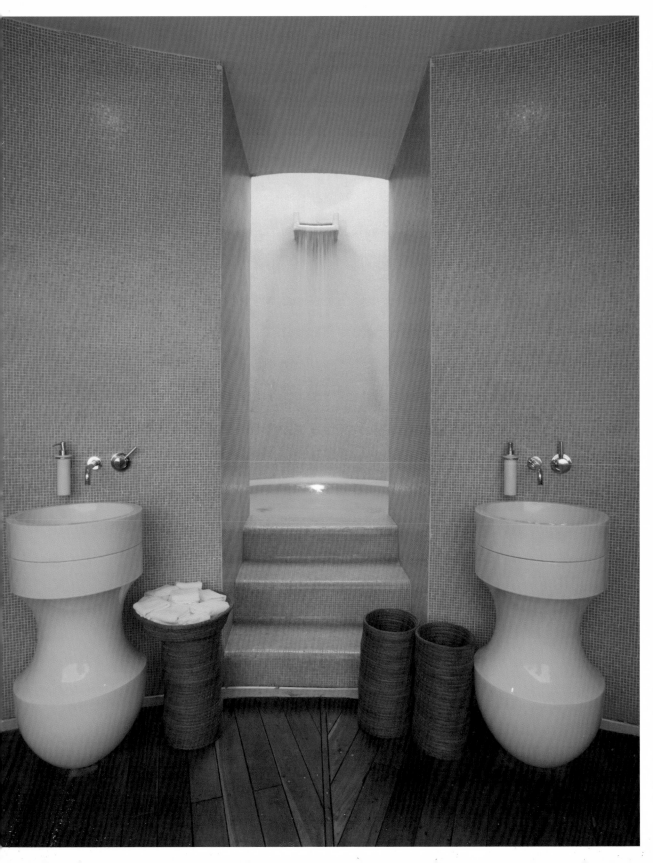

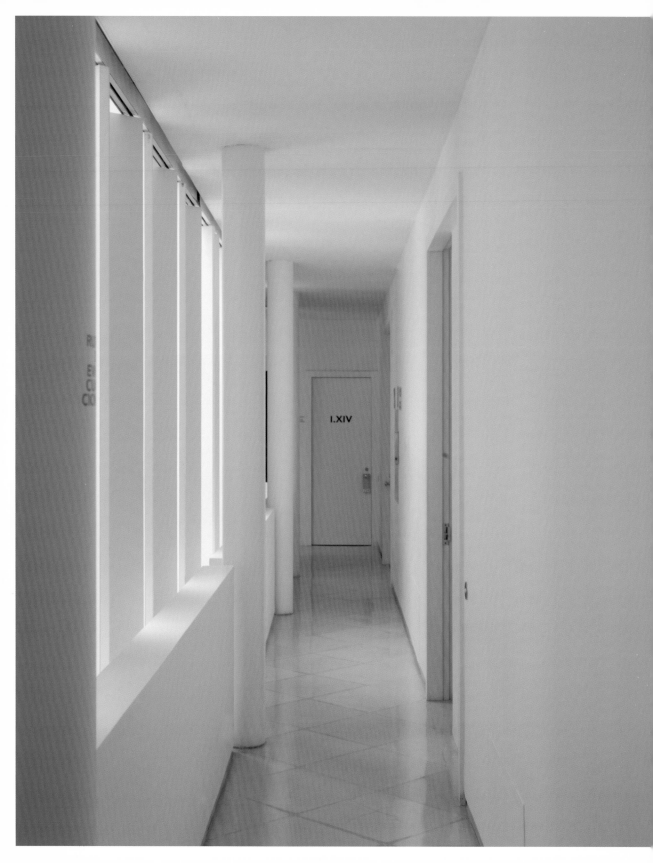

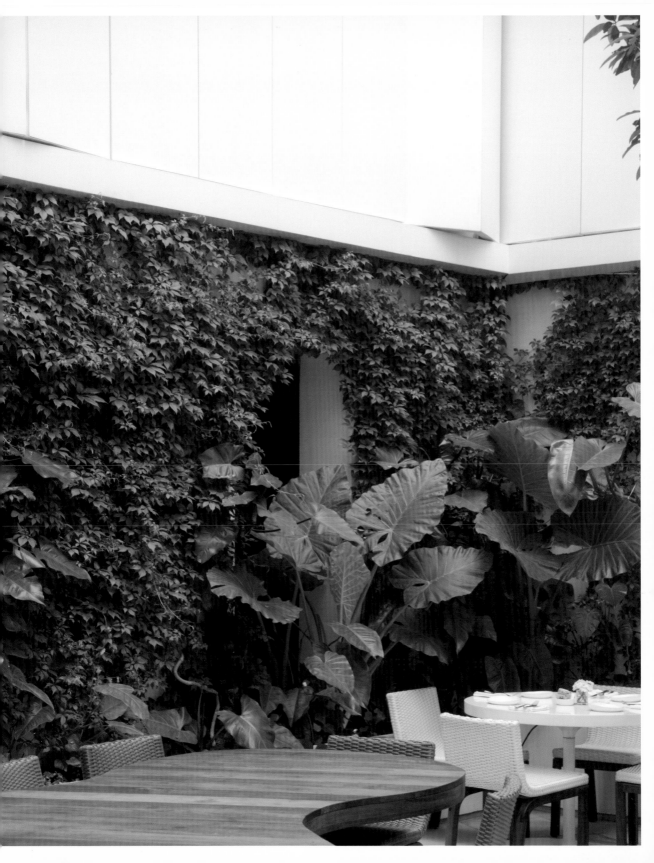

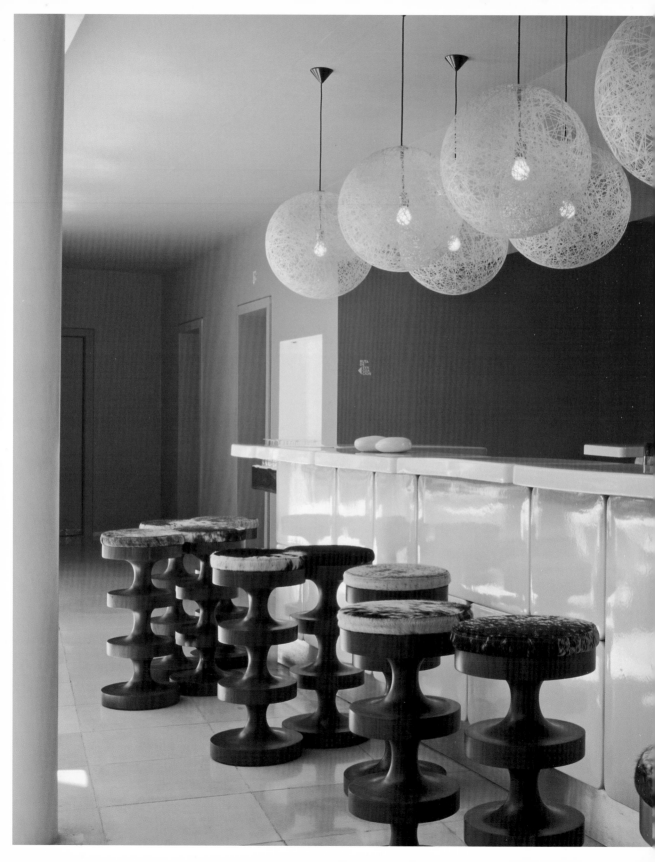

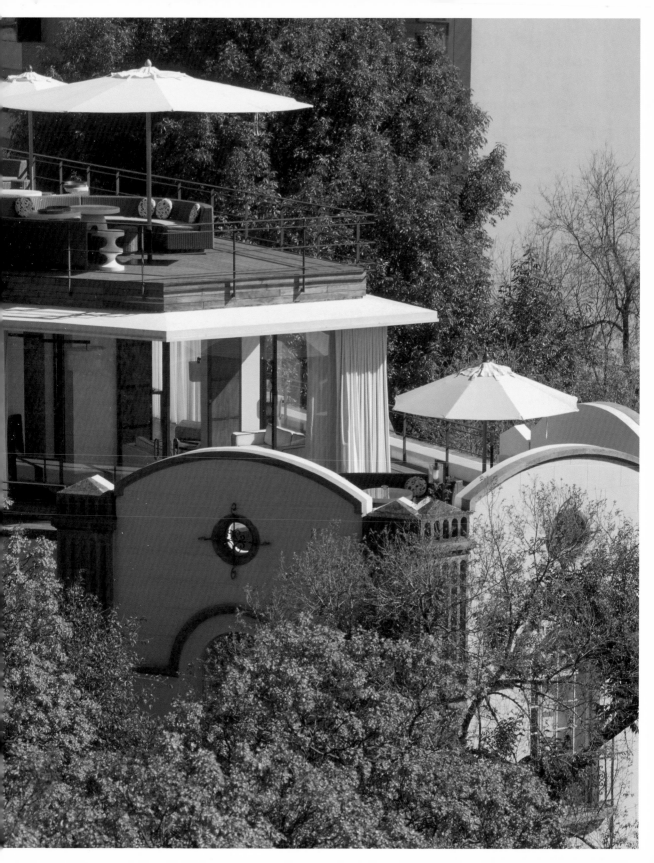

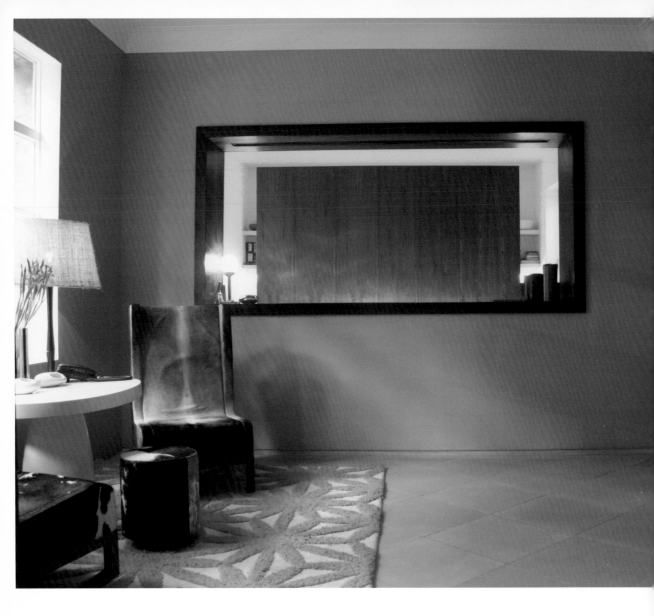

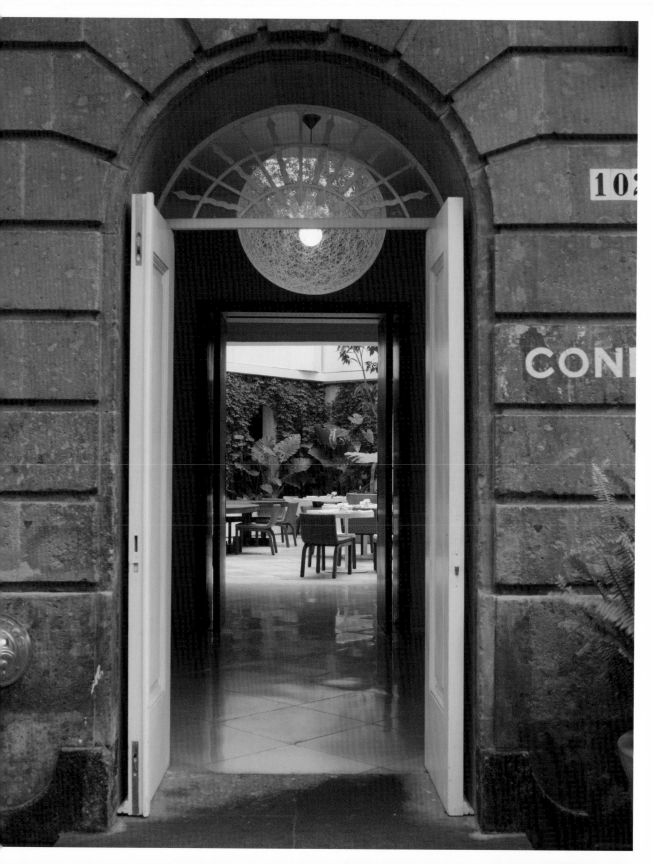

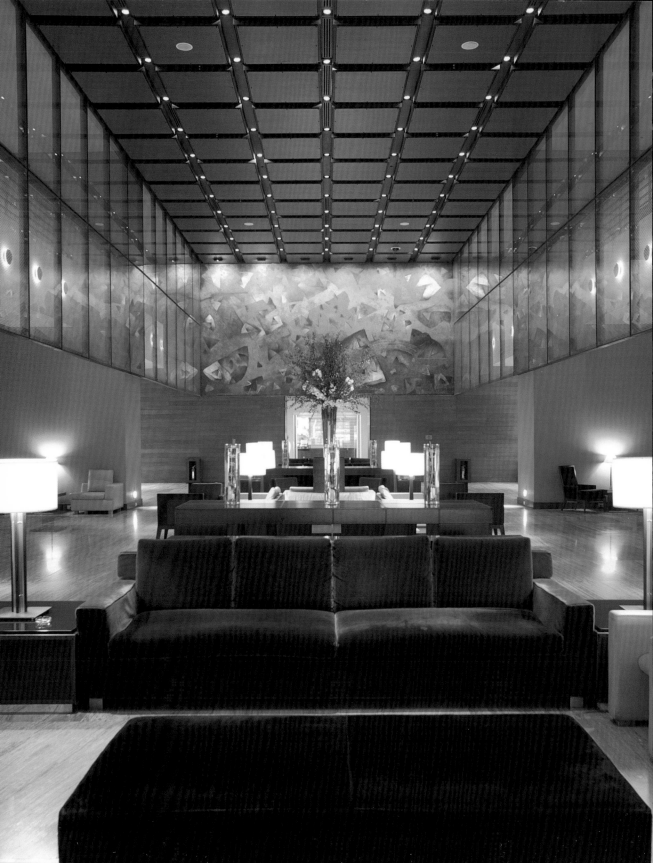

PASCAL ARQUITECTOS | MEXICO CITY
Sheraton Centro Histórico
www.sheratonmexico.com
Hospitality Spaces
Centro Histórico, Mexico City | 2003
Photos: Martin Nicholas Kunz, Michelle Galindo

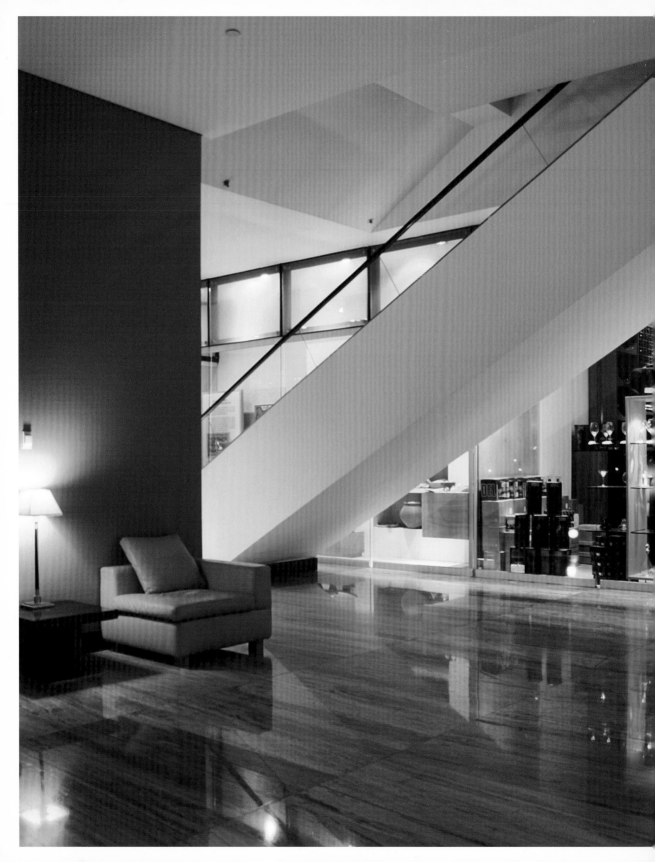

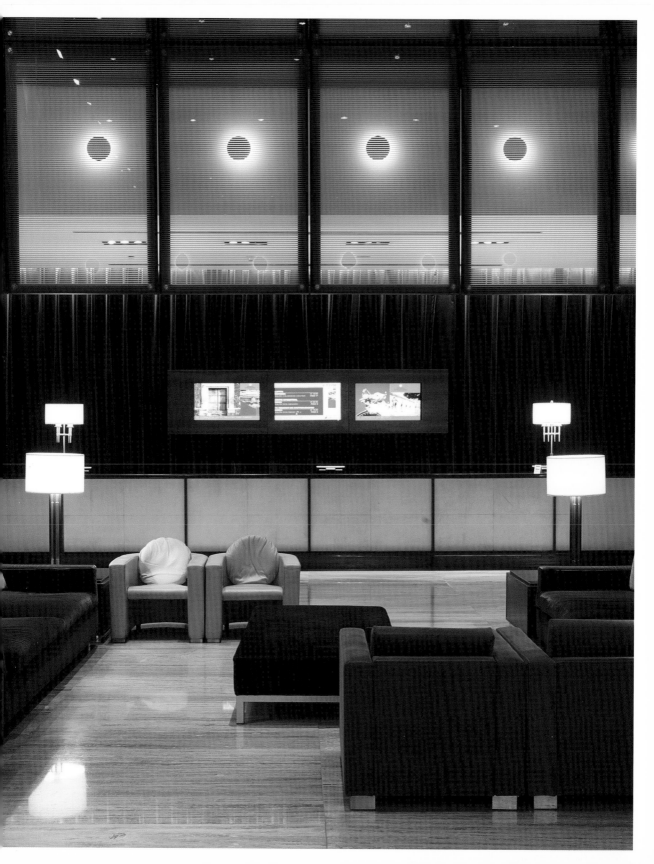

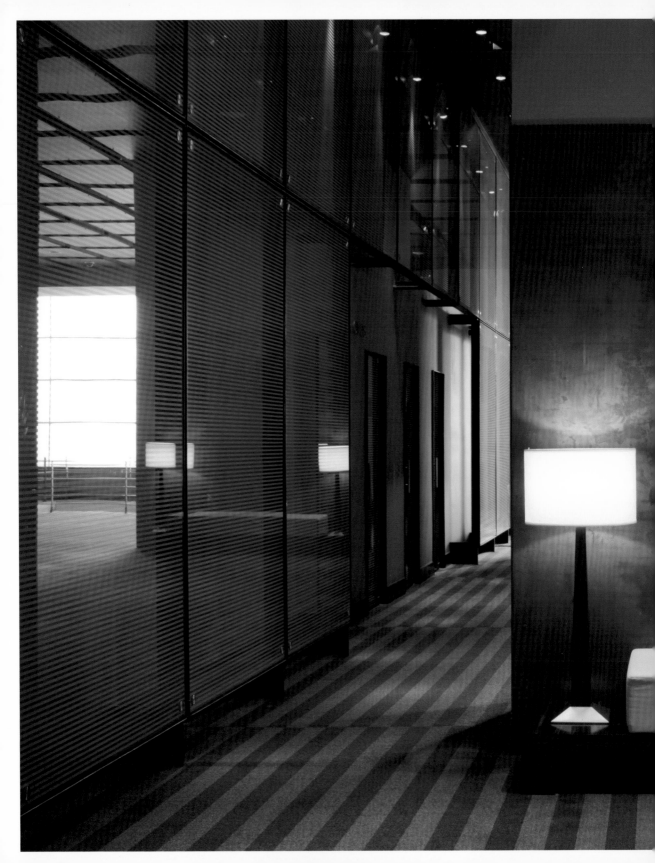

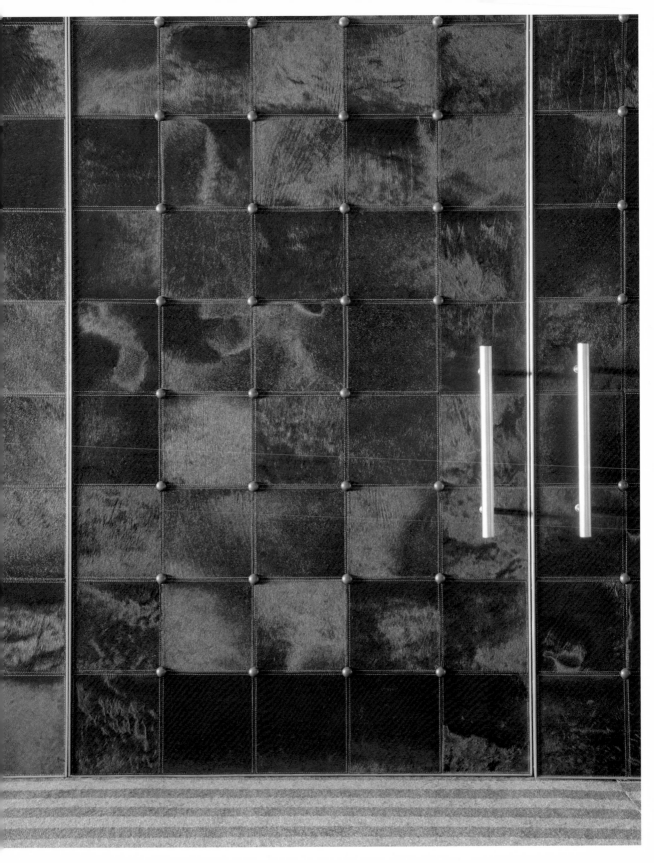

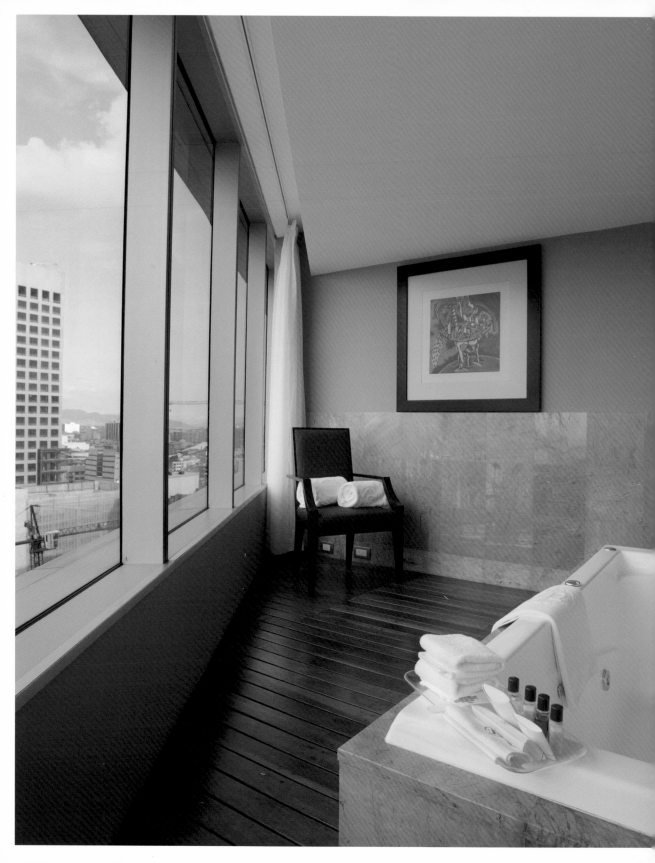

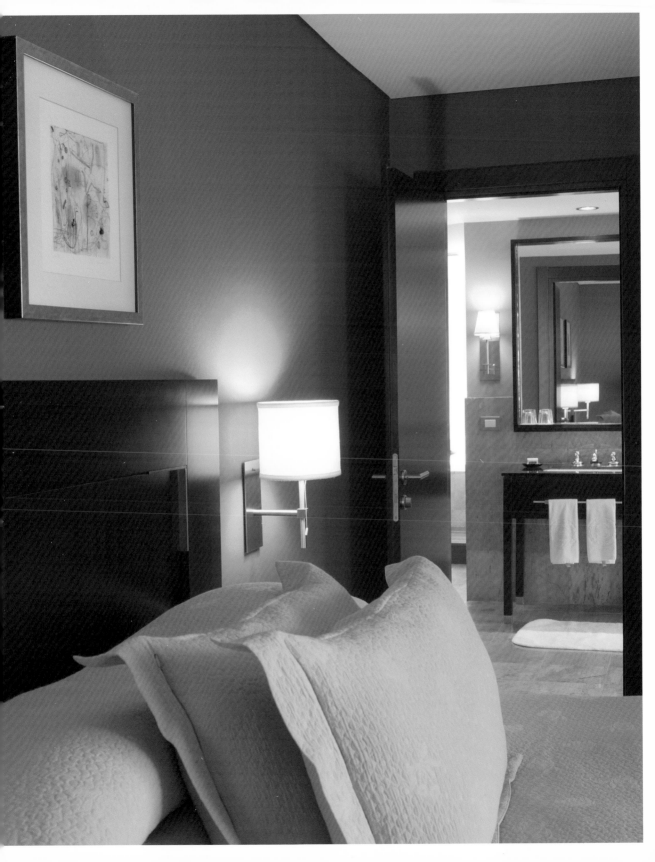

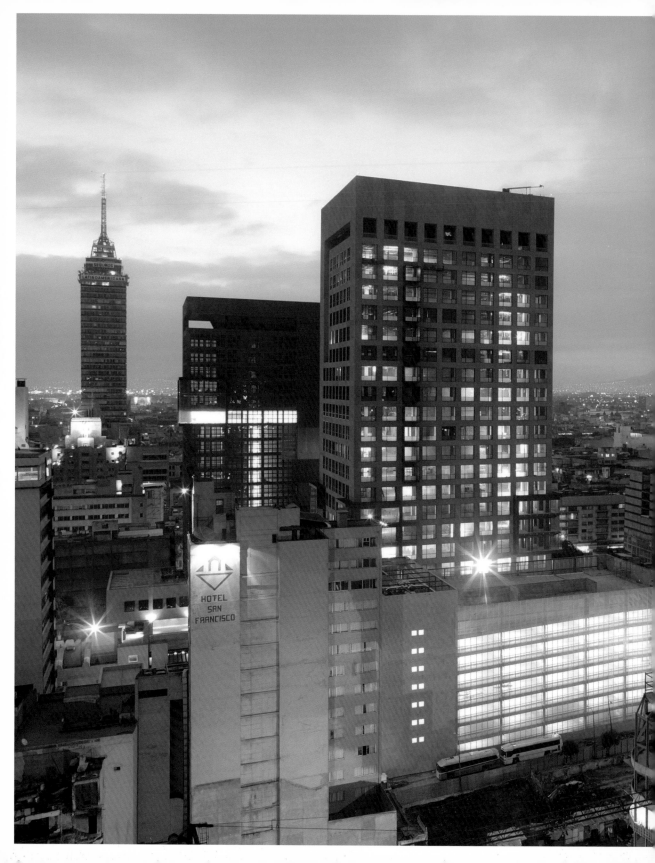

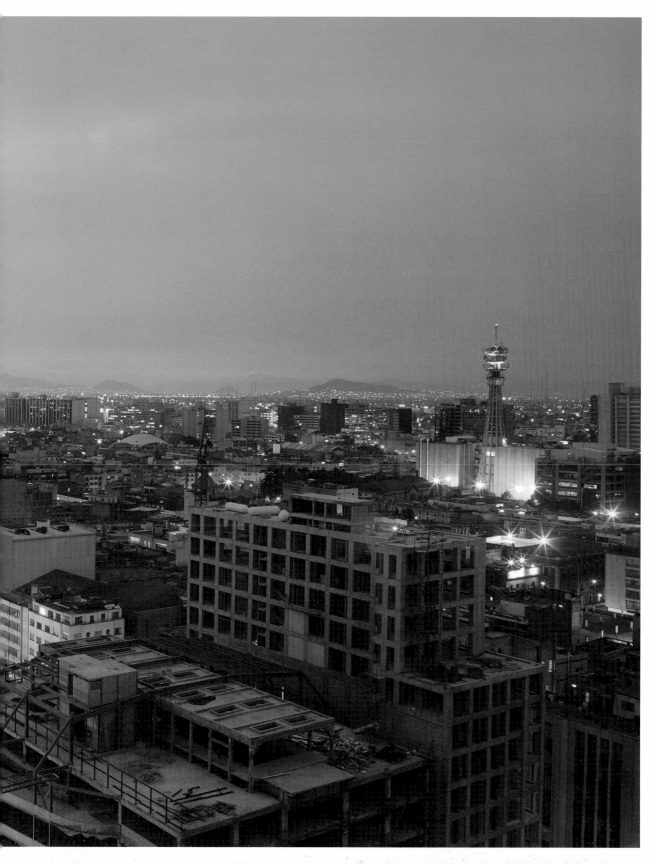

STUDIO GAIA / ILAN WAISBROD | NEW YORK
W Mexico City
Hospitality Spaces
Colonia Polanco, Mexico City | 2003
Photos: Ilan Waisbrod

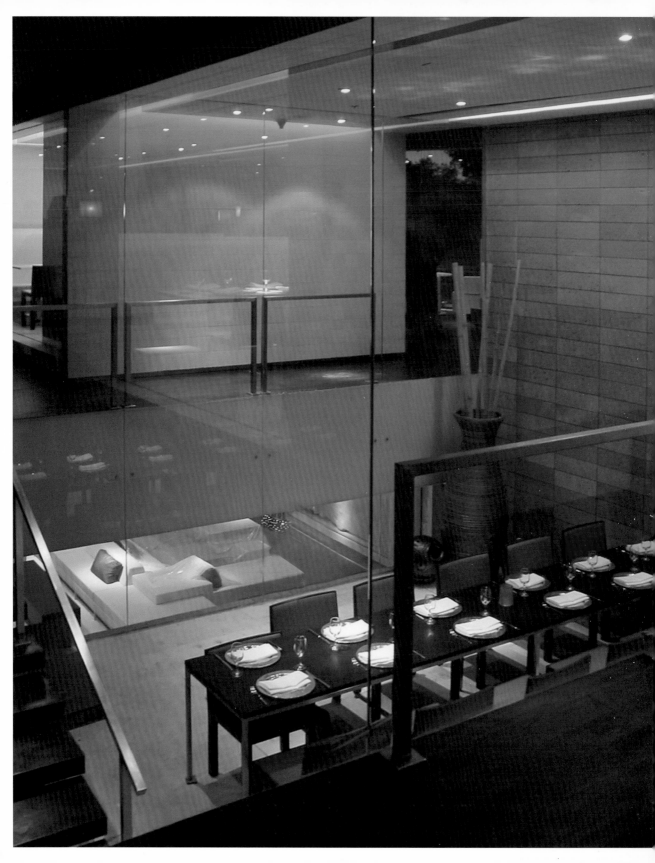

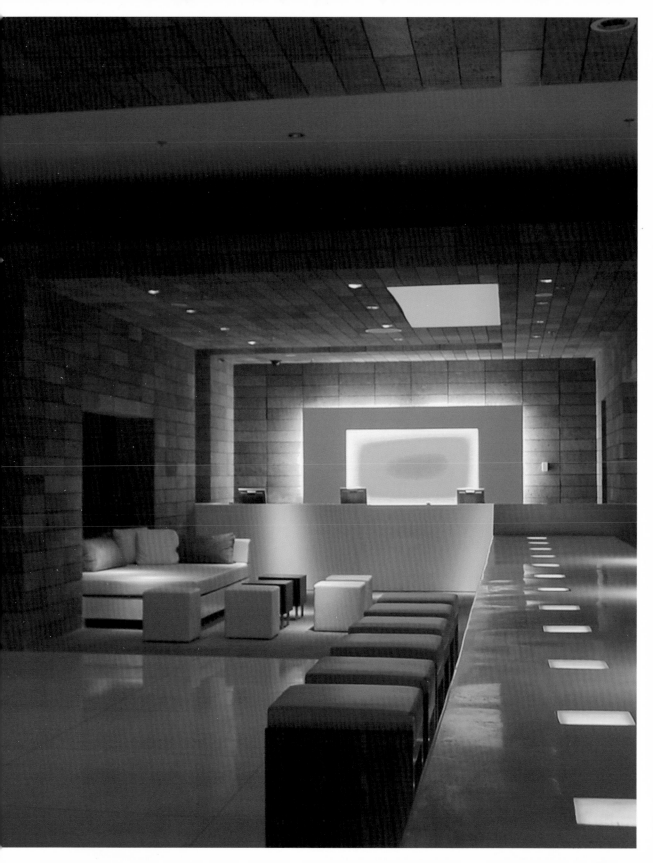

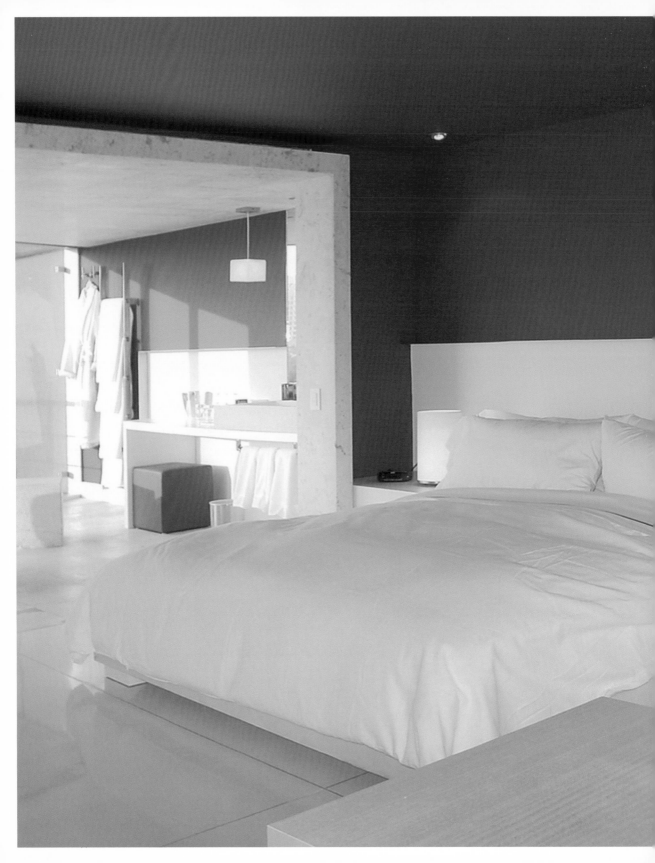

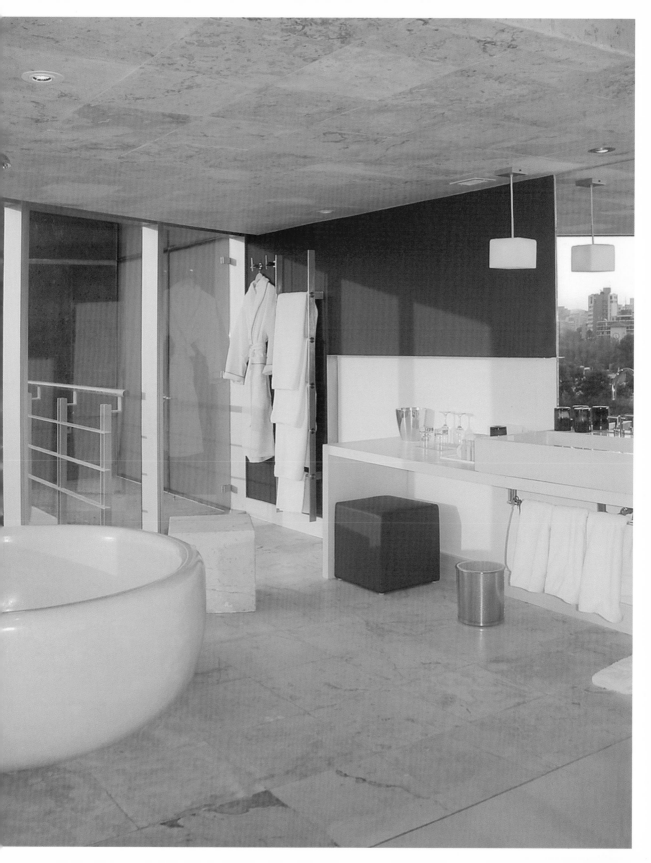

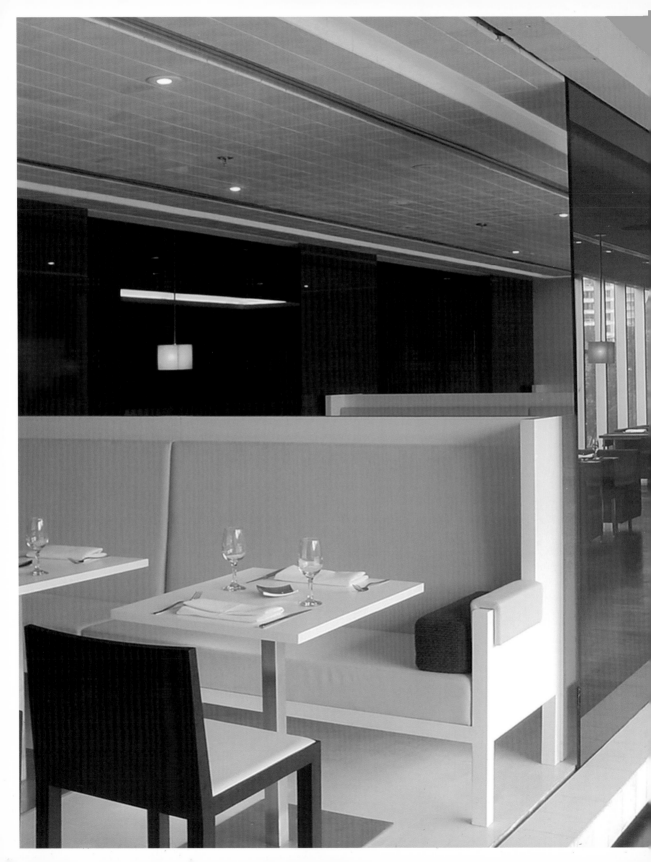

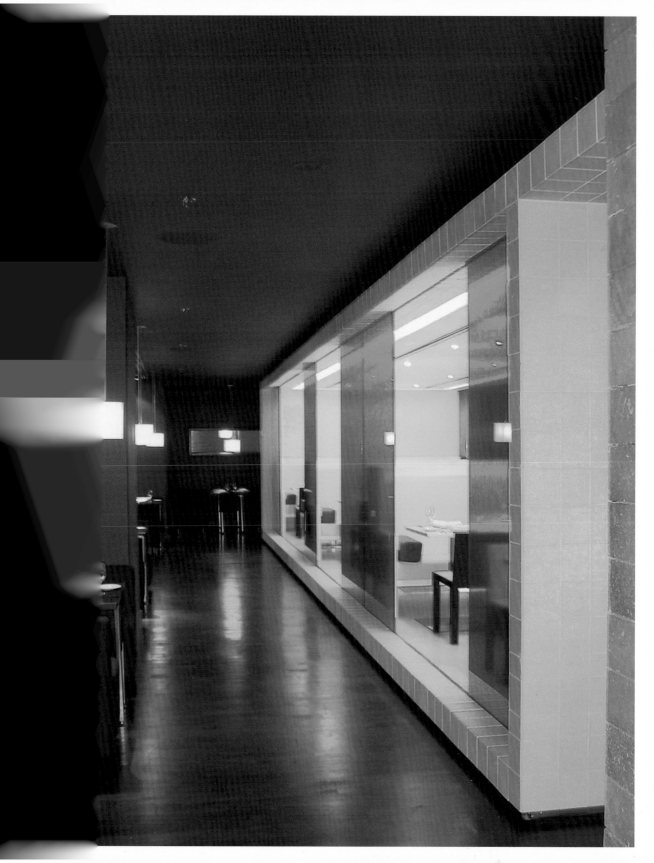

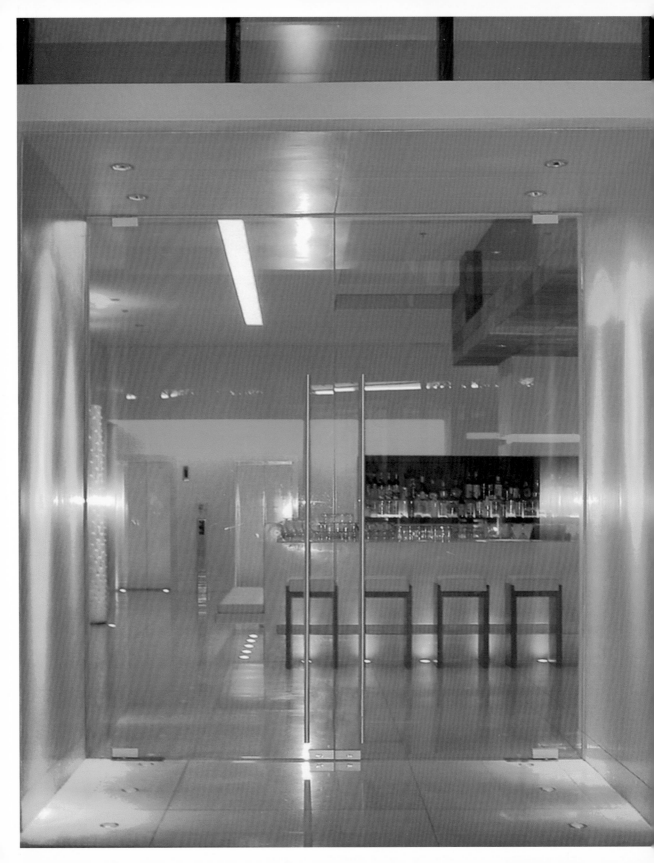

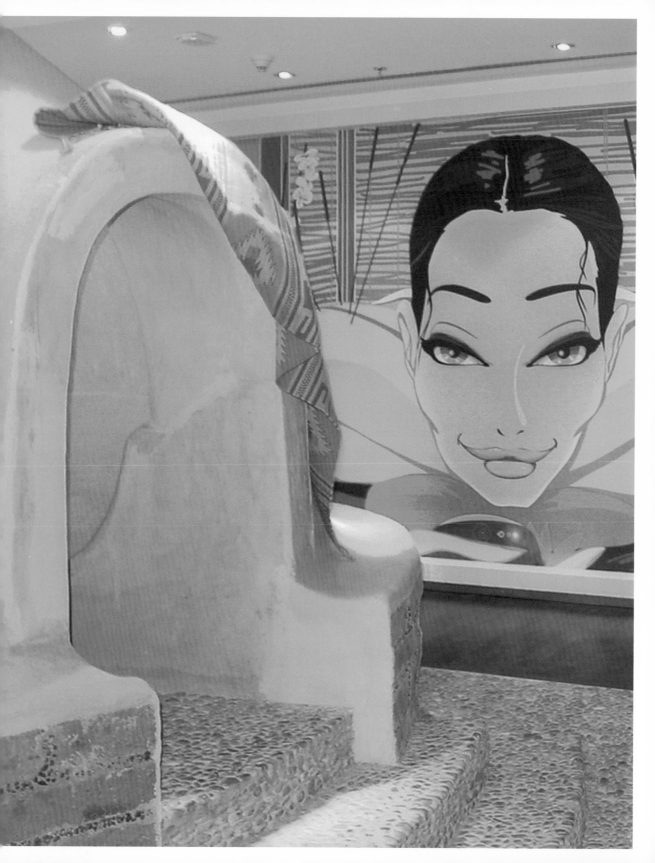

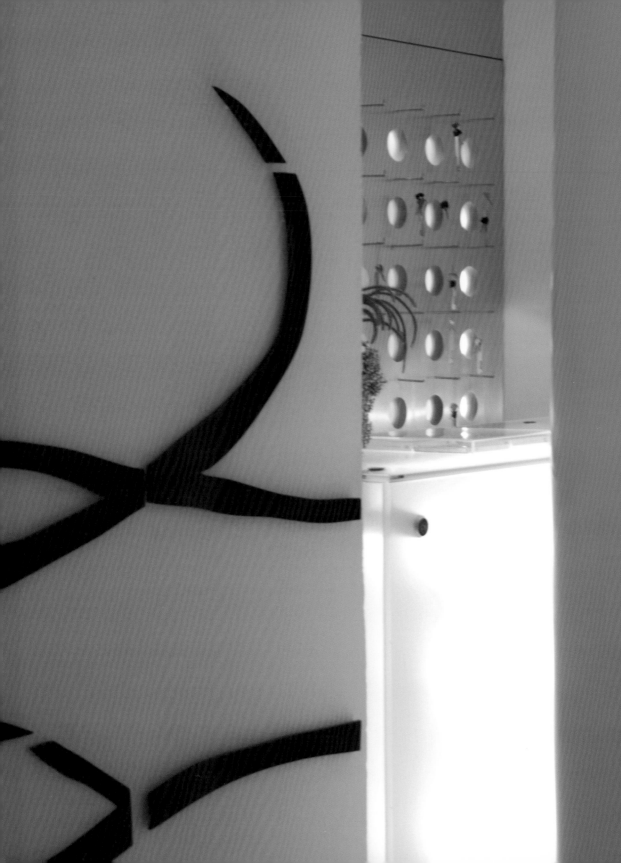

ENRIQUE NORTEN, BERNARDO GÓMEZ PIMIENTA, TEN ARQUITECTOS | MEXICO CITY
Habita Hotel
www.hotelhabita.com
Hospitality Spaces
Colonia Polanco, Mexico City | 2002
Photos: Martin Nicholas Kunz, Michelle Galindo

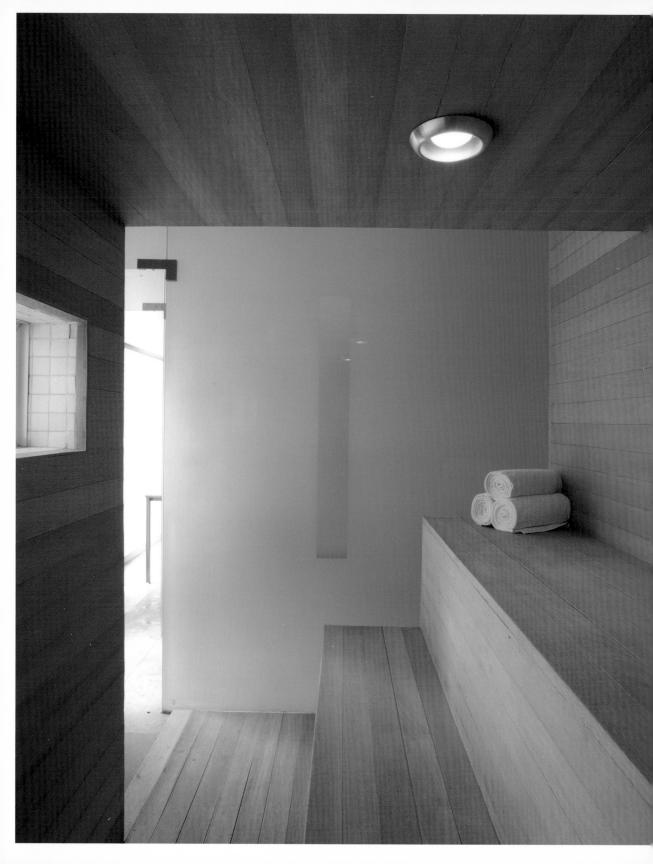

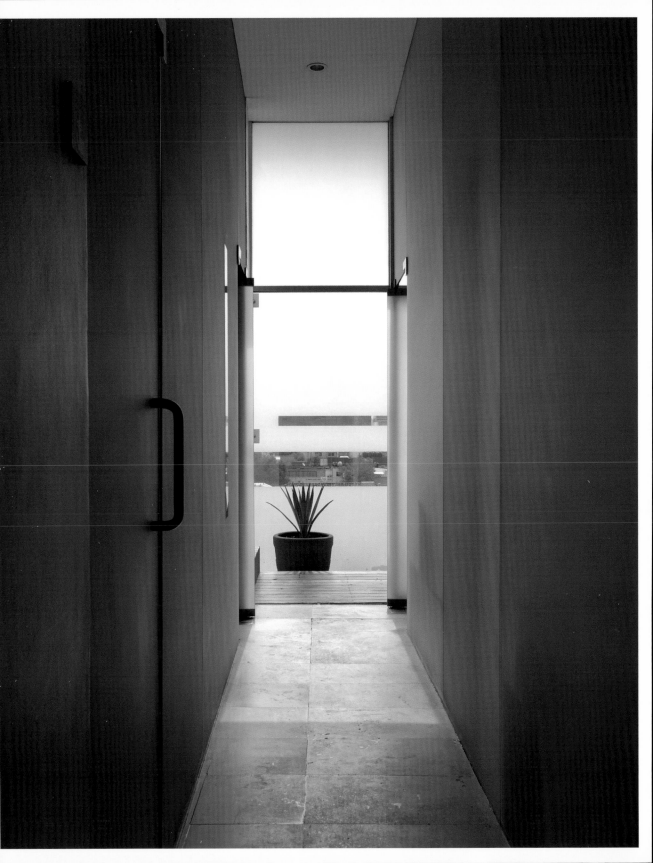

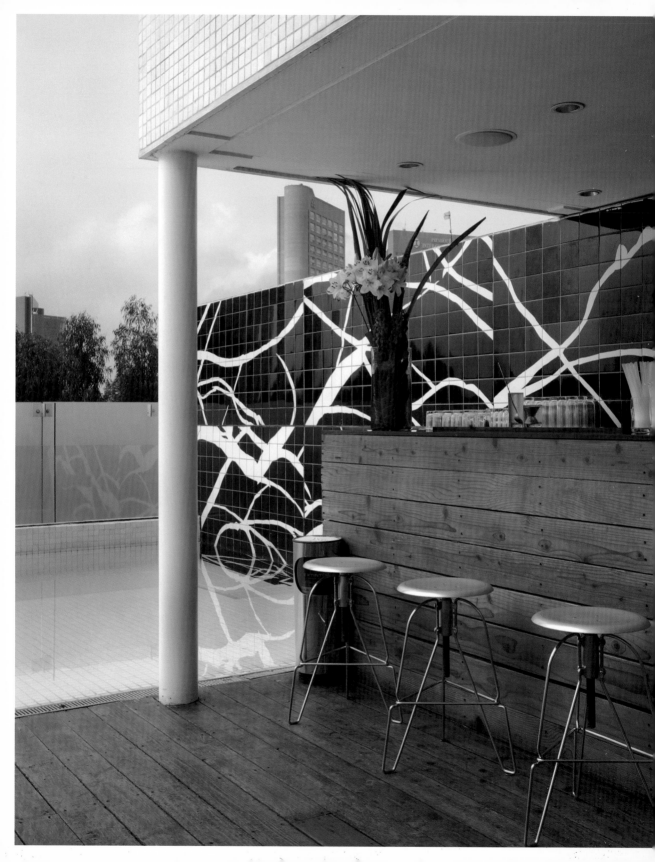

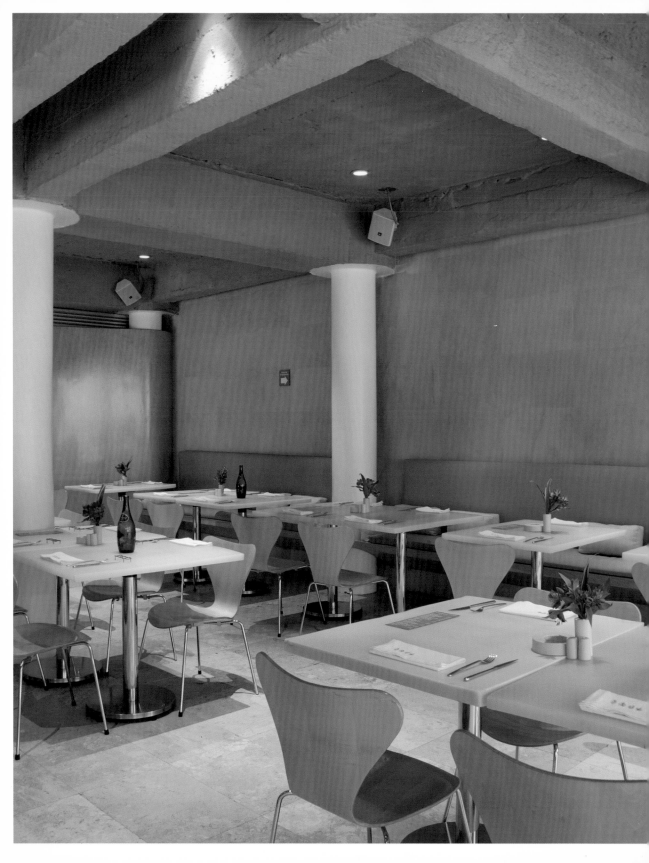

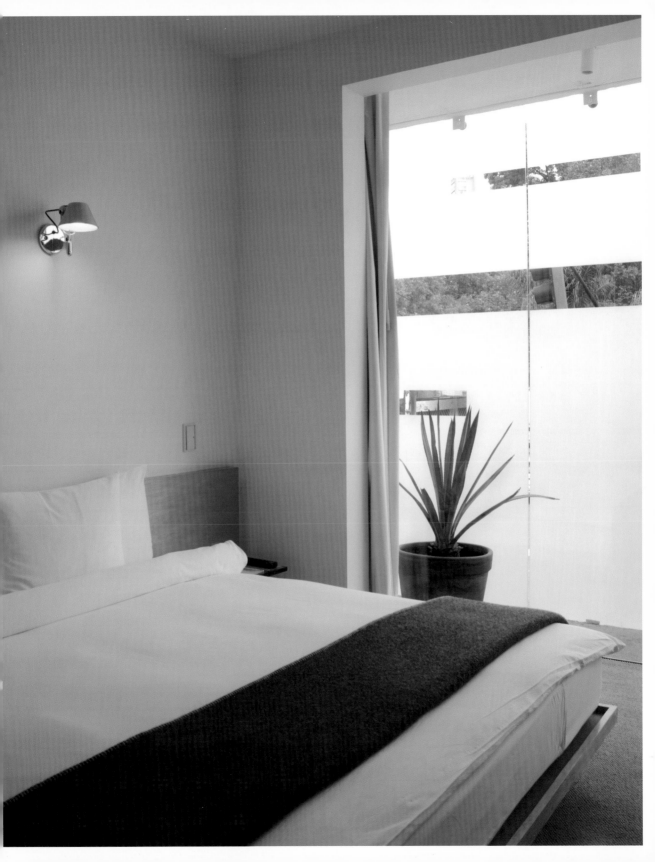

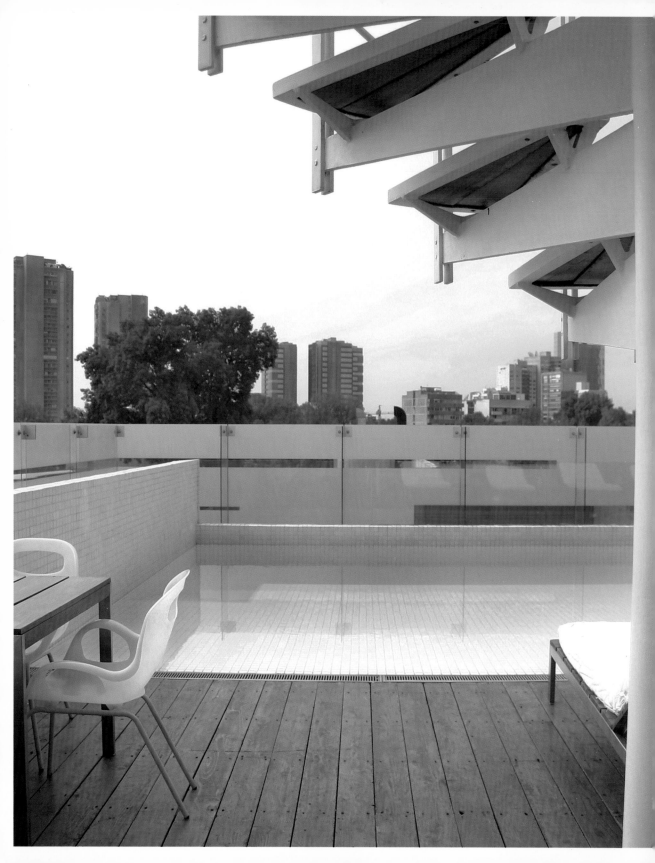

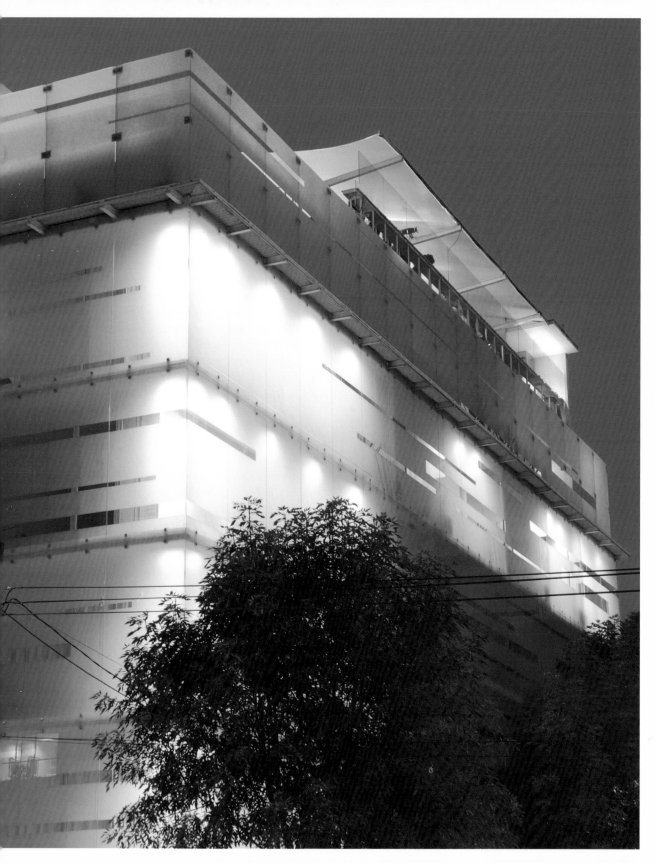

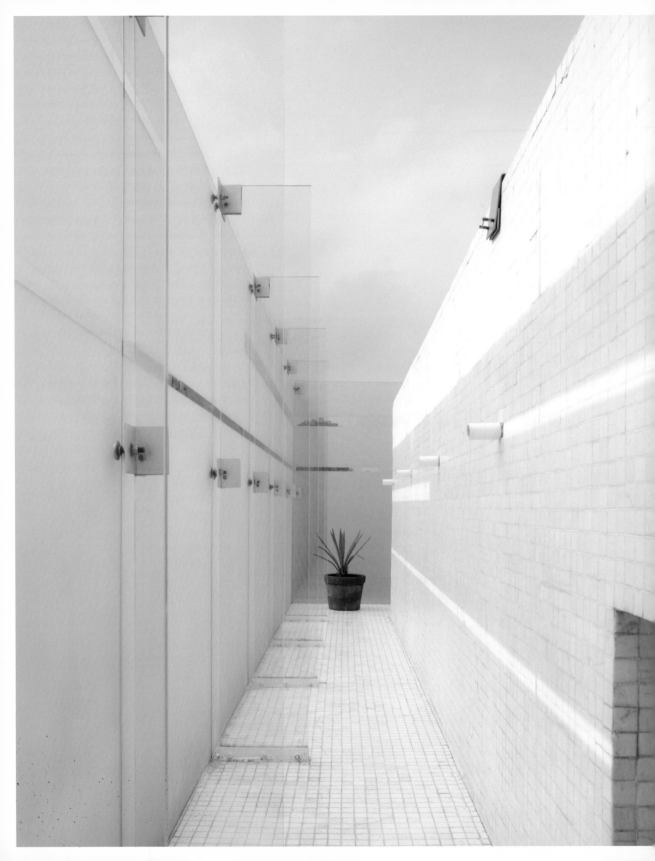

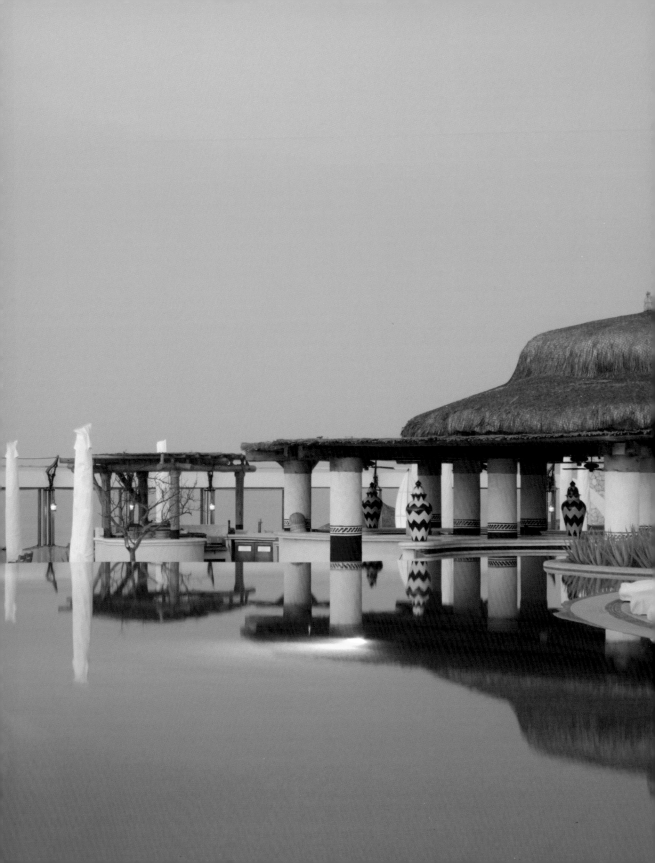

WILSON & ASSOCIATES | LOS ANGELES
Las Ventanas al Paraíso
www.lasventanas.com
Hospitality Spaces
Los Cabos, Baja California Sur | 1997
Photos: Martin Nicholas Kunz

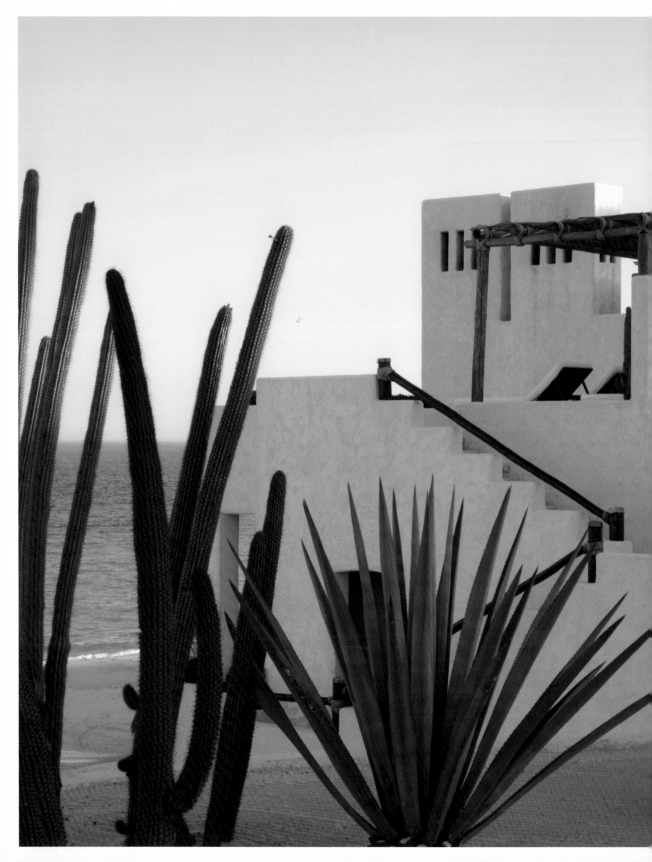

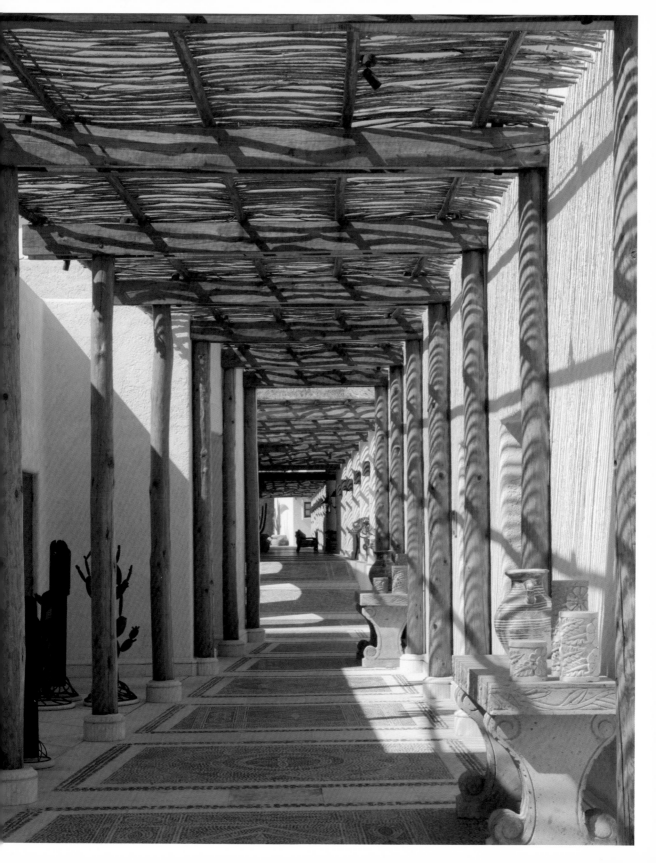

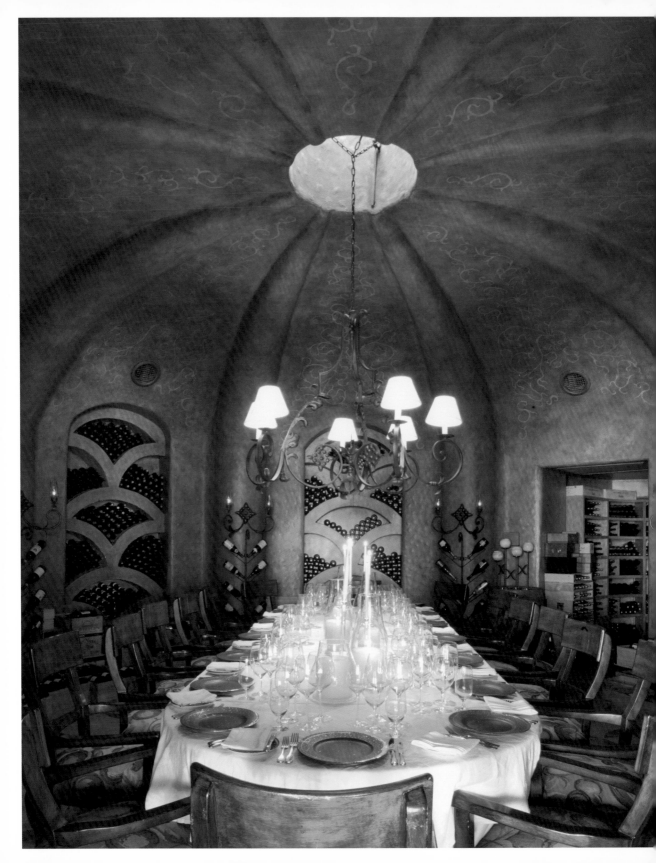

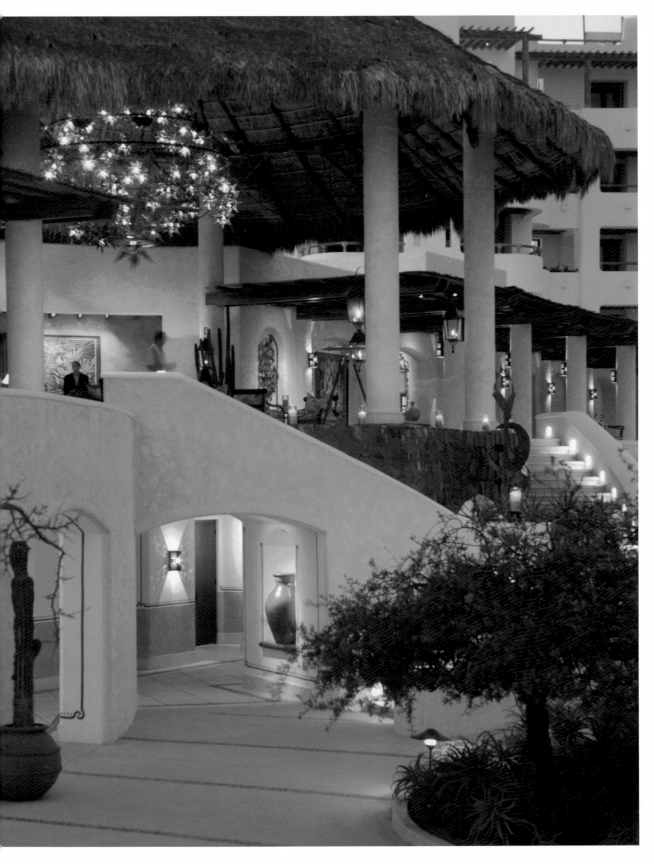

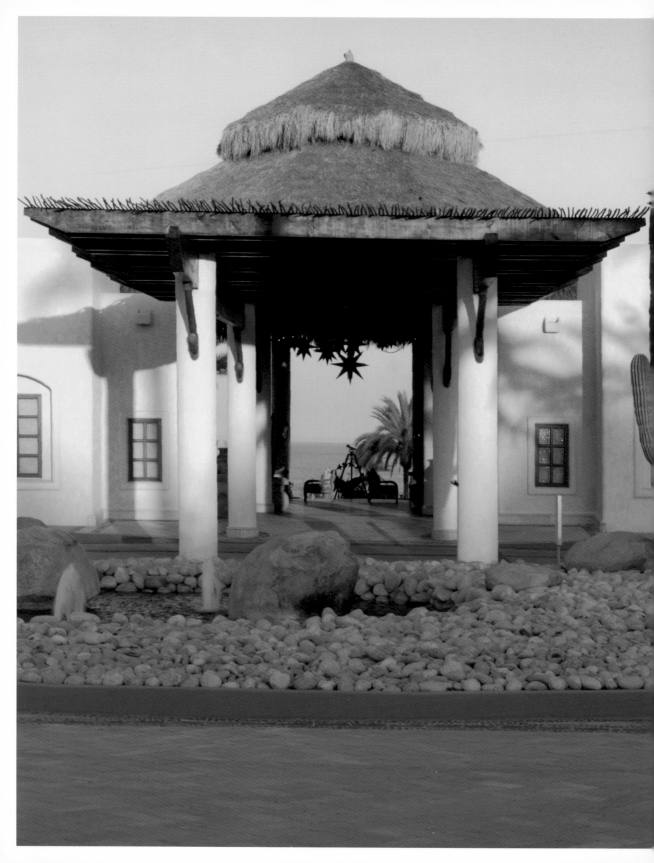

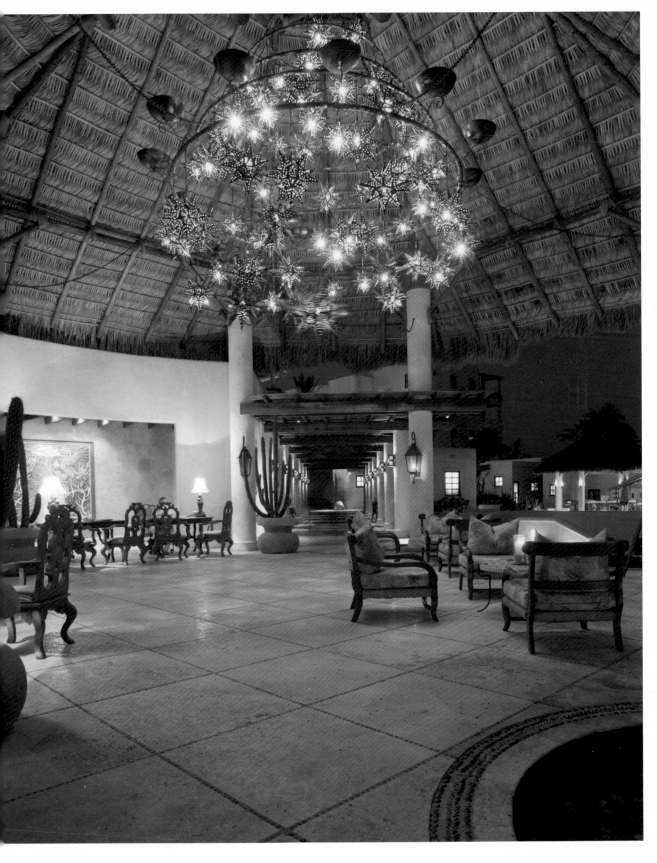

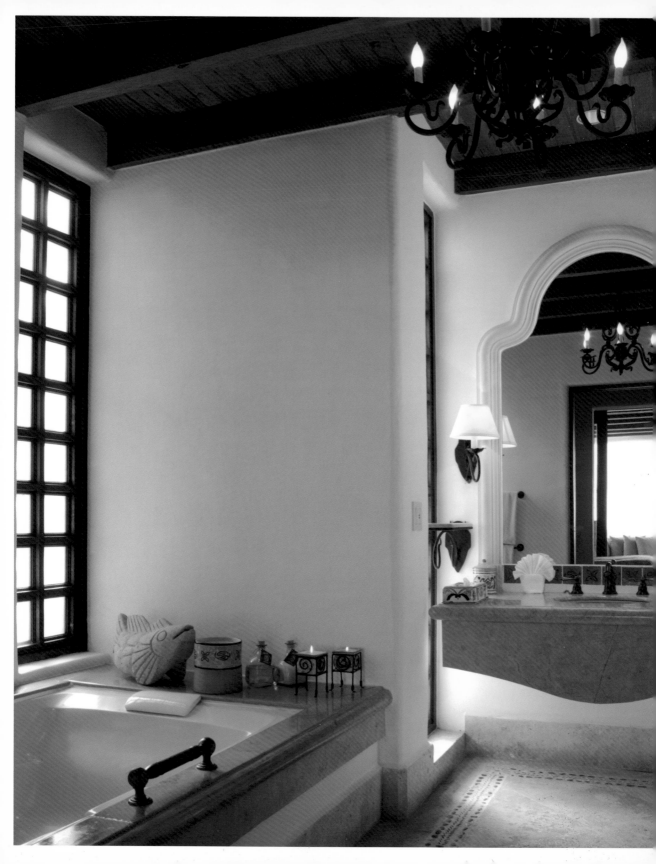

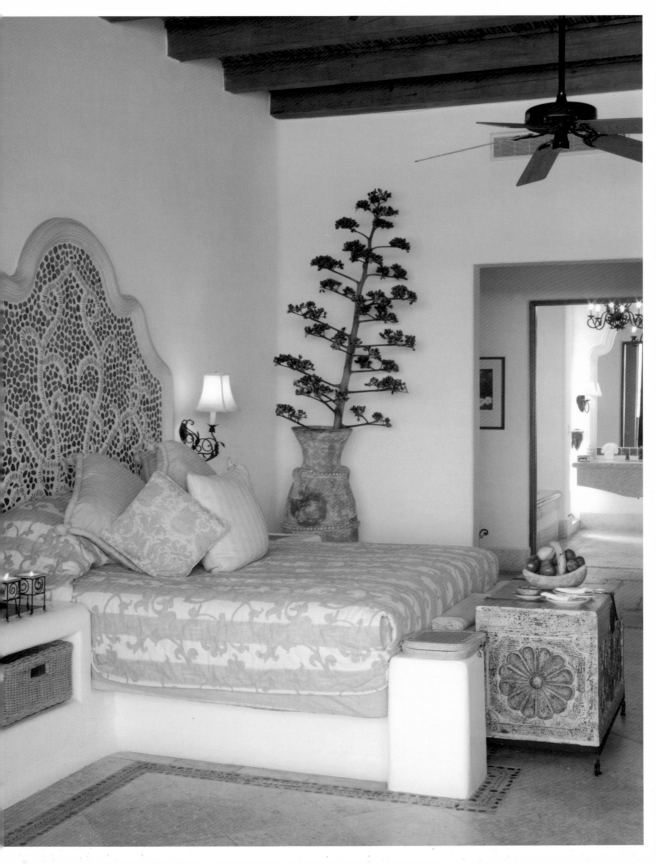

LEISURE SPACES – RESTAURANTS, BARS, LOUNGES & CLUBS

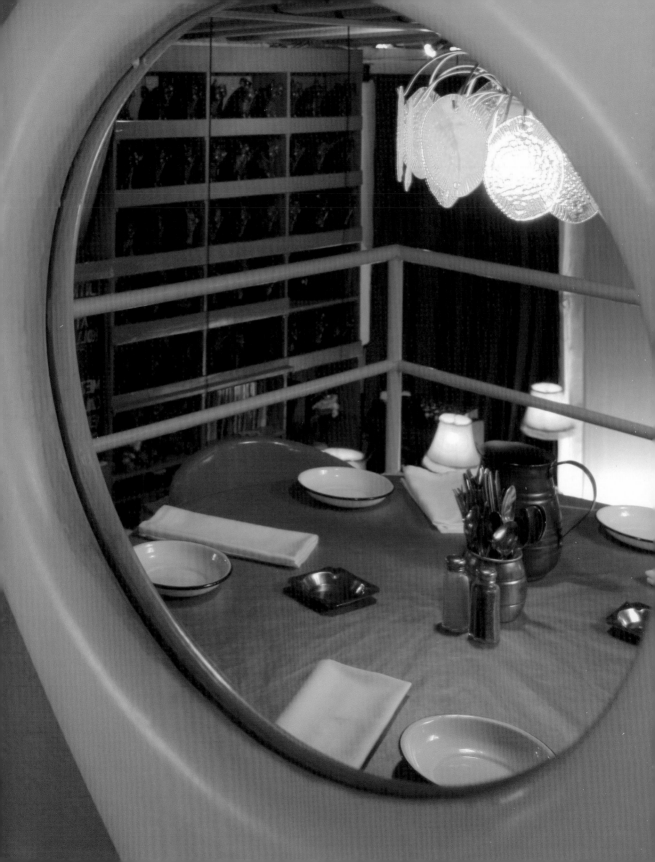

GERARDO CENDEJAS LÓPEZ | **GUADALAJARA, JALISCO**
LORENA & MARIA JOSÉ ZERTUCHE DÍAZ | **GUADALAJARA, JALISCO**
Restaurante "I Latina"
Leisure Spaces
Guadalajara, Jalisco | 1999
Photos: Carlos Díaz Corona

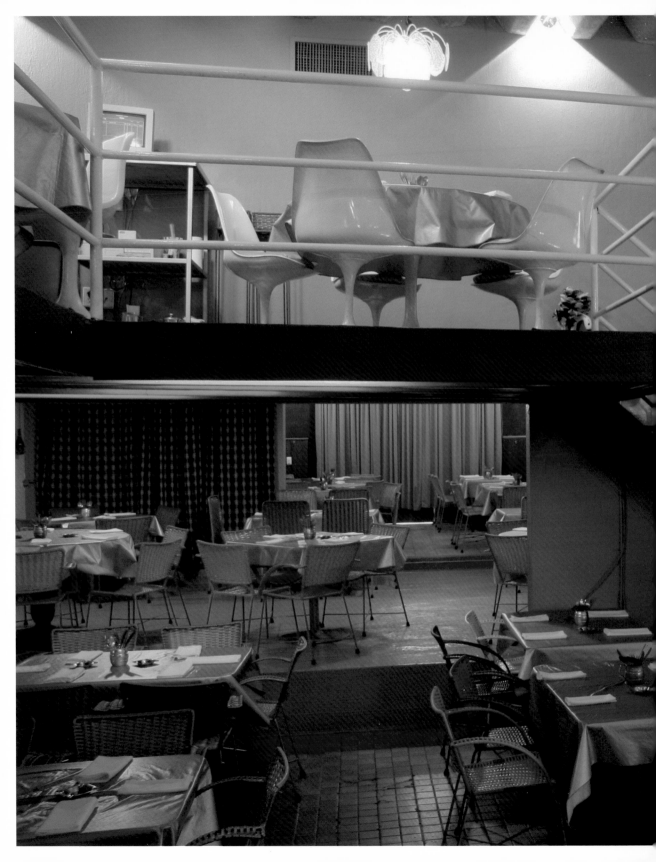

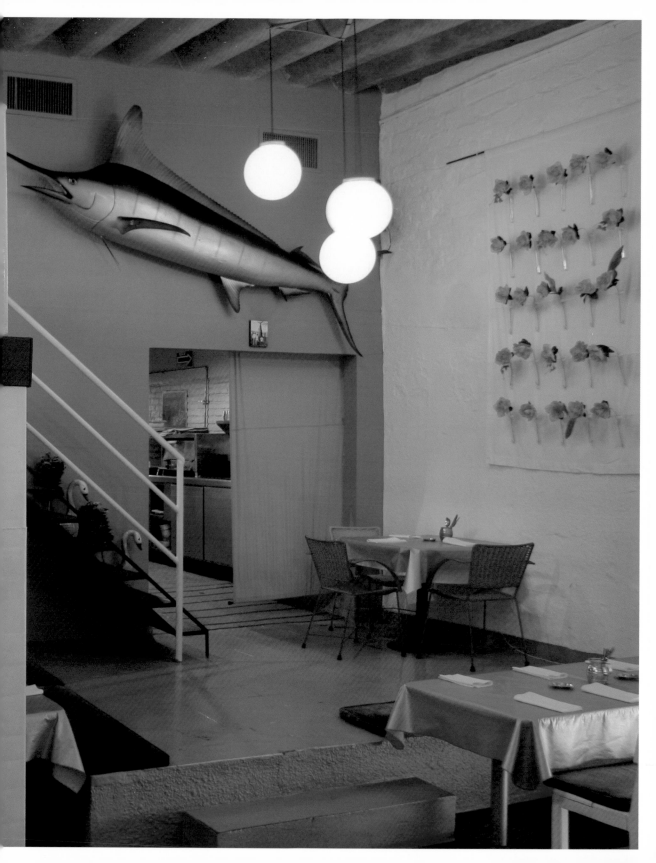

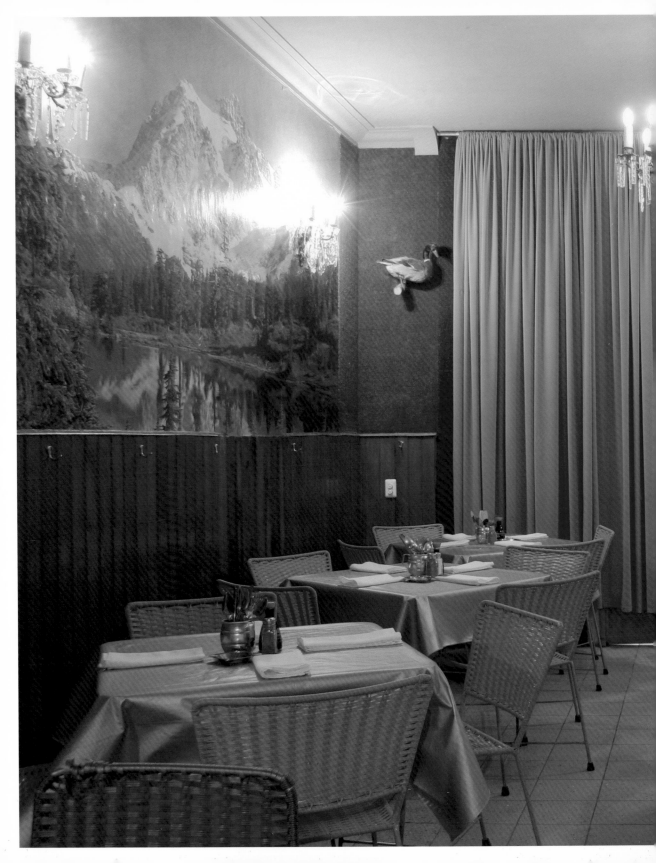

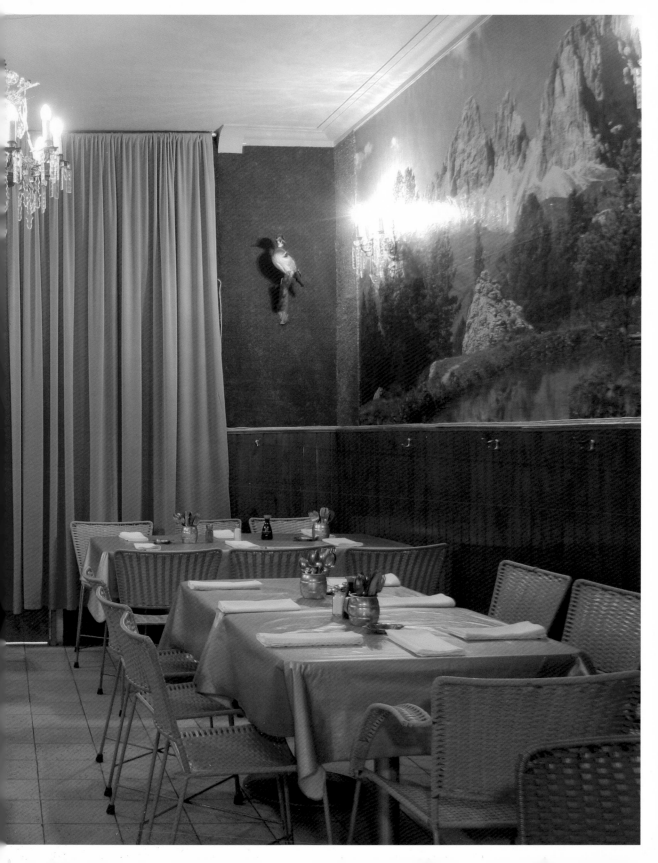

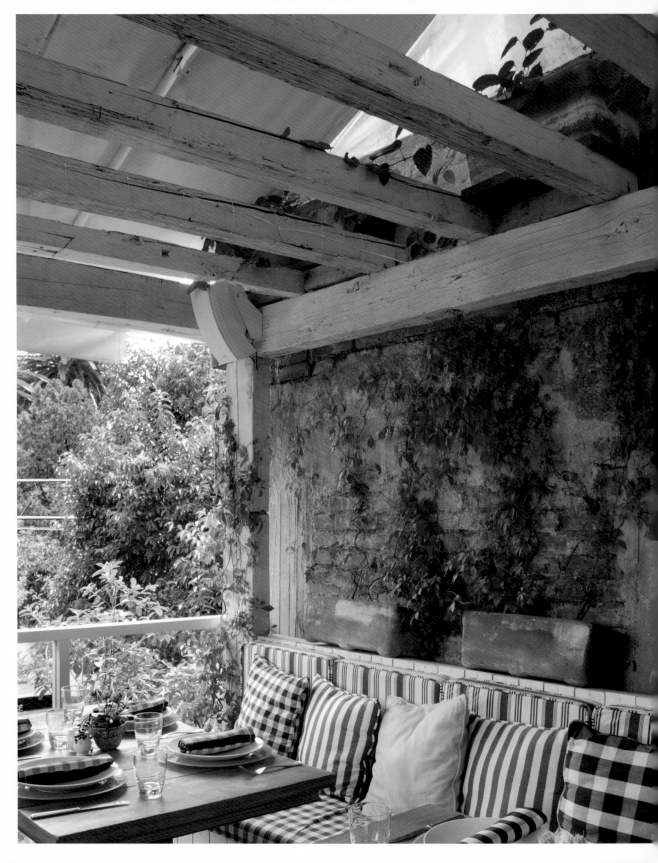

FRANCISCO VAN HAUSSEN | **MEXICO CITY**
Ivoire
Leisure Spaces
Colonia Polanco, Mexico City | 2005
Photos: Martin Nicholas Kunz, Michelle Galindo

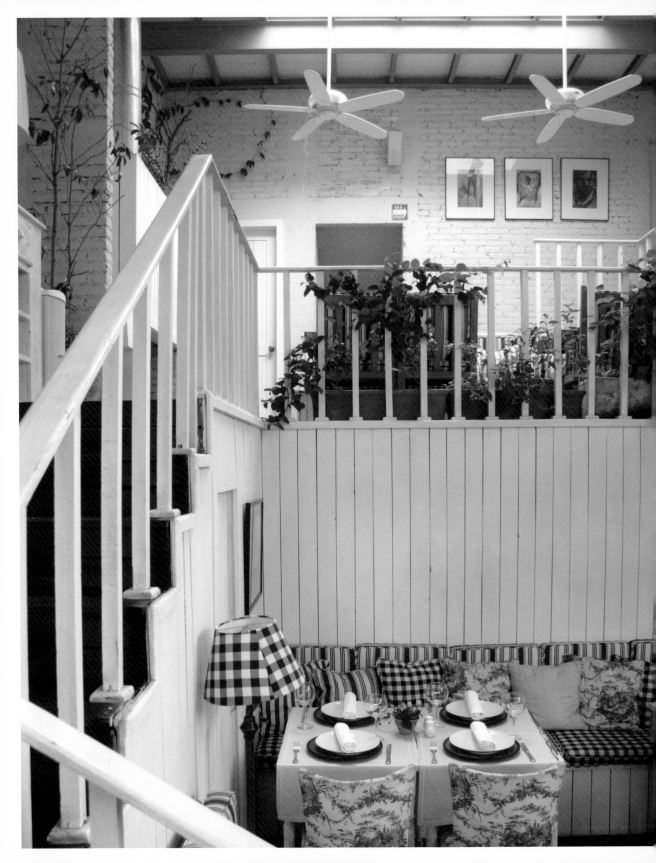

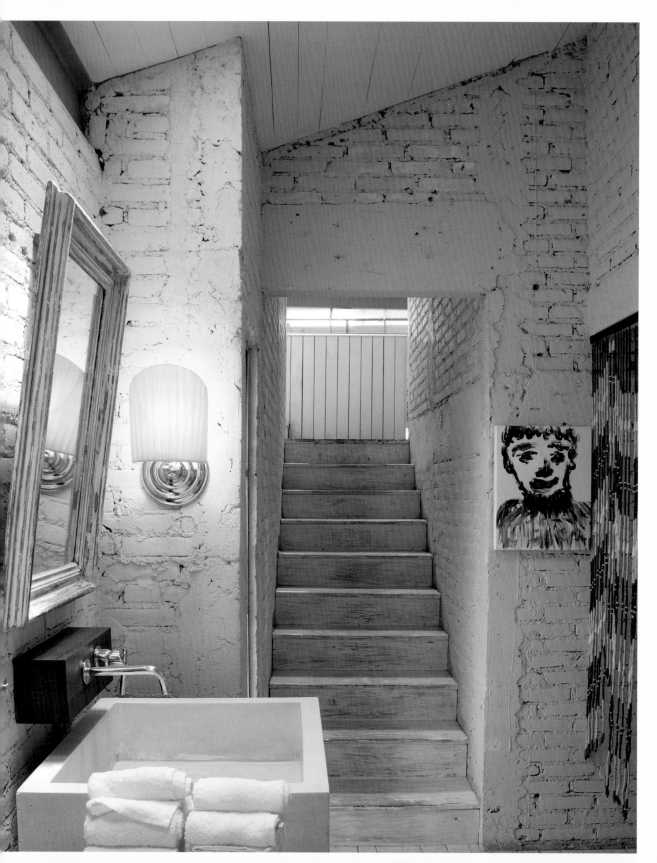

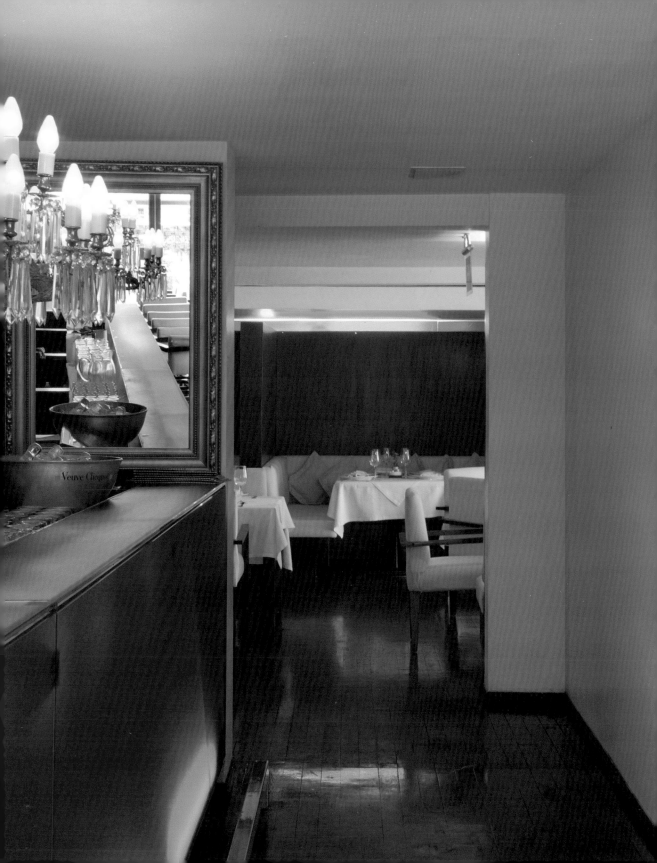

HIGUERA + SÁNCHEZ | MEXICO CITY
D.O. denominación de origen
Leisure Spaces
Colonia Polanco, Mexico City | 2002
Photos: Martin Nicholas Kunz, Michelle Galindo

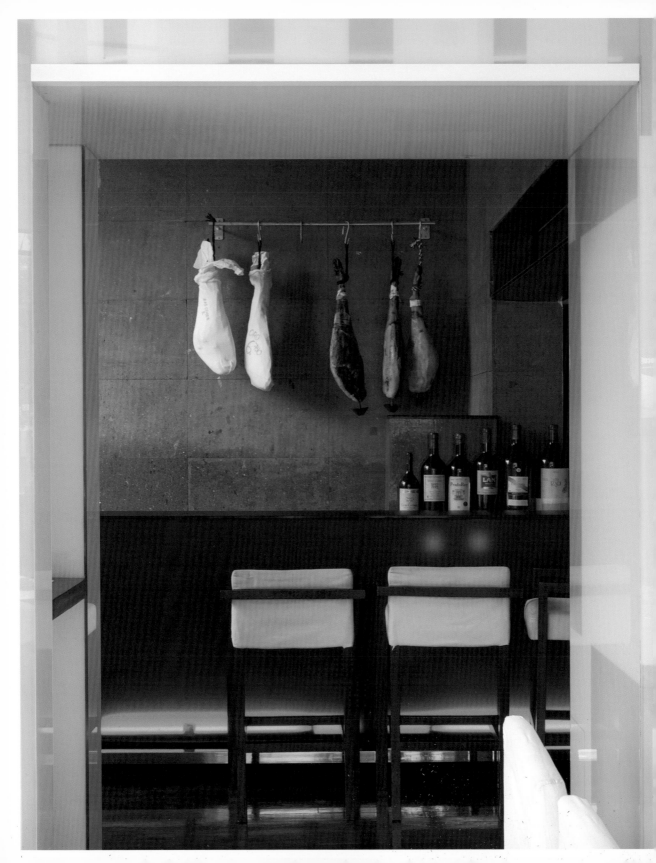

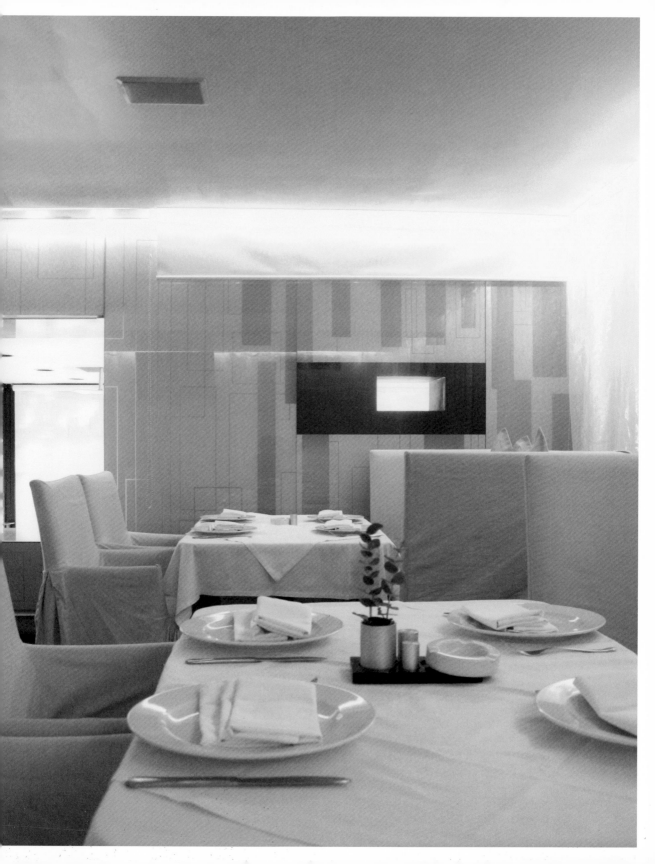

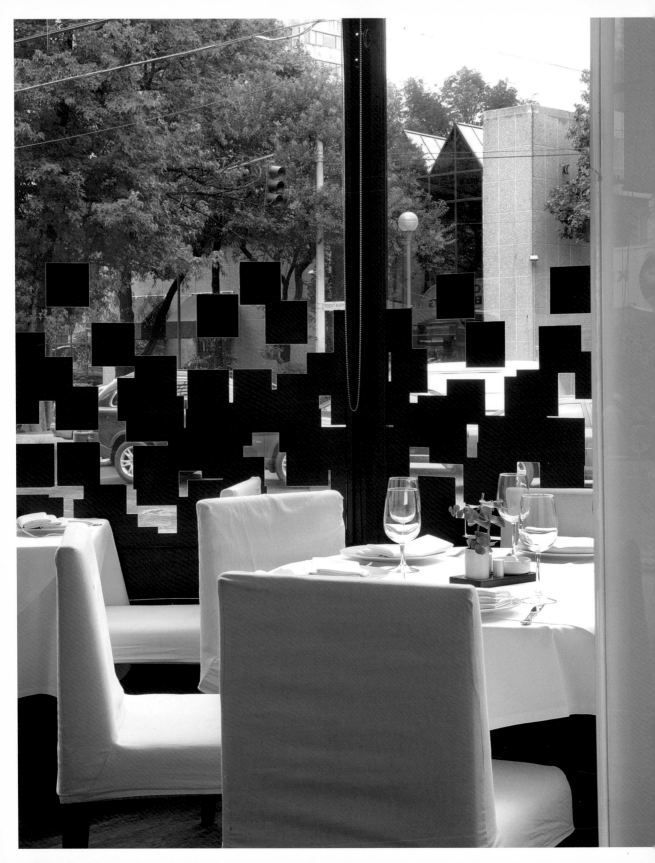

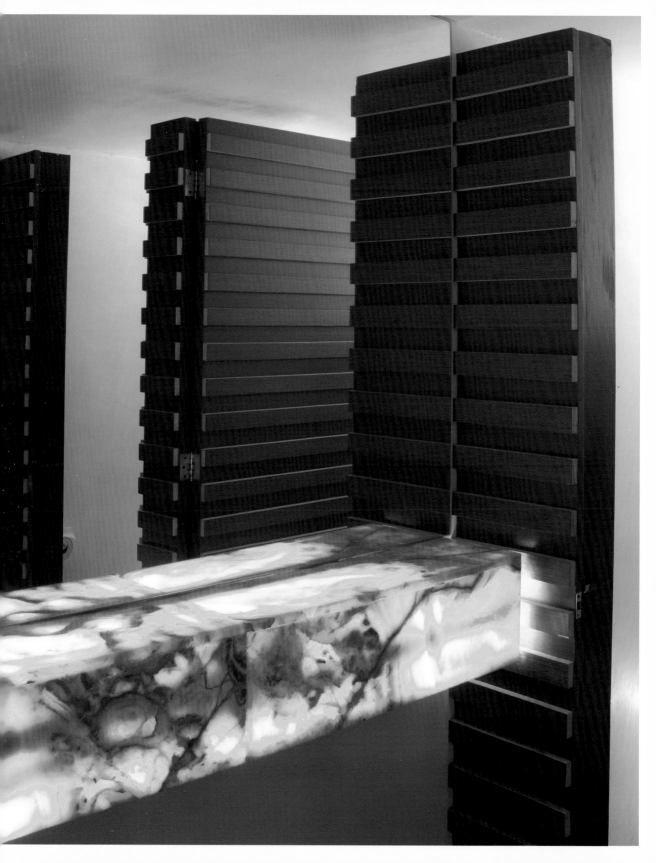

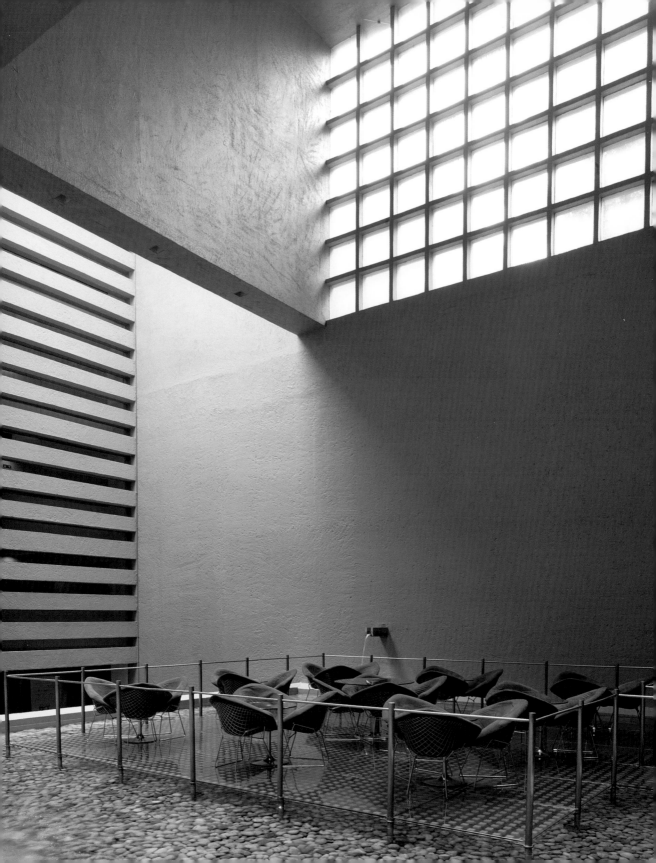

LEGORETTA + LEGORETTA | MEXICO CITY
Blue Lounge (Camino Real México)
Leisure Spaces
Mexico City | 2003
Photos: Martin Nicholas Kunz, Michelle Galindo

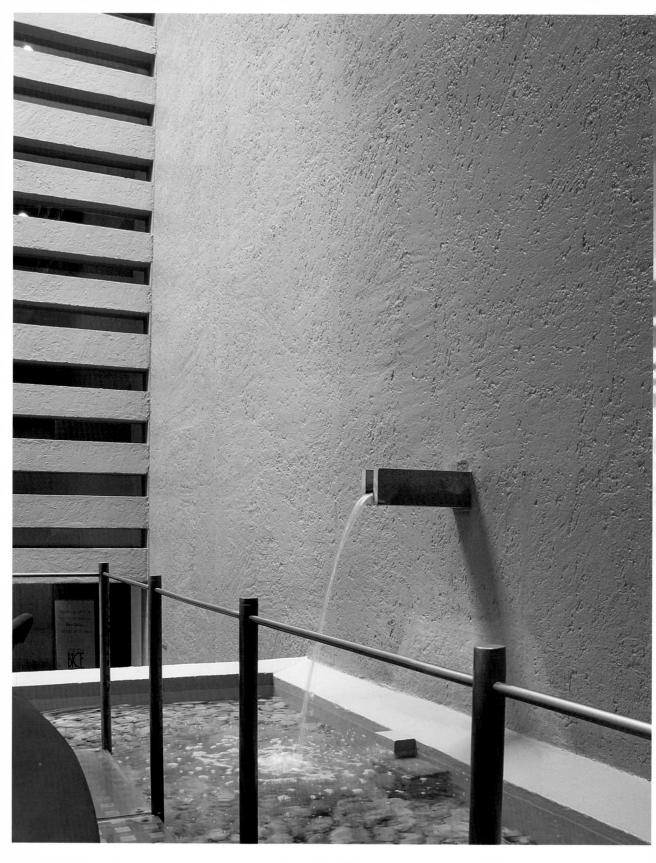

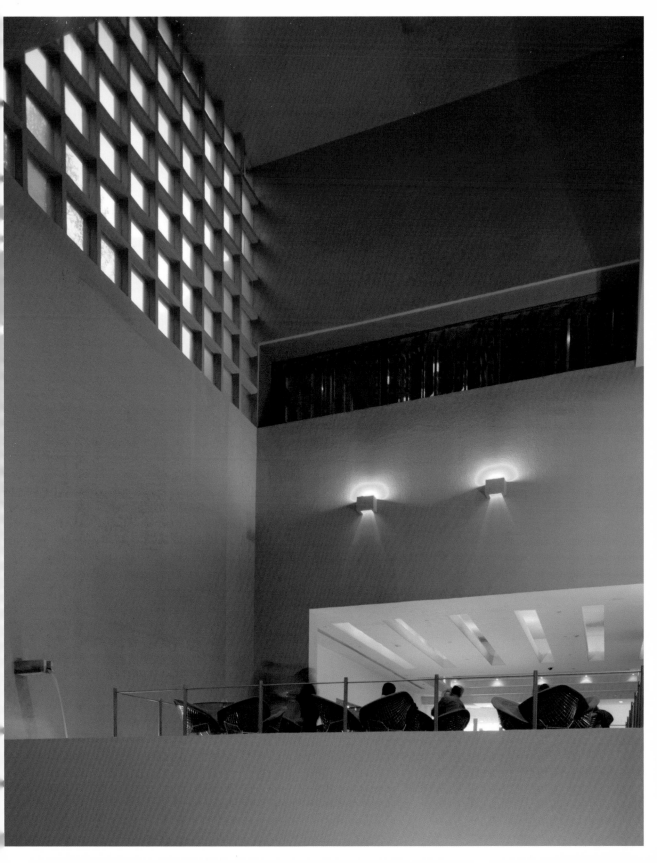

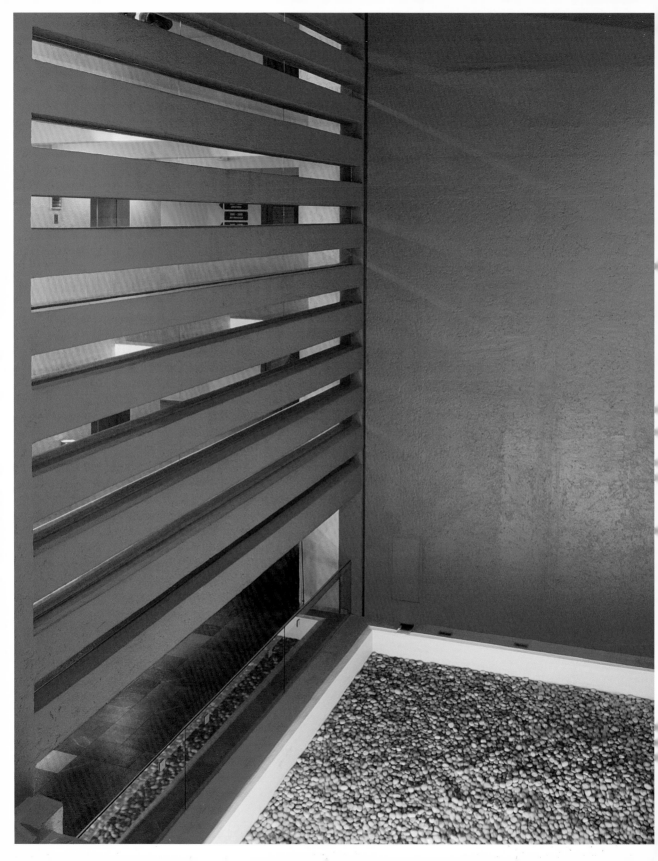

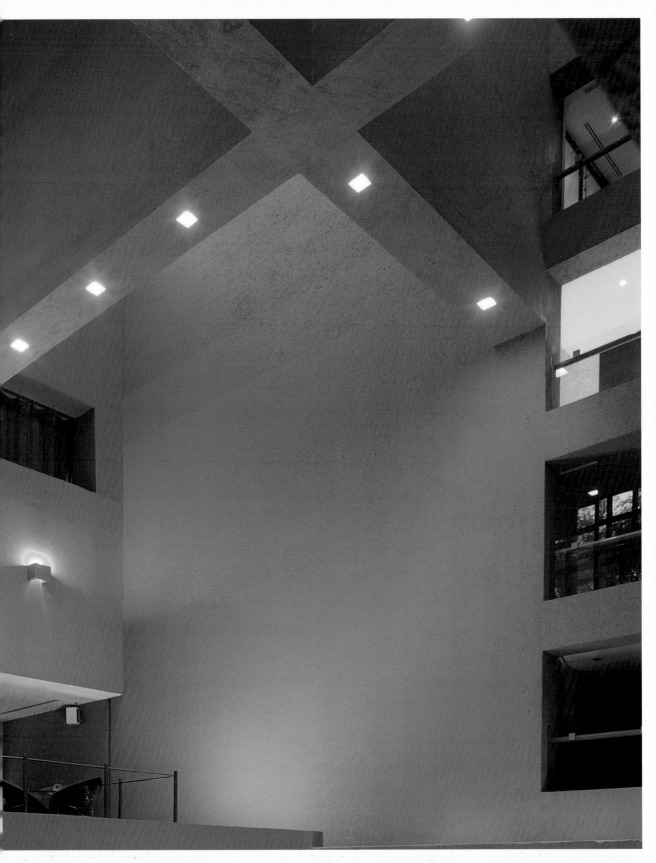

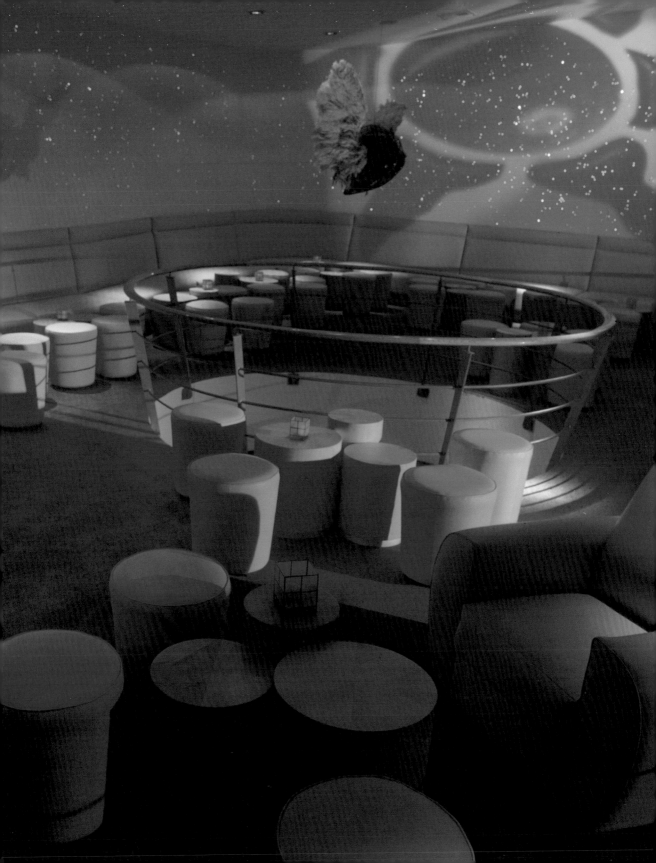

GILBERTO L. RODRÍGUEZ | **MONTERREY, NUEVO LEÓN**
Varshiva Night Club
Leisure Spaces
Monterrey, Nuevo León | 1999
Photos: Carlos Tardan

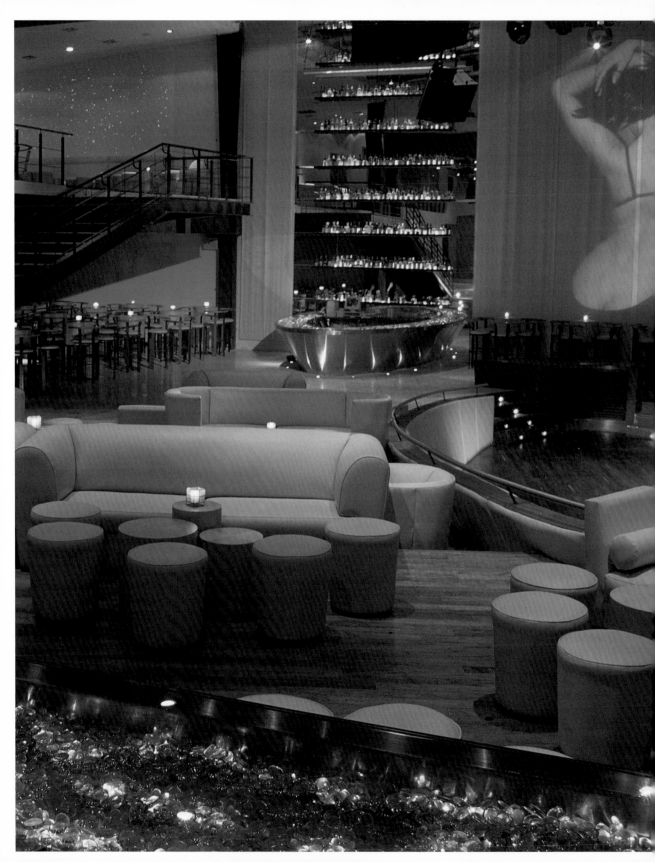

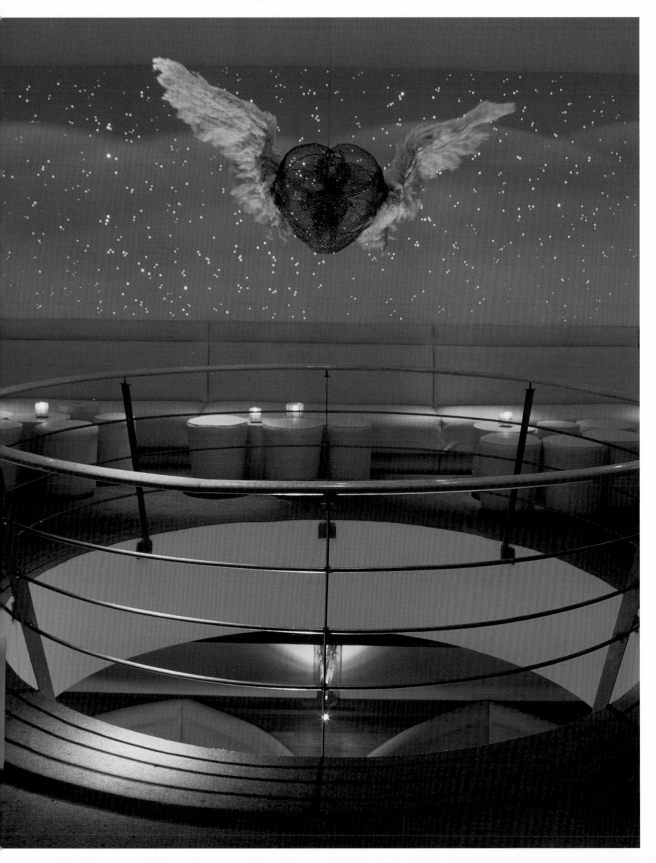

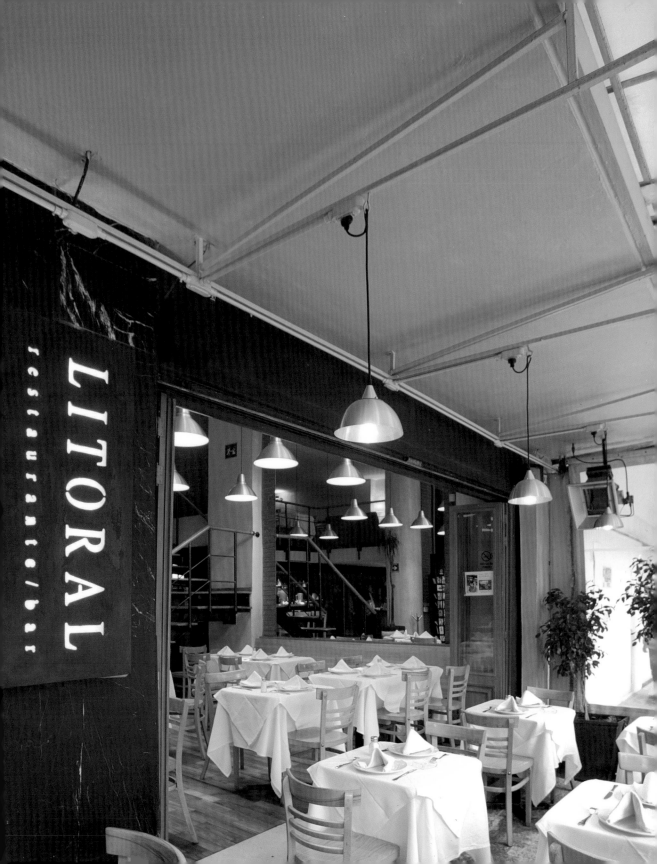

KATHUR SÁNCHEZ OCAÑA | MEXICO CITY
Litoral
Leisure Spaces
Colonia Condesa, Mexico City | 2000
Photos: Martin Nicholas Kunz, Michelle Galindo

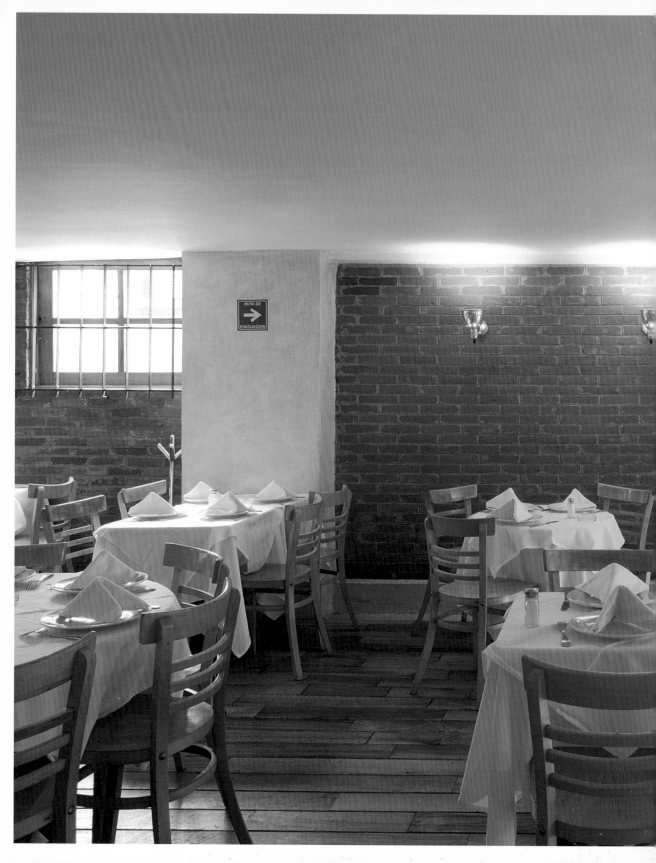

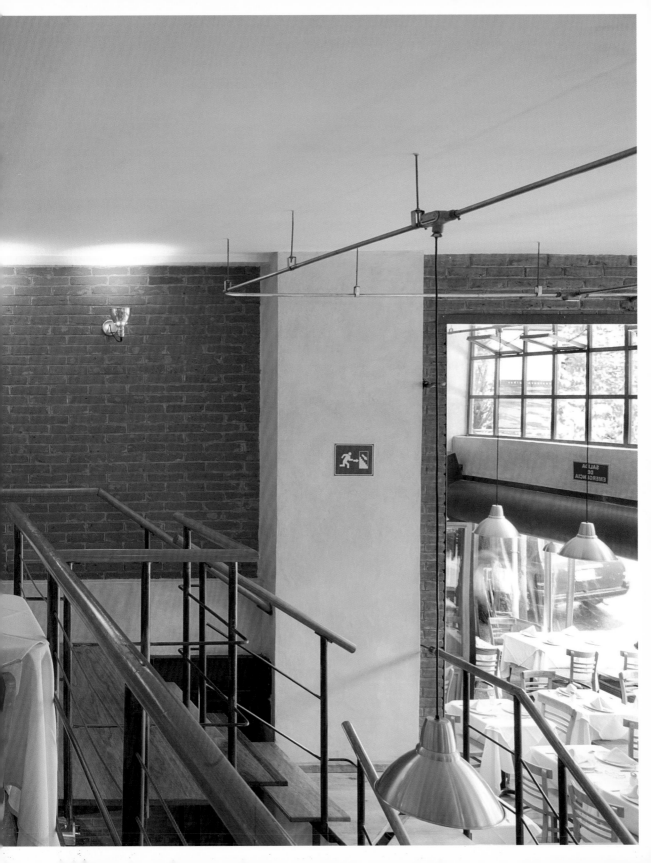

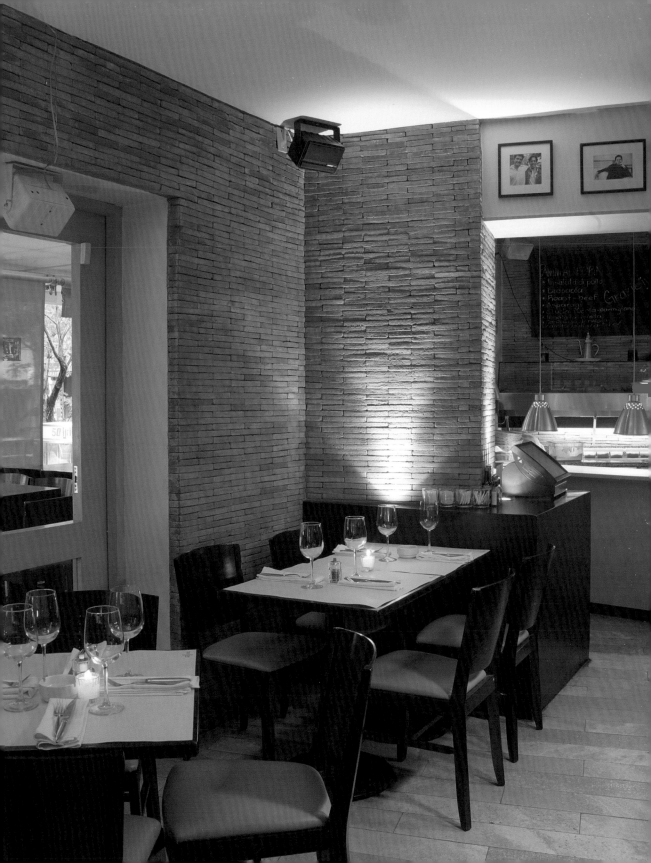

SERRANO MONJARÁS ARQUITECTOS | MEXICO CITY
50 Friends
Leisure Spaces
Colonia Condesa, Mexico City | 2005
Photos: Martin Nicholas Kunz, Michelle Galindo

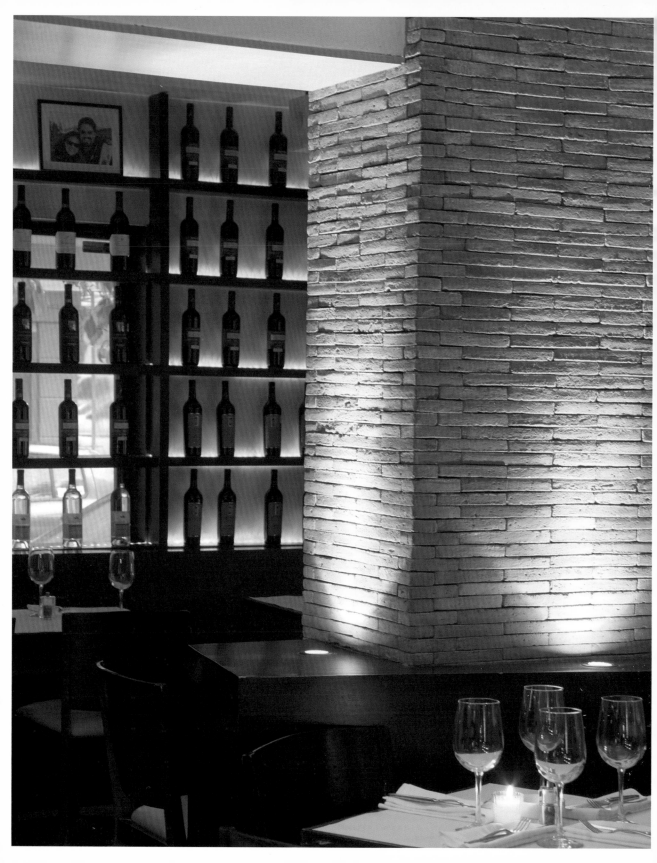

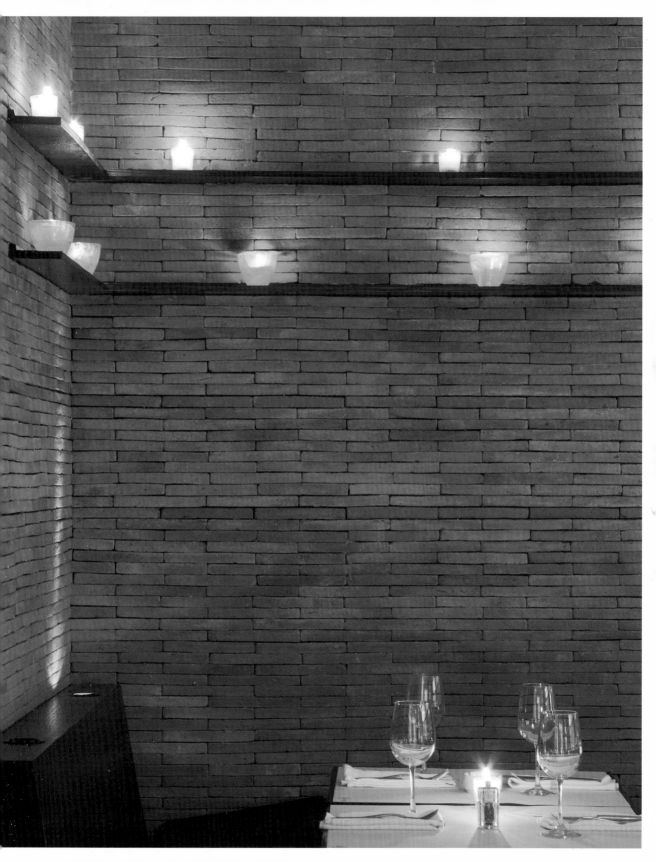

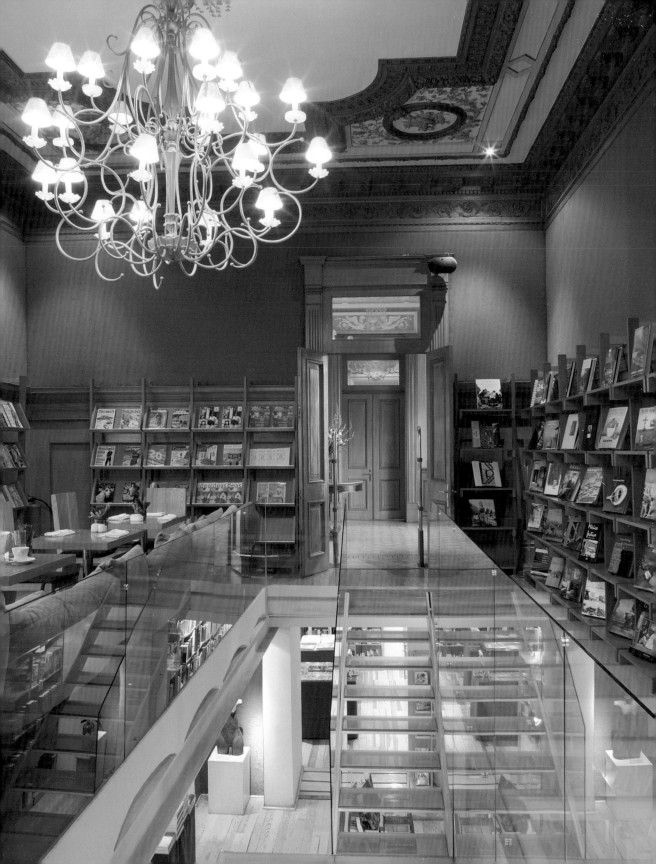

**SERRANO MONJARÁS ARQUITECTOS | MEXICO CITY
ENRIQUE MACOTELA, PABLO SERRANO**
Restaurante Lamm
www.lamm.com.mx
Leisure Spaces
Colonia Condesa, Mexico City | 2005
Photos: Martin Nicholas Kunz, Michelle Galindo

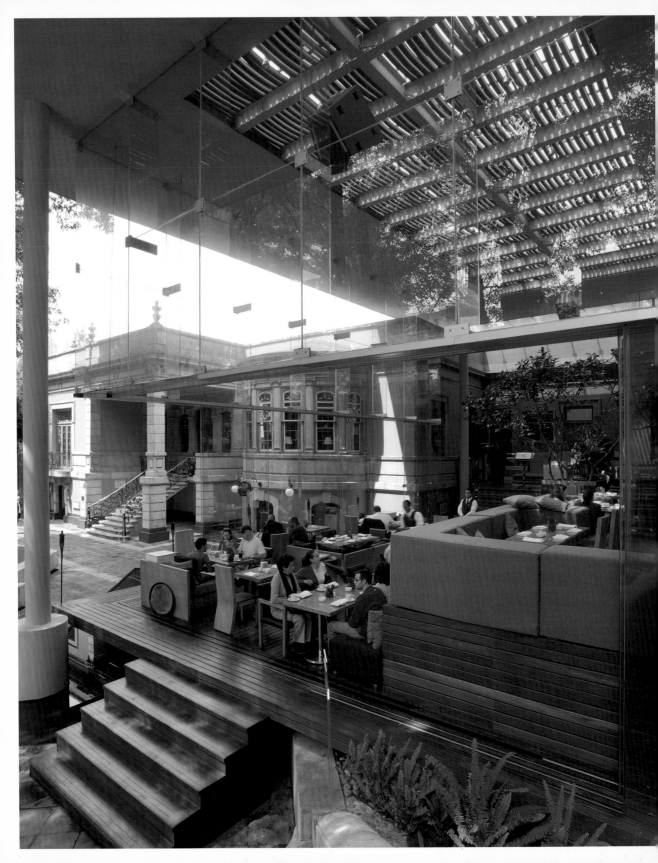

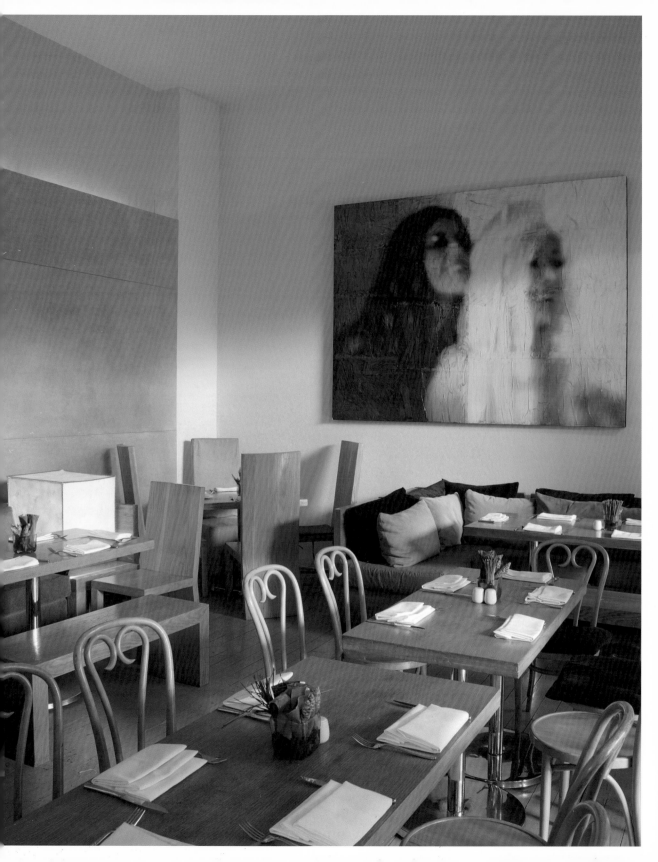

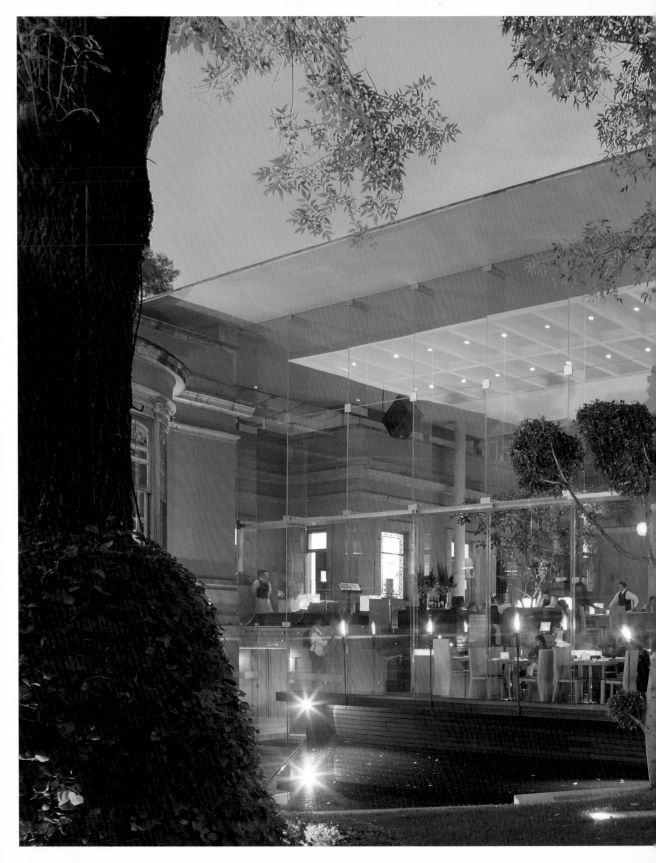

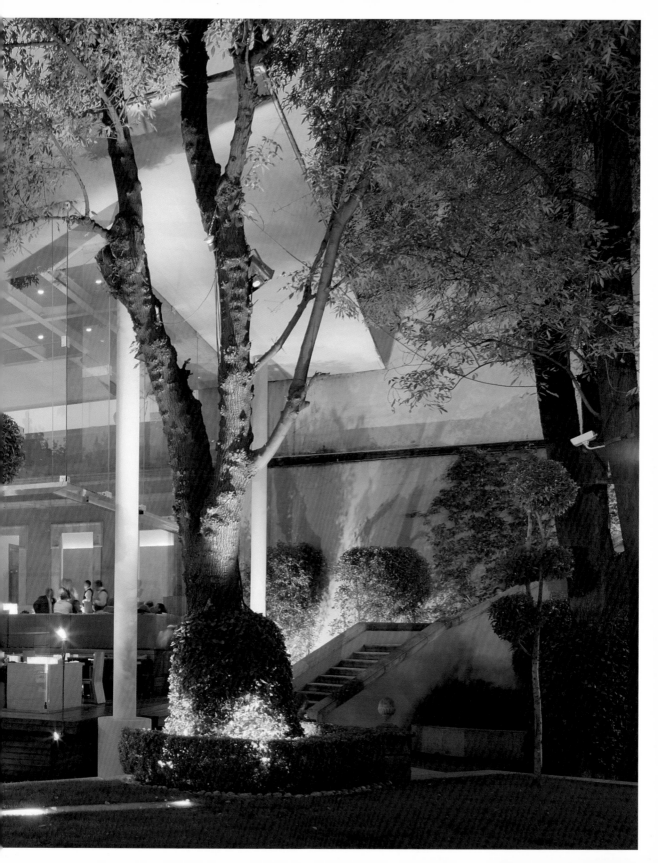

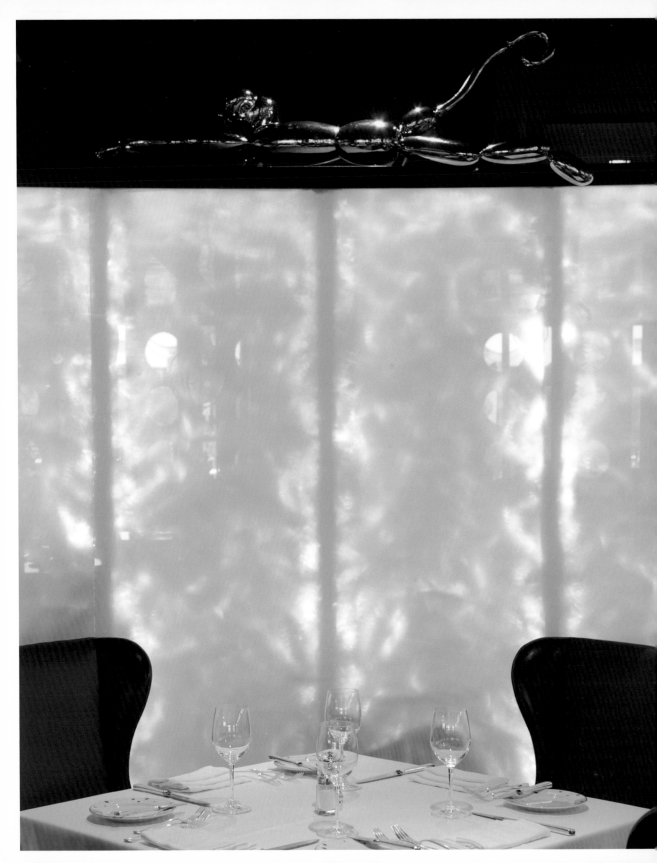

TIHANY DESIGN| NEW YORK
Le Cirque (Camino Real México)
Leisure Spaces
Mexico City | 2003
Photos: Martin Nicholas Kunz, Michelle Galindo

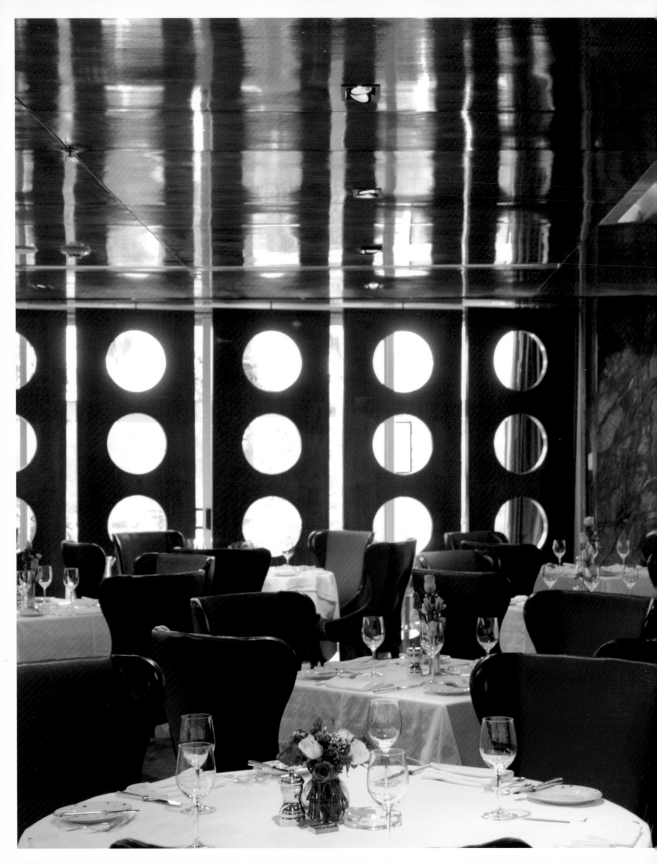

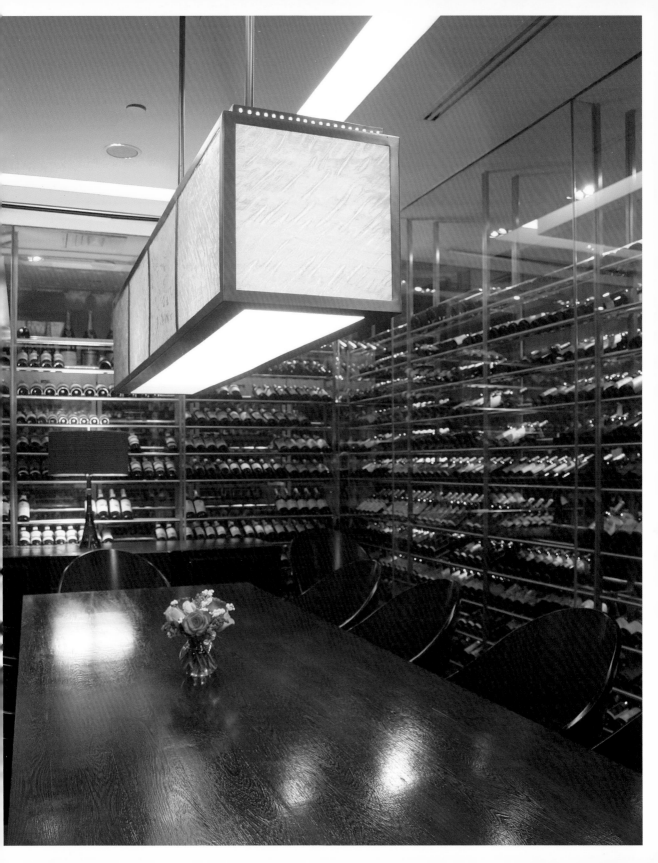

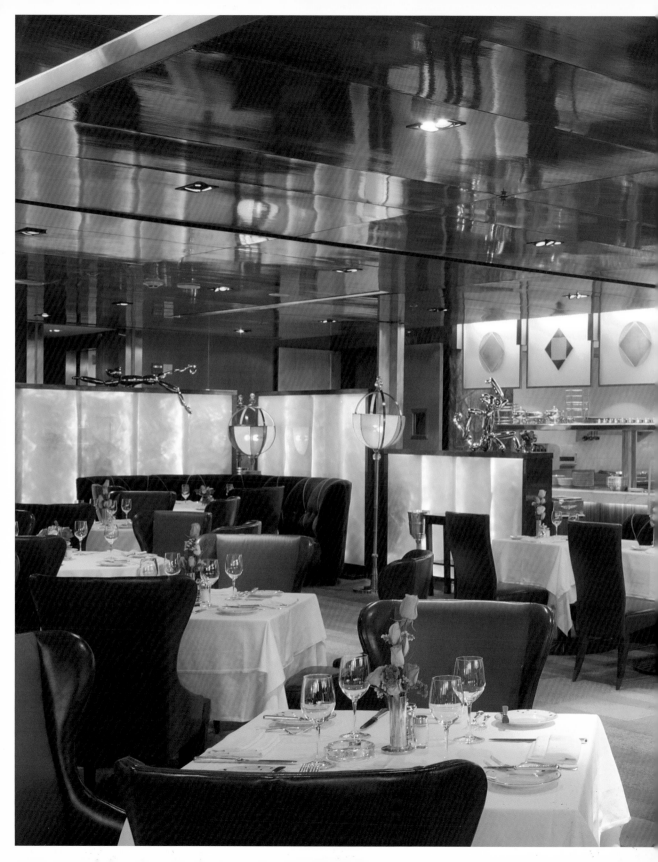

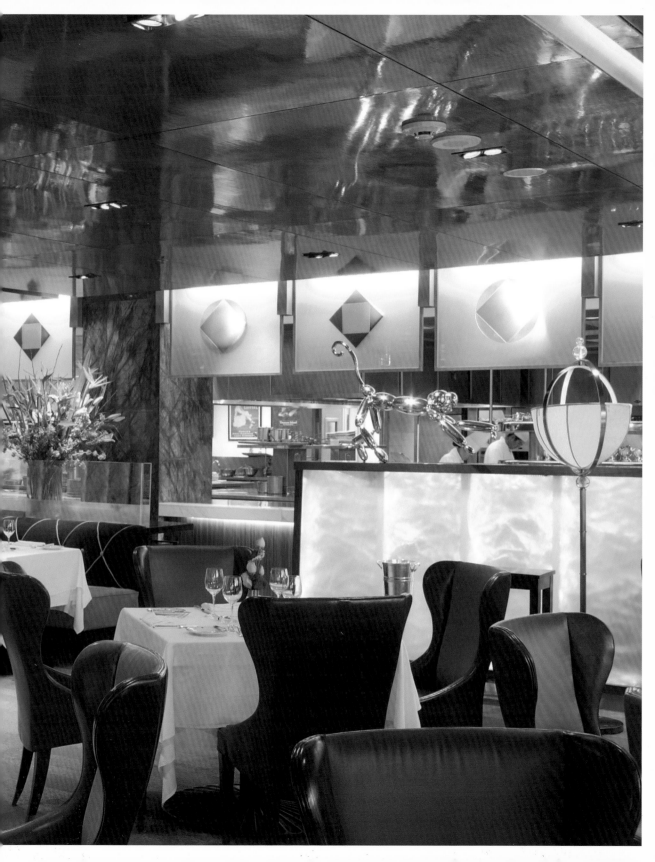

RETAIL SPACES – SHOWROOMS, SHOPS & MARKETS

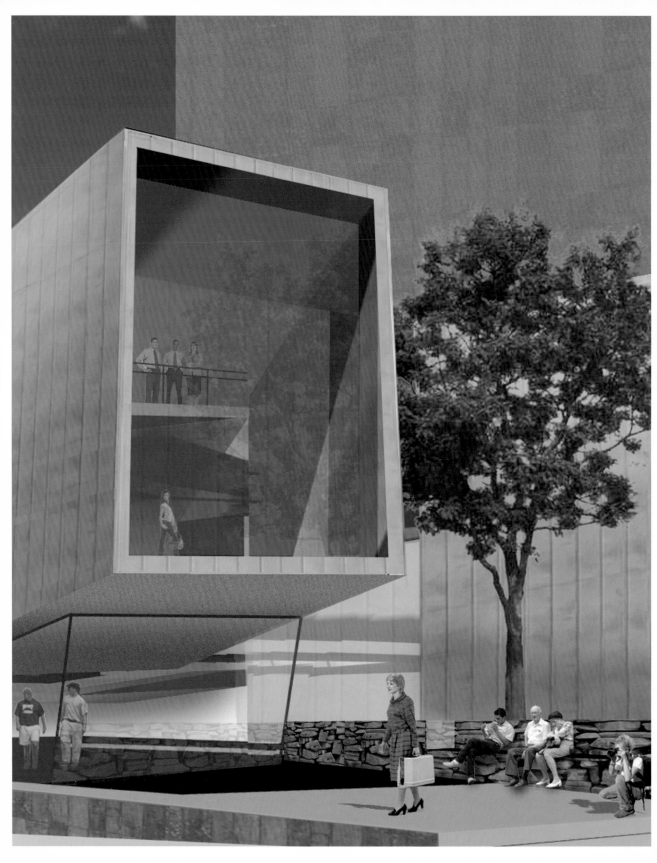

ARQUITECTURA 911SC | MEXICO CITY
Librería Porrúa – Insurgentes
Retail Spaces
Mexico City | 2003
Renderings: arquitectura 911sc

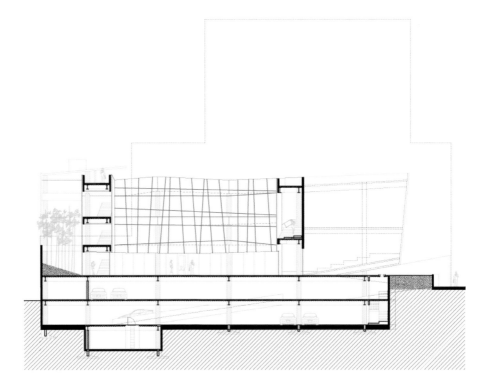

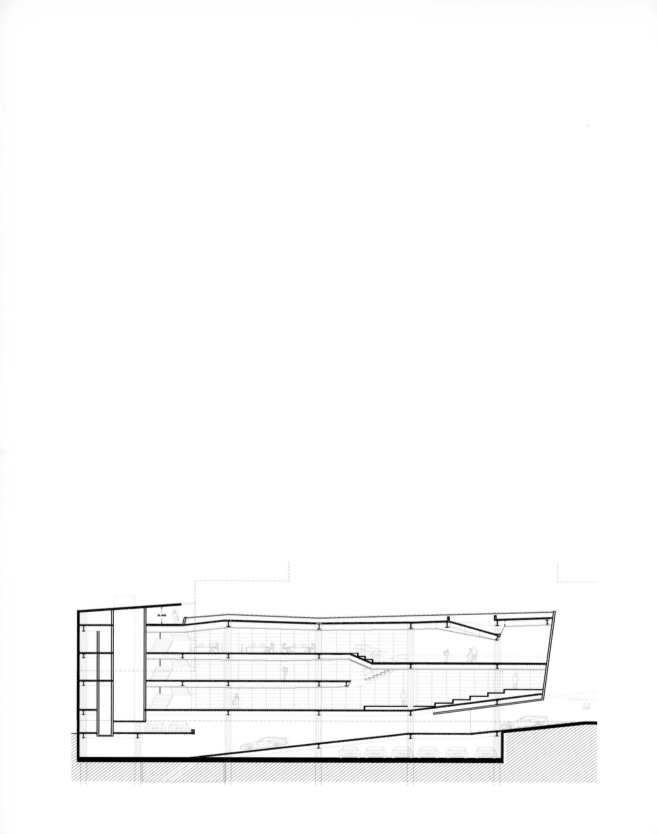

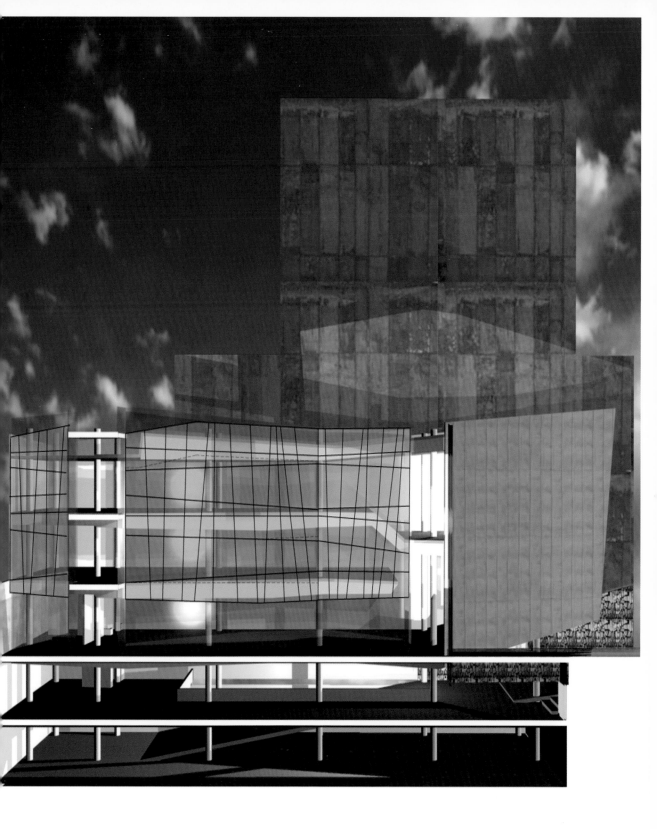

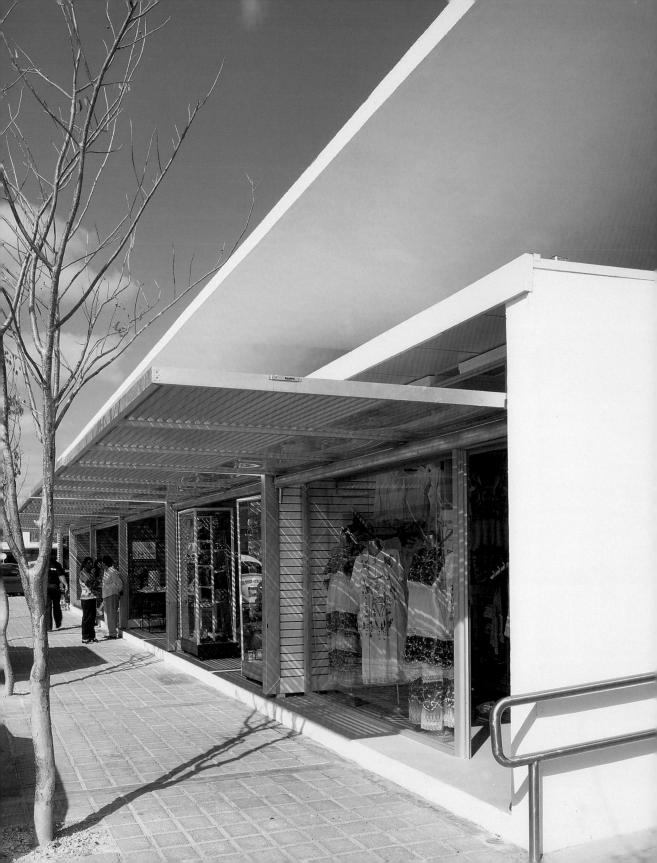

DUARTE AZNAR ARQUITECTOS, S.C.P | **MÉRIDA, YUCATÁN**
Mercado de Santa Ana
Retail Spaces
Mérida, Yucatán | 2003
Photos: Roberto Cárdenas Cabello

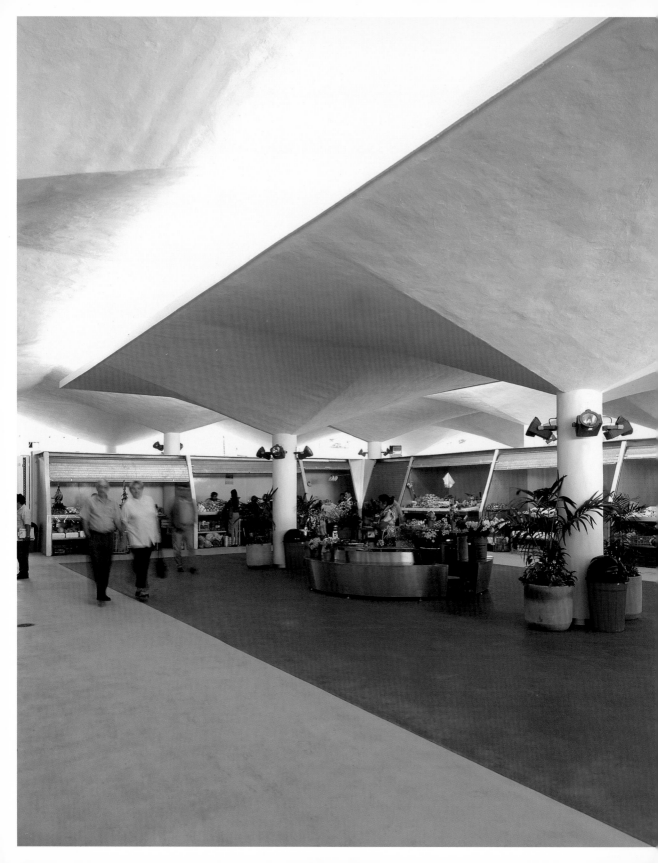

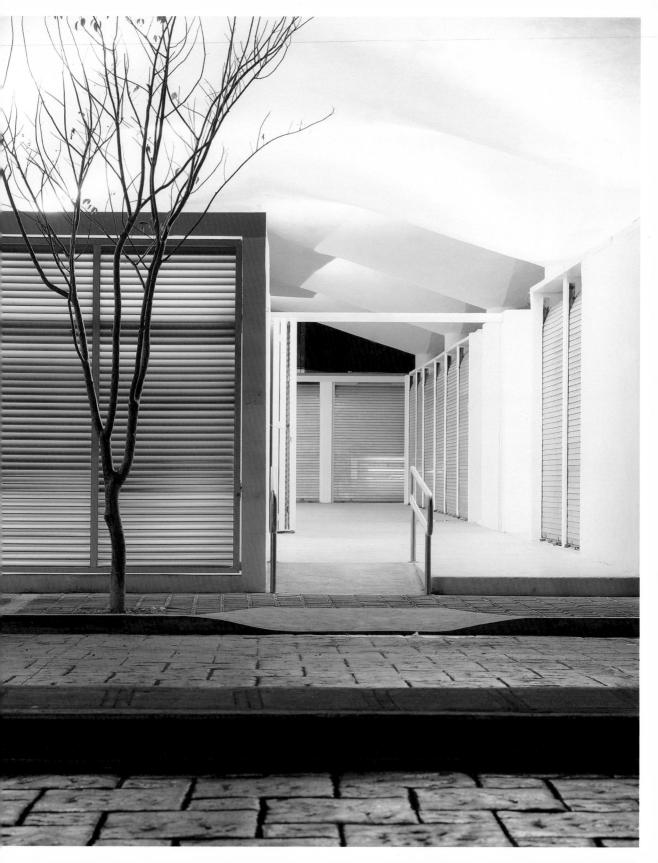

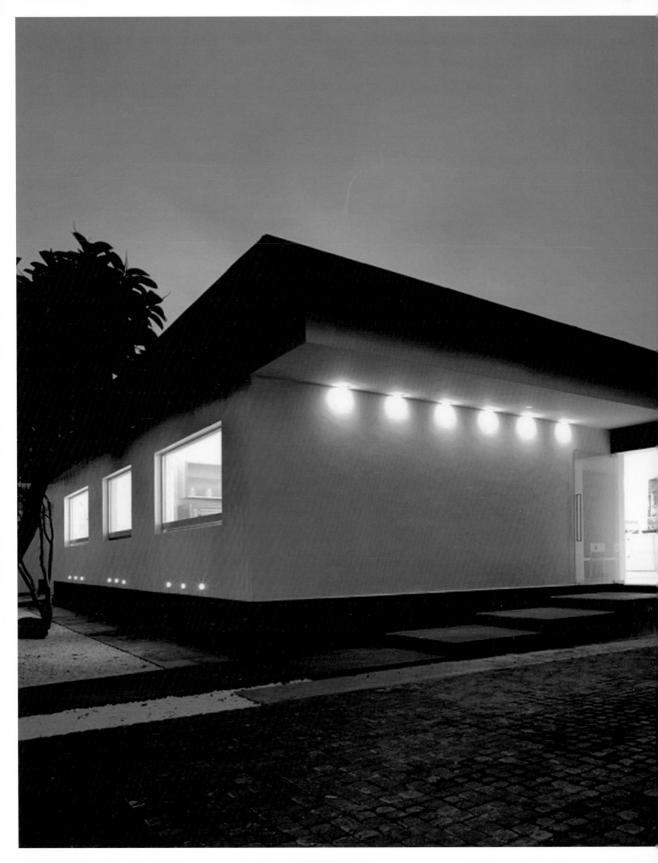

HIGUERA + SÁNCHEZ | MEXICO CITY
Piacere 2
Retail Spaces
Colonia Polanco, Mexico City | 2002
Photos: Luis Gordoa

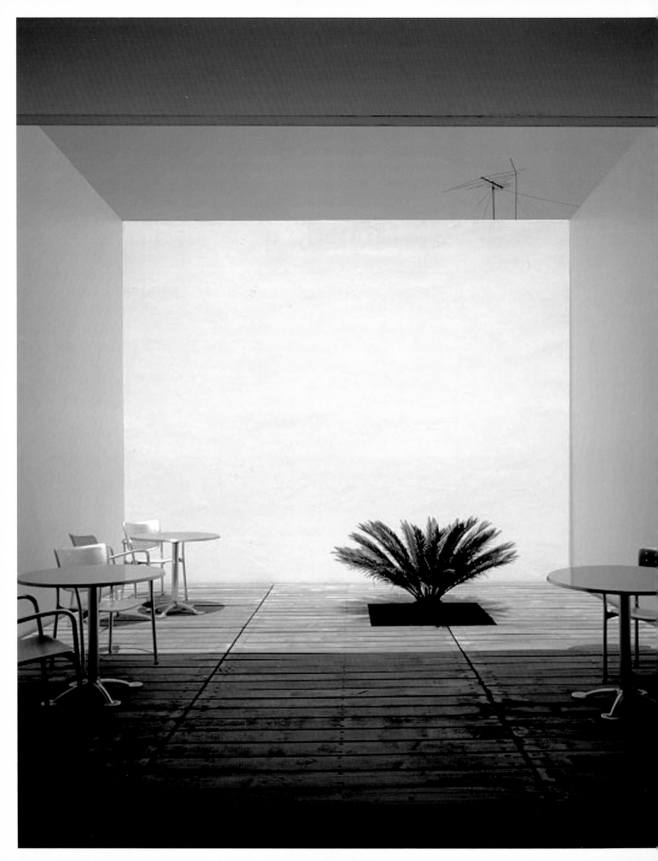

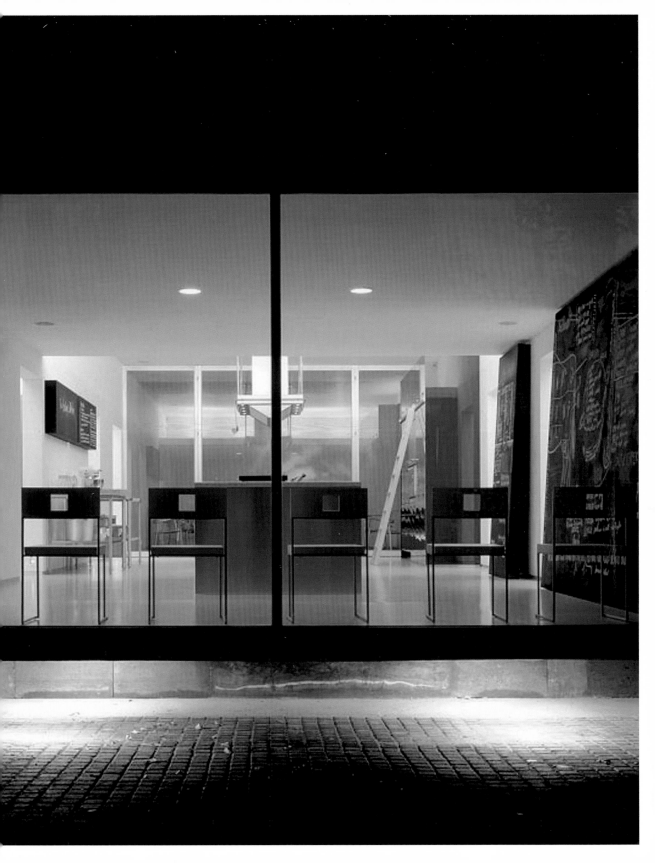

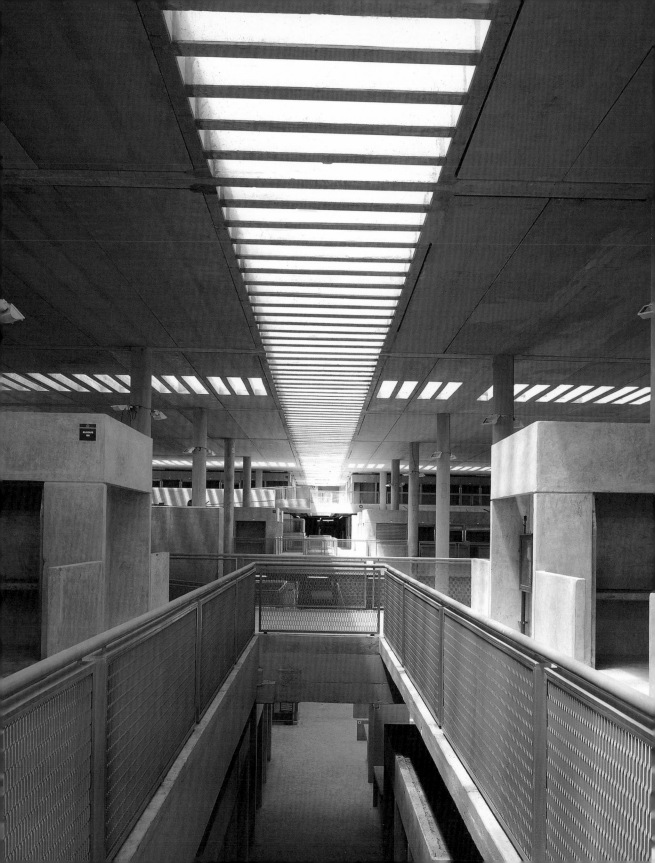

MUÑOZ-QUIJANO ARQUITECTOS | **MÉRIDA, YUCATÁN**
JAVIER MUÑOZ MENÉNDEZ, AUGUSTO QUIJANO AXLE

Mercado Municipal San Benito
Retail Spaces
Mérida, Yucatán | 2002
Photos: Roberto Cárdenas Cabello

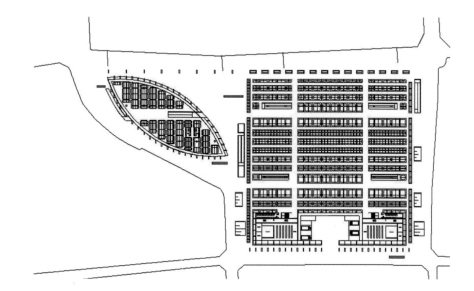

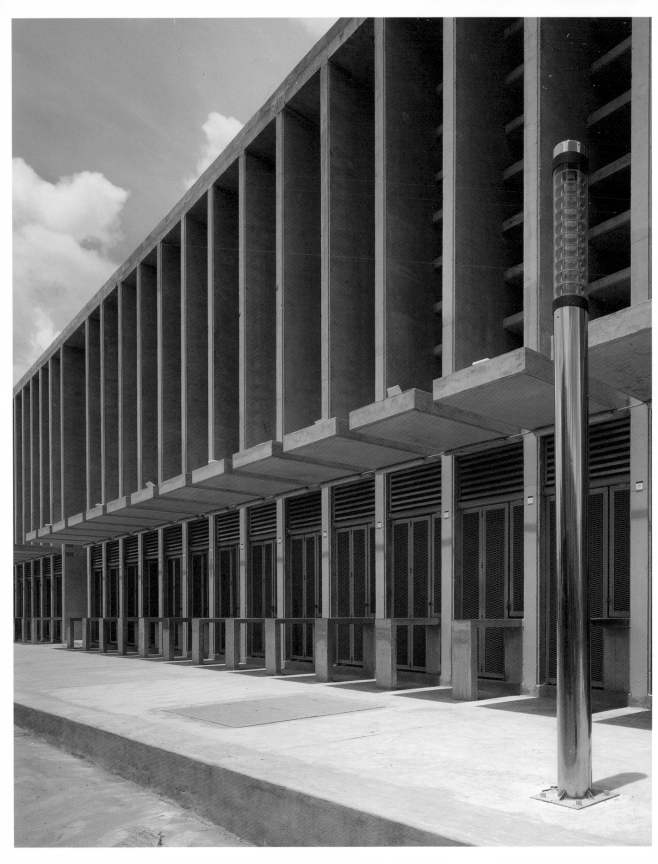

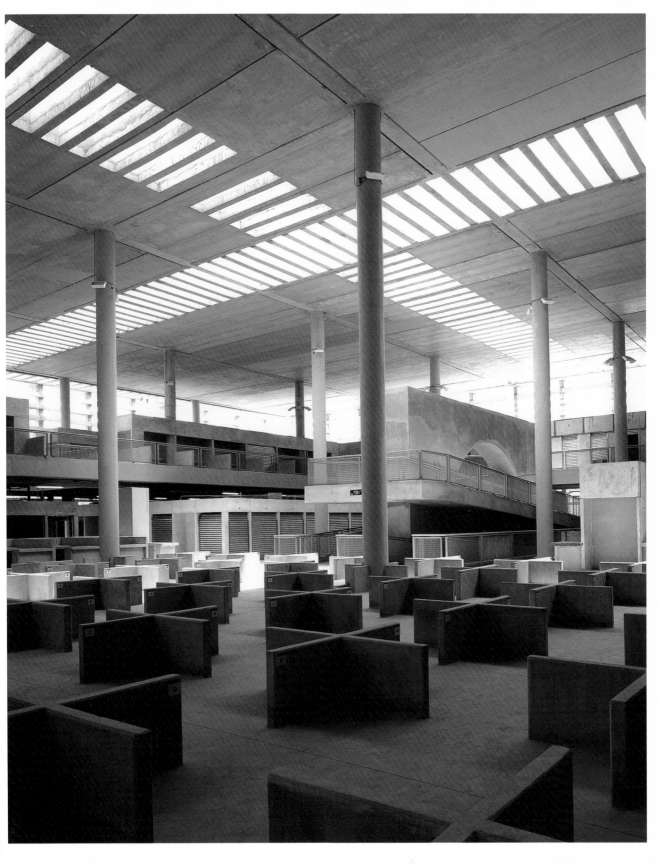

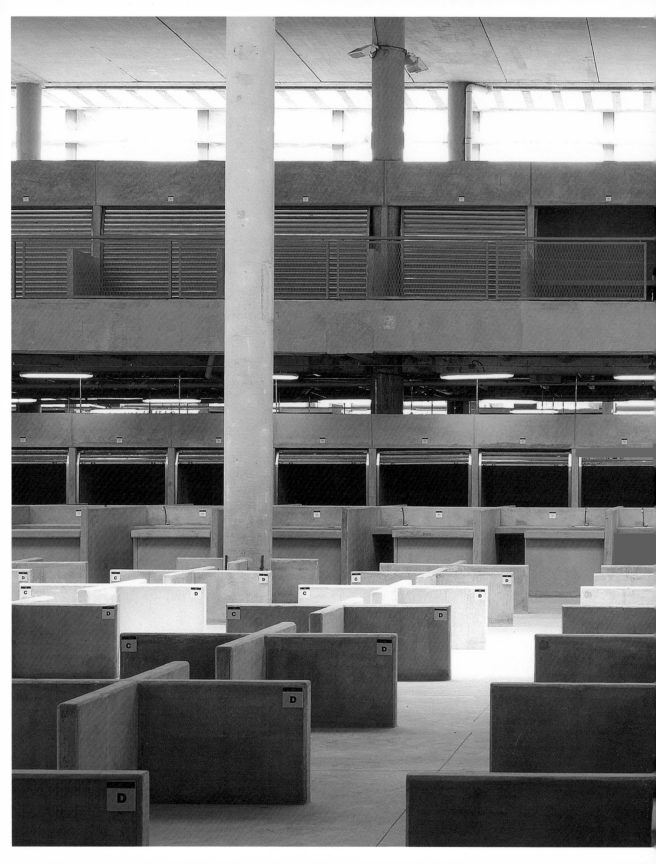

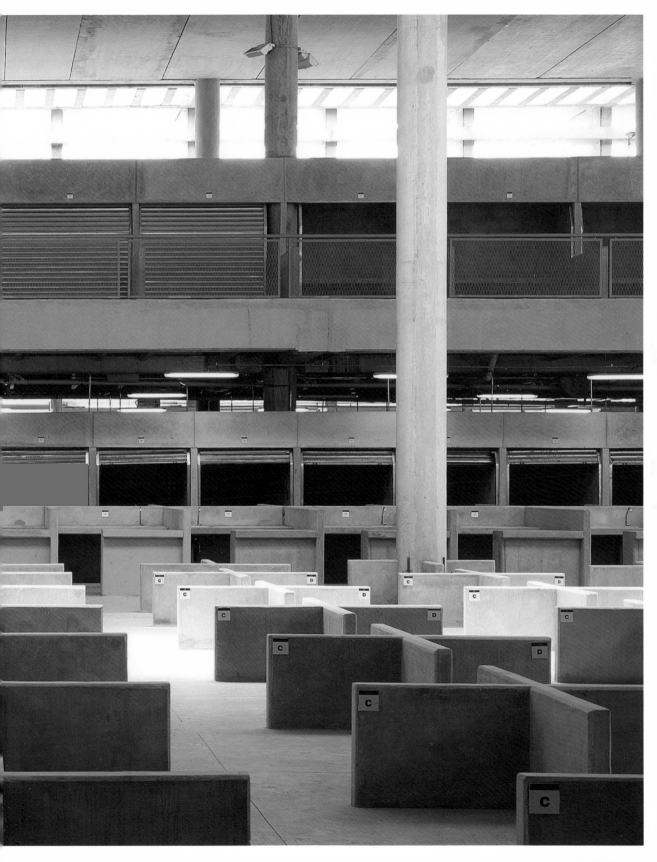

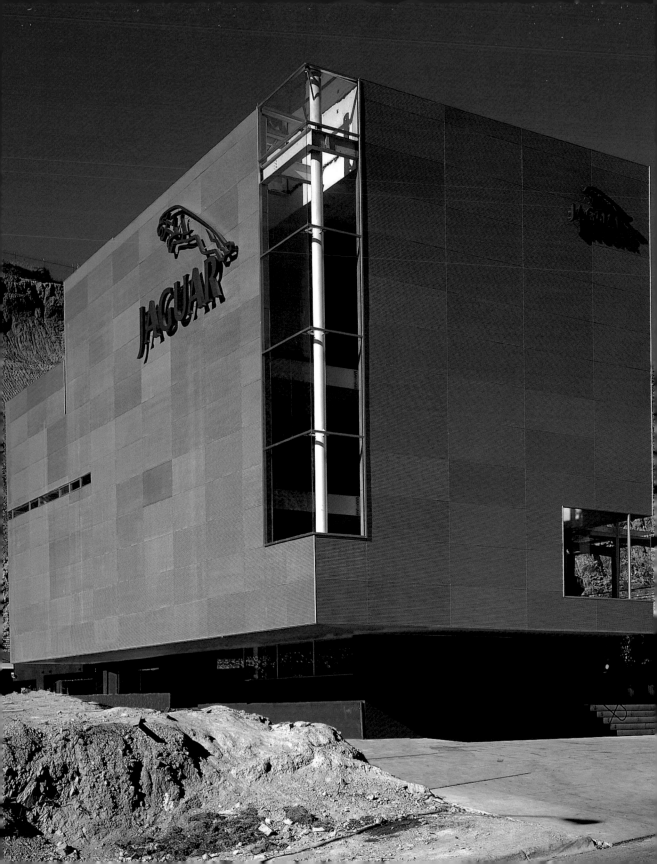

TALLER DE ENRIQUE NORTEN ARQUITECTOS, SC | MEXICO CITY (TEN ARQUITECTOS)
Jaguar Dealership
Retail Spaces
Mexico City | 1997
Photos: Luis Gordoa

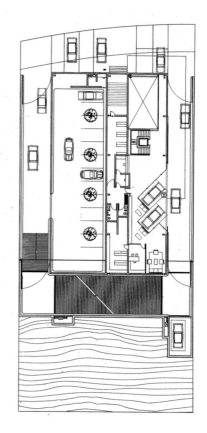

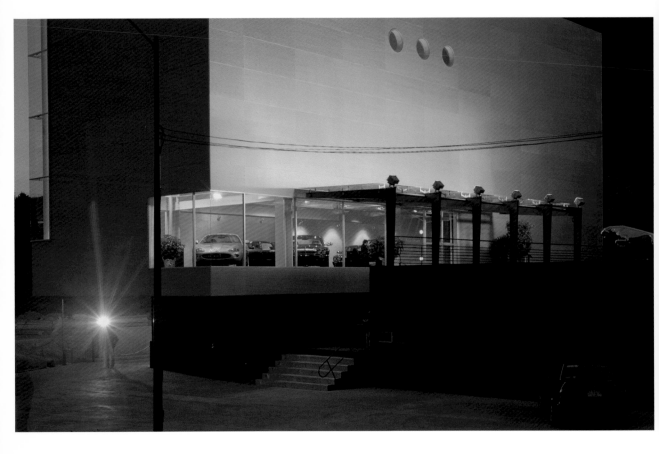

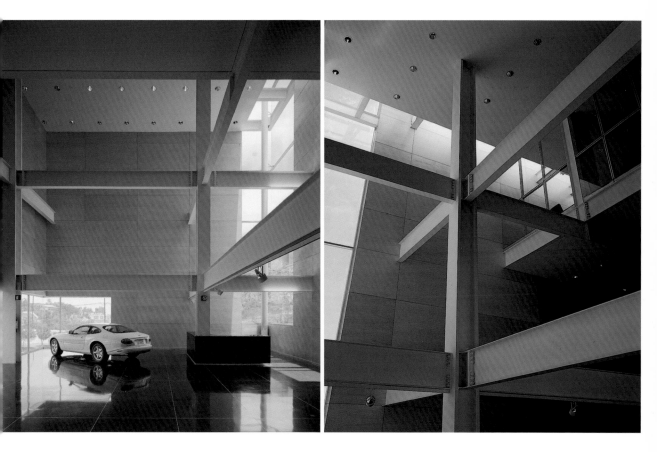

WORKING SPACES – CORPORATE BUILDINGS & INTERIORS

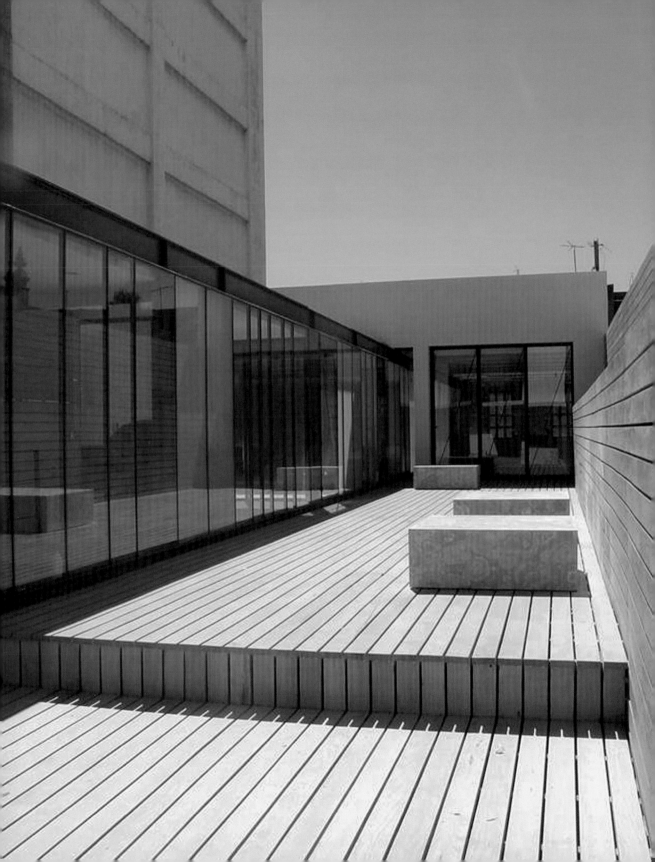

ARQUITECTURA 911SC | MEXICO CITY
Edificio de Oficinas Justo Sierra 32
Working Spaces
Mexico City | 2003
Photos: Luis Gordoa

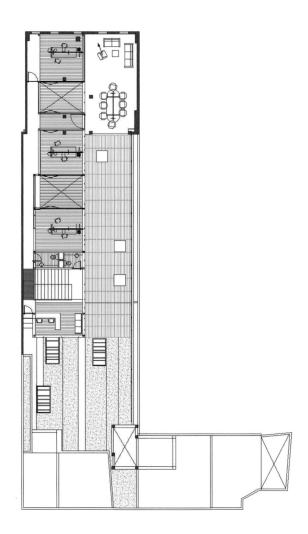

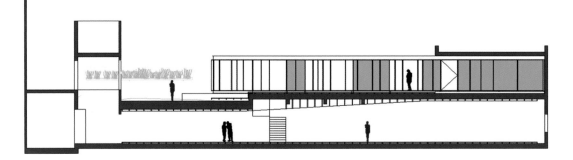

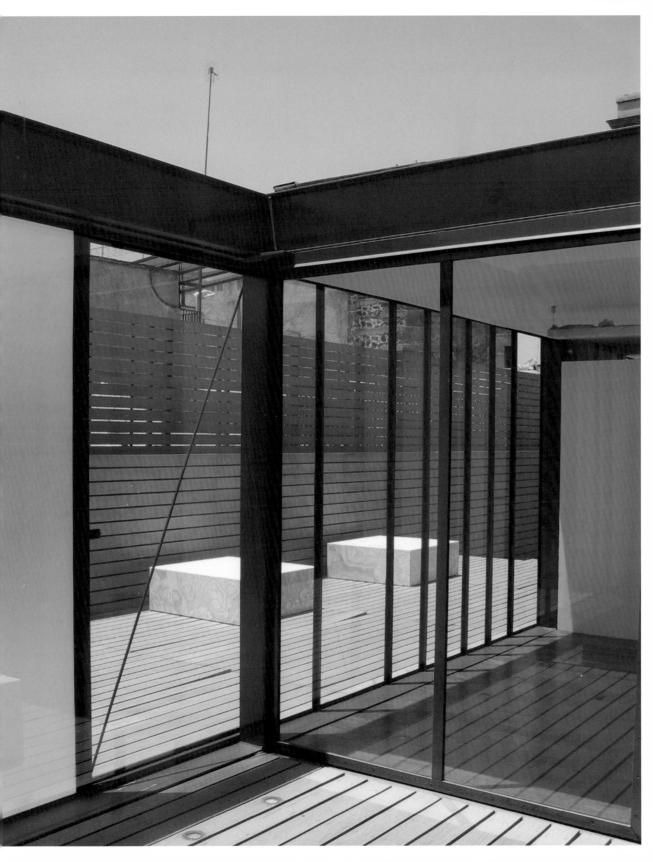

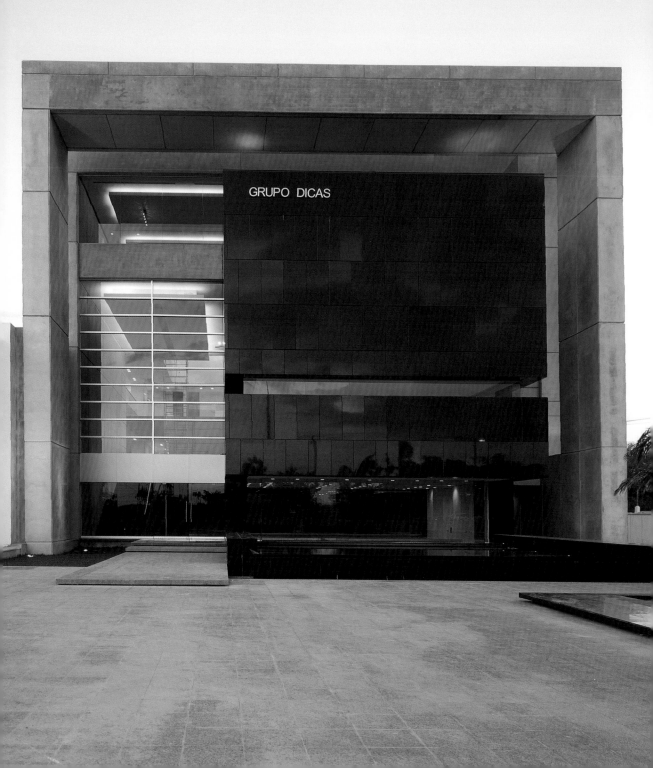

AUGUSTO QUIJANO ARQUITECTOS, S.C.P. | MÉRIDA, YUCATÁN
ENRIQUE CABRERA PENICHE, AUGUSTO QUIJANO AXLE
Corporativo Dicas
Working Spaces
Mérida, Yucatán | 2004
Photos: Roberto Cárdenas Cabello, Ignacio Rivero Bulnes (374, 377)

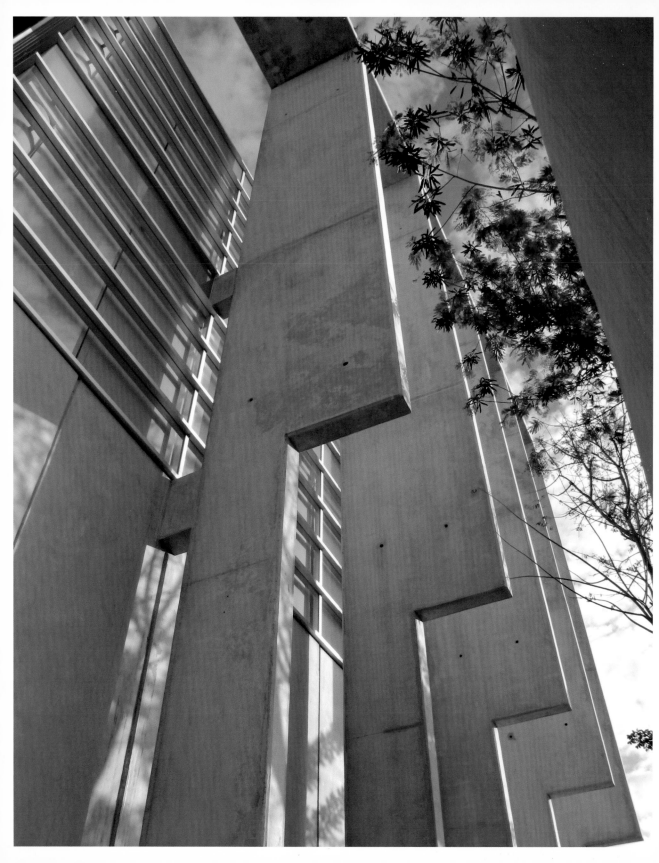

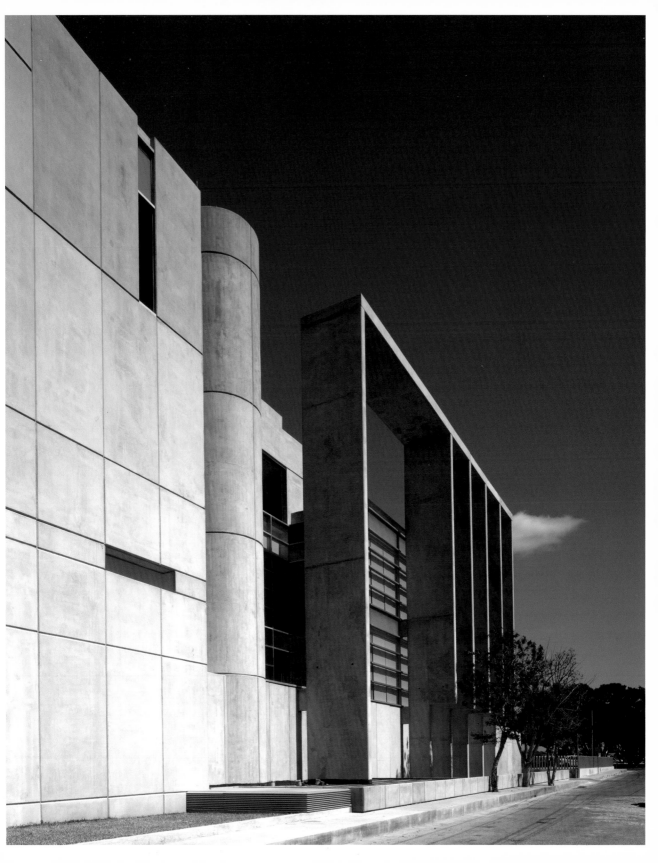

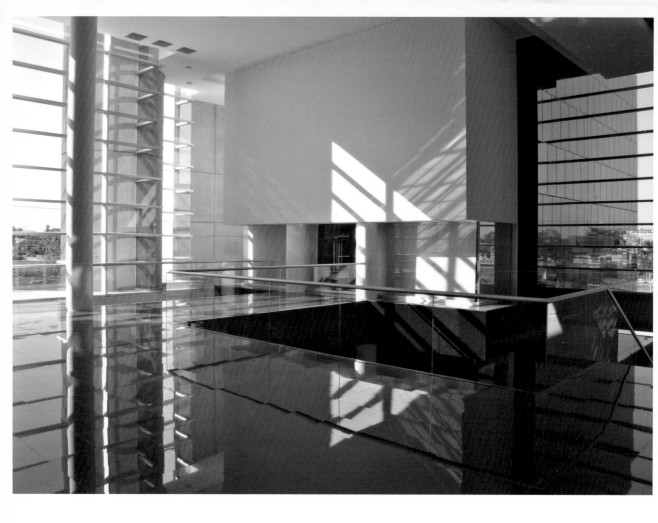

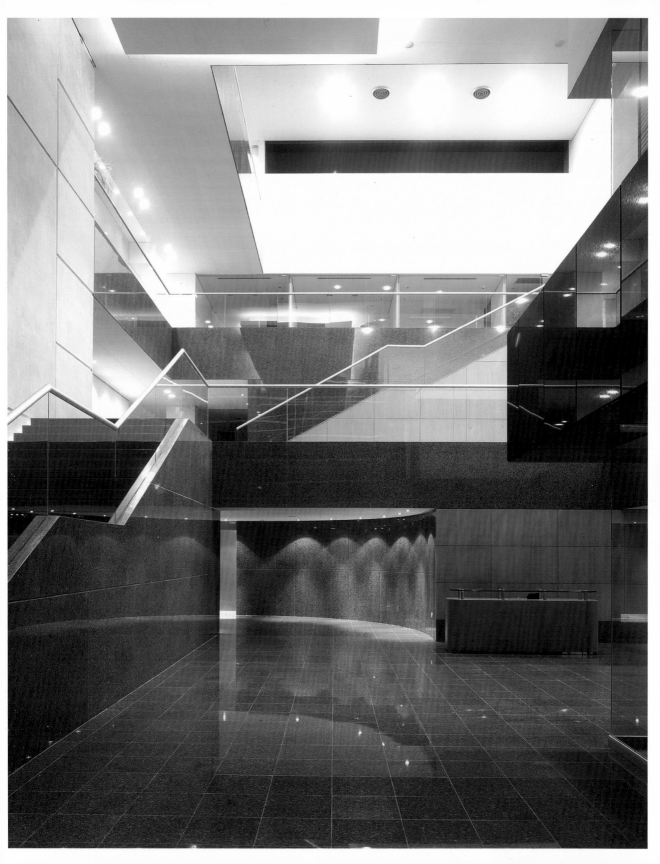

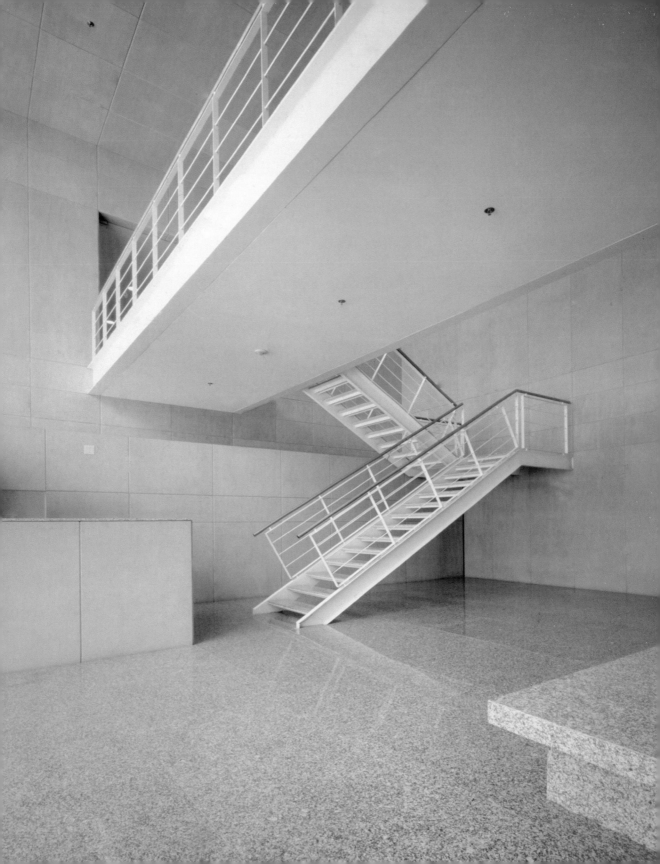

CENTRAL DE ARQUITECTURA | MEXICO CITY
Corporativo EVT
Working Spaces
Mexico City | 2001
Photos: Luis Gordoa

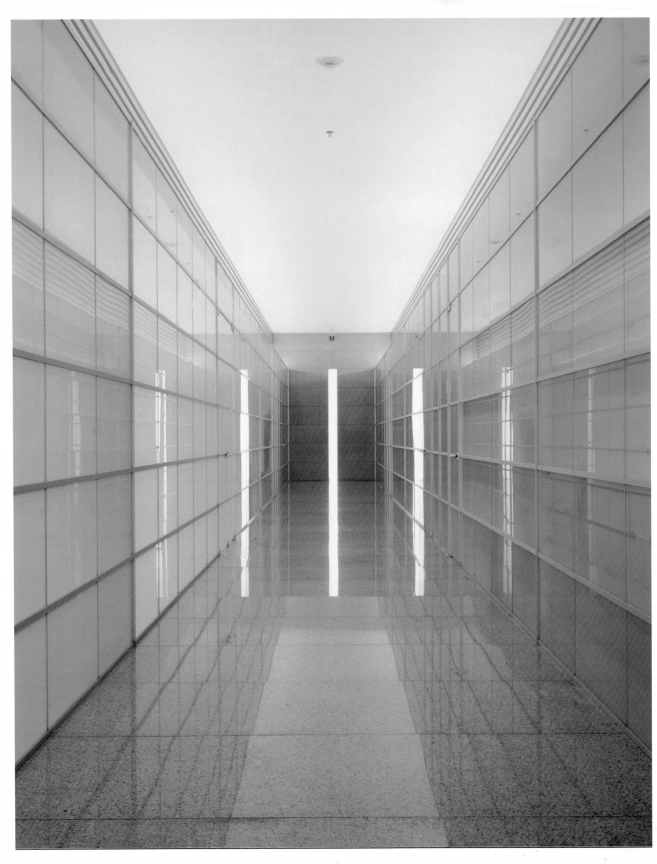

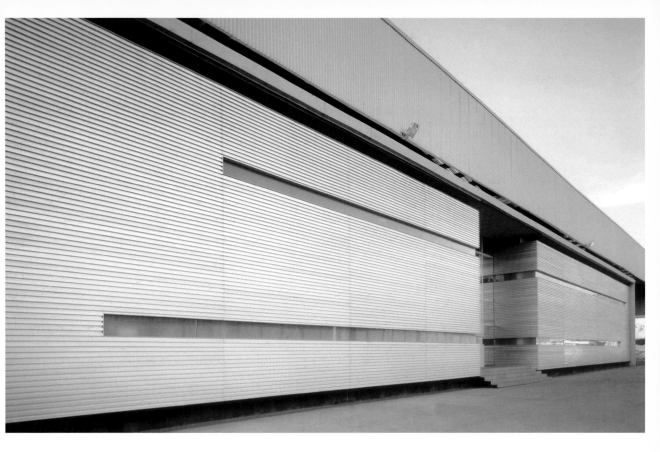

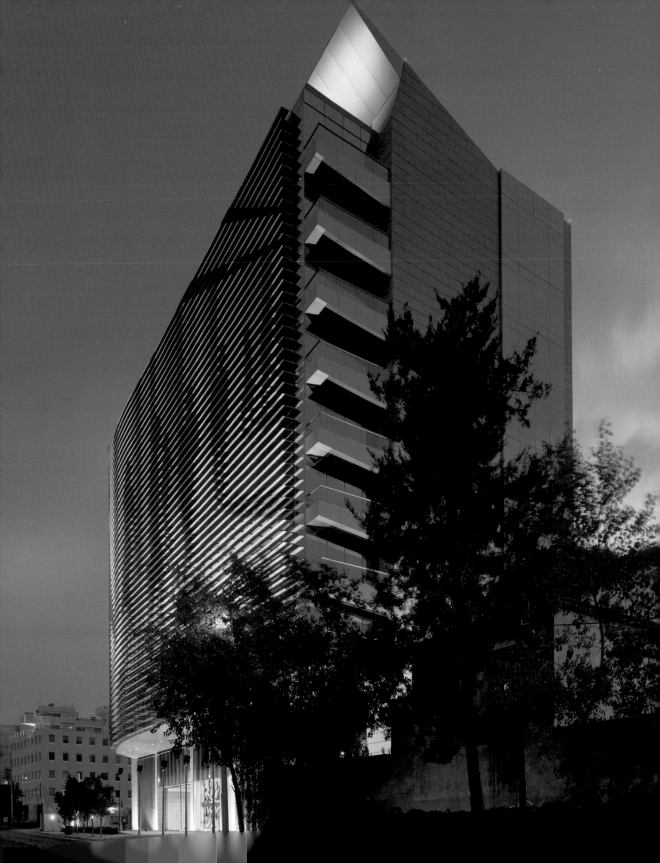

JAIME VARON, ABRAHAM & ALEX METTA, MIDGAL ARQUITECTOS | MEXICO CITY
Corporativo Las Flores
Working Spaces
Mexico City | 2002
Photos: Paul Czitrom

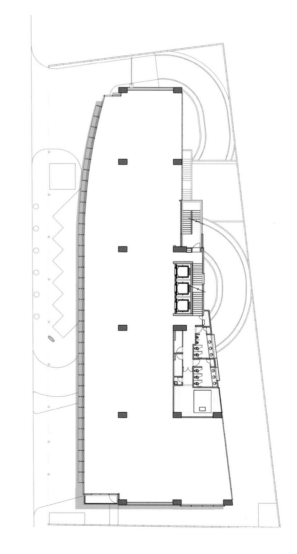

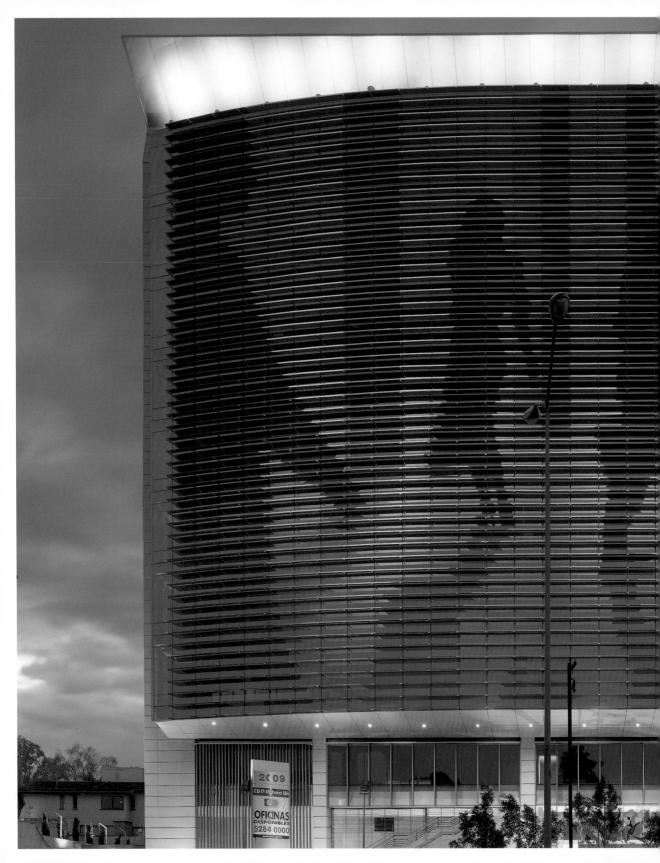

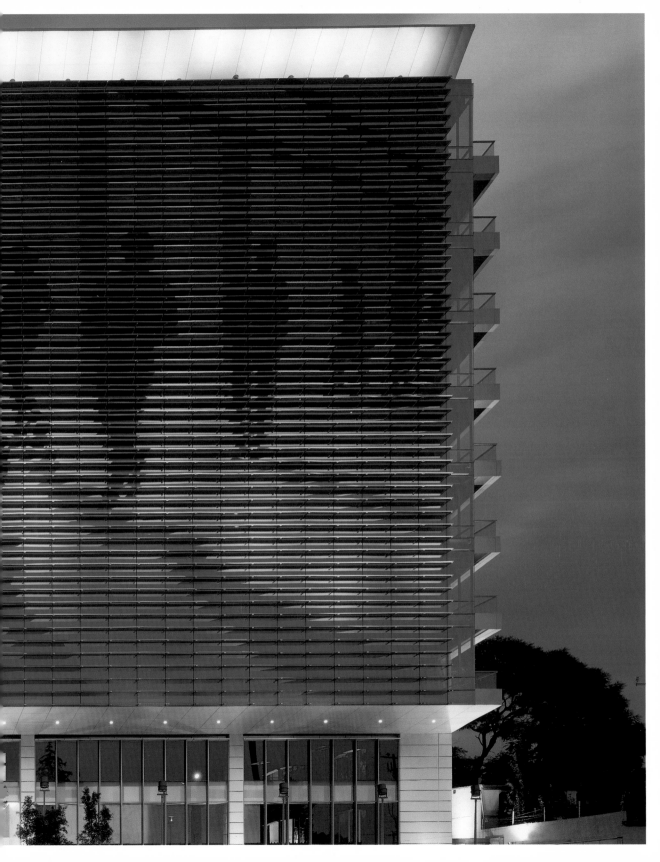

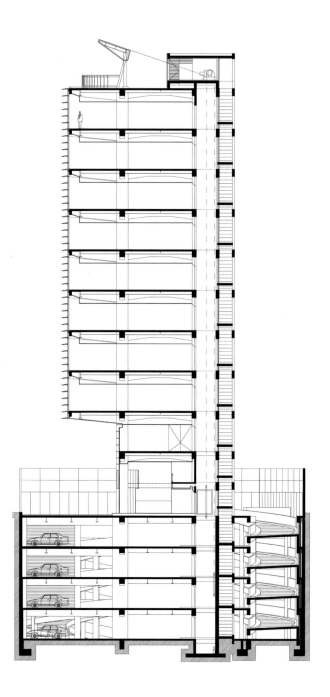

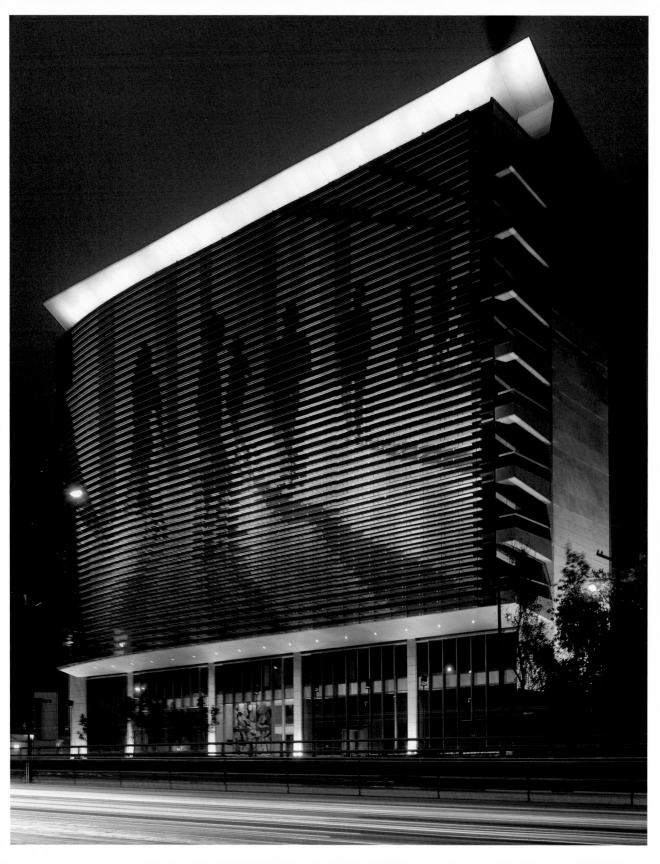

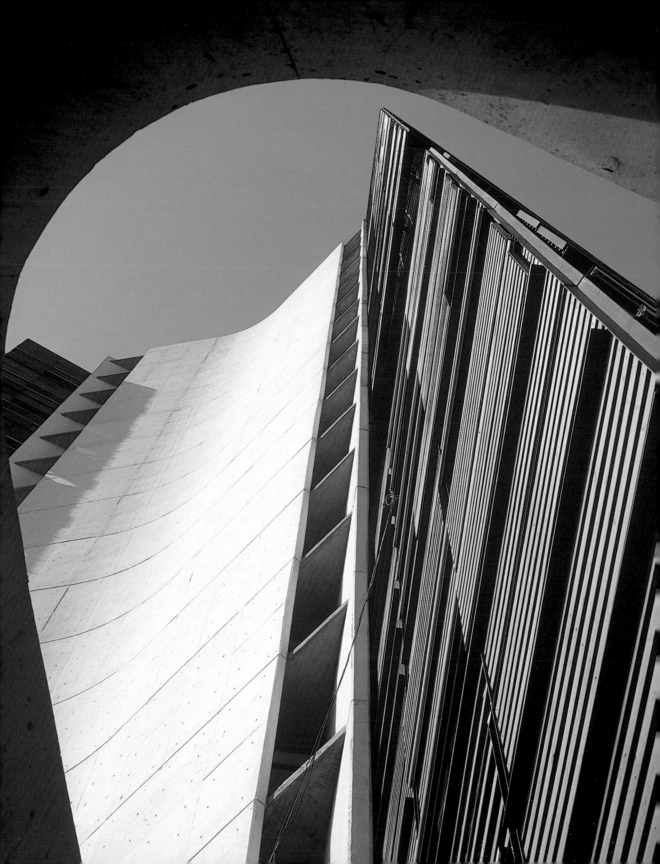

ESTUDIO CARME PINOS | SPAIN
JUAN ANTONIO ANDREU, SAMUEL ARRIOLA
FREDERIC JORDAN, CESAR VERGES
Torre Cubo
Working Spaces
Puerta de Hierro, Guadalajara, Jalisco | 2005
Photos: Claudia Arechiga

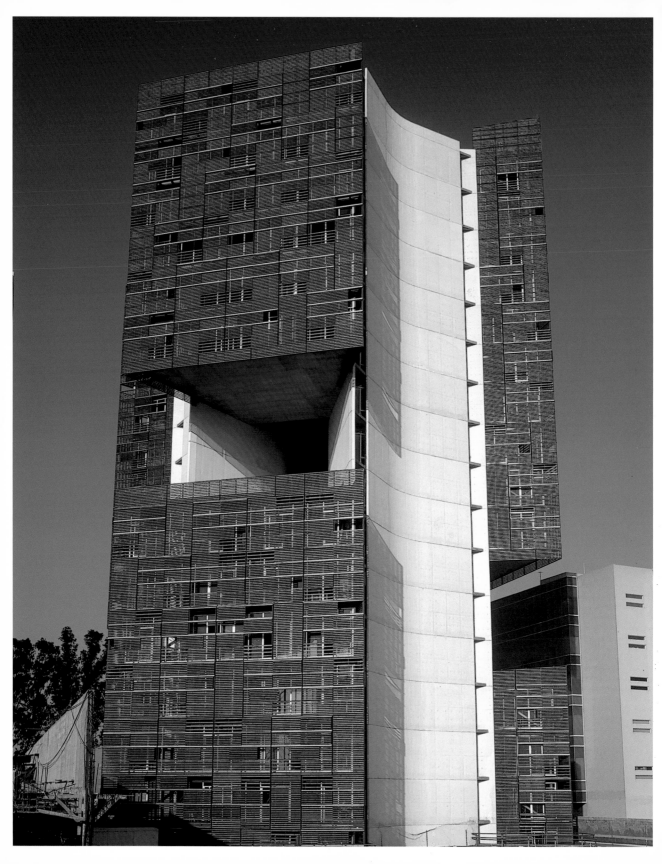

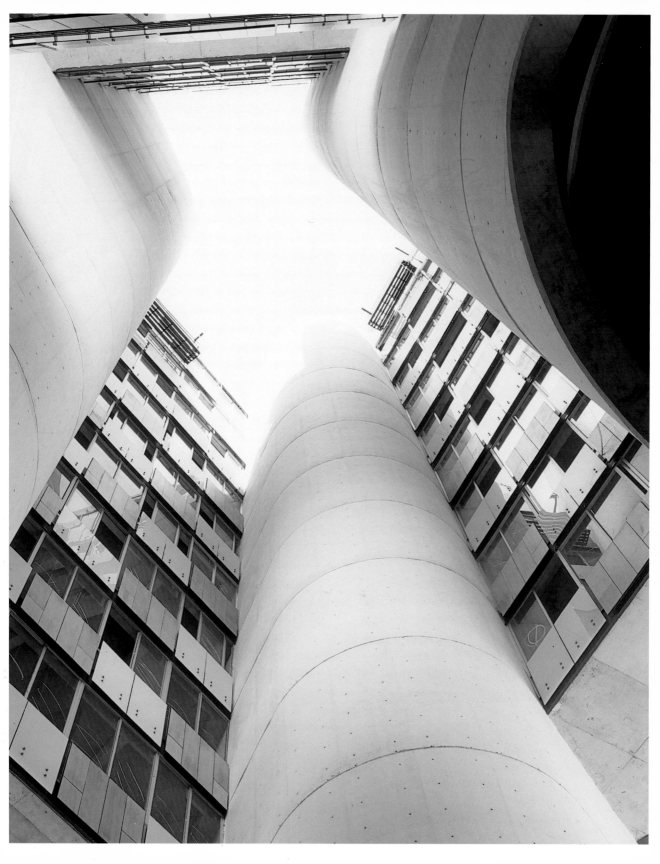

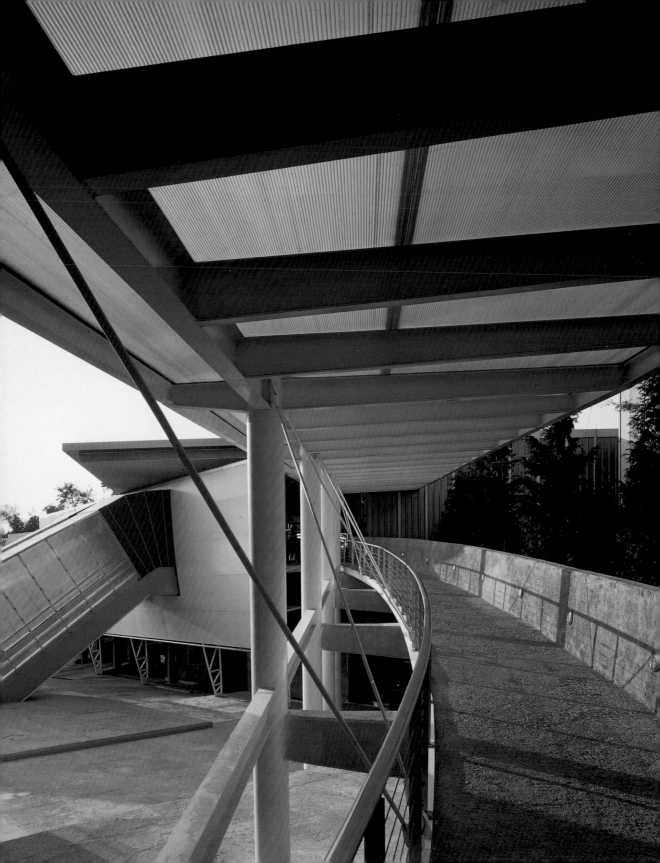

TALLER DE ENRIQUE NORTEN ARQUITECTOS, SC | MEXICO CITY (TEN ARQUITECTOS)
Televisa Dinning Hall
Mexico City | 1993
Photos: Luis Gordoa

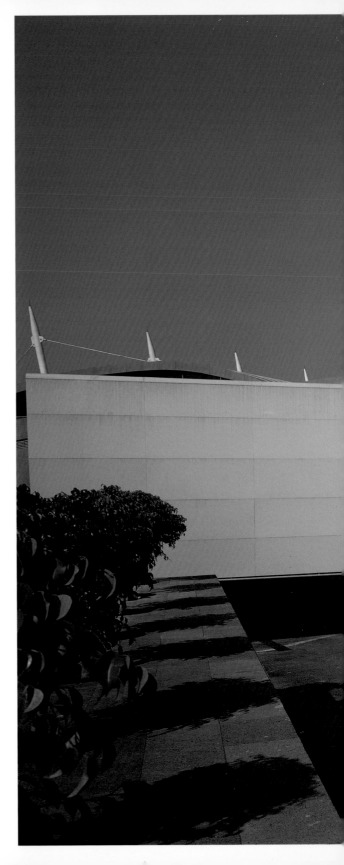

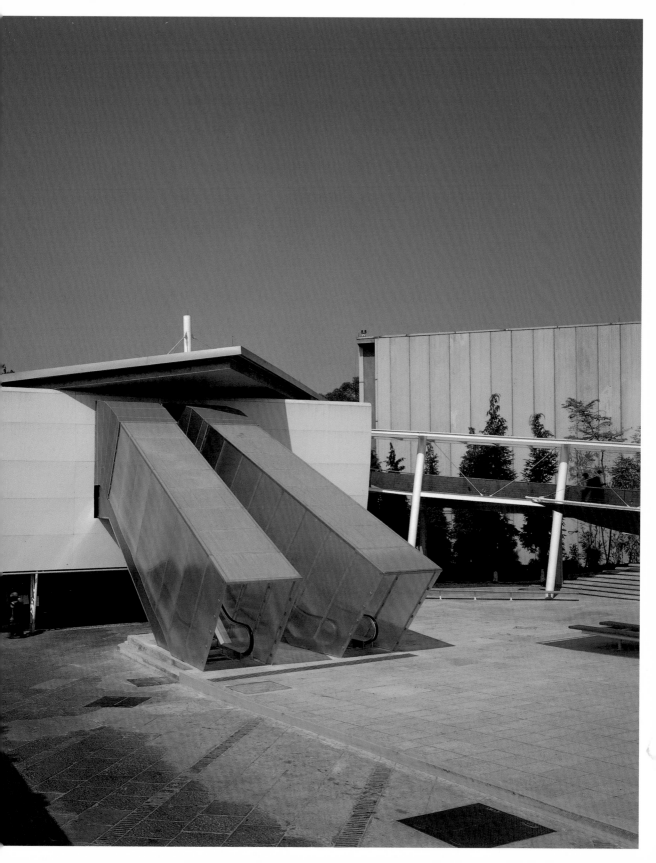

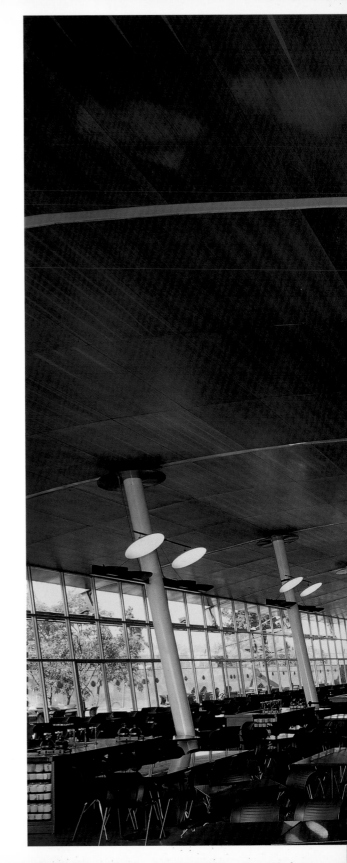

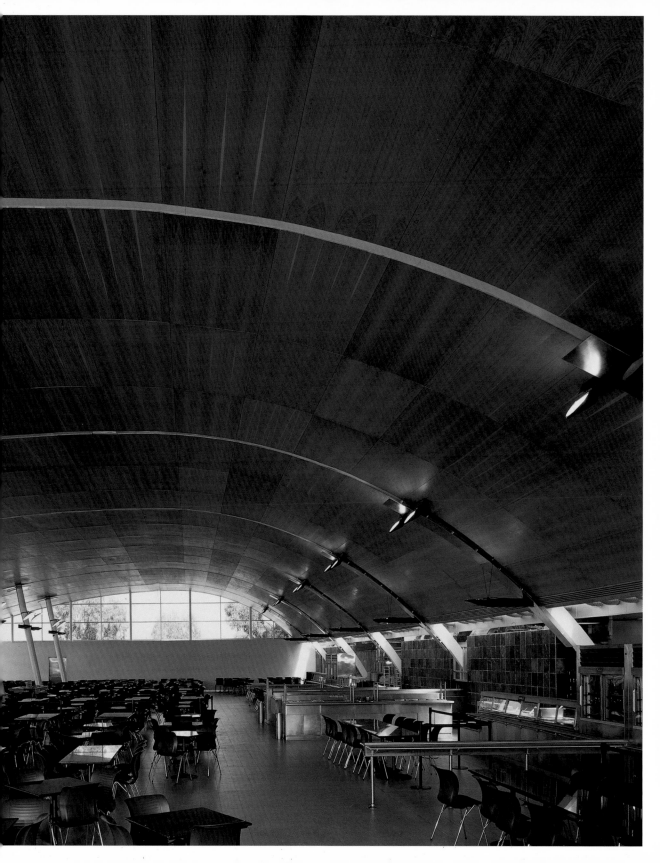

Index

© 2005 daab
cologne london new york

published and distributed worldwide by
daab gmbh
friesenstr. 50
d – 50670 köln

p +49-221-94 10 740
f +49-221-94 10 741

mail@daab-online.de
www.daab-online.de

publisher ralf daab
rdaab@daab-online.de

art director feyyaz
mail@feyyaz.com

editorial project by fusion publishing gmbh stuttgart . los angeles
editorial direction martin nicholas kunz
edited & written by michelle galindo
editorial coordination carolina valencia
layout michelle galindo
imaging & pre-press nicole rankers

german translation martin nicholas kunz
french translation jocelyne abarca
spanish translation michelle galindo
italian translation vincenzo ferrara

© 2005 fusion publishing, www.fusion-publishing.com

special thanks to the brignone family, camino real méxico, condesa df, deseo,
habita hotel, sheraton centro histórico and las ventanas al paraíso for their support.

printed in spain
gràfiques ibèria, spain
www.grupgisa.com

isbn 3-937718-52-4
d.l.: B-39634-2005